Americans in Brittany and Normandy

1860-1910

Catalogue and essay by
David Sellin

Exhibition organized by
James K. Ballinger

This exhibition is made possible in part by grants from Mrs. John W. Kieckhefer, an anonymous donor and the National Endowment for the Arts, a Federal Agency, Washington, D.C.

57. *In Brittany (Tremalo)*, 1897
oil on canvas
23½ x 28⅞ (59.7 x 73.3)
Hirschl and Adler Galleries, Inc., New York

88. *The Wedding March*, 1892
oil on canvas
22 x 26 (55.9 x 66.0)
Daniel J. Terra Collection: Terra Museum of American Art

Library of Congress Number 82-245-68
ISBN 0 910407 00 2

The Pennsylvania Academy of the Fine Arts
Philadelphia, Pennsylvania
September 24 to November 28, 1982

Amon Carter Museum
Ft. Worth, Texas
December 16, 1982 to February 6, 1983

Phoenix Art Museum
Phoenix, Arizona
March 18 to May 1, 1983

National Museum of American Art
Washington, D.C.
June 10 to August 14, 1983

Preface

Events never begin nor end on a convenient date for the art historian, but we historians continually struggle to package aspects of the world's cultural history for interpretation. This methodology is a necessity for the museum profession, and Hawthorne's introduction for *The Marble Faun*, finished December 15, 1859, provides the perfect springboard for a discussion of the present project, *Americans in Brittany and Normandy: 1860-1910.*

No author, without a trial, can conceive of the difficulty of writing a romance about a country where there is no shadow, no antiquity, no mystery, no picturesque and gloomy wrong, nor anything but a commonplace prosperity, in broad and simple daylight, as is happily the case with my dear native land. It will be very long, I trust, before romance-writers may find congenial and easily handled themes, either in the annals of our stalwart republic, or in any characteristic and probable events of our individual lives. Romance and poetry, ivy, lichens, and wallflowers need ruin to make them grow.

Hawthorne's romance, as he termed *The Marble Faun*, centered on the artist community of Rome, but his introduction succinctly addresses the concern of American artists at midcentury. He belonged to an earlier generation of writers with Ralph Waldo Emerson and Henry David Thoreau whose philosophies were championed by painters such as Thomas Cole and later comrades of the Hudson River School.

By 1860, the evolving painters of America were no longer interested in only discovering subjects in the country's varied landscape. Rather, they sensed a more international approach to art. Flocking by the score to Germany and France, artists sought not only academic training, but also the comraderie of other painters and recognition in the grand Salon exhibitions. Previous generations had sought educational experiences in Europe, as can be demonstrated beginning with the careers of Benjamin West and John Singleton Copley who were lured to England during the eighteenth century.

Sound art education was available in America for the artists encompassed in this project. The two major art schools of the period were the National Academy of Design in New York City and the Pennsylvania Academy of the Fine Arts in Philadelphia. Many of these artists arrived in Europe confident that their talent should be respected on an equal plane with that of colleagues working in a more international style.

A web of previous studies serves as an outline for the development of American painters by the end of the nineteenth century. Richard Kenim's *Return to Albion: Americans in England 1760-1940* (The National Portrait Gallery, Washington, 1979); The High Museum's *The Dusseldorf Academy and the Americans* (Atlanta, 1972); the University of Kansas Museum of Art's *The Arcadian Landscape: Nineteenth Century American Painters in Italy,* (Lawrence, 1972); and Peter Bermingham's *American Art in the Barbizon Mood* (National Collection of Fine Arts, Washington D.C., 1975) set the stage for exploration of painters working abroad during the latter years of the century. This aspect has been more specifically addressed by the E.B. Crocker Art Gallery's *Munich and American Realism in the 19th Century* (Sacramento, 1978) and Michael Quick's exploration of *American Expatriate Painters* (The Dayton Art Institute, 1976) which focused on stylistic developments of the 1870s and 1880s.

Concurrent to these exhibitions, several other curators and authors have turned their minds to a rather strong look at the development of American Impressionism. Donelson Hoopes (1972) and Richard Boyle (1974) have authored books by this title, and Moussa Domit, Harvey West and Donald McClelland have organized exhibitions documenting the work of Americans which centered around Claude Monet in Giverny (*American Impressionist Painting*, National Gallery of Art, 1973; *American Impressionism*, Henry Art Gallery, University of Washington, 1980, *American Impressionists*, Smithsonian Institution Traveling Exhibition Service, 1981). Given this established framework, *Americans in Brittany and Normandy: 1860-1910* can be seen as important to fully understanding the experience of the American artist in the cosmopolitan art world as it existed during the latter part of the last century.

Perhaps the most important aspect of this project

is the study of Americans working in the art colonies of Pont-Aven, Concarneau and Le Pouldu in Brittany, beginning almost twenty-five years prior to the arrival of Paul Gauguin who made Brittany famous. Their work has been exhibited and their efforts noted in several studies, but never before has the significance and the breadth of these three colonies been realized. With this in mind, and because of the wide attention the American Impressionists have received, Dr. David Sellin's finely detailed essay is consciously weighted toward developments in Brittany. Attention given Normandy is concentrated on the actual development of the American colony at Giverny.

Just as dates never accommodate the historian, geographic boundaries remain almost invisible to the mobile artists of the past century. The intention of this study is to isolate developments in and around the art colonies at Pont-Aven, in Brittany, and at Giverny, in Normandy. But it must be understood that a curious mind causes exploration, thus works depicting the life and landscape of two geographic areas of western France are herewith included. Giverny is located at the very eastern edge of Normandy, thus creating the necessity of including two works which technically fall outside the boundaries of this study, but not its spirit; therefore, their inclusion. Winslow Homer's *The Gleaners* (1867) was painted during his visit to Cernay-la-Ville and Daniel Ridgway Knight's *Market at Poissy* (1876) is one of few works depicting the city of his residence rather than his favorite subjects of Normandy. One other anomaly occurs in the construction of this exhibition. All works included are paintings, with the exception of two works by Charles Fromuth, both pastels. His years at Concarneau, documented by his writings, have made his career crucial to the subject, so his very painterly pastels are included.

Finally, a word must be given to the organization of this publication. Not every painter who ventured to Brittany or Normandy was affiliated with one of the colonies. Several, such as James MacNeil Whistler, Elihu Vedder, Richard M. Hunt and George Inness, arrived prior to the founding of the enclaves. And others were independent artists who merely visited these locations. Chief among these painters

would be Maurice Prendergast. Therefore, the two major divisions of the catalogue sections are arranged so that the precursors and independent artists of each region precede those entries given to the artists most closely related to the colonies. This structure best enables the reader to visually equate the illustrated catalogue with the thesis of the essay.

This study sheds a bright light on the role of American painters in the French art community between 1860 and 1910 when a new generation of modernist painters shifted the manner in which artists perceived and worked. It is by no means definitive, but it is inclusive of the variety of minds and hands at work during the period. As is the case of any solid scholarly undertaking, many new questions are brought to the fore. *Americans in Brittany and Normandy* precipitates two such questions which could be conceived as independent exhibition topics. First, many of the painters worked and lived in Brittany or Normandy during the summer, while the academies and ateliers of Paris were in recess. Activities of Americans in Paris have always been recognized, but never brought together in an exhibition which should naturally have preceded the current one. Barbara Weinberg has addressed an aspect of this topic in a well conceived article, "Nineteenth Century American Painters at The École des Beaux Arts" (*American Art Journal*, Autumn, 1981). Second, many of the painters nurtured by the colonies of western France returned home and were seminal in the development of the many artist colonies of America. This subject too would be a fascinating study and exhibition. The challenges exist and it is our hope that colleagues in the future will be able to use this publication and look back on the exhibition which it accompanies to support a further understanding of the American art experience.

James K. Ballinger
Director

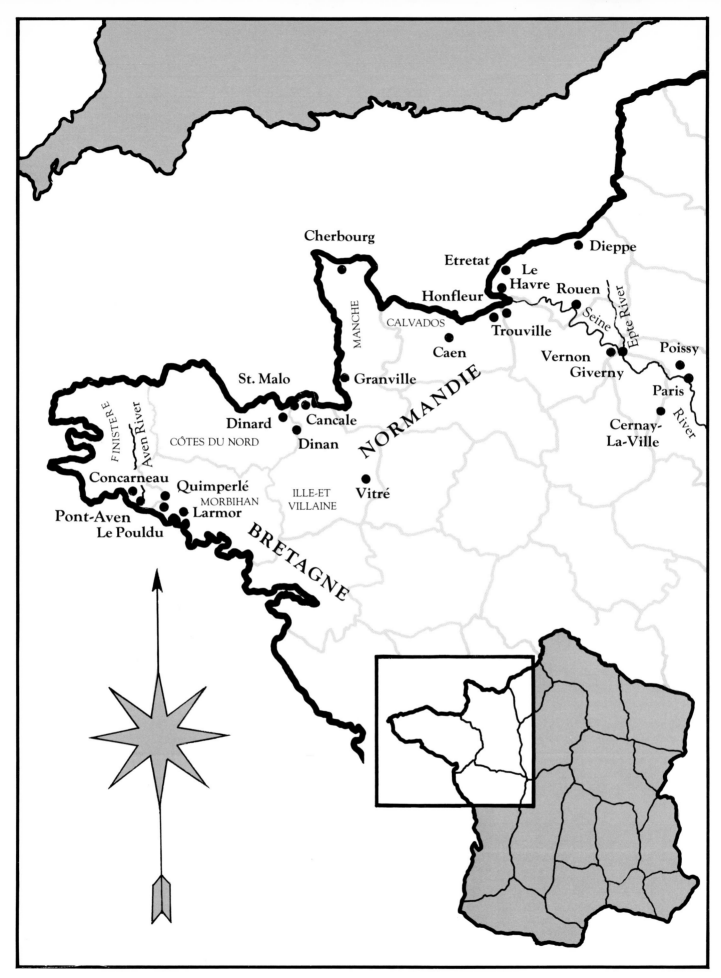

Table of Contents

Foreword . 1
Brittany and Normandy, 1860–1880 . 4
Discovery of Pont-Aven, 1860–1866 . 11
Settlement of Pont-Aven, 1866 . 16
Colonization, 1866–1870 . 25
Pont-Aven to 1880: The First Generation . 30
Pont-Aven Before Gauguin: New Migrations 38
Concarneau, the 1880s . 43
Pont-Aven School, 1885–1898 . 51
Giverny, 1887–1900 . 65
Giverny, 1900–1910 . 76
Appendix . 83
Footnotes . 87
Pont-Aven at the End of the Nineteenth Century, *Charles Guy LePaul* 91
A Walking Tour of Pont-Aven–Map of Pont-Aven, 1886 92
Giverny's Meeting House, The Hôtel Baudy, *Claire Joyes* 97
The Artists at Giverny–Map of Giverny, 1900 98
Color Plates . 105
Catalogue . 126
Index of Artists' Entries and Titles . 225
Bibliography . 227

Acknowledgments

No study of this sort can be done without the assistance of friends and colleagues. Joshua Taylor, Marchall Landgren and James O'Gorman gave early encouragement. Tracy Atkinson of the Wadsworth Athenaeum and the staffs of both the Corcoran Gallery and Pennsylvania Academy of the Fine Arts recommended the loan of works critical to the essential armature at the beginning. Personal research grants from the Smithsonian Institution and American Philosophical Society were a great help in the initial stages.

Nancy Corson, Frances F. Kilmer, Frederick Ramsey and Alice F. Robinson were among those who provided me with original material of extraordinary interest. William Homer, Garnett McCoy, Denys Chast, Elsie Reinert and Mary Anne Goley went out of their way to provide documentary material I could not have otherwise obtained.

In Giverny I was particularly fortunate in meeting Claire Joyes and Jean-Marie Toulgouat, who shared their vast knowledge and experience. *Lezaven* in Pont-Aven was opened to me by Etienne Manac'h, the owner of the manor, who kindly put me in touch with Charles and Judy LePaul, experts on Pont-Aven. Harry Lowe, William Truettner and Susan Gurney at the National Museum of American Art facilitated research and were helpful in many ways. My wife, Anne Sellin, art historian, assisted in fundamental documentary research in the Archives of American Art and Library of Congress.

Joseph Amarotico, Doreen Burke, Jeffrey Brown, Richard Field, Madeleine Fidell-Beaufort, Lois Fink, Trevor Fairbrother, Kathleen Foster, Susan Grant, Susan Gross, Donelson Hoopes, Susan Hobbs, Michael Jacobs, Vance Jordan, Nicholas Kilmer, Annie-Paule Quinsac, Michael Quick, Pierre Quiniou, Patrick Ramade, Cathryn Stover, Barbara Schneider, Anne Terhune, Abbot W. Vose and Nelson C. White and many others generously contributed expertise. And to Nicholas A. Addams, Yvonne Marx, Michel and Regine Moog, Carolyn Pitts, Margy Sharpe and many others who helped in making the work a pleasure go my thanks. Frank Goodyear, Director of the museum at the Pennsylvania Academy of the Fine Arts, Carol Clark, Curator of Paintings at the Amon Carter Museum and William Truettner, Curator of the 18th-19th century Paintings and Sculpture at the National Museum of American Art enthusiastically supported James K. Ballinger, Director of the Phoenix Art Museum, the organizing institution for the project, to make the exhibition possible. The production involved many dedicated individuals. Rosemary O'Neill, Registrar of the Phoenix Art Museum handled the coordination of over seventy lenders with special assistance from Registrar Janice Stanland and Associate Registrar Gale Rowson of the Pennsylvania Academy of the Fine Arts. Barbara Gutierrez, Secretary to the Director of the Phoenix Art Museum, dealt ably with loan inquiries and coordinated last minute manuscript adjustments. The Museum's Librarian, Clayton Kirking, provided necessary editorial information. Special courtesies for lending requests were extended by Jerome Collings and Bob Jenkins at the Abilene Fine Arts Museum, Texas, Maggie Steers at the Hood Museum, David Parrish at the Wadsworth Athenaeum, and the Graham Gallery.

The catalogue is intended as a source for scholars as well as a guide to the exhibition. The design is by Theron Hardes who as a former student at the Pennsylvania Academy, had an added interest in the work.

Mrs. John W. Kieckhefer of Phoenix, and a couple who request anonymity, joined with the National Endowment for the Arts to help fund this endeavor. Without such interest, vision and patronage projects like this one could not materialize in most American public institutions. It is greatly appreciated. Listed separately on the following page are the lenders to the exhibition, individuals and institutions whose unselfish support and understanding make such a project possible by their willingness to share their treasures with a wider public. I join the staff of the Phoenix Art Museum in extending thanks in recognition for their generosity.

It has been a pleasure to work with the Phoenix Art Museum staff and especially with Jim Ballinger, in preparing the exhibition and catalogue. Together we hatched the broad outline and without his unflagging enthusiasm, adaptability, energetic collaboration and management of the production, this exhibition could not have been realized.

David Sellin

Lenders to the Exhibition

Mr. and Mrs. Tony D. Andress, Sr.
The Art Institute of Chicago
Balogh Gallery, Inc., Charlottesville
The William Benton Museum of Art
Jeffrey R. Brown Fine Arts
Mr. and Mrs. Jeffrey R. Brown
Mr. and Mrs. Thomas A. Campbell, Jr.
Dr. and Mrs. Robert M. Carroll
The Century Association
Chapellier Galleries, New York
Colby College Museum of Art
Corcoran Gallery of Art
Nancy Corson
Peter H. Davidson and Co., New York
The Denver Art Museum
Drexel University Museum
Janet Fleisher Gallery, Philadelphia
Free Public Library, New Bedford, Massachusetts
Mr. and Mrs. Roy Garrand
Goldfield Galleries, LTD., Los Angeles
Hirschl & Adler Galleries, Inc., New York
The Holyoke Museum, Holyoke Public Library
The Hudson River Museum
Jordan-Volpe Gallery, Inc., New York
Ipswich Public Schools
Frances Frieseke Kilmer
Mr. and Mrs. Howard Kiviat
Cornelia and Meredith Long
R.H. Love Galleries, Inc., Chicago
Amherst College, Mead Art Museum

The Metropolitan Museum of Art
The Mint Museum of Art
Montclair Art Museum
Musée Departemental Breton – Quimper, France
Museum of Fine Arts, Boston
National Academy of Design, New York City
National Gallery of Art, Washington, D.C.
National Museum of American Art, Smithsonian
 Institution
Helen E. Peixotto
The Pennsylvania Academy of the Fine Arts
The Phillips Collection, Washington, D.C.
Phoenix Art Museum
Natalie Reed
Alice Fromuth Robinson
San Diego Museum of Art
The Shephard Family Trust
Smith College Museum of Art
Staten Island Museum
Terra Museum of American Art
Jean Marie Toulgouat
University of Virginia Art Museum, Charlottesville
Vose Galleries of Boston, Inc.
Mr. and Mrs. Abbot W. Vose
Wadsworth Atheneum
Henry C. White
Nelson H. White
Whitney Museum of American Art
Sixteen Private Collections

Foreword

My curiosity about American artists in Brittany and Normandy began some years ago with the discovery that a photograph showing a group of artists, and once in the possession of Thomas Eakins, was taken in front of the Pension Gloanec in the Breton village of Pont-Aven (fig. 1). At about that time I also received for the Philadelphia Museum of Art, where I was a curator, a painting by Cézanne done in Giverny. When living in that village in Normandy the donors had bought it from the hotel owner, Mme. Baudy, and as proof of Cézanne's residence at her hotel she gave Mr. and Mrs. Frank Osborn the guest register with his name inscribed. Without grasping the real significance of the Baudy register I encouraged Alice Osborn to give it to the museum for documentation of that Cézanne. Also, in a Philadelphia collection there was an intriguing painting by Willard Metcalf of artists at breakfast in Giverny (cat. 82). These things kindled my interest in what Americans did in France when they were not in Paris or Barbizon.

On studying the Baudy guest register I was struck by the fact that Cézanne was the only French artist of consequence among some seven hundred entries over the ten years recorded. The vast majority were Americans with occupation listed as painter, sculptor, or architect. At the time I held the common misconception that American Impressionists, encouraged by Monet and his friends Theodore Robinson and John Sargent, gravitated to an established hotel at Giverny to sit at the feet of Monet. Wrong! The first Americans to come to Giverny were not yet Impressionists, didn't know Monet was there, and there was no hotel. When the American occupation swelled out of all proportion and impinged on his personal life, Monet almost moved out of town.

The aforementioned photograph of artists in Pont-Aven I assumed to date from Eakins' student days in France, from 1866 to 1869. That the man in the straw hat and gaiters seated in the lower left resembled his friend and fellow student Earl Shinn hardened that conviction, but the others evaded identification. It later became evident that the photograph dated around 1881, not the 1860s (Shinn was again in France, so it still could be him). But even false starts can sometime lead to right conclusions. Further investigation confirmed that there was a group of Americans in Pont-Aven in 1866 that included Shinn and other Philadelphia friends of Eakins, and that they were the founders of the famous art colony.

Names new to me cropped up, as well as familiar artists in new contexts. Artists once honored in France and America had been sloughed by our

1

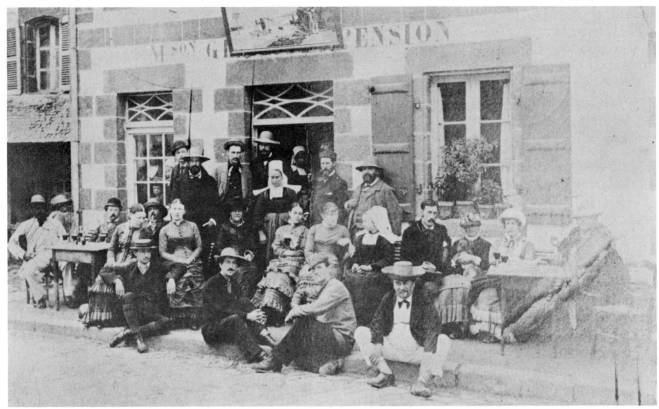

Figure 1. Artists in front of the Gloanec about 1881. Standing, far right, is the Dutch painter Herman Van Den Anker, identified by the Corson photograph (Fig. 11). The seated man on the right appears to be Swift, who was still there in 1881. The man seated on the curb at the left resembles Earl Shinn, who was again in France in 1881-82. If so, it could explain why this photograph belonged to Shinn's friend, Thomas Eakins.

museums. Particularly hard hit were Robert Wylie, Frederick Bridgman, Alexander Harrison, Clifford Grayson, and Frank Penfold. Other founders or members of the Breton colonies are not represented because their Breton work has not surfaced in time for inclusion: Birge Harrison, Richard N. Brooke, George F. Munn, Arthur Hoeber, Earl Shinn, Benjamin Champney, Frank Jones and others.

The pattern that emerged was unlike Barbizon, where there was a group of artists working in a cohesive style that could identify them as "Barbizon School." There is no term that truly characterizes the work done in Brittany. "Pont-Aven School" refers to a very select group around Gauguin – revolutionary, but in no way representative. Americans of the 1870s favored a straight-forward realism. The strongest influence at first was Robert Wylie, who was self-taught and unconventional, inclining to the palette knife and loaded brush, with nature as his guide. His fellow Americans looked to nature as their model and to each other for criticism, and did not evolve any common conventional manner. Many were students of Gérôme, a few of Bonnat or Cabanel, and some came without any French instruction at all.

Except for a brief stint with Gérôme, for instance, William L. Picknell's entire instruction in Italy and France was with the Americans George Inness and Wylie; Howard R. Butler's first Salon success (cat. 41) was done in Concarneau with the guidance of Alexander Harrison and Shorty Lasar, before he had any formal French instruction; Charles Fromuth found in 1889 that there was nothing in Paris schools he hadn't already had in the new Pennsylvania Academy of Eakins.

In Giverny, not established as an artists' colony until 1887, Impressionist vision and methods dominated very early. There were two distinct phases of Impressionism before 1910, however, the second one characterized in the work of artists who exhibited as the *Giverny Group.* But there is no "Giverny School" of painting.

If there is a common thread it is landscape and figure painting in the broad open light of the out-of-doors. In 1866 painters in Pont-Aven were posing their costumed figures out in the open landscape or in their courtyard for close-up figure work. This became the norm with Alexander Harrison, who also began a trend for painting the nude in the open

2

sunlight which, by 1910, became the common pursuit of painters of the "Giverny Group."

If a great deal of attention is given individual artists at the beginning of the period, it is not only to establish the sense of place, but also because this is the least known and hardest time to bring into focus. The pace is slow, but gains momentum until in the accelerated movements at the turn of the century one thinks in terms of crowds of artists and students moving restlessly around, instead of individuals seeking a haven for the next year's work. What starts with a handful of American painters in 1866 grows to an international population of around one hundred by the time Gauguin comes to Pont-Aven. A highlight of the social season is the baseball series between the American painters of Pont-Aven and those of Concarneau. In Giverny some forty sky-lights appear in village roofs. The new hotel serves Boston Baked Beans, and across the road a tennis court is added near Monet's tranquil garden. Evening breezes waft the sound of strumming banjo and Stephen Foster as Americans buy, lease, or build villas and register in droves at the Hotel Baudy. And Monet becomes the father-in-law of an American.

By 1910 Cézanne is enthroned on Olympian heights; Cubism, Fauvism, Futurism, Orphism, and Abstract Expressionism are at the boiling point. The slow but sure progress seen from the beginning of this study with *art for art*, and through the *Talisman* of Sérusier painted in Pont-Aven, leads to the triumph of conceptual art of a sort that introduces a completely new era. Its new colonies are in the heart of Paris, Zurich and New York.

Every work in this exhibition has been selected for its quality and significance in the overall context. Not every one has the same weight, nor did in the eyes of the makers. That is, at the time some were made they were not intended by the artist for exhibition. Discretion, therefore, should be exercised in distinguishing the difference between the Salon painting and the study, or *pochade*. Since the French terms are frequently used by the American artists in describing them, and are interspersed in this text, it would be well to know their meaning. Some of these words cannot be literally translated. An *étude* is an academic exercise in the studio – an *esquisse* is a compositional layout. They cannot be understood by the words study, or sketch. *Le dessin* does not translate as either design or drawing, or both, but refers to the whole art of draughtsmanship. A direct, unaltered, impression from nature, done quickly and in one sitting is a *pochade*, such as the little beach scene by Robert Henri, or view of Granville by Tryon (cat. 46,

73). An *ébauche* may be worked over more, a roughing in of a composition, like Cecelia Beaux's *Twilight Confidences* (cat. 45), a blocking or roughing in of a *pochade*, but on its way to being an *esquisse*.

Plein-air will also be used in the context of painting in the open. Impressionists painted in the open, but *plein-air* painting is much more comprehensive in scope. It did not necessarily have to be done outside, but had to have the effect of outdoor light. Thus, Daniel Ridgway Knight built a green-house conservatory behind his house at Poissy, so that he could pose his peasant servants in the flowers of the field in mid-winter. Charles S. Pearce did the same at Auvers, and William Picknell, visiting Hovenden in Plymouth Meeting, Pennsylvania, did the same so he could paint the snow. Distant landscape views were traditionally done in the open, but for close-up figures, human or animal, the artist had made his studies in the studio. The single source of illumination, usually from above, modeled forms from light to shade to shadow, salients being picked up by reflected high-lights, contours re-enforced at the edges by line. In that light pure color appears at the lightest portion, and is modeled by the addition of dark tone. Outside, the darks are the pure hue on near objects, and the lights are worked up the scale, giving a higher key to the entire surface. Painting was done directly before the subject in the open. For the deliberate worker, the pearly skies of Brittany were prized, and sun breaking through the clouds interrupted his work.

A *Salon*, of course, is a painting produced for exhibition at *The Salon*, the annual official exhibition in Paris, held in the spring of the year. From 1890 there were rival Salons; there were Salons of rejected work; the autumn Salon; before World War I there were three annual Salons with some 17,000 items. But unless otherwise indicated, the term Salon can be understood to mean the prevailing, officially recognized and Government sponsored annual art extravaganza in Paris. To be accepted was to be seen. To be noticed was often relief from penury, to be medalled or acquired for the French National Collection meant acceptance to the brotherhood of those who did not have to submit to juries, and might lead to a decoration for the lapel buttonhole, which by the time existed for no other reason than to hold the insignia of the Legion of Honor. Many of our Americans were awarded decorations and were purchased, but none more than those who worked in Brittany.

D.S.

3

Brittany and Normandy 1860-1880

James Whistler spent about three months on the coast of Brittany in 1861, there for his health. He produced an etching of a forge at Perros Guirec on the north coast, and one painting (cat. 5), which by the beginning of November he had brought back to Paris. But he did not want to show it to anyone until it had been properly framed – "oh! Barnum," exclaimed his friend Fantin-Latour. In Fantin's exclamation lies a great deal of truth about a career that spanned the rest of the century and made Whistler the most widely known and notorious American artist on both sides of the Atlantic. John Singer Sargent and Mary Cassatt were comparatively late in their art debuts, and, while well known, they did not have the universal attention attracted by Whistler, who commanded attention, like P.T. Barnum. Today it is the dandified, rarified aesthete who is remembered, not the thread-bare brawling Bohemian art student in Paris, but both characters resided in Whistler throughout his life. Raised in the French speaking Czarist court of St. Petersburg, where his father was engaged in railroad construction; and intended for a military career, Whistler studied art as a cadet at West Point under Robert W. Weir. Discipline was not his forte, nor chemistry. Had silicon been a gas, he'd have been a major general, Whistler recalled later of a critical examination he failed. The topographical drawing he had done at West Point, however, served him for a time in Washington, where he became a draughtsman and engraver with the U.S. Coastal Survey. Determined on a course of art, he left for France inspired by Murger's tales of the Bohemian life, and arrived in Paris in 1855, the year of the first great International Exposition and of the *Pavillon du Réalisme* of Gustave Courbet. He studied from the life model at the atelier of Charles Gleyre and was soon involved with the art of Courbet and Realism, "art for art" and the Japanese discoveries of the early 'sixties.

The painting done on the beach in Brittany in September and October 1861 is heavily indebted to Courbet in the thick impasto, the unsentimental and unromantic portrayal of the rugged coast. Exhibited in Paris in 1861 as *Seule*, in London the following year as *Alone with the Tide*, and later under permutations of *On the Coast of Brittany*, this picture is the first important work by an American done in the region under consideration in the present study. There had been occasional visits along the Breton and Norman coasts before this, by American artists like Robert Salmon, John F. Kensett, James Casilear, or William P. Dana, but they were incidental and few. *Alone with the Tide* is the worthy starting point for a look at what became a growing American presence in the region of west France, along the coast in general, and in a few specific settlements like Pont-Aven, Concarneau, and Giverny.

Whistler's youth is hardly typical, but then few of the Americans in the earlier part of this period were typical in choosing a career in art. They came from all walks of life and degrees of education. Some were diplomats, engineers, or teachers before entering on a course of art education. Some had been raised on the frontier, or travelled and worked in areas of the far west or Mexico, locations any Frenchman would have regarded as places of high adventure. Others had fought in, or illustrated combat in a war of a ferocity and massiveness that stunned European imagination. Being Republican, during a period of Imperial rule odious to most of their fellow French students, Americans who wanted to take the trouble found little difficulty in gaining admission to the fellowship of French art students.

That Whistler was drawn to the Bohemian life of Paris by Murger's novel, and became a character in another, namely *Trilby*, is also not unique; twenty years later Edward E. Simmons was the hero of the novel *Guenn*, which drew a generation of American painters to Concarneau on the Brittany peninsula. Like Whistler, two of Simmons' contemporaries in Concarneau had come to art through their work with the U.S. Coastal Survey, Alexander Harrison and Howard Russell Butler, which gave them all a taste for the broad horizons and vistas on the Breton coast.

One thing that many of the artists of the period had in common was a background in a related craft: cartography, engraving, wood engraving, bank-note engraving, ivory carving or frame making, lithography or illustration. Few were raw green, even if in 1855 there were few art schools in America worthy of the name. The best equipped was the Pennsylvania

Academy of the Fine Arts in Philadelphia, but it had reopened only that year after a hiatus. So aspiring artists almost had to go abroad for instruction, no matter how skilled their hand. Where they went depended on many things. Language and history bound them to England. The American dilettante read English criticism. However, it did not take American artists long to find out that most English artists got out of England for their own improvement in the arts if they wanted to keep up with the German and Flemish artists that through history had periodically taken leadership from them in their own country. The Italian Grand Tour was essential, but for American painters at mid-century, Dusseldorf and Paris offered the most serious academic opportunity. After the Franco-Prussian War, Munich and Paris were the two great centers of attraction. Aside from different preferences in masters of the seventeenth century to emulate, and general ambiance, the main difference in the art education was that in Bavaria there were different professors for different categories and classes: one each for landscape, figure, history, portrait, and in intermediary and advanced studios. In the Paris atelier system introduced at the school of art after 1863, a student stayed with one professor in professional instruction, as long as mutually agreeable. Arriving in Paris before the 1863 reforms at the Beaux-Arts, Whistler was drawn by temperament and preference to the iconoclastic point of view and the Realism of Courbet, with whom he formed a friendship and pupil-master relationship, in so far as he could submit to any master.

Of *Alone with the Tide*, George Du Maurier learned from Whistler in 1862 that the sand was not laid on with a palette knife, "And there is not one part of the picture with which he is not thoroughly satisfied he says, and its open air freshness nothing can stand against." At the end of his life Whistler still thought it "A beautiful thing – painted in Brittany – blue sea – long wave breaking – black and brown rocks – great foreground of sand – and wonderful girl asleep."[1] But by 1862 Whistler was already drawn to the *art for art* aesthetic then emerging, evident in his preoccupation with problems of painting white on white in his *White Girl* of that year, and fueled by his discovery in Paris of Japanese art. In 1865 he was back on the French coast, this time at Trouville in Normandy, and in the company of Courbet and Claude Monet. Monet's American son-in-law recalled in later years that, "Monet was saying that Whistler was at one time with Courbet, at the same time as Monet, at the seashore doing Courbets as near as he could and that he couldn't help making them Whist-

ler's all the same."[2] Two years later Whistler agonized over the state of his work again with his friend Fantin:

> Ah, my dear Fantin, what an education I have given myself! Or, rather, what a fearful want of education I am conscious of! With the fine gifts I naturally possess, what a painter I should now be, if, vain and satisfied with these powers, I hadn't disregarded everything else! You see I came at an unfortunate moment. Courbet and his influence were odious. It isn't poor Courbet that I loathe, nor even his works; I recognize, as I always did, their qualities. Nor do I lament the influence of his painting on mine. There isn't any one will be found on my canvases. That can't be otherwise, for I am too individual and have always been rich in qualities which he hadn't and which were enough for me. But this is why that was all so bad for me.
>
> That damned realism made such a direct appeal to my vanity as a painter, and, flouting all traditions, I shouted, with the assurance of ignorance, "Vive la Nature!" "Nature," my boy – that cry was a piece of bad luck for me. ... Oh, why wasn't I a student of Ingres? – How safely he would have led us![3]

Ingres' dictatorship had dominated official academic art through the period of Whistler's rejection of it, but all students knew Ingres' motto: *Drawing is the probity of art.* In fact, Whistler had made bad copies of Ingres in Paris. His declaration of the independence of his own talent rings the truest in the above lament.

Underlying Whistler's dilemma is the choice between the natural and artificial. The aesthetic movement just then blossoming favored the artificial path. At its extreme, life itself imitates art; anything natural is by definition crude, uncultivated, unredeemed by art. Genius in art is presupposed. The other route was the more heavily traveled – that using Nature for its guide. This road was shared by Realists and Naturalists, alike. Since most Americans arriving in France faced this choice, it is well to recognize it, for throughout the rest of the century the art student in France is exhorted to seek his truths in Nature. In fact, about the only thing that the Realist and the Naturalist agreed on was that models should not be sought in ancient Greece. Realists generally cannot or do not teach, except by example. In teaching they reduce their observations to principles, and thus become Naturalists. Realists are observers, while Naturalists are analysts, who subject their observations to examination. Nature can be *shown* by Realists

in various aspects, and their work is admired for its illusion, immediacy, truth, or individual quality. But Nature can be revealed and explained by the Naturalist, and this is readily taught to students. Naturalism is intellectual. Realism is sensate.

Courbet, the supreme Realist, had a great impact on Americans coming to France at that time, particularly in his strong, honest, unglamorized landscapes – but also because of his paint manipulation. Illusion of reality is always admired by the layman, but Courbet was a painter's painter. It is this more than anything else that Whistler got from his friendship with Courbet. Jean Léon Gérôme was one of the greatest teachers of the principles that underly the representation of Nature, and in that respect he fits the definitions of Naturalism as known in the nineteenth century in the "experimental method." There was nothing that he taught that could not be demonstrated and repeated. Knowledge, and not inspiration was at the bottom of his art and teaching. Thomas Eakins brought this approach back to America and to a pitch probably not equalled anywhere. "Do what you want, but know what you are going to do." Somewhere in between Realism and Naturalism was Jules Bastien-Lepage, who was also a great influence on American artists. While he did not theorize about his own work, it was readily subjected to analysis in relation to the physical properties of outdoor light.

In the years during and immediately after the American Civil War, American painting had arrived at an interesting point in development. Two artists who painted together briefly in Brittany in 1866 before parting company, Elihu Vedder and William Morris Hunt, demonstrate this (cat. 1, 2, 3, 4). After studying in Dusseldorf for several years, Hunt came to Paris to the atelier of Thomas Couture, in 1847, the year that artist created a sensation with his *Romans of the Decadence*. While practically a cliché of classical subject matter and Venetian composition, the richness of color and tone made it for years the major attraction for Americans visiting the Luxembourg palace, the museum of modern art in Paris. Twenty years later Eakins thought it to be the greatest modern color achievement. As taught to Hunt, and by Hunt to his pupils in Massachusetts, Couture's method created a whole school of tonalist landscape painting associated with Barbizon, where Hunt went to paint with Jean Francois Millet. Hunt and Barbizon conditioned Boston for decades to see nature in tonal masses, with edges but no outlines, and to collect paintings by Millet, Jean-Baptiste Camille Corot and Hunt.

Vedder, on the other hand, was of a different school. In Paris the year after Whistler arrived, he went not to Gleyre, but to the atelier of Francois-Édouard Picot, because he found that more *Prix de Rome* were awarded his students than any other's. "Instruction consisted of a little old man with a decoration coming twice a week and saying to each of us, 'Pas mal! Pas mal!' and going away again. But we got instruction from the older students, got it hot and heavy and administered in the most sarcastic way."[4] In eight months he was never advanced from drawing the cast to painting from life, so he left for Florence. There he became involved with the most radical of the young Italian painters who gathered at the Cafe Michelangelo, *I Macchiaiuoli*, the Italian equivalent of the French *tache* painters – blot painters, painters who saw the larger planes and spots of colors in nature, and not outlines and modeled contours. He became one of them, thus getting into the mainstream of contemporary art. Before returning to France in 1866, Vedder spent six years in Boston and in New York, earning election to the National Academy. Among his friends in the "Hub" were John La Farge and William M. Hunt.

Vedder joined Hunt and his family for the summer of 1866 in Brittany, first at Dinan and then Vitré, both extremely picturesque medieval cities still. With them was their painter friend Charles C. Coleman.

> We found or made a large studio on the ground floor of an old house. It was literally the ground floor, for the floor was the ground, and Hunt delighted in it. You could make holes and pour in your dirty turpentine and fill them up again, and generally throw things on the floor, and Hunt used to clean his brushes by rubbing them on the dirt and dust. I remember his once saying, "Wouldn't you like to take that mud in the road and make a picture with it?" The simplicity of Millet was strong upon him in those days, and indeed affected his art the rest of his life. Painted with mud! Why not?[5]

Actually, this says quite a lot about Hunt and the predominating tonal landscape painting of Barbizon, and is worth remembering when reading the reactions of Bostonian Benjamin Champney to Courbet and to Breton mud this same summer. Vedder favored the clean *tache* of color over the somber mood of tone; "I here painted, just to show Hunt that I could do so, a picture in the style of Millet. It was a tinker mending a large brass kettle, black on the outside, but bright within, and it did look very much like a Millet" (cat. 3). Vedder also did drawings that he evolved into

6

paintings, such as his *Memory*, a face in a cloud over the waves repeating on a shore, and many small studies typical of his own broad color handling.

These small oil sketches from Vitré bear an intriguing resemblance to the work of the younger Winslow Homer at the time and shortly after (cat. 62). Homer is often considered to be self-taught, the home grown natural genius, but there is also noticeable similarity in his work to painters like Eugene Boudin, who was painting in 1865 at Trouville with Courbet, Whistler and Monet. Boudin's work, usually of a small size, is based on an open-air *tache* technique. Homer got his training as a lithographer with the Boston publishing house of Bufford, where his fellow illustrator was J. Foxcroft Cole, a friend of Vedder in Boston. Cole came back in 1864 after four years in Paris with Emile-Charles Lambinet, also a very luminous painter of landscapes in the open air. Homer, who had not yet begun to paint, would have had the benefit of Cole's experience, and also that of Vedder. Vedder, John LaFarge and Homer painted together in 1865 in Newport, Rhode Island, and in 1866 a major Courbet painting was acquired through the efforts of Hunt and the new Allston Club for Boston.[6] So without ever leaving Boston, Homer could have had all of the late art news from Paris and Florence, on top of his natural aptitude in drawing and graphics.

Winslow Homer was one of the legion of American artists who went to France in 1867 to see the second World's Fair to be held in Paris. The United States exhibition included this artist's *Prisoners from the Front*, still crude in execution as a painting – a colored drawing to French eyes, but the effort of an obviously talented artist. Homer did illustrations for *Harper's Weekly* of Paris life, and then took off with Cole to paint in west France. Their full itinerary is not known, but a little panel from Cernay-la-Ville is introduced here, even though it is not quite within the geographic limit of this exhibition. Cernay was a little village to the west of Paris with a friendly innkeeper who welcomed artists – mostly French artists – and invited them to decorate panels, of which this is an example. And it does serve to show the free handling of paint by Homer after a relatively short experience with color. A few paintings done by Homer in France have been identified, but both the *Girl With A Pitchfork*, and *Man With A Scythe*, sometimes said to have been done in Normandy, are demonstrably done in America.

Certainly it was J. Foxcroft Cole who introduced Homer to Cernay. He had returned to France for further study in 1865, was a friend of the painters

Mark Fisher and Frank Hill Smith, both of whom had painted in Cernay a few years before. Cole was enrolled in the atelier of the animal painter Charles Jacque, the "Raphael of Pigs," and excelled in rural landscape painting. Cole exhibited at the Salons of 1866 and 1867, as well as in the American section of the Exposition. In the Salon of 1875 he showed a *Normandy Pastoral, Near Honfleur* (cat. 71), and at the Philadelphia Centennial was medalled for *A Coast Scene in Normandy*. The *Normandy Pastoral* included here is a coastal scene, whether or not the same one. In the background one sees the mast of a passing sailboat, and the tortured tree bespeaks the force of unchecked wind. Cole did not embrace the tonalist tenets of Barbizon painting in these mature works, but the more natural greens and broad light of John Constable and the seventeenth century Dutch painters he admired along with Charles Daubigny and Corot.

Honfleur was a favorite resort of painters, and the cradle of Impressionism. The nearby farm of Saint-Siméon made it the "Barbizon of Normandy."[7] Corot, Courbet, Daubigny, Diaz and Constant Troyon had all stayed at the farm, and Monet, Boudin and Jongkind painted there in the open air ten years before Cole. American artists who painted at Honfleur include Frank Boggs, Homer Dodge Martin, John Twachtman (cat. 67, 72, 51) and Theodore Butler.

Up the coast from Honfleur is the beautiful Norman village of Etretat. On a beach in the embrace of a bay famous for the rock formations carved by the action of the waves at each extremity – arches and pinnacles which spring from an emerald sea–Etretat was settled by Roman conquerers. A mediaeval fishing port, it became in the nineteenth century a favorite summer resort and a magnet for French artists. Courbet and Monet both painted there between 1868 and 1870.

Offenbach had a summer villa at Etretat, and the locale was much frequented by French artists in the 'seventies, as noted by Bostonian Henry Bacon, who had taken up permanent residence in France: "Parisian artists migrate in flocks during the warm months, and Etretat, on the Norman coast, is one of their principal resorts. Here Merle, Fichel, Olivié, Renié, and many others are to be found: …Merle, at certain hours in the afternoon, coasted up and down the shore in a boat with a merle (blackbird) on the flag; while Lamber, Landelle, Boldini, and Vallois were to be met every night at the Casino. But when the long lines of migrating birds fly southward and the northern winds begin, Parisians return to the

gayeties of their 'cher Paris'."[8] Bacon himself was a devoted regular at Etretat, painted many pictures there (cat. 79, 80), and wrote a book about the resort. His own paintings of the beach show awareness of Impressionist light, while those of about the same time by James Smillie (cat. 68, 69), belong to an earlier tradition, not unlike early paintings by Turner or Alexandre Calame and resembling the work of Thomas Moran, with whom Smillie was associated in western American expeditions.

George Inness is a painter who would be recognized among artists of any nation and is international in background. With the exception of some training in cartography and a little criticism from Regis Gignoux in New York, he "arrived" mainly through his own work in Italy and France. His painting of the *Lakawanna Railroad*, done in the year Whistler left for Europe, has all the clarity and luminosity of his Italian landscapes of the Roman Campagna with the distant dome of the basilica of St. Peter. He had also lived in the Latin Quarter in Paris, where in 1854 he was introduced to the landscapes of Théodore Rousseau, Corot and Daubigny. Before painting views of Etretat in 1875, Inness had spent much of the previous four years in Rome and its vicinity, where he offered criticism to a young Bostonian, William Lamb Picknell, but as for teaching, Inness expressed his attitude a few years later:

Pupils can't be taught much by an artist. I have found that explanations usually hinder them, or else make their work stereotyped. If I had a pupil in my studio, I should say to him as Troyon once said in similar circumstances, "Sit down and paint." Still, now and then, I should tell him a principle of light and shade, of color, or of *chiaroscuro*, and criticize his work, showing him where he was right, and where he was wrong. ...The best way to teach art is the Paris way. There the pupils – two, three or more – hire a room, hire their models, and set up their easels. Once or twice a week the master comes in, looks at their work, and makes suggestions and remarks, advising the use of no particular method, but leaving each pupil's individuality free.[9]

As to what the painter tries to do, Inness answered, (in 1878) "Simply to reproduce in other minds the impression which a scene has made upon him. A work of art does not appeal to the intellect. It does not appeal to the moral sense. Its aim is not to instruct and not to edify, but to awaken an emotion." Woe be unto the one who reads into the word "impression" any relationship to "Impressionism." Inness had nothing to do with it, nor with Naturalism. At this stage he was closest to the Realists, although he grew more lyric in his personal interpretation of nature as time went on, finding kinship with Millet and the Barbizon painters in later work. Here he is closer to Courbet. Like Courbet, he found appeal not in the dazzling color in reflected light, as did Monet, but in the solid structure of the rock-bound coast, which is revealed, more than hidden, by the light blanket of turf lying upon it (cat. 63, 64).

In 1875, when J. Foxcroft Cole and Inness were painting at Honfleur and at Etretat, John S. Sargent was just embarking on a career in painting, and the little oil sketch of fresh caught octopi thrown on the deck of a Breton fishing smack (cat. 13) already reveals his superb command of the brush. J. Alden Weir had written home about him the year previous:

I met this last week a young Mr. Sargent about eighteen years old and one of the most talented fellows I have ever come across, his drawings are like the old masters, and his color is equally fine. He was born abroad and hasn't yet seen his country. He speaks as well in French, German, Italian as he does English, has a fine ear for music, etc. Such men wake one up.[10]

Sargent had studied at the art school in his native Florence before coming with his parents to Paris in 1874. There he enrolled with Émile Auguste Carolus-Duran where his fellow students were Will Low and Carroll Beckwith (cat. 111, 93). Carolus was an exponent of "direct painting", painting without preliminary drawing on the canvas. "Seek the demi-tints" was his advice – that is, start in the middle of the scale with a dominant, and work broadly up and down from there. Sargent was a virtuoso painter from his youth, and Carolus-Duran's approach suited him well. In 1877 he was in Cancale, on the north coast of Brittany, as Emily Sargent described in a letter to friend:

He has a great deal of difficulty in finding people willing to pose. The married women never will, and they dislike their children to be painted, and the younger girls rarely will consent. When he does find anyone willing, the crowd around him is so great that he cannot work, so he has to make friends with some old woman to get her to let him paint in her court. An old French artist who has been going to Cancale for the last fifteen years is at the same and only hotel there, and he finds the same difficulty as John does, in spite of his age and experience. When he first went there,

he says they were all willing to pose, but now they are so independent that a much higher price will not tempt them.[11]

Nonetheless, Sargent's quick eye and brush captured many of the figures that became elements in his paintings whether willing models or not. The well established French painter Augustin Feyen-Perrin exhibited an *Oyster Gatherers* the same year Sargent exhibited his own version of the subject, and Feyen may be the older painter referred to. The mention of a model letting him paint her in the court is of more than passing interest, for it reflects the new interest in painting the figure in the open, in the higher keyed and less contrasted light of the out-of-doors, as compared with the directional spotlighting traditional in the studio. Sargent knew Bastien-Lepage in Paris, but he also was familiar with the sunny out door work of the contemporary Italians, Giovanni Boldini and Francesco Michetti, and his treatment of the color in shadow relates more to their work than to Impressionism. It was also in Cancale that Stanhope Forbes, an English student of Léon Bonnat in Paris, posed figures out of doors about this time, influenced by Bastien, leading to a wave of followers in the "Newlyn School" in Cornwall, where the artist went to found a colony based upon the one he found flourishing in Pont-Aven in Brittany.

Sargent's *The Oyster Gatherers of Cancale* (cat. 12) was executed in his Paris studio from studies, and exhibited at the Salon of 1878 as *En Route pour la Pêche.* Simultaneously he showed at the first exhibition of the newly founded Society of American Artists, in New York, the fine compositional study for the painting now in the Museum of Fine Arts, Boston. Both were well received by the critics, with the smaller version being purchased by the painter Samuel Colman. Sargent's career was launched. A few years later his French career had a temporary setback over another work done in Brittany, or from studies done in Brittany at les Chênes Paramé, the summer home of Mme. Gautreau, and exhibited as *Mme. X* in the Salon of 1884. In the brouhaha which followed, Sargent moved to England, to return frequently, however. We find him painting in the garden of his old friend Monet at Giverny in 1888, just one year after other Americans in Paris discovered that little village.

Sargent's experience at Cancale probably indicates why the village never became a really thriving art colony. That it had only one hotel is not the problem. Models were reluctant and expensive, and it is probable that the hotel was not cheap. Sargent's picture probably brought other artists to Cancale when exhibited at the 1878 Salon; that summer Dwight Tryon and a group of fellow Americans from Louis-Marie Jacquesson's atelier at the École des Beaux-Arts came to paint at Cancale and at Granville, in Normandy (cat. 73), but did not return. Forbes Robertson, the Englishman who painted his first important plein-air painting in Cancale, found his way to Pont-Aven, where he remained for some years. Artists did not congregate at Cancale, although it is an attractive little sea port, not far from Mont St. Michel. Generally, at the heart of an artist colony is a charismatic figure, an artist who has arrived in a style which invites emulation, such as Millet in Barbizon or Monet in Giverny, Paul Gauguin in le Pouldu and Pont-Aven. Equally important, and perhaps moreso, is the existence of a sympathetic and cheap pension or hotel: Siron at Barbizon, Chevillon at Grez, Baudy at Giverny, Gloanec and Julia in Pont-Aven, and others at Cernay, Douarnanez, Honfleur, and so on. They all extended credit, sometimes for years, the food was usually abundant, and the guests were poor.

While many American painters were transient, like Inness, who paused before an attractive motif on his way home from Italy, or Edward Moran, who painted a major picture at Rocs de Toqueville in 1878, while in France for the Exposition (cat. 65); others were in France for an indefinite period. The ones who came to study art were in Paris for as long as they could afford, or until they could complete their education. That usually meant as long as it took to get accepted at the annual Salon. Summer brought sweltering conditions in the typical attic studios. The ateliers and schools closed. The best models went back to Italy or to work on the harvest. Exhibitions ceased. The Americans could not go home for the vacation, as a rule, so it was necessary to decide where to go and work in the open air.

"The Salon is over. The medals have been given. A new art fiscal year has begun," Howard Russell Butler wrote in 1885. "Paris has no longer any attraction to the artist. In a weeks time they will nearly all be gone. ... It is under the inspiration of one Salon that the subjects for the next are chosen. Many of the artists go with the intention of spending a whole year ('till the opening of the next Salon) in painting a single picture, all working for the medaille d'honneur."[12] Another American, Arthur Hoeber, recalled the exodus:

Paris was hot and impossible in its whiteness; the brillancy of the light stone-work of its buildings, combined with the glare from the asphalt, dazzled one's eyes and drew all the heat in the simmering July sky. Good resolutions of

remaining at the Beaux-Arts till the last day of the session faded gradually away. The cafes on the Boulevard began to pall; the little room *au sixieme* certainly was stuffy, and familiar faces in the streets became more and more rare. It was time to go to the country.[13]

Established artists and students alike packed up their "traps" – paints and brushes, easel, umbrella, and canvas – and departed Paris. But to go where?

How summer locations were selected by Americans varied. In the case of Giverny it was accidental. A small band of Americans, disappointed in their original destination, saw Giverny from the train window and got off. Only later did they learn that Monet lived there, and in the meantime had convinced a local merchant to rent rooms. In her first decade, Madame Angélina Baudy entered nearly seven hundred names in her register, mostly Americans who listed *artist-peintre* for occupation. Then models and motifs had to be available without great expense or difficulty with the inhabitants. Birge Harrison discovered that even a view had to be rented from time to time in the Barbizon area, just as Monet at Giverny had to pay ransom to peasants to save his trees and haystacks:

> There is some difficulty in obtaining good models at Grés [Grez], and their price is higher than elsewhere – from four to five franks a day. The peasants are a shrewd but not unkindly people, liking the artists well enough, but with a keen eye to the possible sou; disposed, for instance to appear inopportunely with a scythe just when the unfortunate painter is well advanced with his study of a daisey field, and cannot afford to drop it and begin another. In this conjunction of circumstances nothing but a hundred sou piece will keep those daisies afoot. I remember well one old heathen with a hooked nose, a seductive smile and an extraordinary *patois*, who for a long time had regularly mulcted the artists in this way, until at length his cupidity overreached itself and led to the discovery that he owned not one rood of land in the whole region.[14]

When unspoiled haunts became too crowded, or old motifs exhausted, artists exercised considerable ingenuity in finding new ones. Howard Butler, a veteran of the colonies at both Concarneau and Grez recalled one such effort:

> At a dinner of artists held one night in Paris the question came up regarding the best place for summer work. It was agreed that the guests present should start out in different directions and visit the coast towns of France, Belgium, Holland and England and that on their return they should compare notes. ... Ed Simmons had been to St. Ives (Cornwall) and the photos which he had brought back and his enthusiastic description led me to decide against Honfleur in favor of St. Ives.[15]

Edward Simmons, (who we shall meet as "Hamor" in the novel *Guenn*, set in Concarneau) rented a net storage-loft at St. Ives, installed a skylight, and in the summer of 1886 four painters worked together. The next summer more Americans came, as well as English, a German, Norwegian, Swede, Scott, Canadian, Greek, an Irishman and a Frenchman, all trained in France. In nine years the whole row of the twenty-four lofts had been converted to artists' studios, and the experience led Simmons to conclude:

> The artist finds a place that is beautiful, undiscovered, and suits his pocketbook. He goes there for two years. The third year other artists follow him; the fourth year come the retired British admirals and "vamps"; the fifth year the artist leaves; the sixth come the wealthy people who spend a lot of money on it, making it as ugly and dear as possible, but soon tire and go away. Then the artist comes back again; and begins all over, picking the bones of what the Money Bags had killed.[16]

Discovery of Pont-Aven, 1860-1866

Pont-Aven had flourished as an artist colony for twenty years before the arrival of Paul Gauguin. Few are aware that it was "discovered" and first settled by Bostonians and Philadelphians, who established the communal studio in the Chateau de Lezaven that was to serve so many. The origins of that American occupation have been as obscure to art historians as the source of the Nile was to the generation of artists who first made their home where the brawling waters of the Aven River spill through the last mill-race and boulder-strewn rapids to strum the placid little tidal estuary on the Bay of Biscay. A primary purpose of this study and exhibition has been to trace and delineate these origins.

The trail leads back to the Pennsylvania Academy of the Fine Arts in Philadelphia, where the program for studio education began in a systematic way only in 1855. The professors, under the general supervision of John Sartain, attempted to bring professionalism to the curriculum. Chief among them were Christian Schussele and Joseph A. Bailly, both French with Paris training. There was also Robert Wylie, who more than anyone was to forge the link between Philadelphia and Pont-Aven.

An extraordinary number of talented students was concentrated at the Academy around 1860. John Sartain and the faculty critics encouraged them to go to France, and many mentioned on the next few pages went during and immediately after the Civil War. Most of the male students were associated with Wylie at the Philadelphia Sketch Club they founded in 1861 and all knew him at the Academy, as we shall see.

When American students did go to Paris it was sublime, but for some it was cultural shock to find it so full of Frenchmen speaking a foreign language. Conditioning at home for observance of the Sabbath was so strong that it took some time to overlook the fact that in France it was business as usual on Sundays. Some students, like Thomas Eakins and Ridgway Knight took to student life readily, even joyfully. Others recoiled from any contact, revolted by their perception of French morality. Some, without the language and strapped for money, did their work until trained, and came home.

Wylie, somehow, was different. There was something charismatic about him in a quiet way. John Sartain's son, William, remembered him in Philadelphia.

Robert Wylie was Curator of the Pennsylvania Academy of Fine Arts – and I remember him as a dark skinned reticent fellow, one of their best draftsmen, and thought to have much talent. He made a success in France, and about the time I went over was the pilot that conducted the sales to Wilstach of Philadelphia, who bought a Muncacsy and other fine things there. One of his paintings is in the Metropolitan Museum and it is a good one, too.[17] [*Death of a Vendean Chief*: present whereabouts unknown.]

Wylie was born on the Isle of Man in 1839. About the age of ten, orphaned, he came to Philadelphia to live with an uncle, a Presbyterian clergyman. After some schooling he was put to work in an umbrella factory; his skill in carving landed him in the handle shop, which kindled his interest in art. "He developed such dexterity and interest in carving as to show latent art capacity and it led him at length to the Academy class of modeling and drawing from the plaster replicas of the most famous statues of the world."[18] His improvement obtained him the position of Foreman in an ivory carving shop atop Goldsmith's Hall, in Library Street, but in 1859 he accepted the position of Curator at the Academy, "to avail himself of the advantages there presented for observing and studying the objects of art that surrounded him and of drawing and modeling in its schools. He continued in this occupation for about five years."[19]

"Curator" in the old Pennsylvania Academy on Chestnut Street was a combination of janitor, superintendent, preparator, and monitor, and provided an apartment on the premises and a small stipend. He received and returned paintings to artists exhibiting at the Annual exhibitions, handled loans, worked with John Sartain and the regular instructors on a daily basis. Already in 1858 he had been elected chairman of the Artists' Committee on the Life Class, which voted on models and policy of admission to Life Class, and committee minutes show that also on this committee was one Lucien Crépon. The following year they were joined by Daniel R. Knight. Both Crépon and Knight were also listed as students in the Antique class register in 1859, along with Earl Shinn. Emily and William Sartain, and Mary Cassatt enrolled in 1860; in 1861, Augustus Heaton, Howard Roberts, Helen Corson and Milne Ramsey; in 1862, Tom C. Eakins. All of them later studied in Paris and

they all knew Wylie. "He was a most thorough and painstaking draftsman, and made himself of great use in this capacity to the pupils, by correcting their drawings; and what was perhaps of more value to them, playing the kindly but impartial critic, and giving a store of good advice and instruction."[20]

Of this group D. Ridgway Knight was the first to go to Paris, arriving in 1861. During July 1863 Wylie requested indeterminate leave from the Academy to pursue further art studies abroad: "In the interval of my absence it will be my greatest pleasure to do everything in my power to add to the high reputation of the Academy. It is a subject of cordial gratification to me, that I shall leave the Academy in the most flourishing condition; and its schools especially in unexampled success as compared with the means of instruction in the other similar institutions of our country."[21] It is probable that some of his expenses were met by the Quaker family of Augustus Heaton, a student whose physician had prescribed a sea voyage for eye strain (at the very time he reached the age of conscription). "Robert Wylie, a highly moral young man eight years my senior, who of course I knew well, was going to France to study and we could be companions," recalled Heaton.[22] After a visit to family on the Isle of Man, Wylie met Heaton at the dock in Liverpool in mid November, and on December 15, 1863, the two arrived in Paris.

That year was lively in Paris for the art world, which mourned Delacroix, and saw the reorganization of the Government art school, the École des Beaux-Arts, with an expanded curriculum of courses and an atelier system in painting. Edouard Manet had scandalized the Empress with the nakedness of his *Déjeuner sur l'Herbe*, and James MacNeil Whistler the critics with the "art for art" starkness of his *White Girl*, at the Salon de Refusés. For Americans it was tense because of news from home. The Paris colony was divided between sympathizers of North and South, and Philadelphia appeared on the brink of siege.

Just before Wylie and Heaton left for France, Ridgway Knight returned to Philadelphia in order to join in its defense in case of invasion by the rebels. When Knight had come to Paris in 1861 there were relatively few Americans. He was a student of Gleyre, along with the expatriate Pierce Francis Connelly of Philadelphia, Wordsworth Thompson of Baltimore, and Joseph Woodwell of Pittsburgh, an academy student. Woodwell, August Renoir, and Alfred Sisley were particularly close friends of Knight's from Gleyre's, and Knight left them with regret to go home to his imagined duty in 1863, consoling himself with

a ship-board romance. Soon he was hard at work trying to earn enough to return to Paris, filling orders of $50 and $100 for "portraits, views & whatnot", done anywhere on the railroad between Philadelphia and Pittsburgh. On January 17, 1864 he wrote to Sisley and Woodwell: "Have you heard anything of Wylie and Heaton? I hear that they have arrived in Paris. I suppose that by this time they have found you out, and that you are dining at the [Crèmerie] Jacob as in the old times with a full table...Woodwell, don't worry about the country. One would hardly know war is going on."[23]

In his memoirs Heaton wrote: "When I went to Paris with Robert Wylie to study art in December, 1863, the number of Americans interested in that profession could be counted on one's fingers... Ridgway Knight, who had been in Paris for a year before I started, gave me in Philadelphia introductory letters to two or three intimates of his there, but Wylie and I found them associated with French students in their habits, and preferring the recesses of the Latin Quarter to any American Society. So we never met them." Who these might be is not clear. Heaton goes on, "We had a friend, however, in a Pittsburgh student named Woodwell, who had studied at the Academy in Philadelphia." They looked up Woodwell the first morning in Paris, and he took them on a tour before finding them cheap quarters at $8 each a month "some distance up the rue des Saints Pères," in an attic. It did not please Heaton. "We met in the Louvre a French artist at work, named Crépon, whom Wylie had known in Philadelphia, and who aided us kindly in many ways during the winter."[24] The same Lucien Crépon a few years later was kind in helping Thomas Eakins get settled. For his friends from Philadelphia in 1863 he located an apartment on the boulevard St. Michel (where Heaton paid two thirds of the rent).

Crépon or Woodwell probably advised them on studios. Gleyre had just closed his school, Couture's Paris atelier was suspended and Julian, to whom so many foreigners would gravitate after 1873 was not yet in business. "We soon joined a class kept by an old model named Swiss [sic] for study from life, and on January 15 I got permission to begin making oil studies in the Louvre. Wylie had not then begun to paint, believing in a foundation of thorough drawing."[25] The *Académie Suisse* – no instruction, a model for a nominal fee, and freedom to work as one wished, surrounded by those who could not get, did not want, or refused to take formal instruction. It is not surprising that the Académie Suisse, with its very mixed crowd and lack of instruction, was considered

12

a temporary measure. Alexandre Cabanel had been named one of the Professors of the Beaux-Arts, and thus had just given up his private atelier, to which the Philadelphians had inclined, but then they learned that foreigners would be admitted to the reorganized school as regular students. Lucien Crépon, an unsung hero of American art students, again came to the rescue, at least of Heaton:

> By the aid of my good friend Crépon a formal application was written with which a sustaining letter from the United States Minister was necessary. This I procured from Mr. Dayton on January 25th and the next day both were delivered at the bureau of Fine Arts, Monsieur Valliant. On February 6th I found my name registered at the school in a list of applicants but delays in the reorganization left matters stagnant until, on the 23rd, Crépon accompanied me to the school and we met its director, Robert-Fleury, in whose class he had studied, a venerable artist of high standing, but small and thin in person. We were advised to go to see Cabanel who we were fortunate enough to find at work. Stepping down from a ladder before a large canvass, he received us politely and while Crépon was explaining our coming I had a moment or two to observe...He referred to the regrettable delay in opening the school and then asked me to submit three specimens of my work for his approval – a drawing and a painting from the nude and a composition in color. The first two I had ready from study at Swiss' and the last I made in my room a day or two later, selecting a subject from the 8th chapter of Esther.

> These were left at the Master's studio and when Crépon and I found him on the 26th, I was delighted to learn that they were satisfactory and to be told to begin study in his class the Monday following. So on February 29th, 1864, I became the first American of any part of the western continent to enter the great French Ecole des Beaux Arts. ...Wylie had unfortunately passed the age of admission.[26]

Wylie had come to France to study sculpture, but in 1864 the 25 year age limit was strictly applied at the École. At the Académie Suisse he drew. Antoine Barye is listed as his professor in later Salon catalogues, so he spent some time with the great animalist, modeling during his animal anatomy lectures at the Zoo. One Salon catalogue gives Thomas Couture as a professor, but it was a posthumous entry. That Wylie admired Couture is certain; a study by the French painter for the *Romans of the Décadence* hung in his Pont-Aven studio. But it seems that the generally abused claim for a painter being self-taught holds true in Wylie's case. Heaton recorded in his memoir, on Friday, May 13, 1864: "I came to our lodgings to find Wylie trying for the first time to use oil colors in a little study of a lemon. An unlucky day." The following year no foreigners were admitted to the École des Beaux-Arts pending review of admission policies. Years thereafter Wylie would have been admitted, for the age limit was waived for foreigners, but by 1866 he established himself elsewhere.

> Soon after our arrival we were joined at a Duval restaurant by a rather nervous young man named [Charles] Way. He was the son of a Boston millionaire of rapidly made fortune, and had first met the students Knight knew, but had been so plucked by them and befooled by them, that, on finding us safe and moral persons, he clung to us for protection and encouragement. A few weeks passed in daily dinners together, when Way noticed nearby a young couple of Bostonians. The young man, whom he had met there was a handsome fellow of about our age of twenty with long, dark hair and a generally artistic aspect. His wife was a gentle blonde still in her teens. It was a romantic love match. [Henry] Bacon, the son of a clergyman, had ignored opportunities of fashionable alliance in his father's congregation.[27]

Way introduced Wylie to Henry Bacon, who was recuperating from war wounds. He had scant resources, and augmented these by writing for Boston newspapers. It was Bacon who told Wylie about the beauties of Finistère.

Heaton's father had insisted in the summer of 1864 that his son move out of the Latin Quarter to the other bank of the Seine, "nearer to American Society," and the young student records that "as my chum Wylie had gone to Brittany to live, my change was easier." He also mentions that Wylie was back in Paris late in January of 1865, where he probably remained until that summer, when Way joined him on a trek in Brittany. At least part of the following winter was spent in Paris, for in the summer of 1866 the Boston painter Benjamin Champney recalled that, "during the previous winter I had met many times an old acquaintance – C.A. Way of Boston – and had been introduced to Robert Wylie of Philadelphia. They had been to Brittany the summer before, and were so much delighted with everything, that I had promised to meet them there for a few weeks work."[28]

How different Knight, Heaton, and Wylie were from one another, all three Philadelphians from the Pennsylvania Academy. Like Heaton, Knight was Quaker, but Knight had immersed himself in the life of the Paris art student, and obviously enjoyed the Cafés and Boulevards – just the life that Heaton thought degenerate: "A life of voluptuousness would have no doubt made me intimate among fellow students destined to be famous," Heaton said later "…on the other hand, many of these students were so base in their dissipation and so vulgar in language and mode of license as to disgust anyone of true sentiment and refinement." The irony is that he also complained that Cabanel's direction to copy certain masters in the Louvre to learn design, color, composition and technique "could have been replaced to advantage by study in the private studio of some artist of growing fame with a recognition of what was good in impressionism and out-of-door values." *Impressionism* at that time meant plein-air painting of the sort that Bastein-Lepage would make the rage a decade later. Among Knight's friends to whom he had been given introduction were *the* Impressionists of the future, and he had failed to look them up.

Back in Philadelphia, Knight writes to his friends Sisley and Woodwell telling of his work: "If things keep on the same way I hope to be back in Paris in two or three years time, when war and fighting shall be no more… I am almost bored to death after my work is done. I think then of the Boulevards and cafés and how you fellows are enjoying yourselves, perhaps in billiards, perhaps at euchre in the Café Mazarin, or in the quiet of your several domestic circles with your two wives on your knees. Ah!" His shipboard romance with a beautiful lady had been broken up by an irate husband, and Knight adds, "I tried to console myself with a female model, but it was like coming to the Crèmerie Jacob for café and petit verre after dining at Maison d'Or."[29] Heaton returned at the end of the war to a mild success in Philadelphia and Washington in history and portrait painting, and in club life. Knight returned to Paris, where he became not an Impressionist, but a follower of the academic painter Ernest Meissonier, of great fame and high price in America, but also tempered by the soft light and peasant subjects of Jules Breton and Bastien-Lepage.

As for Wylie, with little money and determined to work out the problems of painting, he followed Bacon's advice in the first summer and found an environment and people to his liking in the most depressed and cheapest part of France. It was probably with some relief that he left Heaton, who, despite protestations, did like voluptousness as long as it was of a familiar and chaste sort in the social activities of the Right Bank "colony" of Americans (not to be confused with the art colony). One gets the sense that Wylie's morality was innate, not learned, that he was a disciplined man with a hard core of personal integrity, brought up devout by his Presbyterian uncle, and imbued with a sense of self sufficiency. That he possessed social graces can be assumed from his personal relationships in all ranks. Loved by his Breton neighbors, he was considered also an astute judge of art by American collectors and was held in respect by artists.

Paris always remained the focus of all artists while away from the city because of the schools, museums, galleries, and the Salon. "Every year [Wylie] was careful to visit Paris during the annual exhibition at the Salon, that he might view his own products in juxtaposition with the works of other artists, as without this aid to his judgement he rightly concluded it would be impossible to know what peculiarities of style he might unconsciously be drifting into. He improved rapidly all this time."[30] For Wylie, the Salon was also a field for harvest. He was conscious of American collectors, and when in Paris regularly attended the weekly artist receptions held in the gallery of the resident Philadelphia collector W.H. Stewart. He was also, as William Sartain had mentioned, the chief adviser of William Wilstach in the formation of the collection that eventually became the cornerstone of the Philadelphia Museum. During his annual apparitions Wylie lent Wilstach his expertise, which was well rewarded. It must have been a great help at a critical time to sell his own work, and Wilstach owned two paintings by him dated in 1868 and 1869. Catalogues of the collection make mention of the special interest Wilstach had in Wylie's career. In return he got astute guidance and an expert eye, as Earl Shinn wrote:

Mr. Wilstach's collection…was amassed under unusual circumstances, and under such as seldom lead, as happened in this case to great critical selectness. The canvases were mostly purchased in a two or three years' artistic trip to Europe. The cream of the French Salons of 1868, 1869, and 1870 was drained into the gallery. Mr. Wilstach, a gentleman peculiarly and almost technically interested in art, made the purchases – generally in the company of…Robert Wylie, whose professional taste doubtless confirmed many a doubtful choice, and made the gallery what it is, a true artist's selection. The marked individuality of the Wilstach cabinet is that on a

large proportion of the pictures the same date is signed. Many industrious brushes were tapping together, in cities, far from these shores, to construct the magnificent result we see.[31]

On a gallery tour with Wylie in the spring of 1866, Earl Shinn saw Mario Fortuny's "first essay in the line of rococo themes dignified with Velasquez treatment" at Goupil's gallery, "where it was shown that year in a private room with great mystery to the present writer, in the company of Robert Wylie, who fully agreed with the proprietor as to the splendor and promise of the star just risen."[32] Wylie also guided Wilstach to the studio of Munkacsy, where he purchased the wildly popular *Last Day of the Condemned,* so celebrated at the Salon of 1870, while yet unfinished on the easel of the still unrecognized Hungarian expatriate. So Wylie was no recluse after his withdrawal to Brittany.

There is something in his own work of Munkacsy as well as of Couture and Courbet who were then riding the crest of acclaim. Alas, it is not possible today to compare the works by Wylie in the Wilstach collection with the purchases he advised. The Philadelphia Museum of Art succumbed to the epidemic deaccessioning of once highly regarded objects gone completely out of style. Wylie's two paintings and the *Last Day of the Condemned* were sold at auction along with many other academic American and European paintings in the dispersal of the Wilstach collection in 1954. The Academy entirely lost sight of both intrinsic value and historic connection when it sold its only Wylie, as did the Metropolitan Museum.

Earl Shinn is the principal witness to the foundation and development of the Pont-Aven colony, its recorder and scribe. Born in 1838 in Philadelphia into an old Quaker family, Shinn was enrolled at the Academy of the Fine Arts as early as 1859 and continued studies there until he left Philadelphia for New York at the end of 1864. He was at the Academy during Wylie's curatorship, and there for the return of Ridgway Knight with his tales of Paris and Gleyre's atelier. Shinn was the friend of both Eakins and Cassatt as a student in Philadelphia, and went the same year as they to Paris. There he enrolled with Eakins and Frederick Bridgmen in the studio of Gérôme at the École des Beaux-Arts. The summers of 1866 and 1867, the first of the American colony, he was in Pont-Aven. He visited Couture and Gérôme in their Paris studios, went with Wylie to the galleries and Salon, saw the 1867 Exposition with Thomas Eakins, and took the grand tour before coming back to Philadelphia in 1868 to write literary and art criticism for the *Philadelphia Evening Bulletin.* With the sale of the old Academy building around 1870 art life in the city ground to a halt until the grand reawakening in the Centennial year, so Shinn removed to New York, where he could scratch out a living as an art writer. His health was delicate, and he always lived in near poverty; even in France he supported himself as correspondent to the *Bulletin* on art and general culture and politics. After his two years in Europe Shinn wrote to one of his sisters of his planned return:

> The height of my aim at present is to be a critic and comprehend civilization and things of taste. Art I should like, and I have a vocation for it, but I think my near-sightedness, color-blindness and failing vision are pretty strong hints from nature that that career is not intended for me. I have the powers, and the conceptions, and the understanding, and under a happier star might have been an artist; but I feel debarred from that path, and swept into the current of literature, for which I have not a vocation.[33]

That he did not consider the same hints a hinderance in criticism might seem odd, but he was prepared in several ways to deal with that. He had direct practical experience with making art, which gave him understanding commonly denied critics who never have faced a blank canvas. Then, color (not its perception, but its use) held a place second to value in the dominant academies – "look to your values" was the common admonition in a period that held Velasquez and the Spanish Tenebrists in such esteem. Most important, he recognized his deficiency and left colorists alone or depended upon the judgment of others. Finally, his approach was that of a *Naturalist,* conditioned by the Philosophy of Hyppolyt Taine, whose books he knew in Philadelphia before he attended his lectures on art history in the Hemicycle of the Beaux-Arts. A decade later he emulated these lectures before the students and public in the new Pennsylvania Academy, where Eakins was introducing many of Gérôme's principles of teaching. For the *Naturist,* to understand and explain a particular work of art one must fully grasp its character and surrounding circumstances.

For his generation of American art students in Paris, Shinn was perfectly equipped to do just that. Under the sobriquet of "l'Enfant Perdu," he wrote his articles from France to the *Bulletin.* Because these record in detail the birth and life of the first colony at Pont-Aven, and the origins of the famous studio in the Chateau de Lezaven, extensive excerpts are reprinted in the text below and in the appendix.

On art and criticism Shinn adopted a pseudonym in respect for his Quaker family; to write moral philosophy was one thing, and art quite another. The Quaker regarded art as frivolous, frivolity as sinful. Thus he used the name Edward Strahan to write for *Harpers* and the *Nation*, and produced a number of "center table" editions on art and architecture, International Expositions in Philadelphia and Paris, American art collections, as well as a four volume tome on his master Gérôme. To Taine he wrote that "the antique repose of Bretagne pulsates through my memory as if it had been a dream."[34] And to an American publisher he stated his dream of making a written delineation of Brittany his *magnum opus*, a dream never realized.[35]

Settlement of Pont-Aven, 1866

Early in 1866 Earl Shinn and Howard Roberts left Philadelphia together to study abroad. They arrived in Paris in April, looked up Wylie, who had wintered in Paris, and took lodgings in the same building. Way also had an apartment there with a living room large enough for them all to share. Shinn immediately called at the American Legation, and Secretary John Hay initiated the process for admitting American applicants to the École des Beaux-Arts. For several months Shinn visited museums, galleries and monuments, and the Salon, which that year was particularly rich in the works of Courbet and the Barbizon masters. Evidently Wylie had convinced him early to spend the summer in Brittany, for he built up an appropriate library of guide books and histories dealing with the area. In June he and Roberts departed Paris for Pont-Aven, forgetting to take the books along, to Shinn's exasperation and our good fortune, for he had to depend more on personal observation and experience.

Bostonian Benjamin Champney was also in Paris in the winter of 1866, pausing on the way home from a sojourn in Rome. He too visited the Salon, and was particularly pleased by Corot and Daubigny. "It was with a sense of delight that I turned from the musty old galleries of Italy to find so much freshness and nature here," he said, but it was the work of Courbet that impressed him most: *The Home of the Deer* was the most interesting of all his works I have seen. The wonderful gray of the rocks, contrasted with the soft gray coats of the deer, and the surrounding forest tones made a most wonderfully impressive picture, one I could enthuse over and never tire of."[36] The

Salon, and this particular picture, was the subject of much discussion around the table in Pont-Aven that summer, and Champney's enthusiasm for it is beautifully parodied by Earl Shinn in one of the letters to his Philadelphia paper, reprinted in part below. Beneath the good humor of that narrative there is a great deal to be learned about the sort of thing the Americans were concerned with in their work, and the models they were emulating in 1866, especially Couture and Courbet. In Paris, Champney had met Way, familiar to him from Boston, and through him, Wylie. Their enthusiasm kindled in him the desire to lay over for a season with them in Finistère.

There also arrived in Paris in the spring of 1866 an eighteen year old from Brooklyn, completing the principal *dramatis personae* in the founding of the Pont-Aven colony. Frederick A. Bridgman was already skilled in the craft of engraving through apprenticeship with the American Banknote Company in New York, but he had higher aspirations in art. Financed by advances against future pictures from a group of Brooklyn businessmen with confidence in his potential as an artist, he came to Paris and lost no time enrolling in the Académie Suisse. He was there working from the model in May, but summer cloture suspended studio activities. He too put in his name to the American Legation for admission to the École in the following school year, then departed Paris for the country, and in August found his way to the Hôtel des Voyageurs in Pont-Aven.

Of the original Americans in Pont-Aven, only Wylie and Bridgman are represented in the exhibition, but they are the ones who left their mark and provide continuity. Way's contribution is not as an artist, but that in one way or another he brought people together. Champney happily painted Italian scenes on the panels of the hotel dining room, as he did later on his return to Boston. Shinn gave up painting for writing, which is his greatest contribution to the knowledge and understanding of Pont-Aven. In later years he recalled that first summer of 1866:

An agreeable and harmonious party of American and English students bore down upon the village in that first year..., swamping the Hôtel des Voyageurs, putting Madame Feutray to strange devices to feed and bed us, overflowing into the adjacent house of Tanguy, the notary, and surprising the inhabitants on fair days with a totally new line of purchasers of Breton costumes. The jolly notary who fairly moped when he could not have the society of the artists around the tavern table, was custodian of the keys of a rotten old country house, the Château

Figure 2. The *Place* in Pont-Aven. In the 1890s, the Hotel de Bretagne faced the Lion d'Or, now the annex of the Gloanec, across the wide end of the triangular *Place*. In between was the Hotel Julia, just out of view to the right in this photograph.

de Les-Aven, and readily let us open a studio there, among the delights of a garden run to seed.[37]

Champney wrote of his arrival in the letter carrier's cart, certainly driven by the same prospective bridegroom later described by Shinn, and a local fixture for many years to come. Along with Shinn's letters and writings, the published recollections of Champney are invaluable:

> The railroad landed me at Quimperlé, twelve miles from my destination. The rough, little letter-carrier's cart took me at a creeping pace the next day to Pont-Aven. Here I was heartily welcomed by my friends, and the other American artists who had already gathered there. Among them were Moses Wight of Boston, Earl Shinn and Howard Roberts of Philadelphia. There were also of the party an Englishman and his wife [Mr. and Mrs. Lewis] and now with the addition of a French artist we were a goodly and jolly crowd of artists. ...Earl Shinn of Philadelphia...had not at that time made a serious study of art, and his time was a good deal taken up with letters to a Philadelphia paper, but he used his pencil with great freedom and effect. Howard Roberts of Philadelphia was then quite young, and only commencing his studies as a sculptor. He was a big boy and made one think of a massive young Newfoundland, playful and good-natured, but not understanding the great powers that were as yet scarcely stirring within him. He has since risen to eminence in his profession in his native city.

Later in the season, Mr. F.A. Bridgman, with a young Englishman, [Garraway] came down to join our colony. Bridgman had but newly come to France for study. He was without experience in art, but we soon found he possessed ability and daring.

ひひひ

Wylie had had a good deal of experience with the people of Pont-Aven. He understood their characteristics well. He was always dignified and polite with them, and gained their confidence, more so than any other stranger could have done. We were acquainted with the Notary of the village, a young and jolly fellow, very well educated, and who sympathized with our aims and endeavors in art. There was an old building, just out of the village, half farmhouse, half chateau, neglected and forlorn, and of this the Notary had charge. He gave us the keys and possession. There was a large room with wide open fireplace and a high square window, which served admirably as a studio, and here Wylie brought the village children, girls and boys, to sit for costume

and character models. Most of us joined him here on rainy days.

We explored the rubbish in different parts of the big building, which must have been undisturbed for many years, and were rewarded by finding many relics of the revolutionary period, such as the worthless assignats, and the sous and liards of the date. We amused ourselves after dinner pitching quoits in the grounds for exercise and amusement.[38]

The letters that Shinn wrote to the *Philadelphia Evening Bulletin* in 1866 were weekly front page features appearing under the heading *Rash Steps*. Written for popular consumption, these are vivid and colorful word pictures of artist life in the first year of the colony at Pont-Aven. He cautioned his sisters in letters home that he might conflate experiences, but that otherwise everything was absolutely true. Intrusions have been expunged in the following accounts when they cannot be confirmed as dealing with the specific subject. In the remainder of this section the participants speak for themselves, with Shinn and Champney providing the greatest share. In

48 PONT-AVEN. — *Fête des Fleurs d'Ajoncs.* — LL

Figure 3. Postcard view of *The Place*, Pont-Aven, at the turn of the century; taken from in front of the Hotel Julia looking towards the bridge. At the left is the covered market, town hall and the Gloanec.

Figure 4. The Cafe des Arts of the Hotel de Bretagne. Reading the paper (in the tam) is the painter Maxime Maufra, one of Gauguin's followers.

the following, by Shinn, Champney appears in the character of Ben Adhem:[39]

A little company of old and new friends of mine, who dropped from the clouds into a queer Breton town, sat at night at the table d'hôte at meat...in that occult little town called of the natives Pon'-Am'n.

But such a set of apparitions! Each man was a "long-bearded, solitary," like an Enoch Arden after six months' abstinence from barber shops. They were heavily browned upon the face, hands and back of the neck. There was something outlandish in their dress. Brown men with long hair have a lonely look even when they go in bands. ...Amid the conversation which rattled around the table there was plenty which tempted the profession of the men I found myself among. One enthusiast was button-holing his neighbor.

"...,yes, the effect was the most stunning I've hit upon yet. You know the first curve in the river? Well, there's a huge face of rock there, a little bigger than Couture's "Decadence" it's a mass of gray lichen, very pure Courbet color, plenty of silvers along the gray, with some faint malachite reflections from the trees, and a good bit of burnt umber where they had had a fire against it. Now a pig, that had been out crabbing in the mud at low water, where I passed, had just gone up to rub itself – a monstrous animal. Well, you know the gray on a pig's back is the heavenliest color, well, it just carried off the gray of the rock, slick as lard; then the flesh-tint beginning to move through the bristles down the sides of the animal took the eye safely down into the mud, which showed some warm radiations from a gamboge cloud that hung handy; it was the

hottest mud I've fallen upon yet – remarkable for softness and feeling: quite juicy, you know and singularly clean. Altogether I was enchanted. I made a sketch on the spot: I'm thinking of a flight into Egypt."

The sketch was passed round. In *design* it resembled a plasterer's board when emptied for another supply. After some misgivings, I returned to ask whether he proposed to introduce a pig into the subject he meditated.

"Well, yes, I think so. Sheep are constantly shown along with the Flight in Egypt, and I don't know why I shouldn't introduce some pigs. The pig is greatly preferable to the sheep both for sentiment and texture – less wooliness, you know and a more sustained feeling. By the way, you have been looking at it upside down. Hallo!" continued the artist, in great excitement, bending across the table with his nose over my soup, "it's quite a new effect, so and infinitely preferable. It would make a capital Brazen serpent; groves and people, you know, something like Watteau, all soft and plumy. I can easily make a Moses out of the pig."

ᘉᘉᘉ

The closet doors were paneled off into convenient spaces, each of which was a painting. Many of these were studies of the neighboring landscape. Ben Adhem had painted a lovely Italian scene, with stonepines, a Bay of Naples, and a rich sky. In romantic contrast to this was a sombre Breton subject near by, with peasants, wheeled ploughs, oxen and a Druid column, overshadowed by dark and rolling clouds. On another panel a strong and graceful Bretonne girl was sifting buckwheat, lifting the sieve high in the air for the wind to catch the chaff, and managing her simple implement with all the grace of a tambourine. From another board suspended a large and gorgeous drake, apparently just killed, for a dark drop was oozing from his bill.

"We ate him before his portrait was quite dry," said Ben Adhem with a smile. "These doors are our wet-weather gallery. When it rains too much for landscape study, we exercise here. We have had a long and rainy season, more like a winter in Patagonia than a summer in France. We are rather exhausted, and we know all each other's pet jokes by heart. We look to you to freshen us up. There will be a panel saved for you."

"That is unnecessary," said I, in great alarm.

"It wouldn't succeed very well to pretend being an artist among you. All I ask is to be allowed to stay among you for a little time, and contemplate your ways, like DuChaillu among the gorillas. You haven't an idea how interesting you are to the world at large. Nothing is known of the race of artists except that they sleep in their hats and sit all day long under white umbrellas in the foreground of their pictures."

"No, no," replied the philosopher severely, "we admit no white crows among us; ...Tomorrow you begin to be a painter, at our atelier in the Chateau de Les Am'n (see appendix)."

Shinn did not room at the hotel, but took lodgings nearby with the jolly Notary Tanguy, his pretty wife with the "Indian hair and Spanish eyes" and fifteen month old son Felix. The English couple, Mr. and Mrs. Lewis, also roomed there. The hotel was quite limited in space, but all of them took meals there. In the following letter to his sister in Philadelphia, Shinn described the daily routine of the artists in the studio that Tanguy had made available for them at the Chateau de Lezaven.

Theoretically, I rise at six and a half, but I should be very green to try and make thee believe that I am virtuous in this. If I can keep up the average to seven I am quite satisfied. Dressing quickly, with just a look thrown at M. Tanguy's exquisite garden, I adjourn to the hotel, where the boys are assembled at "café". Meanwhile somebody is trying to rouse Francine, who is a very necessary part of our scheme of things, and Francine will sleep in the morning as though she had been composing sermons half the night. When Francine is awake she goes and calls for the model, and takes her to the studio, where we all assemble at half-past seven. Our character is so good that the prettiest girls in Pont-Aven sit for us without hesitation, but Francine must be by for company. A graceful young villager in the peasant costume is our model at present. We have got her to sit at an old spinning wheel, which she is apparently in the act of setting in motion with her right hand, while her left holds a distaff. She poses like a statue, and Francine sits by her knitting with an endless stocking, and from time to time they pass a few words in Breton. "Sing, Francine." – after we have been working in silence an hour or two "Sing 'Petits Oiseaux'" – and Francine develops her dimples, which stand for ideas and thoughts and everything...the model rests ten minutes. So passes the morning until twelve, when we run home to breakfast. Déjeuner is a dinner with the

exception of soup, and takes an hour and a half to eat, and at 2 we return to the atelier, where we always find our other model waiting for us. He is an old man with a head of black hair as long as thine, nearly, and three blue jackets at once, and white linen knee-breeches "gauged" half way down to the knee and having immensely wide pockets at the sides, and linen leggings buttoned at the ankles, and no stockings but the straw in the sabots; and sabots. That's him. He keeps us 'til six, only some of these bright, hot days we break off in time to catch the salt water at high tide in the Aven, and go off for a bath among the crabs. Dinner is at half past six, and takes about two hours.[40]

"Wylie sat at the head of the table and carved the ducks and gigots," wrote Champney, "and with the unselfishness of his nature never kept back a tid-bit for himself. Yvonne, with the formal head-gear of the town, waited on table with a stolid inflexibility, comparable to nothing but the Sphinx."[41] Mme. Feutray's mother, Mme. Hochet, was a part of the household at the *Voyageurs*, and was for the Americans a link to the historical past of the region, for she could relate accounts of the days of the terrible Vendean wars of Brittany, when she herself was marked as a victim of the terror, as Champney remembered her tale:

The mother of our landlady, Madam Feutray, was quite an old lady, and was a child during the terrible days of the revolution. She was taken with her mother and many other women in carts to be thrown into the water and drowned, but by some accident or streak of pity she was saved, and here she was a hale and hearty, good-natured, interesting old grandmother. Everybody called her "Le Damaroque." Why, I know not. She was past eighty, but sprightly and gay as a girl. And we enjoyed her stories much. She had some friends, two old ladies, living in a neighboring village, six or eight miles away, and one day she invited Wylie and myself to go and visit them and dine. And so we made the journey in their primitive one-horse cart with two wheels and no springs. The ladies were of the old school, punctiliously polite, spoke good French with manners of the well-educated and refined class.[42]

Writing years later about Bridgman, after the colony had an international renown and Bridgman was a medaled and "decorated" artist, Shinn recalled the simple fellowship of evenings among artists away from home in those first days:

There would be perhaps, a twilight hour of utter vacancy, and then, with the window of a very small inn chamber thrown up for ventilation [Bridgman] would coax a violin, worn to the wood, but rather mellow of tone, to tell him the fugitive secret of Art. In the evening there would be talk from wandering sailors, a grandmother's reminiscences of the Vendean war, sporting news from Tanguy the notary, or more cultivated conversation from the Marquis du Montier, a modest nobleman who formed a romantic attachment with Mr. Wylie. This gentleman's daughters, handsome girls, who were seen promenading by all of us in the village lanes, avoided our acquaintance with the usual French delicacy, but during Bridgman's second summer, as the American party were swimming in the Bay of Biscay, not far from where the Marquis's carriage-load of guests were also bathing, the life of one of the high-born girls was saved by Bridgman, with considerable risk of his own, and he and his violin were afterward made welcome at their home. ...The landlady made pets of her trans-atlantic family, and organized feasts on Twelfth-nights and saints' days to show them the customs of the country. The nights in the inn parlor were festal, but not bacchanalian. The curfew bell from the village church broke up every evening's diversions, and as it sounded, Yvonne, the waitress, entered and incontinently dismissed the guests, gentle and simple, to their repose. It was singular to see the grave, Spanish-looking marquis pluck up his hat and retire humbly in obedience to this antique tocsin.[43]

The popularity of the artists at the *Voyageurs* in the community at large was cemented by their own good nature, combined with their practical skills. This produced a symbiotic relationship of very useful kind, for there was never a dearth of willing models. Shinn, riding on a billow of local popularity, described the process to his sister, thus:

August 10, 1866

The courier or postman who drives between here and the nearest railway station, is to be married next month, and last night I caught him with his hand up to his chin, thinking of the event with the happy pensiveness of lovers. Fixing him in my sketch-book with beaucoup de success, I tore out the leaf and handed it to him with a little message to his lovess, and excited him to the liveliest joy. He spent the rest of the evening exhibiting his likeness to everybody who would listen to him, and is very anxious to be sketched

in Breton costume, of which he has a full suit though too much of a dandy to wear it, and by that means I get a model for nothing. . . . La Fuer is throrough Celt, usually tipsy, 6 ft. 1, the handsomest young man in Pont-Aven, and when you have a girl down by the quay weeping day and night because another damsel and not herself is to be the heroine of the ceremony, why I think it is quite a ballade.

🜚🜚🜚

The good folks around the hotel are clamorous for immortality. The travelling photographer scarcely penetrates. I have made several too-easy promises for "some other day". Dam 'roc'h, otherwise Madame Hochet, the landlady's old mother . . ., is to be taken wiping plates (an incident of the meals is plates warm from the dishpan at the latter 6 of the courses). Mme. Landlady complained earnestly yesterday to Champney that we had been sketching her lazy cipher of a husband on all the walls and doors, and never herself. The sottish zero himself is eager for the honor . . . Champney answered with some presence of mind, that he was an oddity, and she was handsome. Champney is rather my favorite in our crowd. He has the art of getting on with others, which I think a very interesting study. The race of artists, whose profession obliges them to go through the world with their nerves bare, are not famous for harmony among themselves. Champney is a model of balance, philosophy, and good humor.[44]

🜚🜚🜚

September 1, 1866

I have taken Felix's portrait, en chemise; it was a pretty drawing, but not like. The little sardine wriggled and wriggled, never still a second, so I could not get his face. However, the photographer has not penetrated to Pont-Aven, and they don't quite know the difference between likeness and no-likeness. It appears to give lively satisfaction. Wylie went over it with light washes of color, and give it quite a miniature appearance; I have to support a reputation for protraiture on the slenderest foundation – the others, wiser than I, do not exhibit their skill, but my head of the postman has given me a very inconvenient celebrity; everybody is falling into rigid attitudes around me, with the eternal cry, *tirez mon portrait*.[45]

The American painters in Pont-Aven were not working under any imposed regimen or academic constraints. Wylie's training had been purely self-directed and paint was still new to him. Everyone agreed that Way's talent was slight. Champney was a straight-forward landscape man, who admired Courbet, Corot, Charles Daubigny and Theodore Rousseau (on his way home from Pont-Aven he stopped in London, and the only thing he found interesting of the English School was Constable). Wight was a portraitist. None of them was working then to produce a Salon painting. And Bridgman, Shinn, and Roberts were beginners in France, not yet enrolled in the École des Beaux-Arts. The Englishmen Lewis and Garraway are unknown quantities. Although several French artists passed through during that summer, only one was in residence with the Americans, Eugene Martin. He was a printmaker, and no pacesetter. Wylie was probably more at home in Celtic Brittany than most Frenchmen, anyway, and made an effort to learn the language and customs. The atmosphere was that of a free academy, drawn together by Wylie's magnetism, which all acknowledged. Shinn's assessment of Wylie seems typical:

Wylie I rather regard as my own particular; he is quiet and sage, with a great fund of information in which he plumes himself in a silent way, and he takes the head of the table and issues dictums; you have to get used to a certain tone of dogmatism, and for my own part I am glad enough to yield all his claims for the sake of peace. I never in my life was in a less combative mood than at present, and besides, Wylie in our first interviews displayed a consideration and sympathy that touched me. Having heard that I had been a little knocked about and battered of late by the weather, he continued to insinuate a slight tinge of compassion into his manner without becoming the least of a bore, so that I was not only disarmed at once, but could not help yielding a part of that confidence we all save up for the confidential spirit we all expect to meet some day.[46]

So the artists were accepted in the community not only as transient oddities, or solely as a cottage industry but as a cordially recognized part of daily life and amusement, with Wylie as their leader:

Our popularity among the Celts continues, to our great delight. We have great pleasure in uncovering to all these heavy hatted Bretons, so as to make them lift their two pounds of felt; also to the French gensd'armes, whose mighty chapeaux, covered like theatrical properties with "toile americaine" or oil-cloth, are not removed without an effort. The French hat very early

begins to loose its gravity in an encounter with another.[47]

❧❧❧

The artist visitors became the lions of Pont-Aven. Beggars used to gather around the door of the chateau-atelier just as if it had been a church. Tourists visited the studio as the museum of the place, and the studies made by Bridgman, Wylie, Moses Wight, Benjamin Champney, Howard Roberts, Martin, Lewis, and Garraway gave a modern air to the old manor-house, or enlivened the closet doors of Madam Feutray's tavern.[48]

The pattern of work evolved by the Americans when left to themselves is interesting. Figures posed in the studio of Lezaven were illuminated in the somber room by a single source of raking light, giving traditional interior lighting then favored by such academic artists as Bonnat. Outside in the landscape they followed the example of the Barbizon painters they so admired. But they also, on good days, posed the costumed figure in appropriate attitudes for direct painting out-of-doors. How common this practice was in 1866 is unclear, but a decade later it was considered extraordinary in the work of Bastien-Lepage. For example, Shinn described the old Breton model who was a favorite of the artists at Lezaven, posing for Bridgman in extra-curricular plein-air exercises: "This quaint old fellow I discovered one morning at sunrise, leaning against a wall in a smuggler-like attitude, with Bridgman painting away from him for dear life, having surreptitiously bribed him to posture between hours for his private and special benefit. What chance was there for the others against a comrade who worked so unfairly at this? Bridgman positively enjoyed making the rest of the artists feel good for nothing." Once again it is Earl Shinn who delineated in a word picture the typical out-door activity of the Americans in Pont-Aven in one of his letters to the paper. It is not just a random narrative of an American tourist, but a document of a critical point in a vanished era in French as well as American art:[49]

The day is short and a drab vapor rolls up from the Bay of Biscay.

The standard of the white umbrella is planted by the river and a landscape man is making a study of the river path, where it balances upon the saddle of a little hill and dips invitingly over into mystery among the interlaced beech trees. Just upon this climax in the career of the river-path is placed Grégoire Canivet, a young model. The tender tracery of the beeches arches over

him, and a late salmon leaps sometimes in the dimpled river at his feet. A figure-man is studying him, and the schools of landscape and of genre, usually so hard to reconcile, are blended upon the peaceful white umbrellas.

"Now, Grégoire, assume a sad expression. You are a conscript, you know. The order with your number on it is folded and thrust beside the feather in your hat, and you grasp your club and start away. But you have paused a moment and uncovered, while you throw a last salute to Pon-Am'n, your native town. So wear an air of emotion."

"As this?" he says, and on examination he is found to have pointed his eyebrows like a tragic mask, and rolled his large wet eyes around to the spire of the town church. It is not a bad bit of provincial acting.

Grégoire was captured at a Pardon. Kneeling among the pious devotees, with his naturally refined face solemnized by the occasion, and the long chestnut lashes lying on his cheek, he looked like some very precious Saint Sebastian by Velasquez. ...He has a bit of the self-love proper to seventeen, and does not pose with avidity. When we had dragged him, much reluctant, to the work-room, there was another task before us in settling him into his father's baggy knee-breeches. These were dear to us for their pictorial qualities, but the leg of Grégoire loathed them, and was as difficult to bag as a wide-awake cat.

"They are no more pretty, those. They are not for me, they are my father's. Men do not wear them more like that."

❧❧❧

Sitting quietly at work hour by hour, the little habits of peasant life come out one by one, like wild things in the woods that only appear after one has been still a long time. The place is just below the town, where the river, after passing the "fourteen houses and fourteen mills," which proverb confer on Pon' Am'n, gets its first taste of the sea and slides eagerly forward to meet the fuller flavor and the larger life. It curls voluptuously southward like a smooth gray serpent, licking many castles with cone-like roofs and pigeon-houses of the size and solidity of chapels, set in the fringing woods. Nearly opposite is the principal mill, a crumbling structure of the middle ages, with gargoyles at the corners that watch the artists working with the real medieval sarcasm in their faces (fig. 5). The river upon its en-

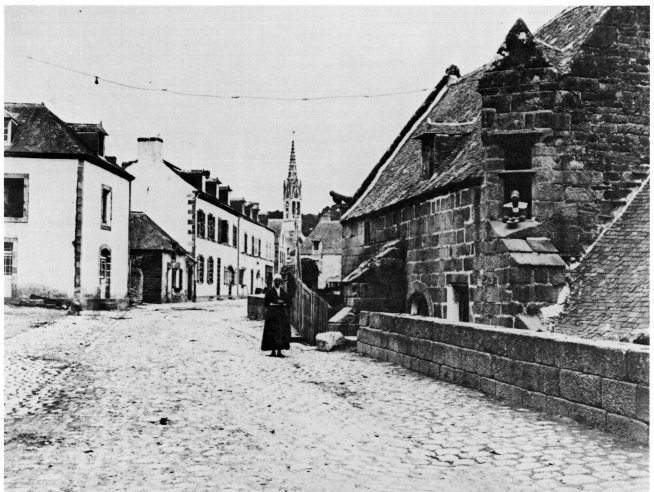

Figure 5. Moulin de la Porte Neuve, c. 1880. The gargoyle at the corner of the mill looks across the street to the place of the old pig market. Photograph by Helen Corson.

trance into liberty is beset with obstructions in the shape of enormous granite boulders. One of these, precisely in front of the white umbrella, has the form of a well-modeled foot, or rather shoe, twenty feet from heel to toe. The poetical dreamers around are unable to improve upon this play of nature. From the foot, Hercules. They hang over it in the air, a shadowy image, with monstrous head nodding high above the town. It is the hero of romances, Gargantua. The stone is his shoe.

Enormous sand-barges float up the river with the entering tide, and deposit their sea-treasure at our feet. Sometimes a fish leaps, sometimes a white sea-bird rides screaming over. The rude farmers from the inner country, with their wild dress and lumbering round-bottom carts, ap-

proach for loads of sand. It is used for lightening the soil, while the proportion of shell-fish serves as a manure. One would think the very bean-blossoms of such a land would smell of the sea. The tall, narrow women, in their lofty white caps, pass and repass, knitting or spinning. Their silence is a sombre reflection from their sad, inarticulate lives.

Nearby at the coastal town of Douarnanez there was a far better Inn where a similar colony of French artists gathered that summer, with Jules Breton its luminary, but the American artists had the wild countryside around the Aven River to themselves, a varied assortment of people, relatively inexperienced, but united in their desire to be artists. For Wylie the die was cast, and he would remain a resident for life. Bridgman returned for five summers, and when money ran out remained several years. Champney went home and broadcast the charms of Pont-Aven among Bostonians coming to France for the Inter-

24

national Exposition of 1867. Meanwhile, Shinn wrote home to his sister in August:

The "Landes" of France are vast heaths – heather, fern and boulder, and they are all around us stretching to the ocean. The country grows upon our love – it is full of artistic material. ...I am among the gypsies of life, remember, where there is another system of expression. ...We say without fear of practical ones listening, the poor fancies that are the terms of our trade: Wight continues to call peaceful evening scenes "stunning", and Champney asserts that the sky is done with Naples yellow and vermillion, and there is none to make us afraid.[50]

Colonization, 1866-1870

At the end of the summer the members of the group at Pont-Aven went their separate ways. Wylie and Bridgman remained. Shinn stayed long enough to see Roberts off at Quimperlé: "We three went to the next railway town to see him off; the previous evening we had one of those dreary French fêtes which the natives can stand to any extent, looking in each others' faces and singing songs without end, but which perforate Americans badly."[51] In Paris, Roberts got the bad news (which Shinn was about to receive from John Hay) that *all* applications would be postponed, there being "no vacancies" in the art school. Champney was in Paris, en route to Boston, and wrote about it to Shinn.

On board ship. Sept. 29, 1866.

I saw a good deal of Roberts and was glad to be with him. Finding he could not get into the Beaux-Arts I went with him to see some sculptors and also the director of the school. He was received very kindly everywhere, and has decided to go into the studio of M. Gumery, a sculptor of good reputation, and if he shows earnestness of purpose he will no doubt soon be in the Beaux-Arts. I should rather be with you all in Pont-Aven looking at the *startling* effects and roaring Aven – Pity me – Give my love to Wylie...

Sunday Morning Sept. 30th

...I should much rather be in Pont-Aven at this moment, with the provoking dimples of Francine in the foreground, or with the good natured smile of Yvonne in view. I cannot say that cooking on board is much superior to Madame Feutray's, and I'd rather take my chance with you all at her table. The landscape of England looked remarkably soft and lovely as I went through – but very fresh and green and drenched with rain. It seemed a little monotonous, however, and wanting in character after the rough, rocky hillsides of Pont-Aven – wouldn't I like to set down before a fine gray rock this minute, with a bit of changing foliage, a bright sky and no shower.[52]

At the galleries in Boston Champney found no figure work, but saw large landscapes in William Bradford's studio, Albert Bierstadt's and William T. Richards'; the landscapes being readied for the American gallery of the impending International Exposition to be held in Paris in 1867. A letter to Shinn reveals the nostalgia generated by Pont-Aven, the cultural shock common in most artists returning to their American cities after residence abroad, and the continuing propaganda spread by Americans who had been to Brittany. Forecast, also, is the mass migration of American artists to France in the spring of 1867, for whom the group in Paris and Pont-Aven were bellwethers. He also had seen *Rash Steps* no. 16:

Boston, November 26, 1866.

What a man you are! To put such wisdom and such noble sentiments in the mouth of the sage Ben Adhem, when you know they all emanate from your own fertile brain. But I thank you for your high interpretation of my character. ...The pigs and the Flight into Egypt – Etc. It was all capital ...And now how does Boston, HOME appear again! Alas, it has a belittled, dirty and forlorn aspect to me. Everything goes helter skelter. Everybody is in a hurry and everything is done in a haphazard sort of way. I was homesick and out of temper, disoriented, ...the two weeks after my arrival was a transition period...
The artists seem to like my Brittany sketches better than anything I have done... What a pleasant summer we had at Pt-Aven! It will always be a pleasant memory to me in spite of dirt and other drawbacks – just think of good Yvonne! What a funny picture you drew of the sick chicken served by Francine! Think of Marguerite and Marie and Jacqueline with the wonderful eyes. And so Wylie remained in Pont-Aven another month. What a good fellow he is. I love him for his truthful, self-sacrificing character. ...I am going to give two young artists who leave

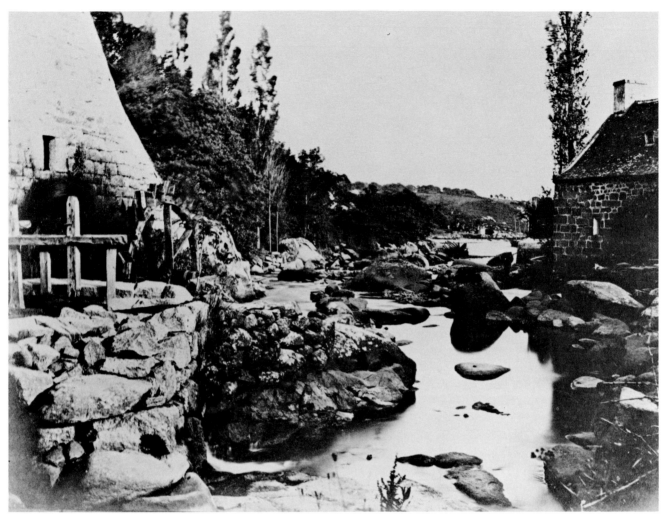

Figure 6. The Aven River at the Fall Line, c. 1880. At the left is the Moulin Ty Meur, on the right the Moulin Ligeour, the last mill before the Aven flows into the harbor which is seen in the distance. Photograph by Helen Corson.

here about the 20 December (1866) a letter to Wylie. They are earnest young fellows who have made some proficiency in landscape painting and being strangers and without a knowledge of French will want a little aid and sympathy. I know you will all be pleased to lend them a helping hand. ...

[Albert F.] Bellows has some exceedingly pretty little things illustrating the months, called "All the Year Round" I have innoculated him with a desire to go to Brittany for subjects. Next Spring there is quite an exodus of artists from Boston for foreign parts. Three or four have already left for Paris, and others are preparing for departure.[53]

Shinn's letters home between 1866 and 1868 are very informative about life in Paris, and life in the studio of Jean Léon Gérôme in particular. A letter of November 10, 1866, gives descriptions of his visit with Gérôme, entrance to the school, method of instruction, and hazing. This excerpt documents the role of Thomas Eakins in breaking the log-jam in admission of Americans.

Thee knows my theory about travelling has been, not to rush, but to saturate yourself with the best part of the life around you. The best part of Paris civilization is most unquestionably either the Institute or the Government Art School. This is unapproached at present on earth, and I am inclined to think, unapproached in all history. Isn't it sensible, while I stay, if I find it accessible, to throw myself into it, as the deepest way of seeing Paris? Well, my last letter described my disappointment in receiving news of our rejection. Just after that came another note from the same Chargé, announcing my admission, in response to a "renewed application" of the U.S. Legation. The fact is, while I was rambling in Brittany, young Tom Eakins was exerting himself

26

in the heat, investigating Directors and bothering Ministers, until he got the whole list of American applicants accepted – they had decided to exclude foreigners. The news was exciting – but I had two doors to knock on yet, those of the Secretary, and of the Professor (Gérôme, the painter of two of my large photographs) either of whom had power to stop me off by saying "You are over 25". However...I was admitted by favor, and entered the classic locality the same morning as my young friend Howard (Roberts) who had arrived at the same result by a different experience.[54]

It is not the purpose here to examine the full curriculum of the reformed École des Beaux-Arts, or to follow the daily life of the American art students and artists in Paris. Heretofore, any attention to that area has been confined to the clarification of particular events and circumstances leading to the congregation of a small band of Americans in a remote Breton village where there had been none before. A

certain knowledge of academic method and training is presupposed in the following discussion, but where it has particular bearing on a specific artist or movement, some attempt will be made to recognize it. Since a great many Americans enrolled in the studio of Gérôme at the École des Beaux-Arts in 1866 and the years following, special attention will be given to his method. His was the most rigorous of all instruction at the Beaux-Arts, but can stand for the general approach. Unlike Cabanel and Léon Bonnat, who spoke English, Gérôme did not, yet he had the greatest number of American students.

The original 1866 list of applicants forwarded to the Beaux-Arts by John Hay contained the names of Eakins, Roberts, Shinn, Bridgman, and Conrad Diehl (who does not appear to have enrolled), and Eakins soon got his deaf-mute friend Harry Moore into Gérôme's atelier.[55] In years thereafter the list of American students of Gérôme also includes the names J. Alden Weir, Edgar M. Ward, Aloysus O'Kelly, Aubrey Hunt, William Picknell, Clifford

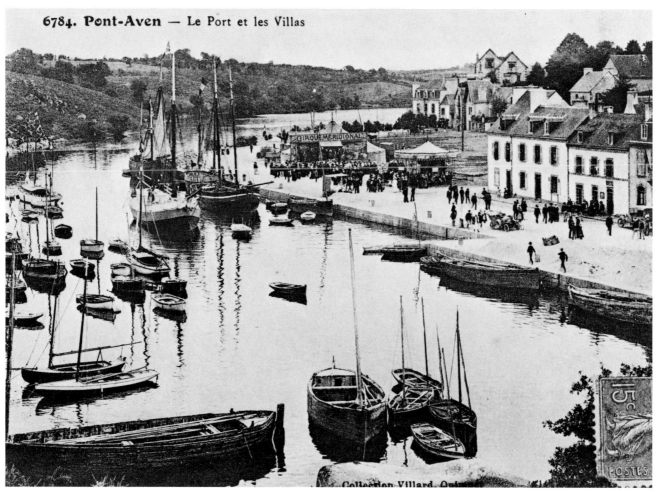

6784. **Pont-Aven** — Le Port et les Villas

Figure 7. Postcard view of the harbor, Pont-Aven, c. 1910. In the foreground is the Grand Sabot, the giant shoe of local legend that lies just below the last mill on the Aven river.

Grayson, Alexander Harrison, Arthur Hoeber, Augustus Lasar, George de Forest Brush, Leonard Volk, Frank Boggs, and Dennis Bunker all of whom went to Brittany.[56]

Bridgman did not enroll in Gérôme's atelier until February 1867. Whether he remained in Pont-Aven until then, or spent part of the intervening time at the Académie Suisse isn't clear, but once in Gérôme's atelier he worked hard at absorbing the teaching of the *Patron*, the *Boss*: "His two years of decipleship under Gérôme were evidently the turning point of his life, and gave him a bent which time is only developing more and more distinctly," said Shinn, who was there when Bridgman entered.[57]
In Gérôme's atelier the main task of the student was to "possess" the subject – the naked model – to master the individual character and proportion without elaboration on nature or idealization to place the figure squarely planted on its feet and filling the sheet of paper, modeling form in chalk or charcoal. Gérôme student J. Alden Weir wrote:

> In the drawing they use the stump, shading just enough to express the darks and half tints and always they make them take in the whole of the paper, the head within a quarter of an inch of the top and the same of the bottom if standing. They find where the middle would come and then how many heads high the model is, looking for the grand lines. Perspective, anatomy, history of art are each twice a week. ...Gérôme is very severe with the drawing and in representing the model as near as possible, which I think is the school for a student. He is liberal and says nothing to the manner; what he wants is to have the student's study serious... In using the stump he will not let the beginner put in anything but the principal darks and not until he has advanced will he let him put in the demi-tint. With regard to the new student in color, give him no theories, he has nature before him, let him represent it.[58]

The requirement that the drawing fill the page made the student think ahead his proportions, to know what he was going to do. The popular notion of the artist forever admiring his thumb at arms length actually shows him recording proportion against the handiest gauge. In Gérôme's studio the drawings were often finished from top to bottom, requiring the student to know exactly where the feet would be before he got to them.[59]

Exhaustive courses in anatomy, augmented by dissections in the hospitals, taught the art student what he was looking at in the model. Ample cadavers were available for study, and art students and medi-cal students worked side by side on a "subject". Paris, being to the medical student what it was to the art student, had plenty of aspiring American physicians, and it would be intriguing to know if the young Philadelphians and future physicians W.W. Keen or Haller Gross ever met Tom Eakins across a fine anatomical section there. At the Beaux-Arts, the professor of anatomy was interested in animal locomotion, and enlisted the aid of students in reducing the trajectory of a run or a trot or gallop into its phases – in the absence of a camera fast enough to capture them – and reconstituting them graphically in a zoopraxiscopic viewer.

For all of the students of the Beaux-Arts perspective was an essential tool, a system by which the forms modeled could be related to one another in simulated space. For Gérôme's students it became a passion by force of his own example. By its use, proportion could be measured, controlled and explained. Details of footprints on the sands of the Colosseum or a circus or Spanish bull-ring could be accurately translated, and thus easily read by the observer, as could the ripples left on the surface of the water by the oarsmen of a Nile barge or a sporting scull. Gérôme was simple and direct in his dealings with students, and readily received them in his studio while painting on some of his best known historical canvases. He was a Realist – some called him a *Historical Realist*, others a *Photographic Realist*, a tourist recording distant times and places – but his realism was that of the brain, not the eye alone, and his paintings were painstakingly constructed. In these visits the students could observe his methods. Eakins saw in progress the gladiatorial combat *Pollice Verso*, (Collection Phoenix Art Museum). Shinn visited the master when his chariot race in the *Circus Maximus* was on the easel, still in the initial lay-out of sweeping curves and intersecting network of orthoganal and horizontal lines and distance points. And Frederick Bridgman, as Shinn recorded, succumbed under Gérôme to the seduction of the Renaissance science of Albertian perspective: "When he seemed only intent on learning the amusements of a student's gaudy nights, he was really dreaming amorously, like good Paolo Uccello, of the tender mysteries of perspective, or cultivating a mathematician's liaison with curves of the higher orders."[60]

The end of our Civil war, improved Atlantic transportation, and the great Paris Exposition combined to multiply the ranks of Americans arriving in Paris. America participated fully for the first time in an International Exposition in 1867. Artists came in droves, from old Samuel F.B. Morse, honored now

for his telegraph, to young exhibitors like Winslow Homer, on assignment from *Harper's*, who would remain to paint for the better part of a year; and Clement Swift, Milne Ramsey and Edwin Blashfield, bent on enrolling in a long course of study. At the Exposition and the Salon they could examine the art of all participating nations, as well as the private pavillions of both Courbet and Manet. Marking the passing of an era, Gérôme's American students marched with others in the funeral procession of the great Ingres that year, contributing a franc to the monument that reads: *Drawing is the Probity of Art.*

By the middle of August 1867 Shinn was back in Paris from a three month tour of Italy, meeting American artists over for the International Exposition at every turn. Paris was full of Philadelphians who called upon Eakins and Shinn to show them the city and be their guides to the museums and cathedrals. Shinn accompanied a visiting Philadelphia physician to the cathedral of Rouen, and Wylie was in town for the Salon and Exposition and consultation with Wilstach. Presumably the young Boston artists Champney mentioned were coming for the Exposition looked up Wylie, and it is tempting to imagine Winslow Homer rapping on his door. Wylie did call on Shinn that August: "Wylie has at least started from his enchanted slumber in the forests of Brocliande, and woven his paces towards the capital; he burst in on me the other night, and will I think take a chamber next to mine. In his year's residence he has learned quite a stock of Breton, and would be the most eligible of companions around the coasts of Arthur, and the battle-fields of the Table Round. He wants me to join him on a trip of that kind."[61]

They spent a month together trekking in Brittany in the fall, meeting beggars and serving girls they had known in Pont-Aven; shared walks with French artists who carried Victor Hugo and Poe for light reading, and who told them about the Hotel de Bretagne in Douarnanez, giving them letters of introduction to the landlady: "She was perfection and exhausted herself over our dinner, the best we have had in Finistère. She was dark, handsome, unique... Dining room with paper full of pictures, which had been all altered by the baker's dozen of artists here last summer – Jules Breton animals."[62] So at Douarnanez in 1866 there had been a colony of French artists similar to the one just hatching at Pont-Aven by Americans.

But Shinn also found that even Pont-Aven could not remain as he had first known it: "Whenever we get back to an old horizon how we find the landmarks changed. Even in Brittany I felt a little cloudy on hearing that my former kind host, Tanguy the Notary, had neglected business and been sold out, involving his wife's family, and his little boy Felix whom I'd sketched had been sketched since in his coffin by Garraway, while marriage had made almost equal slaughter among the names of my different pretty girls at Pont-Aven."[63]

After another season at the Beaux-Arts with Gérôme, both Shinn and Bridgman had financial crises. For Shinn it was compounded by physical problems, and after visiting the 1868 Salon he returned to Philadelphia to devote himself to writing. The Salon that year was in turmoil. The admission and hanging policy threw the establishment into confusion by favoring the unknown and unconventional over the old chestnuts. Many neophytes were admitted. Milne Ramsey showed a *Still Life.* Two other Pennsylvania Academy students, Eliza Haldeman and Mary Cassatt, were accepted, even though they had been barred on account of sex from study at the Beaux-Arts, the latter exhibiting under the name Mary Stevenson. Bridgman was also accepted and hung "on the line" with an engaging and well painted picture of *Breton Children* executed in the Château of Lezaven; after painting only two years he got favorable notice. It was just in time, for his funds ran out: "I studied in the Beaux-Arts under Gérôme," he recalled, "and spent several summers in Brittany. At the end of the second year my funds gave out and for six months an average of 10 sous a day was all that I could allow myself."[64]

The natural place for him to go under the circumstances was back to Pont-Aven, where room and board was cheap and could be had on credit, and there were good models and a free studio, not to speak of a free association with fellow artists who could help him. His first Salon had been done inside Lezaven, with its "aristocratic" flag-stone floor instead of the usual tamped earth, under the keen eye and gentle persuasion of Robert Wylie. Bridgman had not been long with Gérôme, who likely kept him some time on charcoal to soften the liney quality acquired as an engraver of banknote curlicues and flourishes and teach him modeling, so his earliest instruction in color and paint manipulation was probably by example and experimentation in Pont-Aven. There, he also painted out-of-doors: "Bridgman's five successive summers in Brittany, in the dewey, cloudy air full of mystery, amid the companionship of able landscape artists, riveted his attention to the wonders of atmosphere, and made him forever ambitious of landscape excellence."[65]

"It is not the unmixed effect of Gérôme's art to

make every student emulous of his severe intellectual, scholarly style of painting. This is a grief to the *patron* himself. 'Do not try to imitate me,' he will say. 'Seek out effects in nature which are sympathetic to your perceptions. Be realists, be Courbets, or Manets; only use the grand laws I have indicated to restrain yourselves by.'"[66] Despite Gérôme's admonition, his students often tended to follow his example, and the Americans were no exception. Eakins had seen the gladiatorial combats and bull fight pictures of Gérôme and studied his perspective protractions, and when he went to Spain to make his first exhibition picture after concluding his studies he contemplated doing a bull fight. It is no accident that in later years he selected for major paintings the motif of a performance before an audience in an amphitheater, be it in baseball, boxing, or surgery. In the winter of 1869-70, while Eakins was going to the bull-ring in Spain, Bridgman was going to the circus in Brittany, gathering material for the painting that gained him recognition in France, and celebrity in America in 1870: *The American Circus in Brittany* (cat. 19). In a letter to one of the Brooklyn gentlemen who had advanced him money to embark on his career, he described his method: "One must have models for everything, as I did for all, as much as possible, for the *Circus*. I could have many more advantages but with what I had there was a certain possibility, as you see in the result, as earth and an old sail were easily found and I made a part of the ring – the track and a tent – and went to a neighboring city to make a study of the whole arrangement of the interior and costumes."[67]

One imagines the "tent" pitched over a simulated ring in a corner of the courtyard of Lezaven, local models perched upon temporary bleachers in the filtered outdoor light. The lines and shrouds of the tent, the ring, the whole conception is straight out of Gérôme's pictures of The Colosseum and Roman Circus, no matter how rustic or provincial the audience here. Nonetheless, Shinn called it: "A study of nature for its own sake, and without conventionality. This canvas, now owned by Mr. Rook, of Brooklyn, is a sincere setting down of each spot of value, each 'Tache' of color, in a crowd of objects. It is slight. It is imperfectly modeled, but the uncontaminated impression of natural objects in a given light is there."[68] Exhibited the same year in Brooklyn, the *Circus* sold for $750, marking the end of Bridgman's financial tribulations.

Pont-Aven to 1880, The first generation

The Franco-Prussian war suspended art life in Paris in 1870 and 1871, especially for foreigners, who found themselves suspected by the French as Prussian agents, and by the Germans as French provocateurs. Edwin Blashfield and Milne Ramsey, fellow students of Léon Bonnat, arrived at the Rhine on their way to Schaffhausen the day the Germans blew up the bridges. Blashfield returned to America and Ramsey sought refuge in Pont-Aven. There he found Wylie, Bridgman, and a young art student from Massachusetts named Clement Swift, who had just arrived in France with the aim of becoming an animal painter. They all worked together that winter, which was extraordinarily severe for the area, with several weeks of snow and continual frost. The waters of the Bois d'Amour froze over, and the Americans amused the villagers with their manoeuvres on the ice with skates improvised by the local blacksmith after their design.[69] Bridgman wrote his sponsors in Brooklyn that he would stay the winter: "It is cheap and...as good a place as we could find to paint in as models are easily procured and are cheap....As there will not probably be an exhibition this spring in Paris, I may expose in London. My larger picture is mainly finished and others are underway."[70]

Clement Swift stayed over that winter and for another ten years, during which time he was a witness to several convulsions in the colony at Pont-Aven; transitions marked by tragedy, beginning with the suicide of Mme. Feutray in 1870, and ending with the sudden and unexpected death of Robert Wylie in 1877. In the time between, many artists came and went, but there was a hard core of year around residents and faithful regulars: Swift, Ramsey and family, including his sister-in-law Margaret Ruff and their companion Helen Corson; William L. Picknell, Thomas Hovenden, Burr Nicholls, H. Bolton Jones and his brother Frank, Edwin H. Blashfield, George F. Munn, William Lippincott, and visits from Bridgman, back in 1874 from several seasons in Algeria and Egypt with Charles Sprague Pearce. Among the French artists was the landscape painter Léon Pelouse. Clement Swift and Ethel Ramsey Davenport, daughter of Milne and Annie Ramsey, have left graphic and provocative written records.

Swift was a talented writer. In a group of unpublished short stories closely based on his personal

Figure 8. Mlle. Julia Guillou, before World War I. Photograph by Ethel Ramsey Davenport.

experience of village life and knowledge of local lore, he sketched the people, their life, superstitions, and death. His fictionalized but verifiable accounts of the suicide of ''Mme. Foray'', who hanged herself in the garden of the Inn, and the sudden death of Wylie are strong pieces. His description of the transfer of management of the Hôtel des Voyageurs to Julia Guillou in 1870 is given at length in the Appendix because of the importance of Mlle. Julia in the life of hundreds of artists of many nationalities over half a century, but particularly for Americans (see Appendix D, fig. 8).

Returning to Philadelphia in 1872 to show his works, Ramsey rented a studio in the same building as his friend Edward Moran, who visited him later in France (cat. 31). When Ramsey returned to France in 1874 it was with a young wife, Annie Ruff, and baby daughter. Helen Corson came with them to study art, and their circle of close friends in Paris included Blashfield, Chester Loomis, Pearce, Lippincott and Bridgman, most of whom inhabited the same studio building and went to Pont-Aven. In September of 1875 Frederick Ramsey was born in Julia's Voyageurs, with the local veterinarian officiating. For some years thereafter the Ramsey children were in the care of a nurse from Pont-Aven who traveled with the family, but at home gave the children the run of her own family's place. As children they knew the whole village, and the peasants took pride in Fred's birthright. Pont-Aven was undiscov-

ered still by tourists. The rates for pension at the Voyageurs were about ten dollars per month not including tobacco, wine, candles and tips. This was before the enlargements of 1881 and the Annex of 1900:[71]

> We went to Pont-Aven for six summers and they all seem to merge into a series of pictures. When I returned at the age of 17 (i.e. 1891) it was like coming home. Our nurse greeted us like long lost children. As a child, everything had seemed perfectly natural. We shared the pride of the family in ''le bon fumier'' – the black heap of manure piled by the front and only door. We were sheltered from the noon sun in the dark low-raftered interiors, admired the big closet-beds around the wall – not because the doors were richly carved, but because they were the hiding place of various secret treasures. The smell of cider, manure, and the hard dirt floor – where it was etiquette to pour the lees of wine or cider – was familiar and delicious to me.

ᘛ ᘛ ᘛ

> I...remember the sound of wool wheels in the attics, the clatter of sabots on the cobbles – we wore sabots too – the crack of whips, the shouting of drovers and on Sundays the whine of the Bigniou (bagpipes) after Mass until mid-night.

ᘛ ᘛ ᘛ

> [The artist visitor in 1875] would be struck at once by the rugged and handsome people in their picturesque costumes. He would find paintable types in the beggars who gathered regularly at mealtimes and sat patiently on a low stone wall under a pergola at the back of the hotel until they were served leftovers from the busy kitchen. Some of them were related to the maids – undoubtedly an advantage. Quite often one would stray in from another town, bringing news and gossip. They had nothing to sell. Mlle. Julia knew them all and it was like a club where friends met and visitors tarried cheerfully, sure of welcome and food, even if seasoned with good advice.

ᘛ ᘛ ᘛ

> Before Mlle. Julia enlarged the Hotel and finally built the big modern annex across the street, it was comparatively small. There was a little bar, used in the winter when it was too cold to sit out of doors, and a small dining-room, panelled in oak. Here all the meals were served by buxom maids in the Sunday costumes, neatly and fault-

lessly coiffed and bearing themselves with a dignity which discouraged familiarity while they were on duty. Here, also were stored the beginning of Mlle. Julia's collection of Breton wood-carvings, pottery and other craftwares which was to become so famous that it alone was considered worth a visit to Pont-Aven.

Mlle. Julia herself came from the best peasant stock. She was a great-hearted, competent woman, a keen judge of character, with the gift, not only of recognizing talent but of giving the artist tangible proof of her belief in it.

As this was before the days of scholarships or grants to support and encourage art students, many of the artists were practically subsidized by some relative. If they made an occasional sale they spent the proceeds without thought of the morrow and painted when the spirit moved them. For each there was a brother, sister or parent "at home" patiently going without some luxury or easement, upheld by the thought that at least next year, he would make his Salon.

Mlle. Julia extended credit to many of them, and when they got around to it, in order to acknowledge his obligation to her, each painted a panel in her dining room. Later, it was considered an honor to be invited to do this, and many of the paintings are now ranked as collectors' items.

But, while they were waiting for Fortune to take notice of them, these men smoked, consumed innumerable petits verres out on the pavement and argued around the clock about everything. There were a few Englishmen though; they did not come until later...

ՆՆՆ

[Julia's Garden] was enclosed by a high, white masonry wall, and a little brook ran through it. Not cultivated like an English garden, it was sort of an orchard, wilderness and retreat in one. We played in the water... We watched with fascination the ladies who went in to bathe in the shade and seclusion. It was difficult in France to get wet all over at once unless you went into a river, lake or ocean. Bathing suits were more elaborate than ballgowns but the ladies at the Hotel Julia solved the problem by undressing in the thicket and wrapping themselves in sheets. They floated in the shallow stream with a horrid Ophelia-like

effect which impressed itself on my childish mind, and was made further repulsive by the fact that on coming out, it was necessary to look for leeches which...[were] removed with shrieks of horror.

ՆՆՆ

Among American students of Gérôme to paint in Pont-Aven in the summer of 1874 were Edgar M. Ward and his friend J. Alden Weir. Living at the hotels did not appeal to Weir, so he found lodging with a tailor and took his meals at Julia's. With Swift he explored the romantic ruins of the chateau of Rustephan, and scoured the countryside for proper subjects for his brush. Walking one day in the woods he came across a canvas measuring four by six feet belonging to "Count de Monier who stays at the hotel."[72] So the noble amateur whose daughter Bridgman had pulled from the bay of Biscay was still at work. Bridgman, too, was back that summer.

"I have met several Beaux-Arts students here, and one of the best American painters lives here, Mr. Wylie," Weir wrote home in the beginning of August, and the following week he paid a visit to the studio at Lezaven: "His studio is an old kitchen with a large window...the fireplace is about 6 feet long by 5 feet high. His costumes and bits which he has collected for his pictures are very interesting. He has a fine portrait on his wall by Couture, the study for the principal figure in his large picture in the Luxembourg of the *Fall of Rome [Romans of the Decadence]*. He is a quiet, gentlemanly man and a strict Presbyterian, a man of excellent principles, and a strict observer of Sunday."[73]

Already well along on his easel was the painting of the *Death of a Vendean Chief* (or Chouan), an incident from the loyalist combats in Brittany at the time when, in 1793, the Bretons sided with the crown in the Revolution. Memories of the horrors suffered in the excesses of reprisal lingered fresh in memory. Mme. Feutray's old mother was a survivor; and just recently a thrill of excitement had gone through the village at the discovery, in the hollow trunk of an ancient apple tree by the side of one of the old roads, of a skeleton still clutching a musket. The period of the Revolution was a mine for an artist to exploit for costume, drama, and character study. Weir described Wylie's painting as it was in 1874: "[Wylie's] scene is in an old church: a wounded man has been brought in on a litter, the peasants are crowded around, and a priest disguised is administering the last Sacrement to him. The light comes in a side window, and is very finely arranged; the figures are full of character, and the costumes are very rich."[74] In progress for two

more years, this painting lacked only a few touches to completion for the Salon of 1877. One of Wylie's enthusiasts saw it at Goupil's posthumous exhibition of the artist's work in Paris:

> One of these, intended for the Salon of last year (1877) represents an episode in the war of la Vende, the *Death of a Chouan...* It is hardly possible to speak in terms of too high praise of this noble work, which is undoubtedly one of the finest historical pictures from the pencil of an American that has ever been on view in Paris. Those among the French artists who have seen it have been loud in their praise. It ought to be purchased for some one of our American Art institutions, the Academy of Fine Arts in Philadelphia for instance, since the dead artist was a Philadelphian.[75]

In 1874 Weir planned a Salon painting, the subject to be a scene of threshing, and had ordered a large canvas sent from Paris. He found several barnyards to his liking, "which I will at once make studies of and when it rains can study on the models here in the house." By mid August he was making background studies at an old farm (cat. 21). "When I get my large canvas from Paris I can take it up there and start it right away from nature. There is considerable difference between making a study and composing a picture." He made figure studies about a foot high to introduce into the picture, and "In the right hand corner I will bring in one of these old thatched houses with quaint doors and windows and vine growing under the roof; in front of the house there is a moss covered stone well about five or six feet high; the figure will be a little to the left of center; there will be a background of an old thatched stable full of rich grays, some trees and a haystack to join them and introduced for value."[76] A month and a half after commencing studies he started on the big canvas, but did not get it far advanced before going back for the new term at the Beaux-Arts.

While in Pont-Aven, Weir had received encouragement and technical advice from Wylie, and reported home at the end of the summer: "I will bring back with me eight heads, six landscapes, and one study with eight figures, besides my two large studies, so you see my two months have not been idled away. I have also a study to give to the hotel to be fixed as a panel in a door of the dining room."[77]

Awaiting the opening of the school, Weir met Ridgway Knight at their usual Paris restaurant, along with several others "who had just come in from the country," in this case Barbizon. Knight, Henry Bacon,

Will Low and others had spent the summer at Siron's Hotel, with its dining room "panelled with wood, on which my and the preceding generation had painted rather indifferent sketches," according to Low.[78] No doubt the relative merits of Barbizon and Pont-Aven were hashed over. The following summer, when Ward tried to persuade Weir to go again to Pont-Aven he did not, "as everybody is going down there to paint Breton subjects this year, and I know I will learn more and be serious if I remain with the Frenchmen."[79] He avoided both Brittany and Barbizon going to Cernay-la-Ville instead, where Winslow Homer had left a painted panel in 1867. "Everybody" in 1875, in addition to Wylie and Swift, was the Ramsey entourage, including Margaret Ruff and Helen Corson, and their friend Blashfield. That summer or fall they were joined by Thomas Hovenden, who would stay for three years. The following summer Hovenden's old Baltimore friends Bolton and Frank Jones came, as well as Lippincott and Picknell, and others.

Helen Corson was from Plymouth Meeting, on Butler Pike outside of Philadelphia. Like Swift, she wanted to be a painter of animals and was determined to study in France, taking the opportunity to go in the company of the Ramseys, the respectable young Philadelphia family she could stay with. Ethel Ramsey recalled that it was not without personal cost:

> She was a young, high spirited girl brought up in the strict environment of the Society of Friends. She was convinced that her talent could be developed best in Paris and had the means to go there, but one of her uncles, who was a wealthy man, was so outraged at the idea of a young woman studying in a life class, or even studying art at all, and going to Paris to do so, that, although she was chaperoned by my mother and led a life which the average art student of today would consider exceedingly tame, he disinherited her drastically and completely. The excellence of her work, the recognition she received, and the distinction of her husband's life and work had no effect on him (cat. 24).[80]

The husband Ethel Ramsey talks about is Thomas Hovenden, who married Helen Corson in 1881 in Plymouth Meeting, and their home there became thereafter a popular rendezvous for their friends from Paris and Pont-Aven. Hovenden and Wylie had a lot in common, and there was only a two year difference in their ages. Hovenden came to America from his native Ireland in 1863, the year Wylie left for Europe. He too was an orphan, but had already

completed a seven year apprenticeship to a carver-gilder in Cork. In New York, and later in Baltimore he supported himself by tinting photographs, framing, and portraiture, sharing studios with his friend H. Bolton Jones. Encouraged by William Walters of Baltimore, he sailed for France in 1874, and in October enrolled with Cabanel in the École des Beaux-Arts, prudently shaving four years from his age in the application. The following year he went to Pont-Aven. There, with Wylie and other painters of the figure, his method of painting was established, as reported by the Philadelphia *Times* (August 1, 1886):

> (He) then went into Brittany and began to paint studies of the peasants and then to make pictures. He then adopted the plan, which he still follows, of making his picture complete in his studio, with all the furniture, dresses and accessories of every sort lighted in the intended manner, where he has his models to sit or stand, and thus he paints the whole together. It takes a good deal of time and ingenuity to get the entire composition arranged in this way, but he thinks it a saving in the end. This was at Pont-Aven.

This method of arranging a *tableau vivant* and fixing it on the canvas is confirmed by Thomas Eakins, who knew him well; Hovenden succeeded him briefly as Professor of Painting at the Pennsylvania Academy, where Robert Henri was one of his students. (Eakins served as pallbearer for Hovenden when that artist's life was snuffed out in a moment of heroic self-sacrifice.) In a rare interview, probably with Talcott Williams, Eakins talked about his method:

> Hovenden was an unusually rapid worker, as may be judged by the amount that he did. That seems strange, does it not for one whose movements and general characteristics were so deliberate. The reason for it was that he never painted over. He made up his mind so thoroughly and mapped out his work so completely before he began to paint that it came to be simply a matter of how many square feet of execution. He followed his models very closely, but he spent a great deal of time and pains picking out his models. He was very particular about choosing models who exactly suited his subject. All of his paintings were made this way.... He always picked out subjects that told simple stories of events that happen in every household. They appealed to everybody and were treated with a master hand.[81]

Wylie played such an important role in the guidance and teaching of so many Americans in

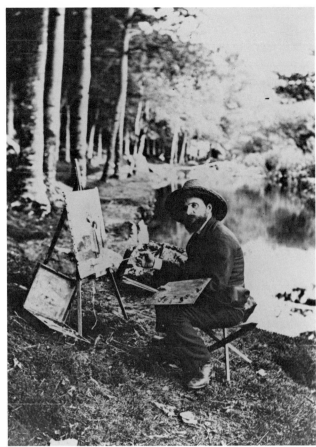

Courtesy Nancy Corson

Figure 9. Thomas Hovenden painting in the Bois d'Amour, c. 1880. In the background is the Moulin Neuf and the same landscape which Sérusier painted under instructions from Gauguin at this exact spot. Photograph by Helen Corson.

Pont-Aven before his death in 1877 that it is worth looking at a résumé of his achievements by his old student and friend, Earl Shinn:

> Robert Wylie, who should probably be ranked as the greatest American painter of our time, died in Brittany, at about forty years of age, leaving a legacy of works like nobody else's, and a repute that with a few added years would have been second to very few. Something massive, and as if forged in a big foundry, belongs in these studies; in national character they are of the soil. His palette-knife work is rich and what the artists call "fatty", and in his broad grasp of his subject he easily escapes any temptation to overrefinement of effeminacy. This superior wisdom of the studio Wylie learned without servility to any master. He is alone among the new American artists in reflecting no school. With rudiments soundly laid in the Pennsylvania Academy, he discarded all guidance, simply practising in the professorless atelier of Suisse, or modeling dur-

34

ing the zoological lectures of Barye. At his Spring invasions of Paris, from the Breton coasts (when he looked like a ship's mate in port), he allowed the general panorama of the world's art to pass before his eyes, at the Salon, and then plunge into the hold of some sardine-lugger for another eleven months. In such habits of hermitage, it is not incredible that a commanding breadth of style grew to be his characteristic, due to the association with wide primitive aspects of nature – a solemn simplicity of life-study, which, as we examine his works, now almost carries us to Franz Hals, and again almost carries us to Velasquez. An abounding good-nature led him to admire constantly some prominent novelty of an ephemeral man, and never was there met a genius so continually in ecstasies with his inferiors. It is our business not to let the legend quite decay – not to let the scroll of the tradition of Wylie's glorious American art drop from our hands because he was distant and died young. The Paris Salon in 1872 awarded to Wylie its medal of the second class, he being the first American to win such distinction.[82]

"I met Mr. Wylie at Pont-Aven, Brittany," Thomas Hovenden wrote, "and was there when he died. He was the first to make the place a resort for artists and was always the acknowledged leader of them. My debt to him is very great, and his sudden death [in 1877] was a great blow to all of us."[83] Julia was a sort of second mother to Frederick Ramsey, who wrote: "She was childless, not married...Afterwards, long afterwards, I learned that her life had not been deprived of romance, and that her romance had had more than the usual touch of tragedy. ...One of the earliest of her lodgers to attain fame was a painter named Wylie, who fell ill and died at Pont-Aven, having received Julia's care to the very end. ...There was a legend that she had been deeply in love with Wylie, and that with his loss she decided that she would never marry."[84] Indeed she did care for him to the very end. His strict Presbyterian observance of the sabbath did not endear him to the Breton clergy, and Weir reported, on seeing notice of his death: "They were going to bury him in the field where they bury those who commit suicide, because they considered him an infidel."[85] This Julia would not tolerate, and Wylie was laid to rest in her family plot in the little cemetery on the hill.

French critics at the International Exposition of 1878 recognized the influence of Wylie on his American successors, like Ward, Lippincott and Hovenden (cat. 27, 25, 26), but pointed out that

their *bretonnisme* tended to be less dramatic. It tended to stress instead the intimate commonplace of peasant life. In the *Breton Interior: Vendean Volunteer, 1793* Hovenden has absorbed completely the historical narrative of Wylie, without his theatrical illumination, no doubt having made use of his store of old costumes, accessories, and knowledge of historical detail. It was well received in Paris in 1878. His *One Who Can Read* was shown the same year in New York – a young Breton girl, the pride of her parents, reads in a peasant interior, while her mother and father admire the achievement that was all but inattainable to their generation.

It is this second category of painting (the thoughtful peasant genre subject) that some of the Pont-Aven painters successfully transplanted to American soil, particularly in selecting subjects from American Negro life. The New England Yankee or Bucks County farmer did not present the same kind of opportunity. Like the Breton peasant, who lived in the most depressed area of France, and had struggled with adversity and savage repression in recent times, the rural American Negro had recently emerged from enforced serfdom and illiteracy without losing personal dignity and strength of character. After locating with his bride in Plymouth Meeting, Hovenden frequently and successfully exploited Negro subjects to the advantage of motifs identical to his Breton paintings. So did Richard Norris Brooke, in his *Visit from the Parson and Dog Swap*, in which he consciously set out to use his Negro neighbors in Warrenton, Virginia in a manner similar to the peasant subjects he had painted in Pont-Aven in 1879 and 1880. Alas, the majority of these Pont-Aven works were lost in a studio fire, but his own record book shows that even back in Washington, D.C., while working on American subjects, he was painting Breton farmhouses in his studio on Pennsylvania Avenue.

An American artist who perhaps best qualifies as a "successor" to Wylie in the intensity and drama of his Breton genre subjects, arrived at his own solutions independently. Henry Mosler filled the vacuum left by Wylie at the 1879 Salon with *Le Retour* (cat. 33). From Cincinnati, he went to study in 1863 in Dusseldorf, and later in Munich, with a stint in between with Hébert in Paris. In 1872 *A Fortune Teller of Brittany* won for Wylie the first medal of its class ever awarded an American. *Le Retour*, a dramatic picture of a grief-stricken Breton prodigal returning too late for the last moments of his parent, seen in the candlelit interior of the *lit clos*, won for Mosler the distinction of being the first American to have his

work acquired by the French government for the national collections. The artist collected his costumes and furniture and made studies in Quimper and Quimperlé. These he brought back to a Paris studio richly furnished with many of the antiquities and props that appear in his Salon paintings (like the bed in *Le Retour)*, and worked them up into finished pictures.

Perhaps the real successor to Wylie, as the greatest beneficiary of his instruction in method, and in attitude, was William Lamb Picknell. Orphaned at fourteen, Picknell left his native Vermont to live in Boston with guardians. That was in 1867, when Champney, just back from Pont-Aven, talked of the wealth of strong landscape work in the galleries; not long afterwards George Inness was sent abroad by his Boston gallery because European landscapes were more in demand than American subjects. Inness spent the years from 1871 into 1875 in Italy, returning in the latter year to America via Etretat (cat. 64). Accounts of Picknell's progress differ. Some say he studied for two years with Inness in Rome, others for two years in Paris with Gérôme, and still others say he did both, before spending an extended period in Pont-Aven with Wylie. All seem to agree that he went to France to study art at the age of twenty-one, in 1874. Since Inness came to France on his way home in 1875, and Wylie died early in 1877, some adjustments have to be made in the chronology. It is certain that Picknell inscribed as a student of Gérôme at the École des Beaux-Arts on December 5, 1874. The short biography in the dictionary of *Artists of the Nineteenth Century*, by Clement and Hutton, says that *after* study in Rome with Inness he spent two months only with Gérôme, and was still in Pont-Aven, where he had gone to study with Wylie. In any case, he was in Brittany in 1876, at the Hotel des Voyageurs. Ethel Ramsey Davenport was in Pont-Aven when Picknell arrived from Paris. Although only a child, she had ample opportunity to learn details of this nature from the Hovendens, lifelong friends of hers and of Picknell, or from her mother in later years:

> There were, of course, some relatives at home who did not believe in encouraging what was, to them, idleness bordering on immorality. This might sound like an exaggeration today but it was a real enough limitation. The story of William Picknell illustrates this. With great difficulty he persuaded his uncle that he had enough talent to justify his going to France to study, but the uncle, a shrewd businessman gave his aid on one condition. He allowed his nephew one thousand dollars which was to be an advance on his inheri-

tance, but, when it was gone, there would be no more. He was neither to ask for it nor to expect it, come what may.

> One thousand dollars seemed an enormous sum of money to an inexperienced youth from Boston landing in Paris. Needless to say, it melted like snow and he found himself in Pont-Aven without a sou.[86]

Writing from a personal knowledge and from interviews with those close to the artist, a writer for the *Century Magazine* recalled these years, when Picknell engaged the problems that would lead him to his own landscape style:

> He went to Pont-Aven in Finistère, looking southward over the Bay of Biscay, where living cost little and the climate allowed work even in the winter. Behind the fishing village stretched broad moors, clothed with heath and other coarse growth. To these fields Picknell the student came in 1876, and there he remained until on them he won the decisive victory which gave him at once standing and fame as a painter. But first were to come four years of patient and concentrated work. At the village inn and the houses around were gathered then a happy company of young painters, whose good work made them known later; among them Hovenden, Harrison, Fellows, Bolton Jones, Dracopoli from Italy and Adrian Stokes from England.

> [Léon] Pelouse, a strong painter of landscape, whose presence in Pont-Aven had attracted many students thither, was still painting there. Picknell knew him and valued his work, but was chiefly drawn to Robert Wylie, by birth a Manxman, but brought up in the United States and sent for his remarkable promise to the Philadelphia school of art. He had won laurels at the Salon, and, though a fatal disease preyed on him, was beginning to enjoy prosperity, which he strove to make those around him share. Wylie, who had great beauty and strength of character as well as skill in painting, grew fond of the young Picknell and influenced his life and work. The latter would tell how Wylie made him paint a certain tree over and over again – it seemed a hundred times – before he would sanction his signing the picture. The wild flower which Wylie pinned on his own canvases, to keep himself up to high and pure color, was a lesson long remembered. He painted largely with the palette knife and showed its effective use to Picknell, who later learned to combine and apply paints with it with a speed

which the eye could hardly follow, and with a brilliant result from the only partly mixed color. Most of his foreground work, in which he excelled – rocks, sand, thickets, coarse weeds, weather beaten boats, and silver gleams of water – was done with the knife.

Wylie was mainly a figure painter, but much of Picknell's strength and brilliancy in landscape came from the application of Wylie's principles and methods; yet his influence as a man was even more strongly felt by the younger painter. Their acquaintance lasted little more than a year, for Wylie died suddenly in 1877, having worked, as Picknell did, to the last. It happened that on the last day of his life Picknell said to his sister: "Do you know I rarely think of Christ without thinking of Wylie? There was a serenity and purity about him that was unique in my experience of men."[87]

D. Maitland Armstrong, diplomat-painter, and his good friend Augustus St. Gaudens acted as jury and hanging committee for contributions by Americans resident in France to the American art section of the 1878 International Exposition in Paris. By acting on the quality of the work, and not the reputation of the artist, they had struck terror into the established ranks, now of considerable size. Frederick Bridgman earned the Legion of Honor for the *Funeral of the Mummy* (a coveted decoration the less fortunate said he embroidered on his underwear), and Armstrong was given the same accolade for his efforts on the committee of the Exposition. Much to the delight of his artist friends, he arrived, a decorated man, to paint in Pont-Aven that summer after completing his duties (cat. 22). Picknell, writing to Armstrong from the Voyageurs, October 31, 1878, reveals the extent to which the landscape painter would go to be true to his subject on the spot, before the motif. Although still strapped, Picknell was beginning to sell and get commissions, and the approach from Goupil was something that Swift and others in the colony would have eagerly snapped up. The "Baron" is presumably Montier (or Monier) still at work. The "White Road" was a small predecessor of a painting soon to make the artist's reputation, bought by Robert Gordon of New York after it was placed with Goupil. Picknell wrote Armstrong, "a little apologetically that he was going to paint another of the same place...and explained that the figures would make the two canvases entirely unlike."

Your letter did indeed have good news for me, for I had begun to feel blue at the prospect of ye frame bills, and the expenses my two large pictures were drawing me into. My picture of the 'White Road' is at Goupil's. They wrote me a flattering letter offering to take my pictures on sale, but I must not lose a moment from my Salon at present. The Garden came out very well and I have sent it to the Dudleys and put £500 on it. Hope I may sell.

There has been a glorious addition to our little colony. An English General, wife and two daughters, 21 and 23 – figures representing daughters – charming, beautiful and talented. You, knowing the old chick, can imagine the feeling of his innermost heart. The Baron still haunts his old haunts and blesses us his children with good advice.

Now when you read the following awe-inspiring confession do not exclaim, "What a fool!" Your humble servant has builded him a house out on ye lande, and yesterday did begin to rub charcoal in a most wonderful manner on to ye canvas. Eight feet by 5½, how is that for size? for cheek? for future headaches? and sleepless nights? Pelouse told me to paint an important picture this year. So thought the best way to get out of the scrape was to make it important in size. Walked about one thousand miles before finding subject, wore out two pairs of shoes, ten pairs of good nature! Subject once found, got permission to build on ye peasant's land. Had said peasant to dinner, gave him good wine, good cigars, and about ten P.M. he went staggering home, a happy if not a wiser man. Result of dinner, jolly good friends with peasant. He laughs at my jokes in French – very appreciative fellow. Two cartloads of colors sent to chateau yesterday, 800 doz. brushes, 4 shovels, and small cannon, American flag expected tomorrow, cider bottle hid in one corner. All creation thinking of working in my part of world, the hut appearing to be a good place to leave pictures in. Shall have newspapers, etc. and charge regular London club prices.

I envy you the glorious opportunity you have of studying the Exposition. I should like to have seen it again but could not afford it as frames for my Giant and Royal Academy loom up like a nightmare in the near future. Jones's Salon is getting on well. Swift is going to paint his from the sketch you liked, Bretons loading mast on old boat [cat. 20]. Am frightfully tired tonight, having been at work all day on big toile.[88]

The new road to Concarneau was a wonder of modern engineering, and must have been especially so to Mlle. Julia, who at the age of twelve trudged the

tortuous *chemins creux*, the rugged concave paths that had served from time immemorial; the ten mile treck from Pont-Aven to her new home at the hotel in Concarneau had taken two days. In the dozen intervening years before her return, Napoleon III had opened up inland vehicular traffic between coastal towns of Brittany with roads that were the admiration of all. Of them, writing to the *Ipswich Chronicle* (Oct. 3, 1885), Arthur Wesley Dow said: "In road building France is ahead of America, at least ahead of Ipswich." And he went on to describe the level, crowned and well drained surface of crushed quartz, "smooth as a floor."

Although his paintings were beginning to command attention, and he sold the small version to Robert Gordon, materials and frames were costly, and Picknell was struggling. According to Ethel Ramsey, Mlle. Julia, convinced he was honest and had talent, supported the projected *Route de Concarneau* (cat. 29): "Everyday until the canvas was finished, she sent him with a horse, a char-à-banc and a boy to the spot he had selected, and said nothing about a bill of any kind. No doubt she paid for the paint...He paid back every sou Mlle. Julia had advanced to him and they remained lifelong friends."

The painting itself made a sensation not only in Paris, but in America, where it was heralded as a brilliant achievement in representing the luminosity of sun-bathed nature, and was purchased by Philadelphian Fairman Rogers. For Picknell it was a justification of hard work, as was the honorable mention it earned him in the Salon of 1880. The following year he painted in England, and soon afterwards returned to Boston. In retrospect Sadakichi Hartmann wrote of Picknell:

> Landscape art consisted, as Edmond About wrote, "in choosing well a bit of country, and painting it as it is, enclosing in its frame all the naive and simple poetry which it contains." ...William Lamb Picknell (1853-97) strove for brutal truth; he joined the school of open-air workers, and painted his pictures directly from nature. His *On the Borders of the Marsh* – a November day in a Brittany field, with the characteristic gnarled trees, overgrown with ivy and mistletoe, and the broad earthen fences peculiar to that region – is most vigorous in its treatment, and peculiar in the way in which he encrusted the surface of the picture with thick lumps of paint. Later on he modified this crude appearance of his brush work, and in his *Road to*

Concarneau, which attracted a great deal of attention at the Paris (Salon) in 1880. ... To suggest anything beyond topographical and atmospheric truths lay beyond his powers. He excels in the illusion which he can give of reality; and his beach scenes, white sand basking in the glowing sun, impress at the very first glance like reality itself.[89]

Pont-Aven Before Gauguin: New Migrations

The death of Wylie marked the end of an era – not that it was the end of Pont-Aven as an art colony. Far from it. Pont-Aven had been "discovered," and Clement Swift wrote that:

> Once "discovered," much of the charm which belongs to quaint, unsophisticated localities was gone – for one person may handle a plum or peach newly culled from some new found tree without great injury to the velvety bloom upon its surface, but if it passes through the hands of a whole company it has forever lost the significance of its rustic exclusiveness – or seems to have done so to those who prize such things. Thus to have the quiet of my little rustic paradise broken by the aimless bustle of summer tourists and to see the ridicule they bestowed upon observances which, now that I understood them I was willing to commend, irritated me, the more as I was now obliged to carry on my chosen work in the midst of a company of idlers, but there was no help for it, and I had to console myself with the thought that they must soon tire and take themselves off to more congenial haunts; and also, that while they elected to stay it was certainly no bad thing for mine [hostess] who had treated me well and to whom I did not begrudge any such fine fish which came into [her] net.[90]

In fact, it became increasingly the subject of articles in journals and travel books, then cycling and camera magazines. In 1878 Henry Blackburn sang its praises: "It is said of Pont-Aven that it is 'the only spot on earth where Americans are content to live all the year around;' but perhaps the kind face and almost motherly care of her *pensionnaires* by Mademoiselle Julia Guillou, may have something to do with their content." He pointed out how remote it was, an "artists haunt" *par excellance* and a *terra*

Figure 10. Pont-Aven looking from the Bridge, c. 1880. At the right is the Pension Gloanec. In the background is the Lion d'Or with its sign visible. Photograph by Helen Corson.

incognita to most travelers even in Brittany. He then told how to get there, how cheap it was to stay, and added, "Let us hope that the mention of this place in a wide-spread magazine will not alter its character for years to come."[91]

Little mention so far has been made of the *Pension Gloanec,* (fig. 10, 11) the place by the bridge that rivalled the *Hôtel Julia,* as the *Voyageurs* came to be called. Joseph Gloanec bought the place in 1842 and operated a *débit de boisson,* or wine and spirit shop there, which was taken over by his widow in 1855. By 1863 it was licensed as an Auberge, and Marie Jeanne Gloanec thrived as the regular art colony grew, the painting over the door, renewed now and again by one of the inhabitants, proclaiming it a place for artists. Having few beds, Mme. Gloanec made arrangements in the vicinity for rooms, providing board, and at about half the cost of the Voyageurs. Eventually, in 1892, her son bought the *Lion d'Or* for

an Annex, whereupon in 1900, Julia purchased the intervening thatched cottage and constructed a new annex of her own. Of the Gloanec, Blackburn says:

This is the true Bohemian home at Pont-Aven where living is even more moderate than at the inns. Here the panels of the rooms are also decorated with works of art, and here, in the evening, and in the morning, seated around a table in the road, dressed in the easy bourgeois fashion of the country, may be seen the artists... whose works are known all over the world.[92]

Shortly after 1880 two brothers from Philadelphia arrived in Pont-Aven, Birge and Alexander Harrison, the latter to become a perennial visitor to Pont-Aven and Concarneau. Birge recalled the Pension Gloanec of those days:

The terms at the Pension Gloanec, or the "Auberge," as it is familiarly known to the artists, are two and a-half francs a day, or seventy francs a

month. This will sufficiently indicate the relative social status of the two places, and it will be only necessary to add that the delectable cuisine of dear, wizened motherly old Marie Jeanne is famed far and wide among the artist fraternity. Three active maidens – Nannie, Jeannie, and Soisie – serve the crowded tables and bring the smoking dishes in the midst of much uproar and hilarity. From time to time Marie Jeanne herself appears at the kitchen door to join in the merriment or to inquire as to the success of some special delicacy.

The Auberge has but two rooms on the ground floor. The first, which opens directly upon the place, is the kitchen and living-room, with its great cavernous fireplace, its shining *batterie de cuisine*, its long oaken table and its high and richly carved cupboard bedsteads ranged around two sides of the room. In the rear of this is the dining-room, paneled from floor to rafters with sketches and studies. The bedrooms are few, and most of the artists room about the town according to their convenience or fancy. For these fifteen

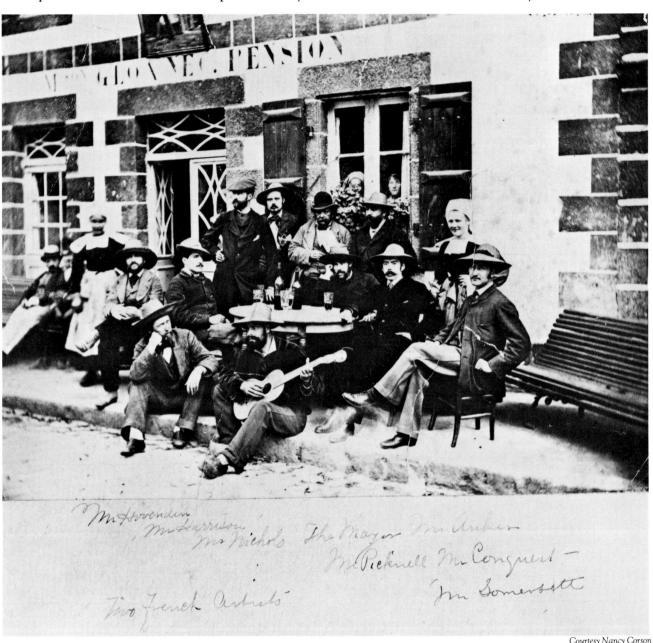

Figure 11. Artists in front of the Pension Gloanec, c. 1880. Harrison could be either Birge or Alexander who strongly resemble each other, but neither would appear before 1879. Burr Nicholls was in Pont-Aven in 1880-81, and by 1881 Picknell was in England and both Hovenden and Corson were in Pennsylvania, where they were married in that year. The two French artists so far escape identification, and it is unclear whether the Mayor is the man in the bowler hat or the figure to his right. Photograph by Helen Corson.

francs a month are deducted from the pension. There are numerous good studios at moderate rents, twenty francs a month being held dear. Models are paid from one to two francs a day, but they are scarce and intractable.[93]

"Often in my walks, while following the course of the river, I would come upon a number of girls and women engaged in cleansing the family linen, and also that of the artists," one visitor to the village remarked. "They discussed the relative merits of their patrons, one declaring that 'her Monsieur' could paint the best pictures in town, whereon would ensue a war of words, until one would think he was in Bedlam."[94] So, by 1885 the care and feeding of artists had become a cottage industry. There were perhaps a dozen artists at one time in the village when Shinn sat among the "seven original sinners" in 1866; Blackburn found in 1878 that from fifty to sixty might be accommodated; when Willard Metcalf came with Arthur Hoeber in 1883 or 1884 they found an international community of artists numbering close to one hundred. Hoeber's description is of the artist life on the eve of a revolution about to erupt in this rustic idyll, for Paul Gauguin was about to descend upon them all in his search for a paradise.

What follows is from "A Summer in Brittany", by Arthur Hoeber, written in 1895, but recalling the trip of more than a decade previous, and illustrated with sketches made then by his companion Willard Metcalf:[95]

We started one morning many years ago, two young students, laden down with traps of the artist sort. How new and interesting it all was, and how much there seemed to be in life. We left the train at Quimperlé, in Finistère. There had been rain, I remember, and it was clearing up in the west. Near the horizon was a band of brilliant light, while above there still lingered ominous dark clouds, sullen, leaden, and full of suggestion, regular Brittany weather. The houses of the little town stood out bright against the background, touched as they were, here and there, by the sun; and the queer stunted oaks along the roadside, as we drove by in the diligence, seemed to take on weird shapes, and looked uncanny in the uncertain light of the closing day. Presently we turned a corner and were suddenly confronted by a wedding party, dancing on the road before a wayside auberge, their wooden sabots clattering in slow and cumbersome movement to the music of a bagpipe and a clarionette.

The musicians were seated on boxes placed on inverted barrels, and all the party were in full Breton costume. It was like a scene from an opera, and we felt that we had gone back a century or more. ...I think the great white coifs and collars of the women impressed us then more than all else. We came to know these wretched things later on, and to learn the difficulties they presented to the painter, with their stiff outline and graceless shape.

✿✿✿

It was an interesting colony we had that year at Pont-Aven. There were nearly a hundred painters – American, English, French, and scattered nationalities, – some already famous, others since arrived at distinction. The brothers Harrison, Alexander and Birge; Walter Gay, Eugene Vail, Frank Penfold, and a host of lesser lights; the Englishmen Stanhope Forbes, Adrian Stokes, Frank Bramley, Mortimer Menpes, and poor Paul Peel, the Canadian, carried off at the threshold of fame and success some years later; among the Frenchmen, Emile Vernier, the landscapist Pelouze, and finally the great Bastien-Lepage, with his inseparable comrade, Charles Bode, the wood-engraver. All were men of sterling ability, interesting, companionable, and serious workers.

Out of doors, around the small tables after *déjeuner* and over our coffee, what pleasant stories and reminiscences, what sociability and good-fellowship!

Picture to yourself mine host, old Père Gloanec, prince of scoundrels and incomparable idler, with a halo of vague and misty tales of his early life as smuggler and wrecker on the wild coast near by, never quite authenticated but giving him much distinction and interest; and his faithful, kindly slave of a wife, red of face from much stooping over the fire, ready to beam on the new arrival, or weep over the departing guest.

✿✿✿

As the summer slipped away and the days became shorter, the sunlight of August and September faded into the gray of autumn, that Brittany gray, the like of which is seen nowhere else in the world – a soft, pearly, luminous color, giving qualities of opalescent light to the landscape and enveloping everything in a tender tone of sentiment and poetry, a joy to look at and an inspiration to the painter. Then the artists began to evolve their Salon pictures, and in flannel blouses and straw-lined sabots, for the roads became muddy and damp, and the ordinary shoe of civilization was of no avail, they could be seen

at big canvases, utilizing all the daylight and plodding away. Easels were set up in the fields, on the roadway, and in cottage and garden, while old and young men, women, and children were pressed into service as models. So usual a sight was the painter at work, that his arch enemy, the small boy, no longer thought to stop and watch him; or, if he did, his was no more than a mild, passing interest.

Did some old, quaintly picturesque peddlar or umbrella mender stray into town unsuspectingly, then straightway was he pounced upon and made to do duty as a model; the ragged beggars throve, – the more hopeless, poverty-stricken, and ragged they were, the greater the demand they created. They regarded us as lunatics, I am sure, to give them good money for doing nothing but sitting still, until they began to realize that perhaps their services were worth more, and then the few sous of pay grew into a franc, and the franc increased to two silver pieces. Studios were improvised by those who could afford no such formal luxury, and garrets and lofts did duty for painting-rooms after the rainy weather set in.

When the night came, the men gathered in the dining room of the hotel, and after the evening meal was disposed of settled down to quiet talk and interchange of ideas. The walls of the room were covered with panels, painted by the artists who from time to time had sojourned there, many of them characteristic bits; fresh impressions that stood out in bold relief, challenging admiration and interest. The talk was entertaining of course, though mostly of the shop, for there is no class of men in the world who talk shop more than artists...

Here were men who had painted Italian sunsets and the blue of the Mediterranean; who had idled under the shade of orange trees at Capri, or studied the cooler tints of the North Cape and the beauties of Norwegian fiords. Others, too, had come from the canyons of the Yellowstone, and the land of the Zuni, with sketchbooks full of suggestive bits, and canvassed studies of bright sunlight, or the brilliant color of savage costume with bead and feather, caught under the blue skies of Arizona.

It was a delightful crowd of intellectual men, all animated by the same impulses, serious students of nature, and careless of all the little things of life, but true to their art.

Courtesy Charles LePaul

Figure 12. Postcard view of Pont-Aven taken from the bridge, c. 1900. To get to their studios at Lezaven the artists crossed the bridge and walked up the Old Road to Concarneau.

Concarneau, the 1880s

Earl Shinn visited Concarneau in 1866, watched the great fishing fleet enter the harbor with its catch, toured sardine factories and the extensive aquarium, and steeped in the fulsome stench of the chief industry of the ancient city. Less than ten miles away, Pont-Aven then had eight artists. Concarneau had none. Then a native son, Alfred Guillou, went to Paris to Académie Suisse and Cabanel at the Beaux-Arts. The art life of Concarneau came in the 'seventies with his return, and with him his brother-in-law, the artist Théophile Deyrolle. The origins of the international art colony belong to the next decade, when Pont-Aven over-flowed the Hotel Gloanec and Julia's hotel, and artists seeking new accommodations and *motifs* looked elsewhere in the vicinity. Conspicuous among the first foreign artists to settle there was Edward Simmons, who came for a five years' residence in 1881, followed by the brothers Alexander and Birge Harrison, Walter Gay, Clifford Grayson and Arthur Hoeber, all veterans of Pont-Aven; and Howard Russell Butler and "Shorty" Lasar. Four of them were old students of Gérôme. Birge Harrison described the old fishing port that his brother dubbed SARDINEOPOLIS:

Concarneau is an offshoot of Pont-Aven, but an offshoot that has grown into a formidable rival. It lies about eight miles to the west, in the curve of a great bay. The land slopes gradually away from the shore, the town rising with it, until the streets finally lose themselves in winding *chemins creux*, lined with the pollard oaks which give such a distinctive character to all the Breton landscapes. There is a deep inner harbor, whose mouth is protected by a very ancient citadel still connected with the land by an old drawbridge. Opposite this is the public *place*, beyond which stretches the more modern but still ancient town, with its great rambling *usines*, or sardine-packing establishments. The shore in front of and beyond the town is a mass of magnificent rocks, richly and deeply colored, carpeted with moss and lichens, and broken with quiet reaches of sand.

The accommodations are very similar to those at Pont-Aven, both in price and in quality of fare. There are two excellent hotels, the "Voyageurs" and the "Grand." The "Voyageurs" is perhaps the one most favored of the painters. Both of these demand five francs a day for board, but there is also the Hôtel de la Gare at seventy-five francs a month. Though it is hardly to be compared with the charming old Pension Gloanec at Pont-Aven, it is still fair and tolerable.

~~~

When it blows great guns and the rain comes down (and it *does* blow and it *does* rain in Concarneau) there is plenty of studio work to do, and plenty of fine old lofts with improvised studio windows to do it in. One delightful and enthusiastic gentleman, the owner of a great sardine factory, has honeycombed his place with scratch studios and made the artists at home there: and many a well-known picture has gone out into the world from this place redolent with the odor of sardines. Those not so fortunate as to find accommodation with this hospitable gentleman are still in no danger of remaining shelterless, for there are many other studios in the town to be had at very moderate rentals, twenty francs a month or thereabouts being a fair average price. One of these is a beautiful old chapel, with the stained glass still in the windows.

The most agreeable season of the year in Concarneau is perhaps the winter and the early spring, for, owing to the proximity of the Gulf Stream, the climate is always mild, and the prevailing weather in the year's infancy is a beautiful silvery gray, without rain. It is then that the most serious work is done. Then the Salon and Academy pictures are painted, and every hour of daylight is greedily employed. Early hours and self-concentration are the rule. Each painter lives very much like a hermit-crab in his hole, coming forth from his studio only to breathe, to sleep and to take in sustenance.

It would be a difficult task to name all of the eminent Continental painters who have made Concarneau their temporary home. Jules Breton, Renouf, Kroyer l'Hermite, Paul Dubois and Guillou are a few only of the most noted among them; and the regretted Bastien Lepage spent some of the last months of his life there, and there laid down his brushes for the last time. Among the English and American painters of note who owe much to Concarneau may be mentioned Simmons, William Stott, Alexander Harrison, Aubrey Hunt, Hulton, Stanhope-Forbes and C.P. Grayson.

In conclusion, let me counsel anyone who contemplates a visit to Concarneau (and I shall be thanked for the counsel) to read beforehand

the romance of "Guenn," by Blanche Willis Howard. Four or five seasons ago [i.e., 1881] Miss Howard spent the summer at Concarneau, and "Guenn" is the outcome of her visit. In its pages Concarneau, with all its gloomy superstitions and its quaint and picturesque life, lies embalmed, like a fly in amber. The book is written with rare sympathy and intuition, and as a mere study and record of a strange people it stands nearly alone in the literature of the day. Many of the characters of the book are well-known Concarneau artists drawn to the life, and only thinly veiled. The hero, Hamor, except for his all-pervading selfishness, is Mr. Simmons, the American painter. It will perhaps interest the readers to know that the picture of Guenn, so vividly described in the novel, was really painted by Mr. Simmons, and when exhibited in America became a great and legitimate artistic success.[96]

≈ ≈ ≈

In his memoirs Simmons recalled those years he lived on the Breton coast, from 1881 to 1886, as a step back to the Middle Ages. In Concarneau he felt that the superstitions, traditions, customs, dress, ideas, and rhythm of life was unchanged from the 13th century:

The beauties of the sea, and, as usual, the low cost of living, brought the artist to Concarneau. My studio was a wheat loft, and any peasant was a model for a few cents. We painted them in their native dress, which was picturesque enough, and, besides, no Breton woman would allow you to see her hair, so that it was obvious that the *coif* stayed on. These headdresses gave them a distinctly medieval air, and each town has a certain style, more fixed than the laws of the Medes and Persians, so that you can tell immediately where a woman comes from. ...Blanche Willis Howard wrote her book called *Guenn* in my studio and it afterwards became one of the popular novels of the day. I think she greatly exaggerated the romantic quality of the artist who fell in love with his model, however, as all the Breton peasants I ever saw washed below the chin only twice in their lives – once when they were born and once when married.[97]

Allowing for the requirements of plot, the novel is indeed a faithful account of the art season of the first American painters at Concarneau. Since it is readily available, and still very engaging, there is no need to go into its fabric. Simmons' recollection of it is faulty only in that the fiercely independent Guenn

of the novel falls for the blandishments of Hamor, the artist, who is only interested in possessing her image for the Salon painting. Readers will be happy to discover from the following pages that Guenn lived to marry her fisherman, and that little Nannic did not waste away, but years later is still spotted by fans of the book. And there were fans – like Cecilia Beaux, Howard Butler, Arthur Dow, Robert Henri – who read the book before coming to Concarneau. What Blackburn's writing did for Pont-Aven in England, *Guenn* did in America for Concarneau, Simmons recalled:

The British artists passed by Concarneau and went on to Pont-Aven, where there were ready-made landscapes for the water-colorists. Truth to tell, they were frightened by the bigness of the coast and left it to the French and the Americans, who formed a very happy crowd, all living at the Hotel des Voyageurs. There was Thaddeus Jones, who has since painted a portrait of the Pope; Alexander Harrison, the famous marine painter; Frank Chadwick; Howard Russell Butler; M. Brion; Emile Renouf; Paul Dubois, the sculptor; and Bastien-Lepage. Bastien was the first in importance in the Concarneau older set, being almost the father of the Realistic movement.[98]

Simmons was typical of the men of the 'eighties, in that he did not attend the École des Beaux-Arts, but the Académie Julian. Because of the ever growing number of foreigners seeking admission, the entrance and language requirements at the Beaux-Arts had been stiffened, eliminating many aspiring applicants – particularly by the language. Art education had improved markedly in America in twenty-five years, so that coming to Paris was now as much for breathing in the atmosphere, the experience of communion with the international fellowship of artists congregated there, of being at the fountainhead, as it was for obtaining the rudiments of an art education. And living was cheap for those willing to live cheap, galleries abundant, models plentiful, and no one would ask why you wanted to paint one in the first place or be an artist at all. Anyone who could afford a small tuition in advance could enroll in any of the ateliers managed since 1873 by Rodolphe Julian, and could come and go as he or she pleased. Unlike the Académie Suisse, Julian's school offered instruction by distinguished professors of established reputation to both men and women. The instruction did not differ much in its basic principles from one professor to another, or from that at the Beaux-Arts, as far as the life-class was concerned. Most of them exhorted the student to master drawing, commencing with

contour outline, without deviation from the model.

Harvard graduate, and student of the Boston Museum School and Dr. William Rimmer, Simmons had led a life of adventure in the far West, when it still had "the bark on." Upon his arrival at Julian's to pursue his chosen career, he confidently pitched right in with paint, only to be told by professor Boulanger that he might as well go home and make shoes if he did that. He was put to work drawing the model in the manner of Gérôme, painstakingly observed and copied – over and over – until he found there were no short cuts to the grunts of approbation of his master but hard labor. After two years, a painting of his was accepted at the Salon, and in that year he went to Concarneau to paint figures in the open air (cat. 42). How Blanche Howard picked his studio and life for her novel, is unclear, but she was a native of Bangor, Maine, where Simmons taught school for a time before coming to France.

The most celebrated American painter in Pont-Aven and Concarneau of the period was Alexander Harrison. He shared with Simmons a taste for the largeness of the coast of Finistère, having acquired it from five years of service with the U.S. Coastal Survey in Maine, Rhode Island, Florida and Puget Sound. When he left the Survey in 1877 to study fine art, he studied eighteen months in The San Francisco School of Design, then sailed for France. He studied also at the Pennsylvania Academy, but whether as a boy in the old Academy, or with Eakins in 1878, is not clear. Both his brother and sister were students of Eakins (the latter posing for the singer in his *Pathetic Song*). By May 1879 Alexander was enrolled with Gérôme at the Beaux-Arts, and spent part of that summer at Grez, near Barbizon. His younger brother Birge had already been in Cabanel's atelier for a year.

In 1881 they were both in Pont-Aven, where Alexander painted his *Castles in Spain*, a large canvas with a young Breton boy lying supine upon a beach, dreaming beside his gathered shells and sand castle. From sketches made upon nearby beaches, the painting was worked up in the studio courtyard in the village – presumably at the chateau. There, Harrison built his own beach, as Bridgman a dozen years before had built his circus ring, in order to pose his young model undisturbed in the open light of the out-of-doors. It was for this purpose that the brothers went to Pont-Aven, according to a contemporary writer, to seek seclusion for serious study of out-of-door nature, "entirely apart from French influences; trying to see nature with their own eyes, and to grasp and render it after their own fashion." He went on to say that contrary to the general impression in America, that holds all Americans working abroad are weak imitators of stronger foreign masters, French critics of the Salon of 1882 were enthusiastic in praise of Americans who were introducing freshness and originality of style into the Salon, where *Castles in Spain* was a conspicuous success.[99] It also caught the attention of Bastien-Lepage, then at the height of his popularity, which led to a meeting and friendship between the artists.

The influence of Bastien-Lepage on this generation of American artists cannot be overestimated. His was an art that was understandable in terms of the direct and personal interpretation of nature without traditional studio convention, combined with a virtuosity in paint manipulation. Realist to some, to others a Naturalist, Bastien was to many a "Primitive." He did as the professors recommended, went to nature and painted directly what he saw and knew. Even when painting his huge *Joan of Arc* (which his friend J. Alden Wier purchased in 1880 for an American collector) he cut the canvas in two pieces for convenience in painting everything directly in the open. The resulting high key on the scale of value, surface pattern and optical depth of focus was his very own. Augustus St. Gaudens was with him one day when Gérôme, visiting the studio, suggested some alteration in the distance, which, of course, he would not make. His peasants had neither the monumentality of Millet's memory images, nor the social message of some of Jules Breton's peasants, and to many critics they seemed as stupid and unredeemable as the sheep they tended. They knew the weariness of labor and the bite of the frost, and their visions were as primitive as the sculpture they worshipped in their churches. That he could not paint a halo cost Bastien the *Prix de Rome*, and the students of the Beaux-Arts bestowed their own laurel crown, led by Sarah Bernhardt.

By 1878 and the International Exposition, Bastien's position was officially established and recognized with honors and decorations. He spent some time in England, and Alexander Harrison tried to promote a trip to America. Writing from Concarneau in the summer of 1883 to the Pennsylvania Academy, Harrison said:

> For the last month I have been here in company with Bastien-Lepage, and have persuaded him that he could do well for himself and for America to make a tour of six months in the largest cities and paint portraits & c. I may say that I am the cause of his going. I have always been a great

admirer of his talent...Besides that I am his friend and chum.[100]

Bastien's companion and friend, Marie Bash-kirtsev was a frequent visitor to Concarneau, where her cousin Bojidar Karageorgivich had a combination sketching and fishing resort about four miles down along the coast, where Sara Bernhardt came to paint. Marie was well known among the American painters, and perhaps responsible for Bastien's presence there in 1883 and 1884. Both were familiar to Simmons, Harrison, and the others. Simmons recalled of Bastien:

One day I caught him painting a sketch of the little stone church on the shore at the edge of the town, something we had all tried. He was drawing and painting with meticulous care, every slate on the roof, each with its little lichen. I brought the subject up, after dinner, when we were sitting on the sidewalk having our coffee.

"M. Bastien," I said (no one ever called him Lepage) "we have all been taught by Lefebvre, Boulanger, Cabanal and Duran to *ébaucher* our subject broadly and put in only the details that are absolutely necessary. I saw you today painting every slate on that roof for its own sake. How about it?

He laughed.

"I have tried all these different methods, but none of them got me what I saw; so now I do everything as truthfully as I am able, then take my picture to Paris, where, in my studio, away from nature, I can consider it broadly and remove all the unnecessary detail."

"Yes," said Harrison, "but when we younger men see your picture in the Salon we do not think you have done what you say you do."

He threw his hands in the air.

Hélas! Hélas! Sacre Nom de Dieu! Vous avez raison. I am so much in love with it when I see it in my studio that I cannot bear to touch it."[101]

"In every country the most promising youths were frankly imitating his work, with its ideals of exact representation of nature as seen out of doors, everything being painted on the spot in a grey light, in order that there might be as little change in the effect as possible while the artist was at work," recalled the English painter Archibald Hartrick, adding: "At all the art schools at home or abroad it was solemnly debated as to whether he painted with large or small brushes. Alexander Harrison, an American painter who had gone into the country where Lepage was working in order to acquire the latest 'tips' on the subject, inquired on this matter of the master personally.

Lepage who had been painting with small brushes, immediately turned out with brushes two inches in width and with them produced results equally fascinating for his admirers. I believe this was the origin of what became known as the 'square brush act.' Stanhope-Forbes introduced it here, where it became the hallmark of the Newlyn School."[102]

Meanwhile, Harrison was becoming more and more absorbed with painting twilight and nocturnal effects of sea and sky, requiring of necessity memory of effects, rather than direct transcription. Walking one evening in the summer of 1884 with Bastien on the embankment at Concarneau, Harrison remarked to his friend that he would make of that moonrise over the twilit bay his masterpiece. A small memory sketch the next day was followed by a series of studies to improve composition, color and tone, and during that winter he worked up two paintings, *Moonrise* later acquired by the Corcoran Gallery and *Crépuscule*, later acquired by the St. Louis Museum. One of the intermediate studies had an honored place in the Grand Salon of Mlle. Julia's in Pont-Aven. His method of work was established.

That winter Bastien died at the age of thirty-six, as did his friend Marie. Early in 1885 a large retrospective exhibition of his work in Paris, and posthumous auction sale, left a deep impression on the international art community; a number of the painters in our present exhibition, Ridgway Knight, Charles S. Pearce, and Chester Loomis reflect his influence (cat. 74, 75, 76, 78, 77).

Harrison painted two large canvases in 1885, using the method of painting a series of memory sketches prior to the finished work. One of them was *The Wave* (cat. 37), and the other, now destroyed, was called *Bathers*. Both, when exhibited at the Salon of 1885, made quite a splash. The effect for *The Wave* was from a memory of a promenade taken at the coast near Pont-Aven. Cecelia Beaux described the process:

He could not be called a Nature-lover, for he loved Nature perhaps only when married to art. He saw large and wished to paint large...He was enamoured of the successive opaline surfaces of low incoming waves and strove for the Sea's gift as it comes to one facing it on long beaches. His method was searching, and had the quality of science, perhaps because he had been trained as an engineer, which profession he abandoned for painting. His attack began with a small study, only a few tones of the choicest, an *ébauche* for a

certain effect, at a certain hour, but whose sign and substance was to last and be the key to all future development of the work. From the five by ten inches to the great canvas measured by feet, he passed by means of six or seven graded sizes, each containing accumulated truth, until the next to the last, which would be a not distant approach to the final.[103]

*The Wave* had a universal appeal, and was not regarded in America as the work of some expatriate, held in thrall by foreign styles or subjects, as pointed out by a friend of Harrison's from later years. The painting was acquired by purchase in 1891 by the Pennsylvania Academy of the Fine Arts, and the following year Harrison S. Morris became Secretary of the Academy: "When in his heyday he painted the sea, which has no nationality, he did so so realistically that one of the foolish old Directors of the Pennsylvania Academy was wont to draw his friends up to a French marine of Harrison's on the Academy walls, and enlarge on his acumen in having discovered for himself just the point on the Florida coast from which it was taken."[104]

Harrison's *Bathers* took him seven months, commencing with sketches done on the coast near Pont-Aven of naked boys in and out of the water. His purpose was to paint the nude in simple and natural surroundings, a logical combination of the plein-air interest and academic emphasis on the the nude. Intermediary studies won him honors in Munich, and one of the studies was purchased in Philadelphia for the Wilstach collection. *En Arcadie* followed, done the same way, worked up from twenty or thirty quick impressions done in dappled light of sunlit groves in Grez and Pont-Aven (cat. 36). Only one out of four or five of these he regarded fit for use, and from them he selected one on which to base the composition for the large picture which Beaux described:

> a lush dell, with small trees and several nude figures of women about to bathe in the river near by, unseen, but felt in the color, growths, texture of moist grass, and the humidity of a hot summer noon in the shade. The figures, about half lifesize – as the scene was large and they were back in the middle plane – were incidental, only values, and far from faultless in drawing, but giving the final sensation of presence in such a place, and the luxury of the moment.[105]

She adds, that "he had with him the sympathy and the 'moment' among his confreres, and the critics as well as the artists enjoyed what they might have called 'inhaling' his pictures as well as viewing them." William Rothenstein, who walked with Harrison along the Breton coast from Quimper, through Pont-Aven to Concarneau, recalled that at that time he "enjoyed a great reputation among Frenchmen. He was a *plein-air* painter, and had made his name with a painting of nude figures sitting about among trees. To paint figures *en plein-air* was then the fashion. His sea-studies were prominent features in every Salon, and well liked.... Harrison was a charming companion. He spoke French perfectly and understood the French character."[106] When he exhibited *En Arcadie* at the Salon of 1886, Harrison listed himself in the catalogue as a student not only of Gérôme, but also of Bastien, giving credit where it was due, fully aware of the aura reflected. For many, Harrison became the torch-bearer for the plein-air movement with these paintings of nudes in the open sunlight. They had neither the controversial connotations of the otherwise classical motif of Manet's *Déjeuner sur l'Herbe* of twenty-odd years earlier, nor the palette of contemporaneous experiments by Renoir, but were generally regarded as audacious forays into difficult but acceptable territory. The motif of the nude in the open sunlight – out of the studio and onto the grass – soon became commonplace among Americans in Giverny, behind their garden walls, whether clothed in classical narrative, or simply as carnations challenging the Impressionist brush (cat. 110). As for Harrison, although he numbered Rodin among his friends, knew Monet, and could not have avoided Gauguin, he was blithely unaware of much that was happening around him, and had never even heard of Cézanne, let alone his *Bathers*, well into the 1890s.

At that same Salon of 1886, an honorable mention was given *Seaweed Gatherers* (cat. 41), by Howard Russell Butler, who had arrived only one year before to study art. In Paris he found about one hundred art students gathered. "I have met Alexander Harrison," he wrote home in May, "who has the most beautiful picture in the Salon, a single wave coming towards you just about to break."[107] He met Bridgman, then well established in the Paris-American colony. He met Arthur Hoeber, and at the Bastien-Lepage auction he became the envy of them all by staying to the end, and acquiring a fine oil study for a song.

In mid-June Hoeber departed for Concarneau. Harrison soon followed. Butler determined to join them there, and in July took lodgings at the Hotel des Voyageurs, where he encountered Simmons:

> Ever since I have been here I have been running across the objects and characters mentioned in

the book *Guenn*. The artist hero is himself here, only he is a married man now. His wife is a nice little woman, also an artist. ...I have not yet seen very much of Guenn, although she was pointed out to me the first or second day. I did encounter her a few days ago down by the river, at the washing. She was teasing one of the old chatter-boxes who finally got up and chased her; but Guenn is a rapid runner and quickly disappeared over the hill.

A few nights ago, when we were taking our coffee in front of the hotel, who should turn up but 'Nannic,' the little hunch-back. His face fits the character perfectly.

The studio in the loft where I have been working myself for several days is perfectly described in the book. Altogether I feel as if I have returned to an old home, for I can hardly turn a corner without seeing something that I remember.[108]

Butler was struck by the strange craze for painting "ugly faces in gloomy light," predicting it would pass, and noticed "a tendency among young artists to avoid sunlight effects, preferring the most uncomfortable, chilly, somber days to those which certainly give one the most pleasure out of doors," (he had not been there long enough to fall under the spell of Bastien) and intended to show the men in Concarneau what could be done with bright sunlight. Soon he was hard at work along with Harrison and a painter named Herbert Denman, "trying to keep my color pure, and introducing figures in my landscape." He described the tribulations of a plein-air painter as the season progressed:

Clifford Grayson has been painting a picture of a peasant girl seated on a wheelbarrow. He began it in the spring with a delicate background of light green leaves and blossoms. He enriched the greens during the middle of the summer and removed the blossoms – the blossoms having fallen off. In September the leaves began to turn, and now, October 11, there is a russet background. I don't know but what I like it better than any of the others.[109]

Butler had come to painting, like Harrison, from years of service with the U.S. Coastal Survey. Like Simmons, he had college education, and like both had travelled in the West, in his case on into Mexico with Frederick Church. He spent many evenings with Simmons, and thought him, next to Harrison, the best among the American artists in Concarneau, most of whom he found inclined to be lazy: "Harrison is an exception to this. He wastes neither time nor

opportunity. He studies almost every twilight and he has the rare gift of taking an effect without painting it. I consider his color very pure and very true to nature. If he lacks anything it is imaginativeness, but then he inclines to a class of subject in which simplicity and truthfulness are more needed than imagination."

By summer's end Butler had made forty oil and water-color studies (pochades), some of which he intended to work up into two finished pictures by the beginning of November, and for that purpose obtained the use of one of the studios described in *Guenn*. One was *La Récolte de Verechs* or *Seaweed Gatherers*, based on a study made on the beach at Concarneau just after sunset, showing a horse-drawn cart being loaded with tidal seaweed deposits. From the beginning studies to the blocking in, this picture was done before he had the advantage of any French instruction at all. What he had in Concarneau was from American colleagues: "I am struck with the generosity of criticism exhibited by some of my friends. The most popular here is Lazar [sic]. He has succeeded in condemning almost everything painted in Concarneau this year." Charles Augustus Lasar had been a student of Gérôme with Harrison, Hoeber, and Grayson at the Beaux-Arts, but in the season of 1885 he was remembered best for engineering the total defeat of Pont-Aven.

"I am the only artist left in Concarneau," Butler wrote to his family on July 26, "All the rest have gone on a picnic to Pont-Aven nine miles hence." The event was a baseball game, a challenge from the artists of Pont-Aven, "these being real rival towns as far as art colonies are concerned." Butler did not join them, not yet having brought himself to playing ball on the Sabbath – a common American trauma in France, and usually quickly overcome:

August 23, 1885

Some three or four weeks ago the artists of Concarneau received a challenge from the artists of Pont-Aven for a game of baseball to be played at Pont-Aven. In true French style the game was called for Sunday and as I refused to go or play, an Englishman took the place that I should have otherwise had.

Pont-Aven had had the benefit of practice, and accordingly beat; and Concarneau returned home feeling very blue. The scores were almost equal, however.

Baseballs were immediately sent for and Concarneau met last Tuesday for a practice game during which I showed the Concarneau men some fancy twist pitching. They were all delighted with it and a return challenge was sent to Pont-

Aven for yesterday (Saturday) having been agreed upon in order that I might play.

We were all Americans and Englishmen who knew the game. The game was called at 9:00 o'clock on a field offered to us by a rich gentleman here who also provided awnings, and tables and chairs for our invited guests – of which there were about fifty; mostly French ladies who were deeply interested in seeing what was to them an entirely new form of sport.

Some brought American flags which they had made in honor of the occasion and with its other decorations the lawn was as beautiful as the day was fine.

Well, we beat them 47 to 15 and this notwithstanding that they had practiced nearly every day since the preceding game. After the game we had a sit down breakfast for seventy under the trees, returning to the hotel at 5:00. Pont-Aven went back with very long faces.

ひひひ

Credit for the game was due to our little captain, a St. Louis man who is about a head shorter than I am and almost as broad as he is long. We call him Shorty. He is a very comical fellow and really showed a great deal of skill and pluck in managing his nine. His real name is Lazard [sic]. He stood first in drawing at examinations for the Beaux-Arts last year.[110]

"Shorty" Lasar was a legend in Gérôme's atelier, and if by 1885 he stood first in drawing, it was predestined. Charles Augustus Lasar was born in 1856 in Johnstown, Pennsylvania, and enrolled as a student of Gérôme at the Beaux-Arts on November 18, 1881, a month after Hoeber. There he commenced drawing from a cast of one of the figures from Michaelangelo's *Medici Tomb*. An English boy named John Shirley-Fox, working nearby as a fellow *nouveau*, was witness to Lasar's first encounter with the *patron*, Gérôme:

These are complicated things to draw, and poor Shorty, not possessing then the power of draughtsmanship that he subsequently attained, got into a horrible mess with his "angles" and direction of the limbs. This the *patron* at his next visit, was not slow to point out, explaining the fact in language more forcible than polite. Now Shorty had positive genius for overcoming obstacles and usually an ever ready "scheme" to help him out. So realizing that something must be done, and that the case called for special measures, he then and there devised his famous "angle

machine", an invention which, I believe, he subsequently patented, and which was of the greatest benefit, in later years, to many pupils. This "angle machine", like most great inventions, was beautiful in its simplicity. It was just a rectangular frame, such as one might cut from any postcard, with a plumb line attachment in the center. Armed with this instrument, he once more attacked the offending drawing, and, with infinite pains and labour, set to work to measure and correct every possible angle it contained. At the professor's next visit the guardien, who used to while away his time listening to such criticisms as he could conveniently overhear, had approached Lasar's drawing to catch what the great man had to say.

Seating himself in the student's place, and adjusting his pince-nez, Gérôme began to examine the work before him, glancing quickly again and again from it to the statue. This went on for some time, and his face assumed a puzzled look. Seizing a crayon, and holding it at arm's length, he proceeded, in his quick, decisive manner, to verify certain of the angles depicted, measuring them with the utmost care. Then he tried others, and his puzzled look increased. At last he spoke. Turning round sharply and looking at Lasar as if he were some strange curiosity, he rapped out his words. "It's astonishing," he exclaimed. "I don't understand! How did you do it?" On Lasar making some vague reply he continued, "I can't understand it at all; the angles are perfect; there is not an error." The guardien's eyes at this point were bulging with astonishment. Gérôme ended his criticism by remarking: "Of course you can't draw a little bit, and as far as your proportions they simply don't exist. But your angles! They are wonderful – perfect! Raphael himself could do no better.[111]

Incredulous students drifted down from the life studios to see the prodigy, drawn by the rumor spread by the guardien that there was a *nouveau* thought by Gérôme to be better than Raphael. The sorry drawing was pointed out and provoked derisive hoots: "What, *that* better than Raphael? Why it's absolutely rotten!" If only out of a sense of self-preservation Shorty Lasar had to learn to draw, and by the time he engineered the defeat of Pont-Aven, he was number one in drawing in Gérôme's atelier.

Lasar's "angle machine" was only the first in a long line of aids he developed for the study of art. Some of these he gathered together in a book called *Practical Hints to Art Students* (New York, 1910);

- If you wish an object to look large keep its edges simple
- If the interest is in the middle of the scene with an irregular silhouette, the foreground, sky, and background must be simple horizontally.
- The objects generally may be vertical, with horizontal accents, or they may be horizontal with vertical accents to suit the circumstances.

Generally, he stressed the importance of tone, and of a unifying color, seeing purple as the dominant hue in the air that envelopes a landscape. "What he doesn't know about color is not worth knowing," said one enthusiast.[112] And Cecilia Beaux recalled that, "Until I went for a month's criticism to Charles Lasar, no word of theory was ever spoken to me by any of the masters who criticized me at the Julian Cours."[113] About that time, Arthur Wesley Dow, painting in Pont-Aven and Concarneau (cat. 35), benefited from the ever abundant advice of Shorty: "Think me not a heretic," he wrote Benjamin T. Newman, "But I have lately tried Vandyk brown and black in skies!! My trouble has been to get a dark grey that has not either blue, green, or purple. Shorty says it does not matter how many colors you mix to get a tone – but when you put it on the canvas you should catch your brush corners into some pure colors, as cobalt, garance rose, or chrome yellow. I think that is a good point."[114] Dow's comrade Henry Kenyon, one can be sure, shared any such advice, and seems to have used it in some of his own Breton landscapes (cat. 43).

Both Lasar and Alexander Harrison opened schools in Paris. Lasar taught women, in the main, and among his students were Cecelia Beaux, Florence Esté, Violette Oakley, and many others. "He is a man of ideas," according to a report of 1911 in the *International Studio*, "and for some years, by his wonderful power of exciting interest, conducted one of the largest art classes in Paris. Many today have much to thank him for. . . . Public exhibitions claim little of his attention, but what he has done for others and is still doing today, makes him a prominent personality in the American colony of Artists in Paris."[115] In fact, records of Macbeth galleries indicate that Lasar sent work to New York for exhibition, but there was little public response, and no sales (cat. 44). As for Harrison's school, it was tied up with a movement to wrest some of the power that Julian had accumulated through the predominance of his professors in the administration and jury of the Salon. About twenty or thirty of Julian's best men went over to Harrison in 1889. "He teaches them for nothing and they adore him," wrote Cecilia Beaux. "Julian went to see

Harrison and told him he had 'sent his last picture to the Salon.' I don't believe Julian actually did that, but of course he hates Harrison."[116] Actually Harrison got the gold medal that year at the Exposition, the World's Fair, was resident American in charge of the Committee handling art for the United States, and was awarded the Legion of Honor. The following year a rival Salon was established, with Harrison on the Committee.

Cecilia Beaux had come early in 1888 to Paris, where she enrolled in the Académie Julian with Tony Robert-Fleury. That her superiority was immediately recognized, and progress rapid, should not be surprising, since behind her was a decade of professional experience and instruction at the Pennsylvania Academy, and as a "Billy Girl" with Bonnat's old student William "Billy" Sartain. She met Harrison and Lasar in Paris during the winter, and with the end of classes, decided to join them in Concarneau. Traveling with her cousin, May, and a Mrs. Conant and her daughter, Beaux visited the picturesque mediaeval town of Vitré, where Vedder and Hunt had painted years before, and continued on to Concarneau, Mlle. Julia herself being their traveling companion for a time in the train compartment. At Concarneau the girls went directly to the Voyageurs, "with which we were already acquainted in a novel, 'Guenn,' then at the height of its popularity."[117] But soon they found lodgings on the edge of town.

Several paintings occupied Beaux, a portrait of Mrs. Conant in the garden, and one of two girls on the beach. The first was a classic plein-air problem of a figure in the filtered light under the trees; the second, "two life-size heads, at dusk, on the beach; two girls of the merely robust type in conference or gossip." Shorty came in every day to offer criticism. "'The lost and found' was his slogan at this time and his perfect honesty and humorous illustration gave zest to all his opinions." Harrison showed interest, but they both were more interested in the portrait than the other "because they are all tired of coiffes." As for the heads, Shorty thought she had "bit off more than she could chew," but she persevered. "If I succeed with my two heads it will be the opening of a new lea for me, that of working from *pochades* for large simple outdoor effects. I can see that the strongest part of what gift I have is my memory of impressions." So Harrison's influence was being absorbed. She took charcoal studies made in the studio down to the beach for annotation on color. "You know my effect only lasts about fifteen minutes:"

There is one strange thing about these peasants. They don't look common. They have a certain

look of face which one only sees in high bred people. ...Marguerite who is the model for one of my women's heads is of the broad rough type – eyes *very* far apart. She looks like a cow. But you come to draw her and you find her bone structure ...sound and fine and that she is distinguished (cat. 45).[118]

Proximity to the other artists gave Beaux the opportunity to observe them at work. "Hoeber and Harrison have been doing lots of small work pictures for exhibitions in America and England. Some of A.H.'s perfect dreams of sea and sky – no figures – it's awfully nice, as you may imagine, to see them grow." She started a portrait of Harrison, with whom she was obviously very taken, and of Hoeber, and wanted to do one of Lasar, but the summer came to a close. For Beaux it was a turning point. It convinced her to go on in art; she broke an engagement to marry in Philadelphia; her method of painting changed under the constant guidance of Lasar and Harrison. Painting in the open air, she abandoned the dark tonalities of the previous studio paintings, in favor of a much higher key on the value scale, and the adoption of color in shadow; and the painting of the girls on the beach was a success, under the title *Twilight Confidences* (present whereabouts unknown).

Beaux left an amusing record of the ebullient Lasar, something of the Sancho Panza to Harrison's Don Quixote, and of the entertainments and masquerades with which the artists amused themselves. Before departing Concarneau in October, Beaux and her friends returned the invitations with a high tea, writing doggerel and verse on the place cards. For Harrison:

> Oh who can bear comparison
> Was painter ever seen
> Who for ocean blue or green
> Or glimmering opal sheen
> With pinky throbs between
> Most mooningly marine
> Who can then bear comparison
> With Alexander Harrison.[119]

# Pont-Aven School, 1885-1898

Since 1874 the group that became known as the *Impressionists* had been exhibiting in Paris. In the American press the term "Impressionist" was hopelessly confused with any French painting of "morceaux", or *bits* of landscapes, whatever the style of painting. That is, regardless if it were painted in a tonalist, Impressionist, or plein-air realist manner, it might be called an impression as long as it had no special content or meaning, and therefore Impressionist. It was synonymous with trivial in the American public mind. In Paris, the outrage felt by J. Alden Weir on first contact with Impresionism can be regarded as typical of the academic reaction. In 1874 the young Gérôme student had gone to paint with Wylie in Pont-Aven; the following year he made friends with some young students, Bastien-Lepage and John Singer Sargent. Only in 1877, with the Third Exhibition of Impressionists did he come face to face with the artists he later would so admire:

> I went across the river the other day to see an exhibition of a new school which call themselves "Impressionalists." I never in my life saw more horrible things. I understand they are mostly all rich, which accounts for so much talk. They do not observe drawing nor form but give you an impression of what they call nature. It was worse than the Chamber of Horrors. I was there about a quarter of an hour and left with a headache, but I told the man exactly what I thought. One franc entree. I was mad for two or three days, not only having payed the money but for the demoralizing effect it must have on many.[120]

Impressionist tenets that eliminated black in the value scale, in modeling or contour, in shadow, and outline, drawing as it was then known, and local color, could not only demoralize, but actually did put painters like Munkaczy into an asylum. Thomas Hovenden even twenty years after the first Impressionist exhibition could still not abide the movement, which by then had been superceded in France by things he could not even imagine in Philadelphia. Harrison Morris, who became head of the Pennsylvania Academy operations in 1892 wrote: "I recollect how he hated the intruding elements of Impressionism. He said he could do that sort of thing overnight – and he did. He confided in me that he was going to paint a canvas, and put it before the jury without his name. I was to receive it at the Academy and run it

through the ordeal. It all came off as planned, and he deeply enjoyed the joke on his fellow jurors – who were more yielding toward the new fad – when they accepted and hung the canvas."[121]

Impressionism came to Pont-Aven with the effect of a flash flood in 1886, sweeping on through to le Pouldu, where it was absorbed by *Cloisonnisme* and *Synthétisme*, and, altered beyond recognition, swept on to Paris and the Café Volpini in 1889. The first exhibition of the *Groupe Impressioniste et Synthétiste* was held there at the same time the French nation celebrated the Centennial of its Revolution with a World's Fair. Pont-Aven would never be the same. The facts that underlie the formation of the French "Pont-Aven School" of painting are too well known to review in detail, but the early action was centered on the Pension Gloanec, where Paul Gauguin and his entourage gathered and ate; the chateau de Lezaven, where Gauguin had a studio; Trémalo, the little chapel on the hill from which he transposed the *Yellow Christ* to a Breton roadside; and the Bois d'Amour.

Paul Sérusier was vacationing in Concarneau the summer Cecilia Beaux painted *Twilight Confidences* there. Each departed about the same time for Paris to separate Julian ateliers, but Sérusier stopped briefly at Pont-Aven. Gauguin was sick abed at the Gloanec, but arose in response to a request for a demonstration of his theories. Together they went to the Bois d'Amour. At the exact spot where a decade earlier Thomas Hovenden sat (fig. 9), Gauguin gave his painting lesson: "How do you see these trees? They are yellow. Well then, put down yellow. And that shade is rather blue. So render it with pure ultramarine. Those red leaves. Use vermilion"[122] Sérusier did as told, painting on a cigar-box cover, and left that night for Paris, where he was *massier*, or chief monitor, at the Académie Julian. There his little *pochade* from the Bois d'Amour became *The Talisman*, seen and admired, worshipped as an icon by students like Maurice Denis, Edouard Vuillard, Pierre Bonnard, and those who would become the *Nabis*, or *Prophets* of modern art. The revolution was complete.

It was almost too much for some of the Pont-Aven artists to take. One old French painter said he would depart the pension if Mère Gloanec sought to hang a painting by Gauguin in the dining-room. (Perhaps the reason his *Fête Gloanec*, a still-life of the makings of a feast, is signed in the name of Emile Bernard's little sister). The painter Maxime Maufra recalled the day in 1890 he first saw the band of "Intransigents," when Gauguin and Meyer de Haan, Sérusier, and others accompanied by Marie Poupée, arrived from le Pouldu in a peasant cart – a bizarre looking bunch even among artists. In front of the Gloanec a tremor of anger passed among some of those gathered at the tables and someone said through gritted teeth: "V'la les impressionnistes!"[123] For his part, Gauguin enjoyed jerking the "pompiers" (academic hacks) whose company he avoided to the extent that when his own coterie was not in residence, and he was confined to his bed at the Gloanec with illness, he wrote his wife that there was no one to talk to, that he was alone in his room with absolute silence. This, one has the sense was torture, but no more so than a conversation which ignored him – he could not be ignored casually.

As for the local people, their reaction was about that of most of the painters. Mère Gloanec took care of him, but did *not* let him engulf the hotel as his group did in le Pouldu. He offered his marvelous portrait called *La Belle Angèle*, of 1889, as a present to the sitter Mme. Angèle Satre, who ran the small cafe next to the Gloanec, which she rejected, exclaiming "Quelle horreur!"[124]

When Gauguin arrived in Pont-Aven for the first time in July 1886 he was still working in the manner of Camille Pissarro, tempered by the structural brushwork and color of Paul Cézanne, and a knowledge of Monet, George Seurat and Paul Signac. Although he became attracted to what was generally described as the primitive, almost savage, beauty of the country, and in retrospect it is easy to see his Breton soujourn as the first step in search of paradise, he probably picked Pont-Aven because he heard from the painter Felix Jobbé-Duval that it was cheap and he could live on credit. He did not come to undiscovered territory, in other words, and find his idyll ruined by the sudden descent of a swarm of hostile painters of traditional persuasion. Quite the contrary, he was the beneficiary of twenty years of good will built up between the artists and inn-keepers and villagers, and his studio had been made possible long before by Robert Wylie and the long forgotten unfortunate notary, Tanguy. At the Gloanec he and his group preempted one of the two ground floor rooms for their own, eating separate from the "pompiers," in an arrangement which must have been mutually agreeable. Despite the objections of the old painter (whose reaction is unrecorded) Gauguin did paint a panel for the dining room, "an autumn landscape, which appeared to most of us who fed there as being very extreme in its crude exaggeration of purple and gold, though of course it was nothing compared with that to which we were soon to become accustomed."[125]

The forceful character of Gauguin soon made

disciples of other painters gathered at Pont-Aven. Young Emile Bernard, on a walking tour of Brittany chanced to meet Gauguin's friend Emile Schuffenecker on the beach of Concarneau that summer of 1886, and obtained from him a note of introduction to Gauguin in Pont-Aven. Together with others they were to forge the principles of the *Pont-Aven School*, based upon a combination of Japanese and mediaeval influences – that is, the conceptual symbolism, clear pure color, and black outline of stained-glass and the painting of what were then called "Italian Primitives," and the non-Western patterns and shapes of the Japanese print. It was a step back one more century from the one admired by the pre-Raphaelites, to models innocent of Albertian perspective or Masaccio's modelled masses. Gauguin advised his followers to:

> Avoid black and the mixture of black and white called grey...nothing is black...nothing is grey. It is well for young painters to have a model, but let them draw a curtain over it when painting it. It is better to paint from memory, then your work will be your own property. ...Who said you should seek contrast in colour? If this were so, you ought not to put two flowers of the same colour in a bouquet. Seek harmony, not contrast. Go from light to dark; not from dark to light; your work is never light enough. The eye seeks refreshment in painting; give it joy, not mourning.[126]

Where Impressionism dissolved local color and edges, *Cloisonnism* reinforced both. Cézanne's edges and planes became flat shapes defined by deliberate outline. If black was temporarily eliminated, it was imitated in a mixture of ultramarine and umbre, and then welcomed back in its own right with the complete rejection of Impressionism. To Schuffenecker, Gauguin wrote: "One bit of advice, don't copy nature too much. Art is an abstraction; derive this abstraction from nature while dreaming before it, but think more of creating than the actual result... synthesis of form and color derived from the observation of the dominant elements only."[127]

The English painter Archibald Standish Hartrick knew Gauguin then, found the landscape around Pont-Aven neither attractive nor varied, and could not say why it had attracted painters; but he found le Pouldu, at the estuary of the Laïta River, fifteen miles distant, a different story:

> For dramatic strangeness, that was a wonder of a place; ...Imagine a country of gigantic sand dunes, like the mountainous waves of a solid sea, between which appeared glimpses of the Bay of Biscay and the Atlantic rollers. All this peopled by a savage looking race, who seemed to do nothing but search for driftwood, or to collect seaweed, with strange sledges drawn by shaggy ponies; and with women in black dresses, who wore the great black "coif."[128]

In le Pouldu the group was alone to revel in their isolation and develop their theories, in contact with Denis and Vincent van Gogh. The young André Gide came by accident upon the little inn of Marie Henry at les Grands Sables of le Pouldu while walking in Brittany with Pont-Aven for his destination:

> Le Pouldu...consisted of only four houses, two of which were inns; the smaller of these seemed the pleasanter; being very thirsty, I entered. A servant girl showed me into a whitewashed room and left me there with a glass of cider. Of furniture there was little and of hangings none, which gave prominence to the abundance of painters' canvases and stretchers standing against the wall. ...I turned them round one after another and gazed at them with increasing astonishment; to me they looked like childrens' daubs, but the colours were so bright, so unusual and full of zest that I lost all thought of resuming my journey.[129]

Before the close of 1890 le Pouldu had been transformed like the garden of Plato, according to Séquin: "Through the arts of the master and his disciples, the commonplace inn was swiftly transformed into a temple of Apollo: the walls were covered with decorations which astonished the occasional visitor, not a surface was spared, noble maxims encircled fine drawings, the windows in the bar were converted into dazzling stained glass."[130]

Before the year was out Van Gogh had ended his turbulent life, and Gauguin returned to Paris to prepare for his departure for Tahiti.

There is not just a little irony in that while Gauguin was at Pont-Aven, so was Arthur Wesley Dow of Ipswich, Massachusetts. Dow is best known in this country as the teacher who evolved theories from Japanese art, and numbered Max Weber and Georgia O'Keeffe among his students. In 1901 Sadakichi Hartmann considered him one of our most abstract artists. In 1890 Dow discovered Hokusai and Japanese art, just as Gauguin was leaving le Pouldu – but in Boston, not in Brittany or Paris. Dow painted through the winter of 1885 at Julian's under Boulanger, receiving the standard figure and composition assignments and criticism. In preparation for going to Brittany he read Blanche Howard's novel *Guenn*, and arrived in Pont-Aven in May, where he

stayed until December at the Gloanec, painting landscapes with his fellow New Englanders John W. Raught and Henry Kenyon. After another winter at Julian's he returned in May 1886 to the Pension Gloanec, and in June wrote his brother: "This summer will do a great deal for me. ...Some of the best painters in France will be here this summer and I expect to learn much from them."[131]

Indeed there were painters, like Achille Granchi-Taylor, Emile Jourdan, Henri Delavallée, Charles Laval, and Ferdinand de Puygaudeau, then as now not household words, and into their midst came Paul Gauguin at the end of July. It was in August that Bernard, in Concarneau, got his introduction to Gauguin at the Gloanec, where Gauguin remained until the middle of November. In September Dow joined Kenyon briefly in Concarneau, but was back in Pont-Aven at the Gloanec in October, along with the painter Otto Wigand. He spent much of that winter in Concarneau, in April returning to New England for a year (just when Gauguin sailed for Panama).

That Dow had not succumbed to the attractions of Impressionism by that time is clear by his assessment of the works done the previous season in Giverny by Theodore Robinson, in which he saw "the most horrible color and handling imaginable."[132] Dow returned to France in the spring of 1888 with a fiancée, and in the company of Wigand and Kenyon. They went back to Pont-Aven for the summer. Gauguin was once again there. Dow's future wife wrote in July about her fiancé's progress: "He thinks he is doing his best work. As soon as he gets it in shape he will want to take it to Mr. Harrison and some of the strong ones to criticize."[133] July was spent in the dunes on a remote island, because in Pont-Aven all the motifs seemed exhausted, and the foliage was "much too green for outdoor sketching." That fall, Dow took a studio in Concarneau and sought the criticism of Harrison and Shorty Lasar, at the very moment that Sérusier left Concarneau, and on a stop-over in Pont-Aven, sat before one of the most over-worked motifs in the Bois d'Amour, with Gauguin dictating the exaggeration of the natural color, and in a few minutes changed the course of art history. Harrison thought Dow's *Au Soir* (cat. 35) to be "harmonious and charming"; into it he put many of the tips given by Lasar about how to achieve a gray sky without using a black-white mixture. At the International Exposition of 1889 Dow showed *Au Soir*, and received an honorable mention. Harrison, who was head of the committee of Arrangement for the American art department, was awarded a gold medal and the Legion of Honor. And Gauguin dominated an exhibition at the Café Volpini.

In retrospect Dow offered a grudging compliment to one of "the stronger ones" when he said: "Shorty had some glimmerings – he did realize that servile copying of nature is not all of art – that there is such a thing as harmony of line, mass and color."[134] It is clear that Dow did have a choice – that is, that he knew Gauguin and his work. He could not have missed seeing it, and mentioned that he had been photographed in the company of Gauguin; they are at opposite ends of a group photo in front of the Gloanec. Many years later, in correspondence with Kenyon, Dow recalled Pont-Aven:

> Hotel Spaander, Volendam
> May 22, 1914
> I never expected to see another Marie-Jeanne's but here it is, only very clean, and on a larger scale. Big low-studded room with beams overhead...The walls are covered with sketches. ...When we got to the table, and one of the painters, an Austrian, began fooling with the *bonne*, and she threatened to throw a pile of plates at him I saw Gloanec's all over again.[135]

In another letter he mentions the "Henri-Davies crowd" and their discovery of things he heard Fenollosa talk about twenty years before, "only now they call it 'rhythm,' 'deductions,' and 'the ultimate reality',," adding: "When I hear of Gauguin I can see him thumbing his nose at Wigand and me. I can't see anything in his work or Van Gogh's that isn't in the most ordinary Japanese print."[136]

Some of Gauguin's band, or "tribe," remained in Pont-Aven to welcome back the self-proclaimed "savage," their acknowledged chief, when he returned for a final visit in 1894. Back from Tahiti, he made a sort of pilgrimage to old haunts, accompanied by Annah, his Javanese mistress, and a parrot or monkey, or both. "Triumphal" would not exactly describe the visit. In le Pouldu he found Marie Poupée out of business and her doors closed, to him especially. In Pont-Aven he found old friends, and he lodged at the new Gloanec annex, the old *Lion d'Or*, a stone's throw from the Hotel Julia. There he met Armand Séguin, a friend of American painters in Paris and Pont-Aven. On a trip with his entourage to Concarneau – Annah, parrot, Séguin and his wife – while strolling on the quai, they got into a brawl. In a port town, the bizarre is not exceptional, but Gauguin still attracted attention. Some small boys winged pebbles at him and Annah. Séguin grabbed one by the ears. He happened to be the son of the pilot Sauban, who came to the rescue by punching Séguin,

who jumped into the harbor to escape further damage; Gauguin decked Sauban, whereupon three sailors jumped the artist. In the melée Gauguin broke his ankle and Mme. Séguin cracked a rib.[137] In all it was a bad summer for Gauguin. Annah ran off to Paris and ransacked his studio while he recuperated in Pont-Aven, and Marie Henry refused to return the paintings left in her care at le Pouldu, with good reasons of her own.

Pont-Aven continued to be an artist haunt, but it no longer was the safe haven for academic figure artists or plein-air landscape painters seeking tones of gray. From the time of Gauguin and his group of "intransigents" it was every man for himself. After 1890 things were changing in Paris as well, with the formation of the Société Nationale des Beaux-Arts and its Salon at the Champs de Mars. Julian's threat to Harrison to bar him from the Salon had not been idle, for his professors had long dominated the juries of the Société des Artistes Francais, which was now challenged by the new more broadly based organization, in whose administration Americans like Harrison participated. Since 1881 the same Americans in Paris had been actively promoting their own paintings in America and at the Pennsylvania Academy exhibitions, in particular, in direct opposition to the general dominance, in New York, of the Society of American Artists by Munich trained painters. With the assistance of Rodman Wanamaker the American Art Club was founded in Paris, and Montparnasse became for Americans, a home away from home, instead of a quarter of a foreign capital. Shorty Lasar was to remain a permanent fixture there until his death in 1936. Julian's various ateliers continued to be the most popular life academies in Paris, and the instruction continued with little change.

Within a few weeks of Sérusier's triumphal return to Paris and the atelier at Julian's with his *Talisman*, a group of students from the Pennsylvania Academy enrolled at the rabbit warren of interconnecting studios at Rue de Faubourg St. Denis No. 48 – students of Thomas Anshutz and Thomas Hovenden, who had replaced Eakins as professors at the Academy in Philadelphia. They included Robert Henri, Charles Grafly, and others (Fisher, Haefeker, and Finney), and would soon be joined by Edward Redfield. During that winter they could not have missed talking with Cecilia Beaux, who was more than enthusiastic about Alexander Harrison and Concarneau. They did meet Harrison, who offered to give them criticism at no cost if they wished. So during the following summer of 1889 they took advantage of the opportunity. Fisher and Henri

stayed at the Voyageurs and took a studio in Harrison's building – probably the one Beaux had the year before. As it had been for her, it was a liberating experience, and under identical circumstances. Henri wrote: "I am never quite so happy as when I settle down to a sketch of a brilliant color subject when there is a strong sun and nice sky – I forget doubts then. There is less science to my method but more heart and I generally pull out a better thing."[138]

An accumulation of experiences in Concarneau that summer broadened Henri's vision and left a stamp on his individual development. The bright little "pochade" of a girl on the beach, so reminiscent of Edward Simmons' painting of a few years before, is a record of that development (cat. 46). In retrospect he said that, "The summer work outdoors is of the greatest importance – it is then that the winter's grinding is put to the test, and the artistic faculties are cultivated. It is then that one studies to paint pictures."[139] That Harrison was able to kindle interest among younger painters is evident in the enthusiasm with which they tackled his own favorite problems:

Tucker and I [Henri] have started a new kind of study to occupy our afternoons for a while. We have a boy stripped nude – all except the 'calecon' – bathing trunks – on the beach. It's very interesting and a most difficult thing a nude figure in the strong sunlight. We will not make studies – only sketches to get impressions rather than carried things. ...To get the impression of sunlight in a sketch is a most difficult thing, and there are the most beautiful colors in a nude figure in the open air, especially as on the shining sands...

Fisher and Redfield have been working over on the other side of the Passage at landscape, while Tucker and I have been continuing our work with Jeanne and making other studies on the beach such as our newly organized nude boy sketching.[140]

Simmons had not had to read *Guenn*, since it was written in his studio, but like Butler, Dow, Beaux, and everyone else coming to Concarneau, Henri had read it; and so had his family at home, to whom he was able to provide an update:

I am always getting more information about *Guenn* – I saw her the other day – yes, the original Guenn, unless my two informants through whom I have traced her are mistaken. This can hardly be, for my evidence, traced through both to this same girl is in perfect harmony with the story and everything connected with it. We saw her on the beach walking along quite as naturally as if she

55

had never drowned herself there for love. She passed with her sister Jeanne and her husband – a good looking young fellow. Was she a beauty? Well, I didn't fall in love with her at sight, but she was very good looking. Grown rather plump. Others saw her and say they think her one of the prettiest women they have seen here. She didn't look very sentimental or book-like, but looked very much as any contented, good looking young Brittany wife might.[141]

In September 1889, Henri, Redfield, and Tucker walked to Pont-Aven, with which Henri already had some acquaintance: "The fellows were much pleased with the old chateau, and I told them the little romance about it, about the painter and his famous duel, too. I pointed him out to them too, for we saw him in Pont-Aven painting a portrait of his good-looking, buxom wife, sitting in a light pink dress among the wild flowers on a little island between the branches of the eccentric mill stream." Just who this might be, or whether the chateau is Rustephan or Lesaven, is unknown, but because of the presence of the volatile and deliberately offensive Gauguin in le Pouldu and Pont-Aven at just that time, the comment is worth recording. If Gauguin was not there, Henri and his group just missed him by a few days on a visit from le Pouldu; they stayed at the Gloanec, and saw the places "haunted by the gaunt looking artists, Impressionists and all."[142]

At Pont-Aven, Wright, who used to be one of our Concarneau family, met us with almost open arms. We found several other fellows there that we know, Raught, Linson, Atkinson, Peel – we took in the principal features of the place seeing almost everything of interest and visited the fellows at their studios. Atkinson, who was once of the P.A.F.A., a Canadian, had quite a number of sketches and pictures on his walls. He has made a most remarkable change in his work since he has been here. When he arrived last spring he painted very dark things. Everything looked like it might have been painted many years ago and had grown dark by time. Now his work presents entirely the opposite effect. Everything is keyed up to the very highest pitch. The reigning struggle for light has taken him and he has not been at all sparing in his conversion to it. There is a great improvement in his work – altho he has probably made too much of a good thing; when he has toned down sufficient to keep within the possibility of values he can be said to have greatly benefitted by his summer in France.

Raught was still working on very much the same things as when we saw him before....[Peel] was working with a very large canvas at a gateway not far from Raught's studio. Peel got a mention in the last Salon on a very fine pair of pictures. He is a Canadian and an ex-P.A.F.A. of away back. We found him working away very comfortably with his wife sitting just back of him engaged at some needle-work. Peel wore a big straw hat over this rather good looking face with its red pointed beard. Instead of a vest he had a Bretagne gilet with the very pretty gold embroidery around the neck. On his feet were the characteristic Pont-Aven sabots – with the toes turned up into a point. This is the general make-up of artists in this part of the country – everywhere, I suppose – a general throwing together of costume which pleases the perhaps eccentric taste of the wearer. Peel had a very difficult subject on hand, and he was handling it masterfully. It was a common old Brittany farm gate with a group of small boys and youngsters generally sitting on its top or peering through the bars. The picture was well advanced...[143]

Before Henri returned to Philadelphia in 1891, another Pennsylvania Academy student arrived to continue his art studies. Henry O. Tanner, an old student of Eakins, stopped in Paris on the way to study in Rome but stayed, enrolling in the académie Julian under Constant and Laurens. His first summer he painted in Pont-Aven, the second in Concarneau, 1891 and 1892 respectively, before returning to Philadelphia for a year to recuperate from illness. Durand-Ruel had shown Monet's *Haystacks* in 1891, and the *Nabis* held their first exhibition. Tanner also became intimate at Julian's and in Pont-Aven with the circle of artists around Gauguin, and Séguin was a particular friend. That summer of 1891 Séguin was at Julia's. Other painters staying at Pont-Aven were Roderick O'Conor and the Englishman Eric Forbes-Robertson, Sérusier, Maurice Denis, and Eugène Carrière. Tanner himself was more noticeable than in the Paris milieu, and made an immediate impression on Gustave Loiseau: "The mulatto Tanner made a sensation. His grin was living advertisement for dentists of the other side of the Atlantic. Gold covered all his teeth – it was horrific and superb."[144]

So Tanner was very quickly aware of the various art tendencies in France, and had before him the choice of personal development. Exotic as he might have appeared, he was respected in both American and French circles as a serious and conservative artist, one of their own. He took what he wanted from Impressionism and Symbolism, and narrative

history painting. In Pont-Aven he painted both landscape and figure, making rough compositional studies and sketches that he would eventually work up for the Salon of 1895; in *The Young Sabot Maker*, a sturdy Breton apprentice working under the proud gaze of an old shoe-maker. In Philadelphia he did a similar genre interior, choosing a Negro subject for the motif in his *Banjo Lesson*. But in Philadelphia he landed in the middle of the controversy precipitated by Henri and some of the other younger men who had returned just before him to enroll in the Pennsylvania Academy under Robert Vonnoh. Recent exhibitions of their work had created a storm around even the tamest aspects of Impressionism, and in that frame of reference Tanner's work was seen by the critic of the *Telegraph*:

> Mr. Tanner has been known here as a land-scape painter, the work he has exhibited at the Academy and elsewhere as well as those sent home from abroad being for the most part plein-air studies made directly from Nature. In his more recent pictures he has shown the influence of Impressionism, or rather an understanding of what the Impressionists are looking for – namely, the ensemble, the truthful presentation of his subject as a whole, the right relation of Objects seen together in the same light. He has, however, maintained his independence and has not been dominated by the "blue bug" craze so far as to sacrifice his prescription of color, and has kept a place on his palette for other tints besides yellow and purple; and one of his latest landscapes painted abroad, a scene near Pont-Aven in Brittany, affords a fair illustration of what might be gained from Impressionistic suggestions with-out abandoning sanity and disregarding the dictates of experience.[145]

Tanner found the atmosphere in Philadelphia stif-ling, and returned to Paris, remaining a lifelong expatriate.

An expatriate of a different sort was Charles Fromuth. Like Tanner he remained in France the rest of his life, but got out of Paris as soon as he could to live in Concarneau, at first for economy. He too had studied with Eakins, for five years, had been involved with his photography of the nude, was a prosector in the anatomy courses Eakins and Dr. Keen con-ducted, and knew everything that geometry could teach about reflections on water. Saving enough from textile design and model building to go to France, he arrived in Paris in time to see the great 1889 Exposition:

I had come from a land of no art in search of art culture and only possessed intuition to guide me aright in this massive display of contemp-orary art. I had inhaled rumors of a new and different manifestation of art created in France with the vague title of Impressionists, but they were not represented here, nor in the Luxem-bourg when I arrived.[146]

≈≈≈

Every evening, exhausted with reflections upon art, I dined in one of the restaurants where my compatriots congregate, driven to Paris from all the American regions to the Mount Parnasse quarter, the headquarters of Americans. . . . After a six weeks life among them I asked myself have I come to Paris for such compatriot contact? Neither I nor they had the slightest contact with the French language, since all were newcomers.

The French Ecole des Beaux-Arts was the ambition of all Americans and tuition was free, but the institution had been obliged to adopt a lot of debarring examinations against foreign invasion. After it the most famous was the Académie Julian, located at No. 48 Rue de Faubourg St. Denis, a veritable beehive of ate-liers, each having two professors in official vogue, open to anyone on the simple payment of dues.

I who had come from the elegant modern convenience of the Philadelphia Academy was shocked at the delapidated conditions of these various ateliers. . . . After an inspection of the various ateliers, all crowded with students from all nations, and without a preference for any of the professors, I chose the largest because one had a choice of two models posing at the same time. It was also nearest to the stairway of exit; another stimulous of choice was I found a group of students from the Philadelphia Academy.

Bouguereau and Robert-Fleury taught, but the theory of instruction in all was the same – that is, the system of David and after him Ingres, which dominated French art, and . . . was imitated gen-erally in the art academies of other nations, and diametrically opposed to the instruction I had received under Thomas Eakins; which was di-rectly plastic and not linear – that is, to attack the model at once in color with the brush in the construction . . . to proceed and build up a figure with the paint and brushes the way a sculptor with his clay, adding and removing or displacing pigments like clay.

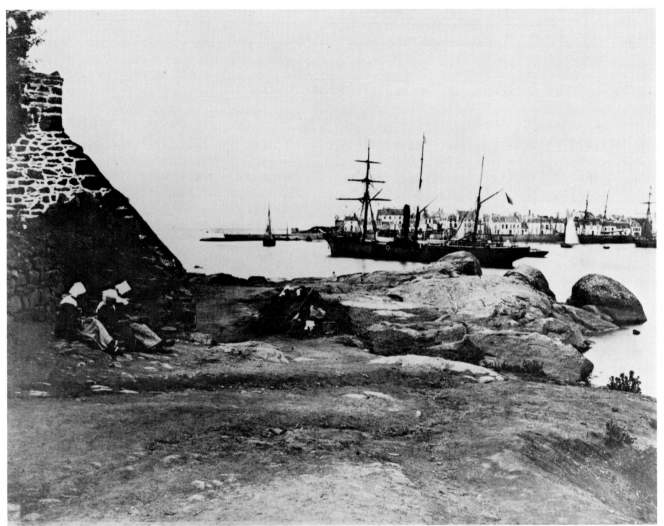

*Figure 13.* Concarneau, c. 1880. View from the ferry slip looking southward towards the bay. Photograph by Helen Corson.

Now a sculptor cannot proceed like the painter first creating a linear drawing with fixed boundary contours and complete the inner requisites afterwards with such a mapped contour. This was the method practised in Paris academies, totally contrary to the education I had received. … I remember one clever fellow, whose daily paint execution had a scientific precision, told me that by the end of the week he he expected to complete the feet of the model…

They were all trying with a measure ruler and plumbline to make a linear outline map of a model the first day of the pose with a fixed purpose, to fill in this…modelling bit by bit.

◊ ◊ ◊

So, I drew according to my education and my gift impulses – that is *emotively*, and was most merci-lessly criticized by Bouguereau who said, where did you learn to draw like that and demanded I draw from the cast.

Having paid six months of his meagre savings in advance he decided to stick it out and see if he could learn something. After a month Bouguereau let him paint, and the French students told him they learned more from the comments of the professor in his attempts to dissuade Fromuth from the direction he had acquired under Eakins, than they did from anything else he said about their own work. From the group of Academy students (who must have been Henri, Redfield, and the others) he undoubtedly heard about Concarneau, and in July of 1890 he quit Paris with the fishing port as his destination.

Quimperlé looked to him like a painter's paradise, but he continued on. At Rosporden, fifteen kilometers distant he smelled sea-air and fish. In that

first month at Concarneau he visited Pont-Aven, and thought of moving there, to its convenient landscape motifs and painter community, dotted with umbrellas within a five minute walk from the *place*. But at Concarneau he was well fed by Mme. Coatalen for sixty francs a month at the Hotel de France, and had a studio loft for very little. He was made to feel like one of the family, and indeed was permitted in hard times to go more than two years on credit for both board and studio without loss of confidence. He also found his motif: "What a background mine, the old Ville Close, little island village walled in with fortification of everlasting granite reporting centuries of weather wear and the salt sea air, decked with lichen, moss at home in every crevice. Sea encircled with docks, quays, jetties all around. I never tire studying it as my background for my subject matter, which seems inexhaustible."

With all of his experience in figure painting, he did not feel comfortable with it. For several months he tried the standard Salon motifs, but found them alien to him, and overworked. Salon artists had harvested them too continuously for him: "field labor á la Millet, landscape painting ... under the influence of Rousseau, Corot and the Impressionists;" genre pictures of Pardons, Brittany interiors; sailors' life on sea or land, at home or in their bistros; sea waves at high tide, or the low tide occupations of seaweed or shellfish gatherers. They were not for him. Nor could he work in the usual scale of the plein-air Salon artist:

> They just went to their art dealer, ordered a very large canvas in a crate to be delivered at their selected painting region. The crated canvas arrived in the country; they began to survey something temptingly framed by their optic capacity in subject matter ... they transported canvas and crate somewhere against a convenient support. A meadow, a tree trunk, and an attractive peasant girl posing sufficed for months of labor copying the matter under a gray day with even light. After the day's labor the cover was screwed to the box containing the canvas, and so on 'til the finish.

> This was a period called realistic naturalism, a "tranche" (slice) of nature sufficed and ... all the wonderful effects of nature in labor were disregarded as the true art theme out of which ... reports must be extracted.

Fromuth's "reports" were to be the living, breathing, heaving, sleeping harbor of Concarneau, first in the Impressionist manner, remade by his own discovery of the Japanese Hokasai, and by long,

daily, intimate observation of the moods and conditions at all times and seasons (cat. 55, 56). He revelled in a scene of a shepherd driving his flock at sunset in the hedgerows, but would he paint it? No! It was not his motif. But the boats, the sardine luggers, with their red-brown sails, he knew from the keel to the gromits. But it was the action, motion, and light and not the stationary object that he "reported."

It was not long before he also found that oil painting was not his medium, but charcoal and pastel – an oil pastel on a support with a tooth, which he felt gave him better control of clean color. In 1895 he began to feel good about his progress, and sent ten oils "in the prevailing Impressionist manner" and six charcoals to the "new Salon." The oils were rejected, but two pastels got excellent places on the line, with Zorn – thereafter he was a regular contributor in charcoal and pastel, and gave up oils completely, regarding himself a painter in pastels, not as a pastellist. By then, Fromuth had come out of isolation. Unlike the others who had come to Concarneau to study with Harrison and Lasar, he had worked alone, going once a year to Paris to see the exhibitions, but only about 1894 met Harrison, who bought three pastels. (He was in Paris the month that Séquin and Gauguin got trounced). Gradually he got official recognition, as well as professional respect. In a Munich International exhibition he received a gold medal, exhibiting among the French. The Norwegian, Fritz Thaulow, without knowing him, got a Russian collector to buy four things out of an exhibition.

Meanwhile, in 1895 he met Robert Henri, back for a second time, with "an influx of Americans forming quite a colony of people with revenue," and they found him a good bicycle, cheap, so that he could peddle with them around the countryside. Some of these passed the winter in Concarneau. His studio was attracting international visitors, and French painters, like Charles-Francois Cottet and Louis LaTouche, and Americans: Henri, Redfield, Robert Logan, Henry Dearth, and the Canadian James W. Morrice. But it was in 1901 that Fromuth tasted real celebrity in Concarneau with a visit from August Rodin and the Norwegian painter, Fritz Thaulow:

> One evening before a dinner invitation in late September, I as guide showed Rodin and Thaulow the magnificent animated spectacle of the harbor; all nature enhanced the spectacle by a beauty change hazard. I had lived as a figure ten years working on the quays, but this animated spectacular evening with crowded spectators, my

passage with two personages carrying the insignia of officers of the Legion of Honor attracted all eyes, and I beheld for the first time in my life that I was attracting attention being in the company of those who in the lapel of their coats had such a distinctive sign.[147]

Thaulow and Rodin suggested going on to Pont-Aven for dinner. "The Hotel Julia was full of guests and our arrival caused a sensation, for Rodin was recognized." Both Rodin and Thaulow bought pastels from him that day.

There were other Breton backgrounds equally stimulating and if anything more dramatic than Concarneau, especially the coast around le Pouldu which Hartrick had described and Gauguin painted. Fromuth found it no less fascinating one stormy day:

Here I encountered nature's mighty sea elements; cliffs and rocks battered by the sea; weighty waves whose rhythmic repeats rose higher, scooped lower as they fell over top first in a whirling foam in designing patterns against the rock obstructions below me from the height of my view, while the foam flakes were blown landwards by the heavy winds...The sand coast here is of yellow sand; the wet sand is violet; the waves are greenish falling over into a foam of a greenish warm white. The whole sea aspect is a combination of greenish and violet coloration, for sandy bottoms makes the water greenish, while the sea weed sections produce a purplish color on surface. The sky near the horizon was flesh colored tone, while the upper clouds were tinged with a pale crepuscule violet and gray coloration.[148]

Le Pouldu in 1890, as described by André Gide, was a collection of four houses, two of which were inns, and one of these had been converted by the Symbolists into a "Temple of Apollo." To the other one, operated by Père Goulven, John White Alexander came in 1891 with his wife, child, and the child's nurse. One of the villas belonged to an Arthur Studd, who apparently still lived there twenty years later. Exactly how the Alexanders obtained reservations, I do not know, but they were expected, and Mrs. Alexander did not have the least concept of the primitive barnyard conditions they would find on arrival. On occupying three of the second floor rooms, they scrubbed down, and prepared to stay for five months.[149] Also at le Pouldu at the same time was an artist who has completely dropped from sight, if indeed he ever attempted to be seen in his own day,

for almost nothing can be found about him – Guy Ferris Maynard. Alexander and Maynard make a fascinating contrast, and a good measure against which to see American art at that moment when Impressionism is at its peak in France, and when it can no longer be considered avant-garde. Gauguin was in Tahiti, but Jan Verkade, Charles Filiger and Maufra, of his entourage were at Marie Poupée's, and Bernard and Séguin probably dropped in from Pont-Aven. The Americans were absolutely at the center of the Symbolist-Synthetist movement. There is no sign at all in Alexander's painting *Landscape, Le Pouldu* that he was even aware of it, although his is a wonderful painting in its own right, reminiscent of Whistler, and of some of the things Twachtman was doing about the same time.

Maynard, on the other hand, if his *Breton Interior* (cat. 59) can indeed be dated from the time, seems to be right on top of what is happening in the Post-Impressionist camp. And, indeed, the recollections of Mrs. Alexander would seem to underscore this, but are equally intriguing by their back-handed ambivalence:

He was a middle sized, red skinned, coarse grained young man, with brown hair and beard; and he wore Breton sailor clothes from motives partly of economy, and partly because he felt he looked picturesque in his sailor collar and rough blue blouse. He hoped in secret that he might turn out to be a genius, a genius of the new school, for he had forged a step ahead of the Impressionists and painted uninteresting still lives in various experimental colors and manners. He had a flair for what was good and up to date, or beyond date.

As a man he did not amount to anything as he had no nerves and no backbone. He was a weak but sensitive character clothed in the flesh of a good natured yokel.

The Alexanders interested and puzzled him because they were comparatively normal. He had probably never been normal, and certainly was far from it when they knew him. ...Maynard came out of space, and when they left Paris was swallowed up again into space. They saw a great deal of him for several years...

Alexander's unprecedented success intrigued Maynard and stimulated him. If A. had painted blue tea sets against a pointilliste background M. might have also admired him as a painter.[150]

The view over the estuary of the Laïta River selected by Alexander must be the most serene in the whole area, judging by descriptions at the time – the

locale is now built up. Alexander's art training was originally in Munich and with Frank Duveneck in Polling, Florence and Venice. In Venice, he knew Whistler, and their friendship continued. In 1891 he was back in Europe after working in America as an illustrator, and renewed his ties with Whistler. In Brittany for his health (like Whistler in 1861), he attacked painting again, and the large canvas of the house at le Pouldu reveals his sympathy with the current taste for Japanese art. But it is not that of the Synthetist for the bright and flat colors and line of the popular print; it is more akin to Whistler's more lyric adaptations from porcelain and scroll painting. Whistler continued to be the most important single American painter at home and abroad, and Alexander seems in 1891 to return to his example for the stimulus he had originally found in the work of the artist in Venice. Twachtman's paintings around Arques la Bataille and Honfleur (cat. 51), show a similar assimilation.

Maynard, on the other hand, is an unknown quantity, this single picture and Mrs. Alexander's description must represent him. From Chicago, and the Art Institute, he turns up in Paris and Grez-sur-Loing, but was associated with Brittany, le Pouldu and, at least later with Fromuth in Concarneau. How often he is confused with the frequently mentioned George W. Maynard can now only be guessed. His biggest excitement at le Pouldu seems to have been sitting on a bench outside of the Goulven inn talking with the coast guard or customs officer, along with an American girl named Maude Mosher, which scandalized an English lady named Gasgoyn. His own predelictions seem to be towards the Synthetist composition, but combined with pointilliste technique and without Cloisonniste outline. There is a caveat in what Mrs. Alexander says, for she talks of his experiments with different colors and *manners*. Given Shorty Lasar's own warnings to students that they should paint each picture in the manner it demands, and the fact that he himself did not paint one picture like another, we cannot assume that there are other pictures by Maynard that represent the same style. However, it is well to introduce him as an individual at a crucial point in the artistic development of France and America. Taken along with the work of such enduring masters as Whistler, and newcomers like Maurice Prendergast, who at just this moment was painting little but important pictures on the beach at Dieppe (cat. 61), one catches a glimpse of the future course of American art.

About the time Arthur W. Dow discovered Japanese art in Boston, Maurice Prendergast departed the city for France. His earliest paintings there in 1891 suggest prior knowledge of Whistler and of the Impressionists, while the little pictures done a year later on the Breton north coast and the coast of Normandy reflect a grasp of the new work of the Nabis (cat. 60). Formed in the Académie Julian in 1889, two years before Prendergast enrolled, this group held its first exhibition in Paris during 1891, followed quickly by retrospective exhibitions honoring the late painters Van Gogh and Seurat. New impulses were stirring in Paris.

With the same critics and surroundings at the Académie Julian, Tanner and Prendergast are an interesting contrast. In the summers Tanner went to the place of origin of the seminal *Talisman*, knew the artists of Gauguin's circle at Pont-Aven, but remained quite academic, perhaps conditioned by his years with Eakins in Philadelphia. On the opposite coast of Brittany at Dinan, Dinard, and northward at Dieppe, Prendergast worked on small paintings of intimate subjects that reveal in surface and texture a sympathy with the latest currents. Prendergast was a close friend and studio comrade of the Canadian artist James Wilson Morrice. They knew Whistler in Paris, Aubrey Beardsley, the poster artists of the new *Revue Blanche*, the Nabis, and of course the Japanese – all of whom exploited flat pattern. The oils and monotypes done by Prendergast in Paris and on his return to Boston in 1895 demonstrate a complete assimilation and mastery of the idiom of the Nabis in general, and of the "Japanese Nabi," Pierre Bonnard, in particular.

Returning to Paris with a group of Philadelphians in 1895, Robert Henri inherited the friendship of Morrice, who was in position to bring the Americans right up to date. Henri, William Glackens, and Morrice painted side by side in the streets of Paris and the surrounding countryside. Henri's earlier work on the beach at Concarneau under the criticism of Harrison, and in Philadelphia with Vonnoh left him no stranger to plein-air painting and Impressionism, but by 1895 a reaction had set in. Manet had achieved Old Master status in the twenty years between the Salon de Refusés and his death in 1883, and in 1884 he had been given a large retrospective exhibition. With the re-assertion of local color in flat shapes on the picture plane, combined with the American love affair with Franz Hals, Manet was bound to become the focus of Americans seeking new models. Only half of the "New Men" seen emerging at the art gallery of the Philadelphia Centennial Exhibition were Paris trained. The others had gone to study in Munich. Most of the aspiring artists from Cincinnati and the Middle West went there in the 'seventies,

when admiration for the buttery paint and loose, brilliant brushwork of Hals, coupled with a new admiration in Bavaria for Courbet, was at its height. Both William M. Chase and Frank Duveneck were drawn to the prevailing modern Munich tendency, and Duveneck played an especially important role for Americans abroad because of his personality and teaching ability. It was as members of the group who called themselves "The Duveneck Boys" that John Twachtman and John White Alexander went to Venice in 1877 and 1878 to surrender their dark Munich manner to the combined spell of the Lagoon and James Whistler, who joined the group. Not only was it an amiable young crowd, but they also had a printing press, which Whistler needed, and paint, which Whistler had little of and a large square brush named Matthew requiring large quantities. The symbiotic relationship established in Venice between Whistler and the Duveneck Boys was a happy one for American art.

The men trained before the Centennial in Paris and Munich were the backbone of the "New Movement" in American art that blossomed with the founding in 1877 of the Society of American Artists in direct confrontation and competition with the National Academy of Design. The Society initiated Annual exhibitions in 1878 to rival those of the National Academy, which had introduced protectionist policies for the benefit of its own membership and had little initial sympathy for the young radicals. By 1881 the Munich contingent so dominated the New York based Society of American Artists exhibitions, that to correct what was perceived as an imbalance of emphasis by Paris trained painters, The Pennsylvania Academy of the Fine Arts actively solicited work by Paris based alumni and their artist friends for the regular Annuals and special exhibitions at the Academy. This accounts for the heavy lacing of Academy exhibitions of the 'eighties with paintings having a strong French academic bias. The committee in Paris created in 1881 to obtain submissions from Americans living abroad included Bridgman, Pearce, Picknell, Sargent, Ramsey, Loomis, Knight and Blashfield; and Alexander Harrison soon became active. It was twice the size of the Munich committee, and many times more productive. Brittany and Normandy were well represented, and there was not a tonalist in the lot. Coming at a time when the Academy schools under Eakins could boast the strongest program of study from the Life, or School of the Nude, outside the École des Beaux-Arts, these exhibitions helped prepare Academy students for later studies in France as no other place

in America could. Impressionism, at this time, had no recognized position in America whatsoever.

While Impressionism was budding, neither Chase of the Munich persuasion, nor Weir of Paris could come to grips with it. By 1895 both of these men had accommodated to so many of its principles that they exhibited in America together in complete harmony as Impressionists. By then differences between students of Paris and Munich that were so strong around 1870 had been resolved by mutual assimilation of style, and by the common absorbtion of Impressionism, which had been once equally foreign to both. Other Americans of a new generation seeking models outside the Impressionist camp, however, found inspiration in the fatty paint and broad planes of Manet.

In the manipulation of paint there is little revolutionary in the work of the five painters from Philadelphia who made up the majority of the group who exhibited as *the Eight*, Henri and Glackens among them. If anything it was a rejection of Impressionism through a retrenchment in Manet, modified by the surfaces of the Nabis and new impulses towards expressionist color. The work of Henri, Glackens and Morrice in 1895 is very similar, and it is no coincidence that there is strong resemblance in the paintings of Robert Logan.

Logan left Boston about the time Prendergast returned. He enrolled at Julian's, and when Henri opened an atelier on Montparnasse that same year, Logan took lodgings in the building and became one of his pupils. All of them became regular visitors to Concarneau and le Pouldu in the summers, and the Breton paintings of Henri and Logan of this period invite comparison (cat. 46, 54). The *pochade* and *ébauche* of prior days had become the end product in many cases, immediacy being prized in its own right. The employment of photography as a compositional aid was common, and it is instructive to contrast Logan and Theodore Robinson compositions based on photographs (cat. 52, 87; fig. 14, 20). Both favor surface pattern with close figures, but each choose an image quite different and deal with it in his own way. Logan's is a frontal close-up, right in the image, with no proscenium frame, and no more depth than a Gallo-Roman relief. Robinson takes the Japanese high vantage point that eliminates horizon and lets the zig-zag pattern of the boats achieve the same efect, but their brush-work is very different. Robinson adheres to the square brush and painterly technique of Bastien, while Logan trowels on his paint like a paste.

Childe Hassam is one Bostonian who embraced

Impressionism with sensitivity to its goals and with command of its methods. A student of Boulanger and Lefebvre at the Julian in 1886, Hassam remained in Paris long enough to see the Salon and World's Fair of 1889. He was well represented with paintings in the American section of the Exposition, and was noticed in the press as an up-and-coming young painter of city streets and roof-tops. While touring the American section of the Exposition he came across Edward Simmons extolling a picture by Alexander Harrison to a group of Americans, one of the medaled paintings in the show. Hassam later painted with both Harrison and Simmons in America, and exhibited with them, but in 1889 there was no connection between his work and theirs.

Hassam's painting developed under the many aspects of international Impressionism – the bright divisionist color of Monet, solid draftsmanship of Gustave Caillebotte, solid structure and texture of Pissarro, and the Mediterranean light of Giuseppe De Nittis and Boldini. Of all of the Americans to absorb Impressionism, Hassam is one of the most eclectic and thorough, remaining true to it tenets throughout his life, although he liked to see his roots in English painting. Why not, since Impressionism can trace some of its roots to Constable and Turner? Hassam was again in France in 1897, looking over the rooftops of Pont-Aven from the heights above the Bois d'Amour and down on busy roads, selecting vantage points favored by Impressionists (cat. 58). One extra-

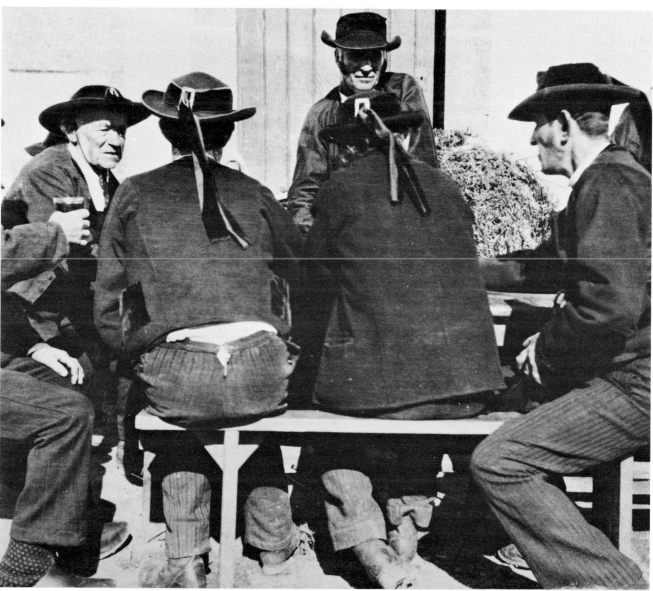

*Figure 14.* Bretons Drinking, c. 1900. Logan was a fine photographer and frequently based his painted composition on instantaneous images he recorded with the camera.

ordinary painting done at Pont-Aven, where he must have stayed for considerable time, is of a couple seated under the old tree outside the ancient chapel of Trémalo, which housed the image made famous by Gauguin in his *Yellow Christ* (cat. 57). It is drawn with the brush in pure hues suggesting the manner of Van Gogh and Neo-Impressionist techniques, which are not tendencies Hassam cultivated on his return to America, where he reverted to the looser mode of direct Impressionist record of effect. By then the Pont-Aven School, and Gauguin and Van Gogh in particular, were linked together in legend in discussions around the petits verres at the Gloanec and Hotel Julia. Hassam might well have been stimulated to go beyond Impressionism in Pont-Aven in 1897,

but in his later works he retreated to safer ground. This is not uncommon at the time. John Sloan, for instance around 1893 was closer to the avant garde than he was for the rest of his long life.

Not long after painting in Pont-Aven, Hassam returned to New York. There he joined his friends John Twachtman and Alden Weir in enlisting Willard Metcalf, Edward Simmons, and other friends to exhibit together outside the Society of American Artists, whose aims had become so identified with, and its membership so duplicated by the National Academy of Design that they soon merged. In 1898 the rebellious friends exhibited together in New York and were dubbed ''The Ten,'' firmly establishing Impressionism in America.

*Figure 15.* Postcard view looking toward the hills to the north from the terrace of the Hotel Baudy, c. 1900.

*Courtesy Jean-Marie Toulgouat*

# Giverny, 1887-1900

The term *Impressionism*, as it is applied today, has a very explicit origin in derisive criticism leveled at a group of artists exhibiting together in Paris in 1874. Intended as an insult, the label "Impressionist" gave the name to the group that had called itself the *Société Anonyme*. The origins of the style – or styles – that came to be known under that name go back to the beginning of the period under consideration, and its development and ultimate triumph weaves a thread throughout. Whistler and Pissarro came to Paris in the same year. Monet, Sisley and Renoir studied together with Ridgway Knight in Paris, and Whistler painted seascapes with Monet and Courbet. Mary Cassatt, who is the only American who can claim to be a true Impressionist, in that she actually did belong to the group to exhibit under that name from 1878, arrived in Paris in the same year that Robert Wylie became the center of the small group of American artists at Pont-Aven. Realism, the aesthetic movement and "art for art," Hokusai and the Japanese print, photography, and the rediscovery of John Constable and Turner by French artists seeking refuge from the Franco-Prussian war in London all played a part in the evolution of Impressionism.

Impressionism was anathema to academic artists. It challenged all of their tenets on line, contour, tonal modeling of form, perspective, and content and composition. J. Alden Weir's attitude, already cited, on his visit to their exhibition of 1877 was typical. Their work seemed undisciplined, unskilled, unschooled, and garish – atonal, without values of any sort. It abolished drawing in its most commonly accepted sense and black from the palette, which is what most offended academic artists and a public conditioned to academic representation. For Eakins and other old Gérôme students to paint without black was like playing music without bass notes. In Impressionist theory, the value scale from black to white did not exist. Black was absence of color – blindness, absolute absence of light. Admit light and you admit color. Complementary color, the retinal response to light was nothing new. Goethe had described and demonstrated it around 1800, and Turner picked it up from English translations of Goethe's color theories in the 1840s. By the 1870s color in shadows as seen out of doors in the sunlight was thoroughly understood and *plein-air* painting was on the rise. The typical plein-air painter selected a gray day, avoiding direct sunlight. The envelope of even light eliminated strong contrasts of light and dark as well as of color. Harmony in value from light to shade, but no deep shadow, permitted transcription of nature's local colors without adding black below the middle of the value scale. The typical Impressionist painter revels in the complementary colors in shadow "demanded" of the retina by the more intense color of the adjacent area illuminated by the sun. Form and mass and local color dissolve and black does not exist – theoretically neither does white, but theories are seldom tyrannical in art.

Edgar Degas, of all of the Impressionists, had the disciplined academic education that Whistler lamented having missed. He remained the greatest draughtsman of the group and had an immense influence on the development of Synthetism and the Nabis. He formed a close relationship with Mary Cassatt, whose style developed under his guidance (one wonders whether she would have come to the same result had she been accepted as a student of Gérôme). That Mary Cassatt does not figure in this exhibition or study is only because she does not seem to have worked within the geographic limits under consideration. While she did visit Monet at Giverny, and sat with Cézanne at the common table at the Hotel Baudy, unlike Cézanne, she does not seem to have painted during her visit.

For Americans, it was the Impressionism of Monet that became synonymous with the term Impressionism, the sort of Impressionism that he fixed upon in 1874 while painting with Manet and Renoir in Argenteuil. Both Renoir and Manet also became the objects of inspiration for Americans, but at a somewhat later date, and Monet was the one most widely emulated by Americans. Although he did not teach, since he said he painted only what he saw, it is quite natural that his admirers went to his motifs to see if they could see in the same way. By 1883 Monet had settled in the little village of Giverny, at the confluence of the Epte with the Seine on the border of Normandy. And it is there that Americans came in droves after 1887. If Honfleur and Argenteuil are the cradles of Impressionism, it was at Giverny that it was firmly planted in the mainstream of American art.

Giverny is a later colony than Pont-Aven and Concarneau, and like them has a small group of pioneers inseparable from its history: Theodore Robinson, Theodore Butler, Theodore Wendel, Willard Metcalf are the ones best known today, but there were others. Dawson Dawson-Watson, an early settler, refuted the common notion that it was Monet

who attracted them. According to him, none of them knew he lived there, and even in the second year of the American invasion he learned of Monet's presence only after six months. In 1888 he went to Giverny with John Leslie Breck of Boston, who told him that the previous year he and Robinson, Metcalf, Wendel and a few others from Julian's atelier were deciding where to go for the summer. Metcalf had been to Pont-Aven, and Robinson knew Grez and none wated to go to either, or to Écouen or Etretat. At Breck's suggestion they went to the railroad station and decided on a new place by selection from the timetables. At random they hit on Pont de l'Arche, and a few days later caught the train for their summer sketching as recalled by Dawson-Watson:

The train follows the River Seine practically the whole way. Just before reaching Vernon, Metcalf rose up and said, "Fellows, just look at that – isn't it lovely?" They all took a look and agreed with him. Then he said, "If we don't see anything better than that by the time we get to Pont de l'Arche let's come back and stay here." That was agreed upon. What had intrigued Metcalf so much was a little village of white houses and a Norman church at the foot of a fairly high plateau, seen through the poplars bordering the Seine and across perfectly flat fields. They arrived at Vernon a few minutes afterward and learned the place they had seen was Giverny. After a short wait they took the train en route for Pont de l'Arche and again to their astonishment they saw Giverny until they realized they had come down one bank of the Seine and they were going back across country to Pont de l'Arche, and so got a second view of the beautiful setting of Giverny. They stayed the night at Pont de l'Arche and as they had seen nothing better or even anything so good in their

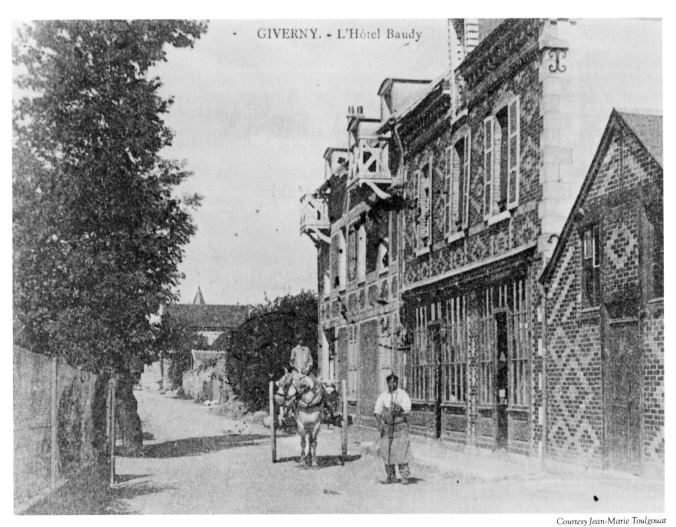

GIVERNY. - L'Hôtel Baudy

*Courtesy Jean-Marie Toulgouat*

*Figure 16.* Postcard view looking west on the high road to Vernon, c. 1900. The distant church tower marks where the Monet-Hoschedé-Butler family lie buried. On the left is the fence of the tennis court overlooked by a balcony from which Cezanne painted several pictures in 1894.

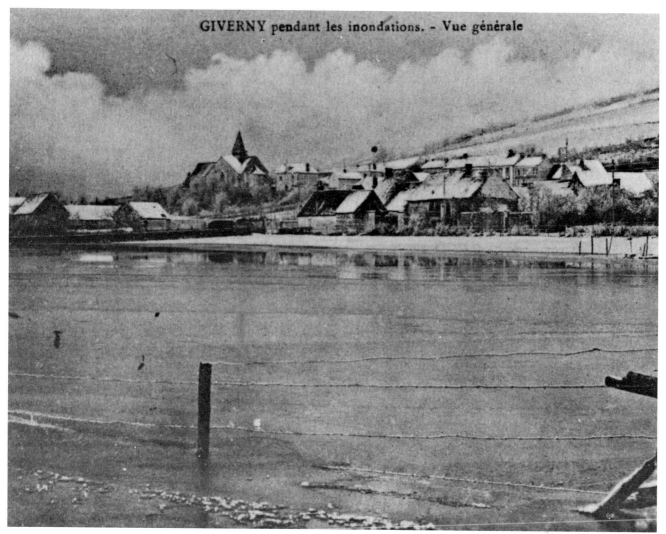

GIVERNY pendant les inondations. - Vue générale

*Figure 17.* Postcard view of Giverny during the winter flood of 1910.

unanimous opinion as Giverny, back to it they went in the morning.[151]

According to Dawson-Watson it was Breck who broadcast the charms of the village with the intention of making an art colony out of it. "Robinson strenuously objected," according to Dawson-Watson, "saying that they had found a lovely spot and should keep it to themselves. Breck's reply was everyone had been so damn nice, he wanted them to reap some real financial benefit." So, the process described by Simmons and Swift, writing about Cornwall and Pont-Aven, was accelerated in Giverny by Breck. Since there are very strong traditions that have come down in Giverny that Robinson had been there earlier, one wonders if his objections to Breck's proposal shrouds a prior awareness of the village and Monet's presence. In any case, in 1887 the die was cast. The Hotel Baudy – or the "Bawdy" Hotel, as it was soon to be dubbed by inmates – was founded. Alas for Monet,

who found himself not only surrounded by Americans, but also near a tennis court that was apparently in constant use, weather permitting. Dawson Dawson-Watson, who went to Giverny in the summer of 1888 with the intention of staying two weeks, found it so pleasant that he remained five years. The following year the English painter William Rothenstein was brought to Giverny by Henry Prellwitz; the Baudy register shows them both there in December, 1889 and January:

> During my first winter in Paris I was taken by an American friend to Giverny, a village near Vernon, famous now as the place where Claude Monet lived and painted, and where he died. I had never before been in the country during the winter; nor indeed among villagers. A new aspect of life was opened to me. There was a pleasant inn at Giverny, kept by Monsieur and Madame Baudy. The little café was fitted with panels, half

of which were already filled by painters who had frequented the inn; and there was a billiard room whose white plastered walls had also tempted them. I, too, tried my first mural decoration on one of its walls, the subject forsooth! a man hanged on a gallows. Attached to the inn was a typical village shop, where I purchased a pair of wooden sabots – not altogether an affectation, for sabots make useful wear for painting out-of-doors, especially in winter...

I know nothing so exhilarating to the spirit as painting out-of-doors. Indeed, I often wonder how anyone can feel the full beauty of a landscape unless he has tried to paint it...This winter at Giverny is unforgettable. I had never before realised the beauty of winter landscape, the shapes of the bare trees, and the austere contours of the fields. It was the first of many visits. For the heat of the studios at Julian's, after a few weeks, became unendurable, and a few days at Giverny were a respite from this.[152]

Five years after the founding of the Hotel Baudy, Will Low visited Giverny. He was a veteran of the colonies of Grez and Barbizon, and had known Robinson there and in Paris, along with Carroll Beckwith, John Sargent, and others associated with Giverny. "Tradition rules that all such communities must have 'a master, a pontiff of the arts' Claude Monet...filled that responsible position," Low said of art colonies, adding that Monet was much perturbed by his popularity in the summer of 1892, "and secluded himself behind the gates of his beautiful garden, or ventured into the meadows, which had been his own undisturbed painting ground for a number of years, at an early hour of the morning when their precincts were not dotted over by the sketching umbrellas of the fair invaders." The American invaders were not only foreigners, but women, as Low recalled:

My friend, Theodore Robinson, had been a pioneer in the American invasion, which, upon a brief visit paid him there, I found to be in possession of the village inn. In my student days the young woman votary of art had made but a timid first appearance in Paris, and the leaf-embowered artistic haunts of Fontainebleau knew her not. In the interval that had elapsed since then, however, she had come in numbers so largely plural that the male contingent at Giverny was greatly in the minority. Giverny, as a hamlet struggling along an unshaded road, offers at first glance little that is picturesque...Its greatest charm lies in the atmospheric conditions over the lowlands, where the moisture from the rivers, imprisoned through the night by the valley's bordering hills, dissolve before the sun and bathe the landscape in an iridescent flood of vaporous hues, of which Monet in his transcripts has portrayed the charm – a beauty which escaped most of the anxious neophytes who were (in the vernacular) "camping on his trail" in the summer of 1892. At a later period when the first vogue of Giverny had departed, and the hamlet had resumed more of its material quiet, I have found the place to be pretty and peaceful, but at the time of my first visit, I own that I should have chosen other adjectives to describe it.

I have already described the Anglo-Saxon invasion of Barbizon, but the imposition of our manners and customs, which were not altogether those of our respective countries, was confined to an assumption of entire freedom, to dress, to act, and to speak as we pleased among ourselves, and there was in other respects, in all our dealings with native guests at the inn or with the painters or peasants of the village, an acceptance of their speech and conformity to their traditions. Above all, none of us would have been so hardy as to interfere with the *cuisine* of Madame Siron, nor, knowing that lady in her prime, could I believe that any such iconoclast would have lived to tell the tale, if he had so dared.

But at the first meal of which I partook at Giverny, Boston baked beans were served! Poor patient Madame Baudy had concocted, under the direction of one of her guests, a *version Francaise* of this dish at which the codfish on the State House above the Common would have blushed, but the presence of its pretence at her board was sufficient evidence that the Philistines possessed the land.

So much Robinson confessed; he, the pioneer who, in company with two others, had "discovered" Giverny a few summers before and who now contritely owned partial responsibility for the feminine invasion, as he had unguardedly recommended the place to one or two young women painters in Paris. Next to Monet, he was, indeed, the painter they most looked up to, all these numerous and charming would-be impressionists; but he was so ungallant as to shun their society, having a room in the village, away from the hotel, deserting the *table d'hôte*, and taking his meals in the little cafe fronting on the street, which, serving as a drinking place for the peasants, was comparatively free from the invasion of the

gentler sex.

The *table d'hôte* was, in fact, a bit of transplanted American seaside or mountain summer resort in midweek, when the men folk are busy with their affairs in the city. There were some thirty painter-esses of various ages; and if there were four or five painter-men present they were so out-numbered, and virtually in the shade, that my memory is equally shadowed as to their personality. It was a strange scene to find on the border of Normandy, where every visible surrounding spoke of France, and where the spoken word was alone and exclusively English. With the conversation, however, the resemblance to a summer resort at home ceased, and with the *toilettes* as well, a Francaise at my elbow reminds me.

The conversation was largely technical, "colour values," "vibration," "decomposition of tones," "the orange light and the purple shadow," was the burden of their song; and where we, old stagers at Barbizon, had talked of Rousseau, Corot, and Millet, with an afterthought of the Louvre, of Velasquez, Titian, or Veronese, these up-to-date young women were exclusively preoccupied with Monet, and an occasional reference to some picture in the last Salon...

In another year or two the sudden wave of popularity deserted Giverny, and the bevy of student-esses deserted the meadows, and the hill slope saw them no longer, though the village is by no means deserted by its artists, and since those

days I have passed a golden summer there, sheltered within garden walls in the gracious society of a *chatelaine* and two charming *filleules*. (cat. 111).[153]

Madame Baudy's guest register commenced in June of 1887, and in the following twelve years almost seven hundred visits are recorded, with place of birth, age, and profession. The great majority lists "painter" for profession, but there are a number of architects (Pope, Codman, Wheelright) and sculptors (Stewartson, MacMonnies, Calder). The painters range from the well known to beginners (like Kenyon Cox and Augustus Tack), the best known being Paul Cézanne, who stayed for three weeks in 1894.[154] Among the first twenty-five names are Robinson, Harrison, Breck, Dawson-Watson, Butler, Theodore Wendel, Philip Hale, and Prellwitz. Metcalf, already housed elsewhere, does not appear in the register at all, so even that volume of visits to the village cannot be considered comprehensive, and this register covers only half of the period under consideration.

In measuring the influence of Monet and Giverny on Americans, it is only necessary to look at work done on arrival by some who later became completely associated in our consciousness with Impressionism. Willard Metcalf's *Ten Cent Breakfast* and Philip L. Hale's *Ornithologist* (cat. 82, 81) were both done in their first year there, and are anything but Impressionist. Theodore Robinson's first works are straight out of the *plein-air* figure tradition, and except for the loose brush-work learned from Carolus-Duran are comparable to the sort of thing being done by Chester

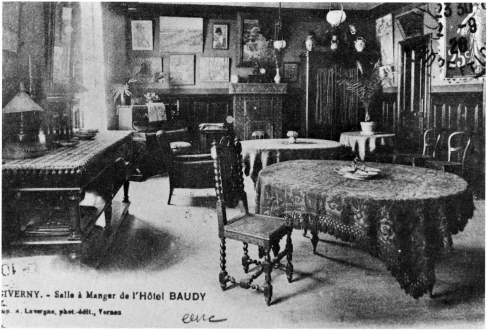

GIVERNY. - Salle à Manger de l'Hôtel BAUDY
ap. A. Lavergne, phot.-édit., Vernon

*Figure 18.* Postcard view of the dining room of the Hotel Baudy. The large canvas at the upper left is one of Theodore Robinson's landscapes painted from the hills looking towards Vernon.

*Courtesy Jean-Marie Toulgouat*

*Figure 19.* M. and Mme. Ledoyen and their daughter Angelina about 1880. Angelina married Lucien Baudy, and in 1887 founded the Hotel Baudy at Giverny.

Loomis, Ridgway Knight and Charles S. Pearce (cat. 77, 75, 78). Metcalf's *Ten Cent Breakfast,* inscribed "Giverny 1887," is an interesting record of personalities intimately involved with the American art life of the period. It might well have been worked up in Giverny from studies done over a period of months or years (a very un-Impressionist thing to do). Metcalf knew John Twachtman, Robinson, and Robert Louis Stevenson, who long have been identified as the models for the figures seated, left to right, and both Reginald Birch and Birge Harrison, either of whom might be the standing figure.[155] Twachtman had left for America the year before, so the painting was either long in the making and finished in Giverny, or done in the studio from sketches. The dark interior, with its several artificial light sources is not unlike similar compositions by Monet in earlier

years, before Impressionism, almost twenty years before Metcalf's picture. Metcalf's lively sketches from his Pont-Aven trip in the summer of 1884 show that he was adept then at plein-air tonalities and motifs, and could capture the character of individual gesture and posture. At Julian's he studied in the atelier of Boulanger and Lefebvre, and was a part of the circle of Robinson, Wendel, and Louis Ritter. Before going to Giverny he had sketched at Grez, the favorite haunt of the Tonalists. So the *Ten Cent Breakfast* can stand for the sum of his accomplishments to 1887, and it is a very fine painting. Whether or not it actually represents the dining room at the Hotel Baudy is another question. There are few identifying features, and the new artists' haunt had not yet acquired any of its characteristic examples of art work for the walls. Metcalf himself was staying at the Ferme de la Cote, a nearby farm.

Two things apparently acted to lighten Metcalf's palette. After the summer in Giverny in 1887 he went to Tunis and Morocco, where he painted in the light that had been a factor in developing the visual sensibilities to color and light of such diverse artists as Eugene Delacroix, Frederick Bridgman, and Monet himself. In 1888 he painted again in Giverny, won the requisite honorable mention in the Salon for one of his north African paintings, and went back to New York in 1889 with his credentials as an artist. Sometime in between returning to New York and painting his *Ten Cent Breakfast,* Metcalf discovered Monet and Impressionism. If Dawson-Waston is to be believed, it was not until well after arriving in Giverny that Monet was discovered to be in residence behind the walls of his garden. In any case, Metcalf's palette lightened, his brushwork took on more of the dab than the *tache,* and he joined the ranks of Impressionists (cat. 83, 84). The last works in Giverny are not yet as fully committed to the Impressionist color and surface texture as later works in Connecticut, so Metcalf continued his development along the lines of Monet through continued contact with his fellow Americans in the United States, and the works of Monet that were increasingly available in museums and galleries in America.

Philip L. Hale also became, like Metcalf, a convinced and honored Impressionist. Son of Boston's well known minister and literary figure, Edward Everett Hale, he left Harvard to study at the Boston Museum School and Art Students' League before coming to Paris to the Académie Julian with Lefebvre in 1887. He stayed the summer at the Hotel Baudy in 1888 when he painted the *Ornithologist.* Since Metcalf was an ornithologist, one imagines a common interest

in the subject; Hale certainly does have in common with the early Metcalf work from Giverny a good indoor studio composition and illumination. Only in the peep through the window at the sunlit foliage is there a hint at his later work. In other words, it appears evident that Monet was not in 1887 and 1888 a cult figure drawing imitators.[156] This is significant in assessing his actual impact in Giverny.

In 1888 Monet did draw a visit from his friend of many years John Singer Sargent, and it is regrettable that no paintings from this visit to Giverny were available to the exhibition for direct comparison with the *Oyster Gatherers of Cancale*. In the interim Sargent had been to Madrid to study the works of Velasquez and grown away from the Neopolitan light of Michetti, and under the influence of Velasquez had painted some of his greatest works. With Monet in his garden he regained a brilliance in outdoor sunlight effects more in keeping with the French example, but, like Whistler painting Courbets in Trouville, still painted Sargents in Giverny with Monet.

Theodore Wendel met Monet when he was still receiving invaders cordially, the Wendel family tradition has Monet speaking highly of his landscape painting. It is interesting to compare Wendel's Impressionism at Giverny with that of Metcalf. Both get much looser, lighter, more Impressionist, but each reveals something still of his previous work, Metcalf for his Barbizon plein-air tonalism – painting in the filtered light of evening – and Wendel for the broad juicy paint of Munich applied to toned canvas. Yet both approach the same end, and each can claim the name Impressionist.

Wendel was an ebullient entertainer, and from his circus days could juggle while playing the harmonica, talents which were certainly called upon over *petits verres* at the Baudy café. He was as gregarious as Arthur W. Dow was reserved, and although it would be nice to think of the two veterans of days with Monet at Giverny and Gauguin at Pont-Aven rubbing elbows, if not bending elbows back in Massachusetts, such appears not to be the case. They lived most of their later lives practically within sight of each other in Ipswich without having, or apparently wanting to have anything to do with each other.

Among the paintings still in the possession of the family of Mme. Baudy are several by John L. Breck, who perhaps more than anyone was responsible for the American occupation of Giverny (cat. 94, 95). Two works here are from 1888, the year he first registered as a guest and stayed a year and a half at the hotel. One of Gaston Baudy in the hotel cafe shows it

before the walls were decked with examples such as this one. In later years, it would be lined with souvenirs of artist visitors. There were many casual visits by artists over the years. The names of Mr. and Mrs. Kenyon Cox, Mr. and Mrs. A. Sterling Calder, Mr. and Mrs. Thomas Dewing, and many others including Mr. and Mrs. Carroll Beckwith appear in the register. The latter stayed only a month in the summer of 1891, but Beckwith left a portrait of Breck as a memento for the hotel (cat. 93), showing Breck as he appeared about the time that Monet discovered his romance with one of his step-daughters, Blanche, and strenuously and definitively intervened; Breck departed for home.

Monet had cordial relationships with many of the Americans who sought him out at the beginning, and Sargent and Cassatt were old friends. But the invasion of his privacy was bound to tell upon him, and he became aloof and selective in his contacts with newcomers. Theodore Robinson, with whom he had been friendly from the beginning, is the one painter most Americans associate with Monet at Giverny, although Robinson's documented presence there was over the span of only five years from 1887 through 1892, during which he traveled elsewhere in Europe and regularly returned to the United States. His name in the Baudy register is the first of an American painter (from September 18, 1887 through January 4, 1888). He registered again from May 19 through September 3 in 1890, but usually took lodgings or rented a house in the village to preserve his own privacy. Robinson was plagued from childhood by severe asthma, which eventually brought him to an early grave in 1896 at the age of forty-four, but his disability did nothing to hamper his *joie de vivre*.

Raised in Wisconsin, Chicago and Denver, Robinson had come to New York in 1874 for two years of study at the National Academy of Design, and in 1876, left for Europe. He first studied with Carolus-Duran, and in November 1876 entered the atelier of Gérôme just a few days after Frank M. Boggs (cat. 67). During the following three years in Europe, Robinson managed to get into contact with every main current of modern art before Impressionism, and he could hardly have been unaware of the Impressionist exhibitions then rocking the Paris art world. On arrival in Paris, he had sought out Will Low, who he joined for the summer of 1877 at Grez-sur-Loing, the last summer before Grez was, in Will Low's words, "finally abandoned by its 'discoverers'; after which it had a brief popularity, until a magazine article effectually spoiled it by bringing hoards of 'tourists' – the usual sign for the departure of the

*Figure 20.* Two in a Boat, c. 1891. The photograph is squared off for the transfer of the composition to Robinson's canvas. Photograph by Theodore Robinson.

artists.''[157] Then in 1879, before returning home, Robinson met the Duveneck Boys when touring in Venice, where he became friendly with Whistler. Thus, Robinson had a good cross-section of what was going on among the Beaux-Arts, Barbizon, and the Munich studios, as well as in the independent and cosmopolitan world of James Whistler when he returned to the United States. He was able to get employment assisting John La Farge in decorative design projects in Tarrytown and New York, and perhaps in Boston, and had saved enough to return to France in 1884.

When Robinson went with Breck, Metcalf, and the others to Giverny to paint, he was still by no means committed to Impressionism. *La Vachère,* (the final large version of which is dated 1888; Baltimore Museum of Art) is fundamentally a plein-air painting of the Bastien-Lepage sort in motif, composition, value and color. Studies and variants indicate that the composition might have been in progress for over a year. Thus, it reflects the same state in his own development as Metcalf's *Ten Cent Breakfast* (in which Robinson is portrayed along with his old friends) and Hale's *Ornithologist* do in their development. None were Impressionist paintings. Robinson's *Two in a Boat* (cat. 87) was done in 1891 and has the values of the plein-air painter, but the perspective favored by the Impressionists under the influence of the Japanese prints Monet himself collected. It is done with the aid of a photograph (fig. 20) – selectively used. It is not a direct impression. The red toned canvas gives an atmospheric unity, but it is not Impressionist.

Robinson did attack the Impressionist problems

of light effects at different times on identical subjects, however, and he did many views from the heights behind the Hotel Baudy looking over the valley and the village (cat. 85), some of which hung in the hotel. Robinson knew Monet's *Haystacks* and saw the *Rouen* series in progress, and he more than anyone enjoyed a casual student-master relationship with Monet. In June 1892 he started a landscape series of a view towards Vernon which came as close to Monet as anything he did: "I had two canvases – worked on the first – grey for an hour, then the sun began to come thro' giving me a chance on the other." A few days before that he had commenced one of them: "Grey day beautiful and still – effect changed rather little for 2½ – 3 hours. Charming – but the sunlight with floating shadows I find moreso." And in September his diary indicates: "A call from the Master who saw my things – he liked best...the one I tho't nearest my ideal – he said it was the best landscape he had seen of mine – he liked the grey – the other sunlight one less."[158]

The painting which more than any other synthesizes Robinson's Giverny experience is the brilliant little record of the day Suzanne Hoschedé, Monet's step-daughter, married Theodore Butler: July 20, 1892, "a great day." Robinson recalled:... "The wedding party in full dress – ceremony first at the Mairie – then at the church. Monet entering first with Suzanne. Then Butler and Mme. Hoschede – a considerable feeling on the part of the parents – a breakfast at the atelier lasting most of the afternoon."[159]

With the spontaneity of a true Impressionist, Robinson painted his *Wedding March* (cat. 88). Like a studio painter, however, he began it two weeks later, "my model being the groom's silk hat, lent me by Gaston (Baudy)." The hat was extremely important to establish the value of the darkest dark, and of dead-black in the open sunlight close to high noon. Given the availability of the street, passing figures, and summer sunlight, the rest was probably easily accomplished under various noonday suns. The result is a happy success, and a wonderful record of an important day for American Impressionism.

Boston saw what was happening in Giverny in a combined exhibition of the work of Theodore Wendel and Theodore Robinson shown in 1891 – so Boston like Philadelphia was being assaulted by the *"blue bug* craze" of Impressionism. Shortly after painting the *Wedding March*, Robinson returned to America. He took over Robert Vonnoh's classes at the Pennsylvania Academy in 1895, commuting from New York. The strain on his frail health probably contributed to his death in the spring of 1896.

Two American painters of very different background and character lent continuity and cohesion to the American artist colony at Giverny: Theodore Butler and Lilla Cabot Perry. Butler remained, except for relatively brief excursions, throughout his life. The Perrys were intermittant summer residents over a period of twenty years from 1889 to 1909. Lilla Perry is the first instance known to this writer of an artist specifically drawn to Giverny because of Monet:

> How well I remember meeting him when we first went to Giverny in the summer of 1889! A talented young American sculptor told my husband and me that he had a letter of introduction to the painter, Claude Monet. He felt shy at going alone and implored us to go with him, which we were enchanted to do, having seen that very spring the great Monet-Rodin exhibition which had been a revelation to others besides myself. I had been greatly impressed by this (to me) new painter whose work had a clearness of vision and a fidelity to nature such as I had never seen before. The man himself, with his rugged honesty, his disarming frankness, his warm and sensitive nature, was fully as impressive as his pictures, and from this visit dates a friendship which has led us to spend ten summers in Giverny. For some seasons, indeed, we had the house and garden next to his, and he would sometimes stroll in and smoke his after-luncheon cigarette in our garden before beginning on his afternoon work.[160]

The Perry family stayed in Giverny that summer of 1889 from June 20 through most of October, and among the dozens of American artists at the Hotel Baudy with them during the same period were Robinson, Prellwitz, Dawson-Watson, Ernest Peixotto, Parton, and William "Peggy" Hart. Frederick MacMonnies, the sculptor most closely associated with Giverny, could have obtained a letter to Monet from John Singer Sargent, who he knew. But MacMonnies and his wife, the painter Mary Fairchild, do not appear in the hotel register until the following summer, and MacMonnies was not shy. The only talented young sculptor registered in the summer of 1889 was Edward A. Stewartson of Philadelphia, who did not long outlive the experience. It must have been he who invited the Perrys to visit Monet with him.

For Monet it was a good relationship professionally as well as personally. The Perrys shared his interest in Japan. Indeed, Tom Perry whose grand-

73

uncle was Commodore Perry, held a professorship of English literature in Tokyo between 1898 and 1901. His sister was the wife of John La Farge. Professor Thomas Sargeant Perry and his wife Lilla Cabot were well rooted in Boston and very much a part of the cultural elite there. Although a new student at Julian's and Colarossi's schools in Paris, Lilla Perry had studied with both Dennis Bunker and Robert Vonnoh at the Cowles school in Boston, so would have had first hand information about the latest trends in plein-air and Impressionist painting in France even before coming. She was also over forty, so her promotion of the work of Monet in Boston would find a ready and mature audience – but the hold of Barbizon on Boston was strong:

[Monet] was not then appreciated as he deserved to be, in fact that first summer I wrote to several friends and relatives in America to tell them that here was a very great artist only just beginning to be known, whose pictures could be bought from his studio in Giverny for the sum of $500. I was a student in the Paris studios at that time and had shown at the Salon for the first time that spring, so it was natural that my judgment should have been distrusted. Only one person responded, and for him I bought a picture of Etretat.

Monet said he had to do something to the sky before delivering it as the clouds did not quite suit him, and, characteristically, to do this he must needs go down to Etretat and wait for a day with as near as possible the same sky and atmosphere, so it was some little time before I could take possession of the picture. When I brought it

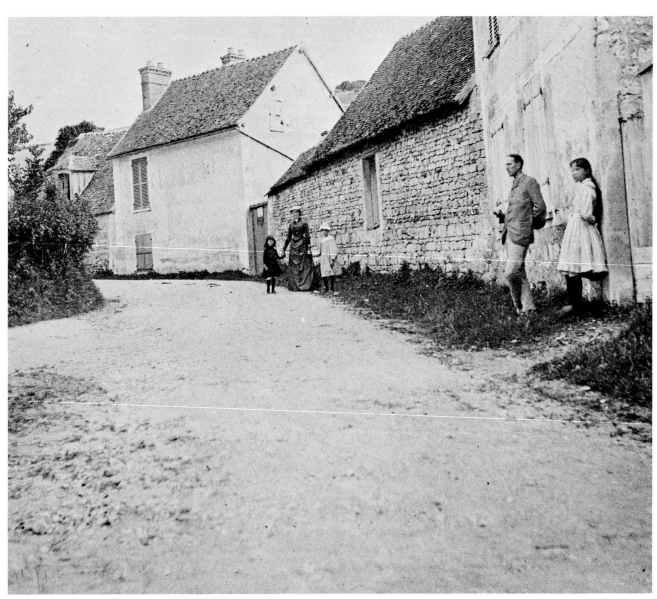

Figure 21. The Perry Family in Giverny, c. 1890. Photograph by Theodore Robinson.   *Courtesy Hirschl and Adler Galleries, Inc.*

74

home that autumn of 1889, ... to my great astonishment hardly anyone liked it, the one exception being John La Farge.[161]

Cecelia Beaux was a contemporary of Perry in the schools of Colarossi and Julian, but had left France by the time the Perrys first visited Giverny. Returning to France in the summer of 1896 after an absence of some years she contacted her friends. "Lilla Cabot Perry was painting at Giverny, to be near Monet, and would take me to see him."

No sun and weather could have been more fortunate for a visit to the specialist in light than we were blessed with. We found him in the very center of "a Monet," indeed: that is, in his garden at high noon, under a blazing sky, among his poppies and delphiniums. He was in every way part of the picture, or the beginning and end of it, in his striped blue overalls, buttoned at wrists and ankles, big hat casting luminous shadow over his eyes, but "finding," in full volume, the strong nose and great grey beard. Geniality, welcome, health, and power radiated from his whole person. There was a sleepy river, lost in summer haze not far away. The studio, which was a barn opening on the garden, we were invited to enter, and found the large space filled with stacked canvases, many with only their backs visible. Monet pulled out his latest series, views, at different hours and weather, of the river, announcing the full significance of summer, sun, heat, and quiet on the reedy shore. The pictures were flowing in treatment, pointillism was in abeyance, at least for these subjects. Mrs. Perry did not fear to question the change of surface, which was also a change of *donne*. "Oh," said the *Maitre*, nonchalantly, *"la Nature n'a pas de pointes."* This at a moment when the *haute nouveauté* seekers of that summer had just learned "how to do it," and were covering all their canvases with small lumps of white paint touched with blue, yellow, and pink.[162]

Those Americans who had entrée to the Monet household were privileged to be among the first to see Monet's works in progress, and to see unbroken series in the studio before they were ever exhibited or sold apart: river, haystacks, poplars, and the great Rouen Cathedral. For those especially blessed, Monet's personal collection of his own early work, and that of Corot, Daubigny, Delacroix, Sisley, Degas, Cézanne, Rodin, Pissarro, Renoir, Berthe Morisot, and the Japanese prints might be admired. Anyone familiar with the circle of Monet might find himself seated at the Baudy Hotel with Cézanne, or

meet Rodin, Sisley, Pissarro or Renoir on the road. This, of course, was exactly the time when Sérusier brought the *Talisman* back to the Julian proclaiming Synthetism, and when the Synthetist-Symbolist group around Gauguin was painting thick outlines around their unbroken color shapes in le Pouldu, renouncing Impressionism.

Theodore Butler was a good friend of the Perry's. He and Tom used to make frequent excursions together in the area or to Paris, visiting exhibitions and restaurants. "Paint - man - paint!" was Butler's motto, his exhortation to Philip Hale in Boston, when the latter got so involved with theory and bogged down with teaching that he could not paint. Butler was the only one of the original colonizers to settle and stay in Giverny and continue painting. For whatever reason Monet found Breck unacceptable, Butler overcame opposition and married the "Boss's daughter," so to speak. To legitimize his own part in the ceremony, once the inevitable was accepted, Monet quietly married Suzanne's mother, Mme. Hoschedé. The Butler procession from the Mairie to the church was celebrated in the aforementioned painting by Theodore Robinson. It was a short but happy union, ended in 1899 by Suzanne's early death. In their seven years of devoted marriage they had two children, James and Lili, who figure in many of Butler's paintings (cat. 89, 91), and they had built a house not far from Monet's.

The paintings by Butler selected for exhibition here are not typical in one sense. Butler was an avid landscape painter, and all of these are indoor and figure motifs. His landscapes over the years were many, and varied. He was not a copier of Monet, and believed that it was better to go ahead and fail than be afraid of failure. To Hale he wrote in 1903: "Do you remember where we used to walk after dinner in '88 - down towards Vernon? I have been there of late - good country for me. I have a couple of canvases of willows, rolling ground and Vernon in the distance. Very tasty. I painted a couple of cows also in a poppy field which was a screaming failure - one of the cows looked like an inflated bladder painted a most uncowlike red."[163]

Hale was all tied up in preliminary sketches, to the extent that he could not get beyond them. Butler's advice from Giverny could almost be the same as that which Fromuth wrote in his diaries at just the same time in Concarneau, and their example of how *not* to do a painting is their common friend Alexander Harrison - they called for spontaneity, emotion, intuitive possession of the subject not too worked over but thoroughly felt and expressed. Regardless of

the different ends reached, their attitude is modern.

Both Birge and Alexander Harrison were regular Giverny visitors, but one has the sense that they brought nothing new nor took anything from the experience as far as their art was concerned. Like Champney coming in 1866 to Pont-Aven, they were already fully formed and probably immune from new impulses, unlike Butler, who wrote Hale in America: "I was over to see Harrison last week – now there's a man who puts more or less earnest preliminary study in things and with what melancholy results – but a pleasant fellow. He had, however never heard of Cézanne. Well neither had I either a few years ago, but I've seen some pretty good things of his this winter and some – for me – as yet incomprehensible."[164]

If Butler was uneven, his successes are very fine. The three paintings of bathing the baby James, Lili at breakfast and the card players (cat. 92) were done between 1893 and 1898. All of them have in common the unorthodox high point of view so favored by Degas, all fill the surface with foreground figures, all have a bold brush-stroke and color sense, starting with the harmonious unity of the earliest one of James in the bath, to the glowing color combinations of the Déjeuner, and the almost Fauve vibrations of color of the Card Players. There are many elements that relate to the concurrent experiments of the Nabis and in particular to Bonnard, who himself made Vernon his home, and almost alone among Americans to Guy Maynard, thought to be so avant-garde by Mrs. Alexander in le Pouldu.

Most important to note is what has happened in Giverny between the arrival of the explorers in 1887 and Butler's painting of the Card Players barely ten years later. Compare the Ten Cent Breakfast of Metcalf and the Ornithologist by Hale with the paintings of their fellow explorer and colonizer Theodore Butler employing identical motifs. Then the extent of the revolution will be understood.

On the death of his beloved Suzanne, her younger sister Marthe assisted Butler with the household and the children, traveling with them to America in 1900, when Durand-Ruel gave him an exhibition in New York. Marthe and Butler were married not long after their return, and the Butlers remained an integral part of the Monet household.

# Giverny, 1900-1910

What does Whistler's Mother have in common with the nudes in Harrison's In Arcadia? Or, for that matter with MacMonnies' Bacchante? At the turn of the century they all could be seen together in the French National Collection at the Luxembourg, along with Manet's Olympia and the notorious Impressionist paintings from the recent Gustave Caillebotte bequest. Aside from that, however, both paintings had been well known in America in the 'eighties, and stimulated emulation or response from other artists. It was probably the challenge of Harrison that led Eakins to pose models naked in the Pennsylvania countryside in preparation for an Arcadian composition. The Arrangement in Grey and Black, as Whistler called his mother's picture, came to Philadelphia and inspired Ceceilia Beaux to base a large composition upon it in 1883, long before she went to France. Beaux recalled that her picture "was to be 'landscape' in form, and the figures were to be seen as if one stood over them."[165] By this she meant that the shapes were to flow across broad areas of the surface, seen close up, and without distant horizon, most easily achieved from that high vantage point. This is exactly the sort of effect that renewed contact with Whistler had, a few years later, on John White Alexander in his figure studies. Costumed figures become arrangements of shapes for their own sake. The nude figure, of course, was the one common object of study for all of the American artists admitted to ateliers in Paris.

A new generation of painters came to Giverny and combined "art for art" and the painting of the nude with Impressionist method and the new tendencies towards flat pattern. Whistler may well have had a substantial role in this. At the end of the century he was associated with MacMonnies in a Paris atelier, offering criticism to pupils, and there is no question that he had a new following at the end of his life. Still writing of his visit in 1892 to Giverny, Will Low recalled that, "Two or three years later, in art student circles in Paris, Whistler was 'discovered,' ...and then 'tonality' came to the fore, and the gorgeous palette of Monet was steeped in gloom."[166]

Not all of those who received criticism from Whistler muted their color. Frederick Frieseke and Richard Miller had the benefit of his advice, let alone example, and their approach to painting characterizes the figure work, clothed or nude, done by the "Gi-

verny Group" around 1910: i.e., posed in broad or open sunlight, seen as one stood over them and composed "landscape" in form. Tonality is indeed of renewed concern – or at least more consistency in value than is common in the broken color areas of Impressionism, but it is not the muted value of Velasquez. They flatten out color areas on the surface to a greater degree than Impressionism would admit, but they do not sacrifice the bright color, and do adopt the surface texture.

Perhaps it was the presence of the MacMonnies in Giverny that made it such a gathering place not only for artists of Impressionist inclination, but also for the so-called American Renaissance. Both Frederick and Mary Fairchild MacMonnies, who became regulars at Giverny from 1890, were artists who had worked on major projects for the Columbian Exposition, and in fact it had been due to the generosity of architect Charles F. McKim that MacMonnies had been able to study in Europe. His sculptural style is a personal blend of that of his masters, St. Gaudens and Jean Alexandre Falguière. He had commenced his studies as a painter in New York, and continued to paint in Paris and Giverny. His fame was assured in 1893 with the *Columbia Fountain*, located in the central lagoon of Chicago's Columbian Exposition, and the lifesize bronze *Bacchante*, which he presented to McKim for the courtyard of the Boston Public Library. It was immediately attacked for its "wanton, blatant nudity and drunkenness" in petitions and the press. What enfuriated some Bostonians most was not the lissomeness of the dancing young nude, but that her infant was obviously equally happy with the grape. It was removed. In 1896 an edition of it became the first sculpture by an American to be acquired by France, placed in the Gardens of the Luxembourg, and the artist was awarded the Légion d'Honneur.

The experience of Thomas Eakins in teaching from the nude in Philadelphia is well known, and when in America around 1900 MacMonnies triumphantly showed Cecilia Beaux a large and voluptuously painted reclining nude study he had just done, "Think of it!" he cried, "Think of doing that in Philadelphia!"[167] It was just this attitude – this difference between America and France that drew and kept this generation in Giverny. When young Gérôme student William De Leftwich Dodge, was working on his decorations for Richard Morris Hunt's cupola at the Columbian Exposition he posed one of his classically half-draped models in the full sunlight of Chicago, high up on the rooftop, and a strange silence descended on Lake Michigan. All

work had stopped as workmen strained their eyes in his direction. Close friends of the MacMonnies, the Dodges came to Giverny between 1898 and 1900. It was then that Dodge took to painting nudes in his garden, in classical subjects and motifs almost as thinly veiled as the models (cat. 110). The academically trained American artists, figure painters and sculptors, began the regular use of nude models behind their garden walls, standing, lying, or sitting nude in the sunlight. It did not take long for the American Impressionists in Giverny to follow suit. "Before MacMonnies and his wife bought their place in Giverny," Dodge's daughter recalled, "they had rented a house and garden there surrounded by a high wall. Here they painted all summer from a nude model in the sunshine against the aspen trees and a quiet little brook [the Rû]. Near them Isadora Duncan had also leased a house. Mrs. MacMonnies thought it quite absurd when she learned that the dancer rose early every morning and danced in the nude on the dewy grass."[168] She only saw her perform later, and understood her qualities. It somehow seems appropriate that Isadora should be dancing next to the sculptor of the *Bacchante*.

Models, of course, were imported from Paris. One vivacious young blond brought by Dodge was the subject of three of his paintings in 1900 including *The Music Lesson, Giverny*. She was dismissed by Mrs. Dodge for answering a knock on the garden gate naked, to find not an artist neighbor, but a stunned small town Presbyterian minister from Virginia clasping a letter of introduction from the artist's maiden aunt. In fact, this sort of thing would have been impossible in Pont-Aven, and the per capita population of garden nudes in Giverny was becoming extraordinary even in France.[169]

Frederick Frieseke first summered at Giverny in 1900. He traveled in 1901 to le Pouldu, and in 1903 did his first large scale outdoor figure painting in Moret. Lawton Parker of Chicago already had considerable success in academic portraiture, an honorable mention at the old Salon, and a background with Gérôme and at the Julian, when he heard of Giverny. He had continued studies at Colarossi and received criticism from Whistler at the end of the nineties, so he would certainly have known MacMonnies, Miller and Frieseke. In any event, he came to Giverny regularly from 1903 to 1913, called there expressly by the impulse to paint the figure in the open sunlight, draped or nude (cat. 107). Richard Miller also came regularly to Giverny to paint. In 1906 the Friesekes rented the house and garden near Monet's once occupied by Theodore Robinson, and he established his

own reputation for painting the nude and draped figure in both the light-bathed interior and in the open air. A painting of 1910 by Karl Anderson, older brother of the writer Sherwood, depicting Frieseke in his garden painting a nude is a fitting and delightful summation of the trend that is so identified with Giverny (cat. 108).

When Abel Warshawsky and Samuel Halpert, young art students in Paris visited Giverny in 1909, they found Karl Anderson and his wife at lunch in the fragrant garden of the Hotel Baudy, admired the small panels painted by Americans in the café, and the landscapes of Robinson in the hotel dining room. At the time they were painting across the river in Vernon:

We crossed the river to Giverny, three kilometers distant – a delightful little village, but somewhat wedged in between the hills and the creek-like Epte. The few hotels there were more expensive, and exclusively given over to an Anglo-American clientele of artists and writers, who had been coming there in increasing numbers, some as permanent residents, ever since Claude Monet, the celebrated Impressionist, had elected Giverny as his residence.

Monet himself, who was a good deal of a hermit..., kept aloof from this foreign colony...

Charming and picturesque as Giverny was, we did not hesitate in our preference for Vernon. Compared with the former, which appeared a little cramped and over cultivated, Vernon had a spacious unspoiled air....

At Giverny the majority of the American artists worked from the model, and I dare say they found the enclosed gardens and tiny river more conducive for figure work outdoors. Richard Miller had a summer class there, and Frederick Frieseke was painting some of his most delightful little nudes in his garden, through which the little Epte stream flowed. Sometimes he would do his figures standing in the shallows, or again it would be a gaily dressed girl in a boat, sheltered from the sun under a Japanese umbrella (cat. 107)."[170]

Before 1910 six American artists exhibited together as the Giverny Group at the Madison Art Gallery in New York: Frieseke, Miller, Parker, Edmund Greacen, Anderson, and Rose. None of them was born when Whistler painted with Courbet at Trouville, and few of them by the time Weir and Picknell painted with Wylie in Pont-Aven in the year of the first Impressionist Exhibition. Guy Rose and Edmund Greacen belong to the earlier style of Impressionist outdoor landscape in Giverny, and Rose

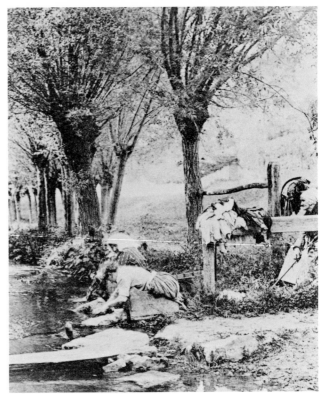

Figure 22. Postcard view of Giverny. This little stream was diverted by Monet to feed his water garden and flowed through the enclosed garden of the Vivier where Frieseke, MacMonnies and others posed their models in the open sunlight.

goes back to the early days of the colony. Rose was twenty-three when he first registered at the Baudy Hotel in 1891, came back in 1894, and again with a wife in 1899. They bought a house and became regular fixtures. His *Late Afternoon: Giverny* (cat. 102) emphasizes the atmospheric effects of raking light at a particular time of day. Greacen, a relative late-comer in 1907, picked up the broken color and granular surface that became so popular in America shortly afterwards (cat. 104). The others of the Giverny Group are more closely associated with figure painting. At the close of 1910 four of the group exhibited in New York, eliciting enthusiastic reviews that effectively summarize their position in the American art scene:

*The New York Telegraph*, December 21, 1910 ...A group of Americans living abroad (who call themselves the Giverny Group) are having an exhibition. There were originally six of these men, but now that Edmund Greacen and Karl Anderson are living and painting at home, there are only four. These are Lawton Parker, Frederick Frieseke, Richard Miller and Guy Rose. These intensely modern young men are better known abroad than in their own country. They paint

sunshine and shadows that are luminous, and they are not afraid to put a figure right out in the glaring light and paint it.

*The New York Herald*, December 21, 1910 …These brothers of the brush are often seen walking arm in arm in the streets of the French capital or dining in the same cafés. They paint in much the same style, usually using brilliant colors and employing a high key. Also they like to limn parasols with the light shining on them – gay parasols in gardens, held at bewitching angles by pretty young women. Three of these painters, Messrs. Miller, Frieseke and Parker, have contributed *In a Garden*, and it is interesting to differentiate between the diverting horticultural exhibits. Mr. Parker has sent to the show an exceedingly well painted nude, which he calls Sous Bois…

*The New York Post*, December 20, 1910 The pictures of the French and American Luminists at the Lotos Club would look actually dull in the company of some of the recent paintings of American Luminists at Giverny. …The total amount of sun to be found in the whole Lotos collection and more seems to have found its way into one picture at the Madison Gallery.

*The New York Evening Globe*, December 23, 1910 …All are fairly well known as men who long ago gave promise of a serious future, and it is entertaining to note that the first three [Parker, Miller, Rose] have, in the years, completely changed their style, choosing to throw their lot with the impressionistic school, or plein-airists, or whatever one may call them, differing entirely from the somewhat academic, low keyed performances of earlier dates. Certainly they have changed for the better…

*The New York Times*, December 25, 1910 …Radiant gardens of color in homogeneous masses, they give us the first strong aesthetic sensation the season has provided. No doubt it would be easy to praise too highly these summer glories seen against the pallor of the current exhibitions, but they certainly contribute a joyous note to the rather colorless art of this big, indifferent town. They are not the last cry of French art by any means. All the artists represented are Americans who appear to be in good and regular standing in the Paris Salons. …But if they are not in the extreme van of the army of the "moderns," they are in the full maturity of that

rich impressionism, the first coming of which was announced with a blare of martial music in the late '70's. …In this country nothing much stronger has been done from the "impressionist" standpoint.

Although the New York Times critic said of the Giverny Group, "They are not the last cry of French art by any means," that does not mean they were unaware of what was going on in Paris with the Fauves, the Cubists and the Futurists. It was tempting to extend this exhibition and study to the outbreak of the First World War, but just the years from 1910 to 1914 are sufficient span for a separate study, and even though many of the young artists who were pioneers in the new movements were already in Paris before 1910, they really do belong to the later period. There is a certain comfort in concluding with the up-to-date work of a matured group of advanced artists, well aware of new movements but secure in a developed mode of expression. Let one myth be put to rest. Matisse was *not* despised as a faker by all Giverny painters, and not by Frieseke in particular. His daughter told me that the interviewer who wrote of his passionate disgust for Matisse and Post-Impressionism in general (N.Y. Times, June 7, 1914), simply made it up.[171] Of course, there are exceptions. A.B. Frost received his training in Philadelphia with Eakins, who detected his colorblindness and told him to stick to black and white. By 1908 Frost had a summer house in Giverny, as Butler wrote Hale: "A.B. Frost is here with his family. That is *too*, non? He is cross-eyed, color blind and early Hudson River School. One son paints with him and the other is working under Matisse who is in my perhaps mean opinion *un pur farceur*. I'm sure you would detest his things."[172] The son who painted with him had to point out the colors. The "other" son can only be A.B. Frost, Jr., who was Monitor, or *Massier* for the Matisse atelier in Paris, and an early Orphic Cubist. Not much can be said for his work, which his academic and colorblind father could not possibly comprehend, and who, in his grief at his son's early death, destroyed all he could lay his hands on to "save" him from ridicule.

The artist who best summarizes the modern art currents in Paris before "modernism" is Maurice Prendergast. He belonged to no colonies, but like Whistler, Inness and Sargent came and went, selecting what he wanted. From the first little studies at Dieppe he showed himself sensitive to what was happening among the advanced students in Paris, and he continued to be interested in the work of the

artists then known as the Nabis. Before painting the *Lighthouse at St. Malo* in 1909 (cat. 60) he had seen and been greatly impressed by the watercolors of Cézanne, had discovered and delighted in the wild colors of the Fauves, and sketched an impression of Matisse's *La Luxe I*.

It should not be supposed that the garden walls sheltered only nudes, and painters painting painters painting nudes. They were also famous for parties. How quickly the Giverny art colony traversed the distance from Bohemia to surburbia! The first arrivals in 1887 were young, single, and very hard up for money. Since they did not come to an established routine of an Inn, but by their efforts helped establish one, they and their immediate successors created their own environment at the "Bawdy" Hotel. It became both a home and a club, with all of the amenities. The inmates were of a varied talent, and at a moment's notice could muster a banjo, bag-pipe, harmonica and piano ensemble, making life in the hotel café boisterous. The cuisine was a questionable blend of French, Scottish, English and American. The little store stocked marshmallows and maple syrup.

With the trend set by the Perrys of establishing a family household in Giverny, and the subsequent long term or permanent acquisition of studios and gardens by the Roses, MacMonnies, Friesekes, Young and others, let alone the Butlers, a ritual was established that led one French summer visitor to complain that to belong to Giverny society it was necessary to speak English. Another added that it was also necessary to enjoy warm wine and odd tasting canapés. As in any such close knit community there were memorable evenings along the Epte under Japanese lanterns, with music that varied from that of the orchestra brought from Maxim's to local improvisations, and certainly the string trio of the Perry daughters. The garden parties usually ended with soulful sessions of singing spirituals and Stephen Foster, and led French visitors to think they really had been carried back to old Virginnie, or plunked down on a Mid-Western prairie.[173]

There are no clear cut beginnings and ends in art movements during this accelerated period. Henry Mosler, the first American to have a work acquired by the French nation, his *Retour* in 1879, was still painting in an academic manner. Gérôme died the same year as Gauguin (1904), still bewildered by Impressionist "filth." The only conceivable good that old Léon Bonnat could see coming out of the first World War was that it might wipe out Futurism. The painting by Will Low, *L'Interlude; Jardin de*

MacMonnies (cat. 111) is a swan song for that period of Giverny in American art. Writing in 1908, Low recalled: "In another year or two [after 1892] the sudden wave of popularity deserted Giverny, and the bevy of student-esses deserted the meadows, and the hill slope saw them no longer, though the village is by no means deserted by its artists, and since those days I have passed a golden summer there, sheltered within garden walls in the gracious society of a *châtelaine* and two charming *filleules*."[174]

The *Châtelaine* was Mrs. MacMonnies, separated and then divorced from the sculptor. His escapades, about which he was not only indiscreet but boastful, were generally known, and were finally intolerable to Mary Fairchild. Will Low, twenty years a widower, married her in 1909. The golden idyll to which he refers is undoubtedly commemorated in this picture of the two MacMonnies daughters. As for MacMonnies, there is a noteworthy irony in a conversation that he had in Giverny with a fellow notorious womanizer, the architect Stanford White. Confiding to his friend that he was worried about threats from a jealous husband, and that he believed Harry Thaw seriously intended to kill him, White asked what should he do? MacMonnies suggested a duel, but throwing up his hands White exclaimed, "My dear chap, in New York, USA? Impossible!" Two weeks after leaving Giverny White was shot to death in New York.[175]

Low mentioned the women painters in Giverny in 1892, something he had not found in Barbizon colonies fifteen years previous. These were seriously committed students of art in Paris ateliers, taking the same kind of break from the regular grind as the men. The trend for American artists to take students in Paris ateliers has already been touched upon – Harrison and Lasar by 1889, Henri in 1895. Around 1898 MacMonnies was taking students, mostly female, but enough men wanted his instruction that he expanded to include both. From 1901 Richard Miller was a professor at the Colarossi school in Paris, and held summer sessions at Giverny, mostly for girls. Once back in Boston, Philip Hale took a teaching post at the Boston Museum School, and sent his students on to Europe and Giverny. Not all the Giverny artists took students, even when they could get them. Butler wrote to Hale in 1905: "Don't send me no fool bête girl pupils – that would be more in MacMonnies' line."[176]

Between the time when there were a handful of American art students in Paris during the 'sixties, and 1910 when the more or less stable number of Americans in Montparnasse was about 5,000, there had

been radical changes not only in art, but in the study and teaching of art in America.[177] These changes spelled the end of the French art colonies, as originated, which had begun as a means to live cheaply and study from nature in the company of understanding comrades. They now became art schools and "sketching grounds" for peripatetic summer students.

In one sense the original usefulness was done. The new movements around 1910 were much more conceptual, intellectual, depending much more on analysis in the studio of impressions, sensations, expressions, and increasingly on the materials themselves. The picture itself became the object studied as well as the end, and not the representation of something observed. All of this could be accomplished without leaving Paris or the studio in most instances.

Although communications and travel had been improved overland since railroads opened up Brittany to the interior in the late 'fifties, and Napoleon III had built model roads, trans-Atlantic transportation had not improved enough to account for the accelerated influx of Americans. It generally reflects changing attitudes to art and art education in America itself. Quite aside from the number of really thoroughly trained artists teaching in good professional art schools and private ateliers throughout the country by the middle of the 'eighties, art and art history were becoming an integral part of the regular curriculum of colleges and technical schools, as well as remaining a staple of the finishing school for girls. The improvement of the arc-light slide projector cannot be minimized. The day of the lecturer standing before an easel with Braun autotypes on it was done. Colleges and schools like Yale, Vermont, Oberlin and Drexel Institute pioneered in art education, and the progressive Mary Wheeler began regular summer art excursions in Europe for the girls of Miss Wheeler's school in Providence, Rhode Island as early as 1887. A serious artist herself, a student for years of Jacquesson in Paris, Miss Wheeler acquired a house in Giverny for a permanent summer base for her girls in 1905.[178]

By the turn of the century there were also many traveling scholarships available to art students, and the era of the peripatetic summer course had been institutionalized. What Frank Duveneck and his "boys" began in Polling, Florence and Venice in the late 'seventies, and the Tile Club continued in America and Europe in the early 'eighties, became routine. That is, groups of artists or art students came together to Europe with an old hand Professor for the summer, or gathered for a season around an established

artist with a studio. Robert Henri, for instance, would turn up with different groups in Concarneau or le Pouldu in different seasons.

It was a new century, and the students no longer gathered by twos and threes around artists like Harrison in Concarneau. He was outdated. "He knocks off moonrises with lake-like waves which curl over and meander along the sandy shore, soberly, quietly, rhythmically," wrote Fromuth after a visit to Harrison's studio. "His painting is in a high gray key of the naturalistic rather scientific school. His work looks lacking in passion and emotion, has the impersonality of photography. ... The young painters decry his art."[179]

In July 1906 Fromuth writes, "The Brittany season for strangers is in full height and my meetings with painters and cultural visitors has begun – especially noticeable this summer." He mentions Morrice, Logan, Abraham and others. In September there is a "visit to my studio of the talented artist J.W. Morrice of Montreal and Paris with a group of painters summering in Pouldu, become famous through Gauguin." Le Pouldu had also become a stop on the art pilgrimage. Frieseke was there in 1901 and Morrice, Henri, Logan, and others made regular stops; prior to 1910 Henry Dearth and his wife organized an art school there.

For some artists all of this was a blessing. Where, before, practically the only way to make a living in art was to do illustration or make frames and tint photographs, now art teaching provided income for many an artist who might otherwise have gone under. For those who did not take students it was not always so popular. Fromuth kept a record of the comings and goings of artists of all nations coming in increasing numbers to visit his studio, which he enjoyed. With these professional callers in Concarneau, however, there also came hoards of amateurs and purveyors of souvenirs, causing him to observe ruefully in the summer of 1905, "This harbor so long my own is receiving an invasion of painters. The other day I counted twenty easels on the quay." A year later he complained, "This is the age of plein-air painting of picturesque sites superficially known and superficially interpreted, for painters float around like the tourists who collect postcards illustrative of their hasty travels. This has created an army of painters who paint these views for touristic consumption, and travel about from place to place in the tourist's tracks."

Even in Pont-Aven, around 1900, the enterprising Mlle. Julia Guillou prepared to open the *Académie Julia!* Instruction was to be provided by Gaston

Linden and Frank Penfold. Penfold was a highly respected painter from Buffalo, who had been in Pont-Aven from at least 1880 (His work had been several times purchased for the French nation, the first in 1882, and he was medalled in the Salons). A pamphlet advertised for the season from October 15 through May 15: "Life models in comodious and well-appointed studios and landscape painting in the open air. Sketching exercises, discussions. French conversations – music, etc.," as well as an experienced and proper chaperone available for young ladies.[180]

An important legacy of the experience of nineteenth century American painters in the French art colonies was the establishment of similar summer colonies in this country. About 1890 William Lamb Picknell and Hugh Bolton Jones gathered about thirty painters from Brittany into what Henry Kenyon called "a regular American Pont-Aven" at Annisquam, on the Massachusetts coast.[181] There they painted in the manner they had acquired at Pont-Aven; in nearby Ipswich Dow wrestled with similar problems. Dow would soon discover Japanese design and open an influential summer school, but in 1890 the predominant style of all these Breton veterans was of plein-air *Tonalism.* About the same time John Twachtman, Theodore Robinson, Childe Hassam, and J. Alden Weir settled at the Holley House in Cos Cob, where *Impressionism* dominated, and there they instituted summer courses for the Art Students' League in New York.

In old Lyme the two styles came into collision. Henry Ward Ranger was a convinced Barbizon Tonalist when he discovered the place in 1899, and intended to make it the "new Fontainebleau in Connecticut." Like Cos Cob, Old Lyme had its sympathetic locale, in this case the house of Miss Florence Griswold. For Ranger it appeared to be the American Hotel Siron, but with the arrival of Childe Hassam in 1903 it became the Hotel Baudy. Tonalism and Impressionism struggled briefly, and with the arrival of Willard Metcalf in 1905 Impressionism won. During these two years Miss Wheeler did not take her girls to Europe, the lease on her French chateau having expired. They spent the summers of 1903 and 1904 in Old Lyme – but not at the Griswold House; that was reserved for artists, not students. But, by the time Miss Wheeler obtained her house in Giverny in 1905, she had certainly heard all of the colony gossip and theory. Metcalf, who was the veteran of both the Hotel Julia and Hotel Baudy, is credited with initiating the practice of painting panels in the Old Lyme dining room, and in general the atmosphere was of that special blend of hard work and raucus good humor, stimulated by the presence of peers. On his return to America from Giverny, Edmund Greacen spent the seven summers following 1910 in Old Lyme at the Griswold House.

Greacen instituted summer courses in Provincetown for his Grand Central School of Art students and Birge Harrison founded the Art Students' League summer colony at Woodstock, New York. About Edward Redfield there grew another colony in the vicinity of New Hope, Pennsylvania. By 1910 both the permanent art colony and the summer school had become as much a part of life for the artist in America, as it was for the American artist in France.

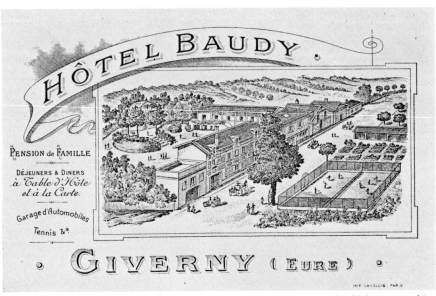

*Figure 23.* Visiting card of the Hotel Baudy

# Appendix A

## The Chateau de Lezaven in 1866

*Establishing the "character and surrounding circumstances" of the first art colony at Pont-Aven is one of the principal purposes of this exhibition and essay. Materials which constitute a background for the understanding of the nature of the colony in 1866 are therefore included. There are no comparable French sources for the initial occupation of the Chateau of Lezaven for studios, for the hospitality of the generous but impecunious Notary Tanguy, or the ambience at the Voyageurs before Mlle. Julia. Following are some vivid word pictures by Earl Shinn, who was there. These are excerpts from his letters written to the* Philadelphia Evening Bulletin *in a series called* Rash Steps, *by "l'Enfant Perdu." "Ben Adhem" is Benjamin Champney, thinly veiled, and with a little seasoning added for the reading public.*

November 10, 1866

"You have the clouds to thank for my escort," remarked Ben Adhem next morning over the coffee; "if there had been any 'effect' to-day, I should be out studying tree architecture in the naked woods..."

We opened the front door. The sky was leathery and low... "The open space in front, is the Place of Pon'-Am'n. You find it triangular, and described by roads which remind you of the Fifth in the First Book of Euclid. At the base you observe our own hotel, and for the other side of the same angle the rival house.

The *Lion D'Or* is kept by three Lionesses, who are more like Tigresses. They are always watching, and trying to fine Madame for selling a glass of cider after nine o'clock, or for sending off a carriage-party without a permit from the gendarmerie. There is a lioness on the watch, as there always is."

Looking up at the window indicated, I could see over the golden animal which served to denominate the rival hotel, an old girl of thirty, handsomely dressed, with black hair, a beard, and a pair of angry eyes directed at us.

"If you have not a perfectly clear conscience, beware of her," said my counsellor. "She would pick a flaw in a saint with those iron eyes of her's".

We passed along through the little Breton town. The *place* was almost solitary, but was now and then crossed by some disheveled, strangely garbed peasant from the country, urging his oxen with their load of hay or of buckwheat, packed into a lumbering, round-bottomed cart. The triangle was bordered by the houses of the burghers. Most of them were of the ordinary bourgeois type – a cube of white plaster, with dressed stone corners, giving them the appearance of being dove-tailed like carpenter work. A few were antique and picturesque. The apex of the triangle was formed by the bridge spanning a rapid little brawling river.

"There is the Mayor's brother, fishing again for the big trout... There is one of the gendarmes washing out his belt in the river. He is in fatigue dress, and you had better not see him. Otherwise we are always careful to cultivate the gendarmes. You observe the Gendarmerie, adjoining the bridge. About noon you can see him issuing out of the door, a perfect dazzle, in full fig, and looking as unconscious as if he had been born with all his belts and cords on him, ready pipe-clayed."

~~~

We paused a moment on the bridge. On either side was the glimpse of a beautiful river, brawling among huge rocks, and turning an avenue of old mills. On the nearest I could see the gothic monsters forming the corner water-spouts, grinning disparagingly as if they was something very peculiar in the water. "The fourteen houses of Pon'-Am'n," says the local proverb, "and the fourteen mills."

We climbed the street that led up from the farther side, but still my head was turned back toward the fascinating water. It swam down to us from the interior country in a soft autumnal dream of beneficence, dividing the brown hills whose harvests it had nursed, and then with a hundred busy hands refining that harvest for human use as it spun its easy way among the mills. Then, at the last mill, it tasted the salt, and away to the sea!

~~~

"Here's the fountain of Saint Joseph, with one shoulder split off his wooden saintship. That is the boundary of the village on this side, and beyond you can see our grove on the hill."

"Ah, there is a grove to your chateau, is there?" I said, with some condescension. "I suppose there is a ghost to the grove?"

"Well, no; we have all the reasonable comforts of a chateau of the second class, but not a ghost. Ghosts are not usually supplied except where there are exterior towers; ours is merely an inside staircase tower, and we simply have a murder."

Through the trees I began to see an ancient court-yard wall, pierced with the greater and lesser portal of the olden time; weeds and young oak trees were waving lustily over the crumbling arches.

"It is nearly noon," observed my friend, and the old woman will have returned from the fields, and be baking crepes in the ancestral kitchen. We will enter by that way."

November 17, 1866

Our entrance into the kitchen was like turning up an engraving after Ostade in a portfolio. The light blazed in from a single window, and struck in bars across an atmosphere of smoke. This smoke had its origin in the antique fireplace, which was a little cabinet of itself, with stone seats for two persons, and an elaborate system of hearths, ovens, jacks, etc. The apartment was a complete family room, and according as you turned yourself you were in the kitchen or the bed-room. One wall represented the sleeping chamber, being entirely taken up with the monstrous Breton bedstead. Imagine yourself sleeping in an uppershelf in a clothes press – that is to be a-bed in Brittany. The window was the dairy. One corner was a private oratory, with images, holy-water fountain, rosary, and colored prints of a mystical character. The aristocratic feature of the room was the floor, which was flagged, instead of being the simple ground. A bare-legged old woman was arranging upon the lofty mantle-shelf her enormous coppers, brilliant as the image of the sun in a Mexican temple. She is famous for crying.

"That old woman is your hostess. One of our fellows was painting this interior, and used to tip her milk pan over every minute with his apparatus; the window-sill is so uneven. She always cried. He would pay her enormous sums, which she accepted readily, still crying eloquently, like a baby with a pin in it. She cried when the cow ate the wheat she had just winnowed; she cried when the pig got his foot into the buckwheat batter…"

Across the hall was the salon. My guide, producing a bunch of strangely-wrought keys, was just in the act of procuring ingress when the pig, that had got his foot in the batter, came driving through the passage like a tempest, almost running us down. His mania consisted in a dream that that ancestral hall was his swill-trough, and he worked up and down it with the velocity of a piston, scorning to take the least notice of the biped occupants. When we had repulsed him with some of the farming implements which were stored in the carved recesses, we admitted ourselves, along with a dusty column of unfamiliar light, into the rotting salon.

Its decorations were tarnished, its floor turning into punk, an earthy atmosphere had usurped its scented aire of festival. The walls were paneled, leaving large spaces which were filled with canvasses, badly painted in the taste of Louis XV. I cannot describe the subjects of the huge gross designs, now dropping with their own proper rotteness to the earth…"The last of the direct line," observed Ben Adham, "was old Mademoiselle Haumant. She died here last winter, about seventy years old, all alone. Our landlady nursed her."

꩜꩜꩜

From the central hall we entered the tower, in which was accommodated the principal staircase of the mansion. The mason work was of that solid, primeval sort which seems to hold time at defiance.

We stepped across the passage…There, inside a little vesti-bule, we paused at a black old door, and my friend knocked. Up to that moment the silence we had been disturbing was the silence of the Pyramids. Now upon our knock, there was devel-oped a sudden chorus of every sort of male voice, roaring through the ancient stone passages, and even whirling down the spiral stairway to astonish the pig. We were bidden enter with a sound I have often heard, and love well to hear – the warm,

interior "Come in!" of artists laboring away among their dreams in silent sanctity of the studio.

The room was illuminated from the upper part of a single, ample casement. This unity of light, in giving effect to a chamber, is a subject very little attended to by architects, though artists have long understood its value. Thus managed, the apartment became at once a Rembrandt subject. Everything upon the corners and edges of the scene was confused in a transparent dimness, while a flood of burning, flowing silver fell from on high upon the centre of the floor, and bathed a girl who sat in the radiance and seemed to spin…

꩜꩜꩜

In a little half-circle around sit the artists, our friends. One is planted upon an earthen crock, inverted, and cushioned with a handful of fern; another on the old ancestral hearthstone; another is quite invisible, having squatted between the two facing window-seats; the column of light skips him totally, as a thing of nought, and he is reduced to a mere voice of welcome as he gives us the cheery "Come in."

# Appendix B
## Dinner at The Voyageurs: 1866

*Shinn does describe in detail some of the dinners at the Voyageurs: Père Feutray asleep among provisions in the little pantry off the kitchen the family used for a bedroom; Mme. Feutray with her famous Gâteau du Roi and the embarassing consequences when Way refused to buy drinks on getting the hidden bean; Shinn's substitution of bubble soap for his soup, from which he produced irridescent globes as the rest ate their soup; after dinner stories, like Way being chased by the cow. One of the regular ceremonies, however, was the Omelette au Rhum. Champney was sufficiently impressed to include it as one of his lasting impressions of Pont-Aven, so here it is by the one artist who did not become a painter. In Shinn's text, Yvonne is called "Jeffik," but we substitute the real name here. In this excerpt from "Rash Steps XVI," Philadelphia Evening Bulletin, November 3, 1866:*

The dinner had lasted an hour and a half by the simple device of making a separate course of each dish, with a fresh plate and a fresh wipe of the table knives, we had been convinced that we were partaking of a meal of seven or eight courses. This fashion gave the table a rather bare appearance, and we could most of the time have played billiards upon it, but for the mountain of butter in the centre, a carved structure of five or six pounds weight, something like a Colosseum. The servant now entered with an omelet au rhum.

Yvonne, having closed the door for fear of a draught, stood in a corner in the fading light, with the blazing dish sustained by one strong hand. The dish was a flat white rock of great weight, but her solid little hand made nothing of it, and she poured the flaming rum over the omelet again and again until it burned itself out. I wish I could describe her so that all might see her as I see her every day. Yvonne has a short and muscular figure. Her face is perfectly circular, like the faces described by our Indians in their simple pictures. She carries the peasant dress of heavy cloth, and there is a little dandy embroidery upon her bodice and along the edge of her enormous ruff. Ordinarily the most frank and obvious of mortals, she wears a little suitable solemnity when standing in the twilight corner of her great work of dressing the omelette. This is her only reserve, and this is the only moment when it is dangerous to trifle with her. The spirit flares irregularly over her sphynx's face, in its Egyptian cap. She becomes for the moment a priestess of Isis, busied with mysterious rites. It is the critical moment between sunset and candles, and we are all fitfully illuminated by the leaping flames which she distributes

84

with her ladle. Her own features shake and waver behind the column of fire that bursts from her hand. Such is Yvonne in her great hour.

# Appendix C

## Accommodations: 1866

When Shinn writes about his accommodations at the Tanguy's, near the hotel, he compares them to those of a Quaker farm outside Philadelphia at the Bennington farm where his sister was then visiting. Recall the repugnance felt by Augustus Heaton for anything unfamiliar, and it is worth looking at the reaction of Shinn, also a Quaker from Philadelphia, to an environment to which he was happy to adapt, and in which he found virtues and freedom beyond cleanliness: Earl Shinn to his sister Lydia, August 10, 1866.

I remember that room – like a square hole just cut in a block of limestone. I approached the bed – I really thought for a second that it was a vast fresh bank of snow new-fallen – turned the Marseilles quilt over and exposed more snow. If I ever felt *dirty* in my life, sister mine, it was that night. And the awful Quaker bleakness of that chamber – but no matter – it is a funny reminiscence now, for I am among people who never dreamed of the pitch of Quaker neatness in their most successful or wildest dreams...Housekeeping! Housekeeping??? Well, by good chance I have cologne with me, and travel through Finistère figuratively and often literally with my aquiline nose dropped into Mary Brown's handkerchief, which is soaking with Farina.

My room – I have explained our arrangement – is a hundred times nicer than any over at the hotel; one great thing,...my room is arranged while I take my breakfast or nourishment, so I have the freedom of it whenever I like. But my friends at the inn, if they go up say at 6 to prepare for dinner, Yvonne is sure to come in at that moment to make the bed. My sheets and towels are nice, which seems to compensate for everything; but if I look into the corners of the doorway or behind the old gilt mirror, there are the tents of the patriarchs...If I open the great rude wardrobe for a shirt, a powerful and familiar odor almost knocks me down; it is the peculiar and personal odor of babies. It is due to Mons. Felix, aged 15 months, who preserves his clothes among my clothes...But the difference between it and the farmhouse under Friend Bennington is, that in the latter you are afraid to sit down except in right angles. Here I find the freedom which you think anarchy...When I enter my chamber and find the little knock-me-over fragrance embarrassing, I march to the little square window, which opens at the center like a double door. The red wadded rolls which they nail along the edges of doors and sashes, grate, as I open, over the deep sill in the stone wall. So then I am in the garden. I get the Champney rose in my Mark Antony nose. The figs are getting yellow among the leaves, which flap like elephants ears in the ocean breeze. And the beautiful little river hums past the rocks with the sound I have learned so well by the Brandywine and Darby creeks. They shut the window whenever they can, being benighted heathen as to the gospels of Dr. Dio Lewis, and I open it whenever I can, and all night, and there we differ.

# Appendix D

## Mlle. Julia and the Hotel des Voyageurs, ca. 1870

Clement Swift's account of Julia's assumption of the possession of the Hotel des Voyageurs in Pont-Aven differs in some details from that of her biographer Leon Tual, but he was writing in 1927, and Swift was a resident of the hotel at the time of transition. Tual gives a persistent local legend that Julia's purchase of all of the furniture for 10,000 francs left her so depleted that she had no money for the day to day operation of the hotel, which she held under mortgage. Her American guests, so runs this story, came to her aid by advancing money against their pension in order that she might buy provisions on market days.

Swift protests village gossip. He was poor and dependent on family members in Massachusetts, who were urging his return. Therefore, in a letter home, he might have wished to avert any possible rumor that he might be sharing an all too meagre allowance, if indeed he did. But as an example of the generosity her Americans offered to Julia, Tual cites the last will and testament of Swift, which cancelled at his death all I.O.U. receipts of an unspecified amount from Julia. Swift's letter, preserved on microfilm in the Archives of American Art, describes the event as follows:

Oct. 30, 1871
Hotel des Voyageurs

Our hotel has seen a new mishap. There has been news of lawyers and all kinds of people here for the past three weeks setting up affairs; the result is this: They have sold the furniture and everything belonging to the place for 10,000 francs and the new mistress rents the house. With this sum of 10,000 they are able to pay off the debts and have something remaining.

Now a word about the mistress. Her mother is an old resident of Pont-Aven whose business is to make buckwheat which are all the fashion here and are called crêpes. She has two daughters, Julia and Marie. Julia is a remarkable tall and large girl with a very good and pleasant face and character as well. She was a "bonne" at the hotel in Concarneau for several years and made the reputation of the house. In reality it was Julia who managed the hotel, and not Père Laurens. But trouble began with her after Mr. Laurens' death. Mme. Laurens, who was jealous of Julia's superior managing qualities, finished by turning her away. Not content with this she circulated reports to her discredit which no one believed. Julia then came to Pont-Aven and our landlady secured her here as "bonne" but she did not get on much better than with Mme. Laurens. It was not long before the boarders saw the difference between Julia's cooking and the old lady's. Julia was distressed by the disorder of the place and want of proper care and economy. She tried to vary from the routine and began to clean up and put things in order. The old lady got jealous and her son who cooked (and badly) got angry and insulted the girl. She complained and the mother took the boy's part and threatened to send the girl away and heaped all sorts of petty annoyances upon her. The old lady slept in a little room right off the kitchen full of all kinds of rubbish and never opened to let in the air. She was very filthy in her habits and obliged this girl, who is always neat as a pin, to sleep with her in this little room, not even allowing her a bed of her own where there were several in the house; sometimes in the hot summer weather the girl would sleep in a chair in the kitchen or on the staircase. The only reason she did not leave was because some of the ladies staying at the hotel were very good to her and she stayed on for their sakes. At one time the boarders went in a body to the lady to intercede for the girl and the old woman declared, "That girl and she could never abide in the same house."

So foolish, so jealous, when she could have taken her own ease sitting in her armchair while her hotel went on like clockwork and much better and more advantageously than she could have done it. She also stooped to trying to injure the girl's character. At this, one of the ladies was going to Nantes and offered Julia a place which she accepted and stayed until this summer when the lady returned to Pont-Aven. It then came to that pass that Mme. Feutray becoming unable longer to carry on the house wished to sell to Julia, and went to her begging her to take the burden off her shoulders which she could no longer carry. "It shall be between you and me and no one shall know,"

said she, but Julia said they must have fair and open dealing or none at all. It had been agreed that as soon as the son-in-law had given his legal consent Julia was to buy the furniture and rent the house allowing Mme. Feutray a room in it. I have already written you about the sad end of that lady. Immediately there were a dozen candidates for the position who thought that as there were debts the hotel would be sold to the highest bidder. But it was admirable to see the manner affairs were arranged without the slightest difference. They all seemed to desire to carry out the old lady's intentions and instead of grasping all they could get, sold the furnishings and let the house to Julia in the former terms – so this is the whole business.

The poor old woman is gone and with her the reign of disorder. Julia has already put order into everything. Her sister waits on table and her father attends to the stable. It is a happy family. The old wives of Pont-Aven shake their heads and say that they do not understand it all – how a girl born among themselves – one of them – should be able to do all this, and they are trying hard to find fault and originate stories. One of these tales is as follows: that we, the Americans, have bought the hotel and hired Julia to run it and wish to make it appear that it is herself. If they only know how far I am from doing such a thing it would astonish them still more.

Some think the house is haunted and wonder how we dare sleep there, but the truth is – there is an apparition: i.e., cleanliness, which stalks continually through the house, armed with a dustpan and broom, that people would never let slip so fine a chance for a ghost story; and the little garden is said to be haunted – this is alright, and proper, and in accordance with the ideas of the country; – but stoical as I am, I can hardly repress a shudder when I think of that night, when I was tossing about wrestling with horribly undefined visions, and not 50 feet from my window the old lady was swinging in the rain and mist.

# Appendix E
## The Death of Wylie: 1877

*The following letter from Thomas Hovenden to Goupil and Company, Wylie's dealer, was reprinted in the* New York Evening Post, *March 2, 1877.*

Pont-Aven, Feb. 14, 1877

Messrs. Goupil & co.

I am very sorry that I have to write you the sad news of Mr. Wylie's death. He died this morning between three and four o'clock of a hemmorage (of the lungs, it is said, and I presume correctly). On the twelfth he went to Lorient, returning yesterday about noon, in excellent health and spirits. In the afternoon he was out boating for sometime, and as usual with him had an oar himself. In the evening he dined with an American family staying here, leaving their house at about ten o'clock. On arriving at the hotel he talked very pleasantly with those he saw there, and retired very shortly afterward. About three this morning the maid servant heard the bell of his room pulled, and on arriving there found the blood flowing from his mouth and nose. She immediately called the landlady, who lost no time in reaching him. When the latter arrived Mr. Wylie told her to dip her finger in the blood and pass it over the side of the *vase de nuit*, so that he might see the color. When he saw it he said to her, ''I am going to die,'' and muttered his poor mother's name a few times. In a short time there were several persons in the room, including the doctor, but it was too late. He spoke only a few words to the landlady, and very shortly after became unconscious, dying before four o'clock.

He had been working very steadily for some two months past on a large picture and could have finished it for the Salon, he seemed to think – though I am not certain he intended sending it. Anyhow, he worked very steadily on it, and so accomplished a vast amount in that time – perhaps it was a little longer, as I speak from memory.

I fear he worked too hard on it, as he expressed himself very glad that Saturday evening had come on several occasions, notwithstanding his health seemed excellent, and for some days previously he appeared in unusually good spirits.

I take it for granted you will be interested in everything concerning him, and so write you of his end. We, his friends, feel the blow terribly, It was so unexpected!

Yours truly,
T. Hovenden

# Footnotes

1. Andrew McLaren Young, Margaret MacDonald, Robin Spencer, Hamish Miles, *The Paintings of James McNeill Whistler*, 2 vols., Yale University Press, New Haven/London, 1980, p. 16f.

2. Philip L. Hale Papers, Archives of American Art, Smithsonian Institution, Theodore Butler to Phillip L. Hale, n.d. (c. 1894), D-98/703.

3. Edward Simmons, *From Seven to Seventy*, New York/London, 1922, p. 133.

4. Elihu Vedder, *The Digressions of V*, Boston/New York, 1910, p. 129.

5. *Ibid.*, 294f.

6. James L. Yarnall, *The Role of Landscape in the Art of John LaFarge*, Ph.D. Dissertation, University of Chicago, 1981, p. 189ff.

7. John Rewald, *The History of Impressionism*, 4th revised edition, New York, 1973, p. 109f.

8. Henry Bacon, *Parisian Art and Artists*, Boston, 1883, p. 224.

9. George Inness, "An Artist on Art," *Harper's Monthly*, vol. LVI, 1878, p. 458.

10. Dorothy Weir Young, *The Life and Letters of J. Alden Weir*, New Haven, 1960, p. 50.

11. Emily Sargent to Violet Paget, letter dated July 29, 1877, Special Collections, Colby College, Waterville, Maine.

12. Howard Russell Butler Papers, Archives of American Art, Smithsonian Institution, Howard R. Butler, July 3, 1885.

13. Arthur Hoeber, "A Summer in Brittany," *The Monthly Illustrator*, vol. IV, no. 2, 1895, p. 74.

14. L. Birge Harrison, "In Search of Paradise with Camera and Palette," *Outing*, vol. XXI, 1893, p. 313.

15. Howard Russell Butler Papers, *op. cit.*

16. Simmons, *op. cit.*, p. 165.

17. Macbeth Gallery Papers, Archives of American Art, Smithsonian Institution, gift of the Estate of Robert MacIntyre, William Sartain to Macbeth, December 1, 1904.

18. Augustus Heaton, *The Nutshell*, Irregular periodical privately printed and distributed to subscribers by the author in the 1920s. It is a combination of commonplace book, reminiscence, and platform. To my knowledge there is only one complete bound set in one volume, Heaton's own copy, in the Library of the Office of the Architect, U.S. Capitol, Washington, D.C. Pagination is such that specific page citation is meaningless, so here and in subsequent references no page will be specified.

19. Unidentified newspaper clipping of February 26, 1877, preserved in Earl Shinn's *Commonplace Book*, Pennsylvania Historical Society, Philadelphia.

20. A.V. Butler, "Robert Wylie," *The Aldine*, vol. IX, 1878-79, p. 77f.

21. The Pennsylvania Academy of the Fine Arts, Archives: Schools, July 15, 1863.

22. Heaton, *op. cit.*

23. Joseph Woodwell Papers, Archives of American Art, Smithsonian Institution.

24. Heaton, *op. cit.*

25. *Ibid.*

26. *Ibid.*

27. *Ibid.*

28. Benjamin Champney, *Sixty Years Memories of Art and Artists*, Woburn, Massachusetts, 1900. p. 115.

29. Joseph Woodwell Papers, Archives of American Art, *op. cit.*, Daniel Ridgway Knight, January 7, 1864.

30. Shinn, *op. cit.*, note 19.

31. Earl Shinn (Edward Strahan), *The Art Treasures of America*, Philadelphia, 1880, 2 vols., II, p. 36.

32. Earl Shinn (Edward Strahan), *The Chefs d'Oeuvre of the Exposition*, Philadelphia, 1878, p. 81. The picture of *The Connoisseur of Engravings*, was acquired by W.E. Stewart.

33. Earl Shinn in a letter to one of his sisters, n.d. Cadbury Collection, Friends Historical Library, Swarthmore College, Swarthmore, Pennsylvania. The collection contains letters from Shinn to his brother and sisters and an aunt; letters to Shinn from Thomas Eakins and Benjamin Champney; Shinn's notes on travel in Brittany; memorabilia. Hereafter referred to as Cadbury Collection.

34. Earl Shinn, undated draft of letter, Cadbury Collection.

35. *Ibid.*

36. Champney, *op. cit.*, p. 115f.

37. Earl Shinn (Edward Strahan), "Frederick A. Bridgman," *Harper's Monthly*, vol. LXIII, 1881, p. 696.

38. Champney, *op. cit.*

39. Earl Shinn (l'Enfant Perdu), "Rash Steps XVI," *Philadelphia Evening Bulletin*, November 3, 1866.

40. Shinn to sister Elizabeth, dated X266, Cadbury Collection.

41. Champney, *op. cit.*, p. 116.

42. *Ibid*, p. 120.

43. Earl Shinn, *Harper's*, 1881, p. 697f.

44. Shinn to sister Lydia, August 10, 1866, Cadbury Collection.

45. Shinn to a sister, September 1, 1866, Cadbury Collection.

46. Shinn to Elizabeth, *op. cit.*

47. Shinn to Lydia, *op. cit.*

48. Shinn, *Harper's*, 1881, *op. cit.*

49. Shinn (l'Enfant Perdu), "Rash Steps XIX," *Philadelphia Evening Bulletin*, December 15, 1866.

50. Shinn to Lydia, *op. cit.*

51. Shinn to a sister, September 1, 1866, Cadbury Collection.

52. Champney to Shinn, September 29 and 30, 1866, Cadbury Collection.

53. Champney to Shinn, November 26, 1866, Cadbury Collection.

54. Shinn to Richard, November 10, 1866, Cadbury Collection.

55. Eakins' own copies of this correspondence and discussion of procedure are in the archive of the Philadelphia Museum of Art.

56. See Barbara Weinberg, "Nineteenth Century American Painters at the École des Beaux Arts, *The American Art Journal*, vol. XIII, no. 4, 1981, p. 66ff.

57. Earl Shinn, "Frederick A. Bridgman," *Harper's*, vol. LXIII, 1881, p. 698.

58. Dorothy Weir Young, *op. cit.*, J. Alden Weir to brother, J.F. Weir, March 21, 1875, p. 70.

59. For a discussion of the First Americans in Gérôme's atelier, see David Sellin, *The First Pose*, W.W. Norton, New York, 1975.

60. Earl Shinn, *Harper's*, 1881, op. cit., p. 696.

61. Shinn to his Aunt Anna, August 15, 1867, Cadbury Collection.

62. Shinn, notes made on a Brittany hike, Cadbury Collection.

63. Shinn to brother Richard, December 5, 1867, Cadbury Collection.

64. Autobiographical note written in 1878 at the Hotel Beau Séjour, Grez, Archives of the Walker Art Gallery, Liverpool, England.

65. Shinn, *Harper's*, 1881, op. cit., p. 699.

66. *Ibid.*, p. 699.

67. Frederick A. Bridgman correspondence, January 3, 1871, Pennsylvania Historical Society, Gratz Collection.

68. Shinn, *Harper's*, 1881, op. cit., p. 703.

69. "Bridgman's American Circus in France," *The Art Journal*, vol. II, 1876, p. 48.

70. Frederick A. Bridgman correspondence, Pennsylvania Historical Society, Gratz Collection.

71. Ethel Ramsey Davenport, *Ladies Didn't*, unpublished manuscript memoir by the daughter of Milne and Annie Ruff Ramsey. Courtesy of Frederick Ramsey, Jr., from the Ramsey Archive.

72. J. Alden Weir Papers, Archives of American Art, Smithsonian Institution, J. Alden Weir, September 6, 1874.

73. J. Alden Weir Papers, Archives of American Art, Weir, August 8, 1874. See also Dorothy Weir Young, *op. cit.*, p. 46, for letter of August 30, 1874.

74. *Ibid.*

75. Lucy H. Hooper, "American Art in Paris," *The Art Journal*, vol. IV, 1878, p. 89f. This work was deaccessioned by the Metropolitan Museum of Art, New York.

76. J. Alden Weir Papers, Archives of American Art, Weir to mother, August 25, 1874.

77. *Ibid.*, September 21, 1874.

78. Will H. Low, *Chronicles of Friendship*, New York, 1908, p. 33.

79. Dorothy Weir Young, *op. cit.*, p. 77.

80. Ethel Ramsey Davenport, *op. cit.*

81. *Philadelphia Press*, August 17, 1895.

82. Earl Shinn (Edward Strahan) *The Art Treasures of America*, vol. II, Philadelphia, 1880, p. 135f.

83. Hovenden quote and *Post* letter enclosed in correspondence from Ohme, Knoedler & Co. to Corliss, Secretary of the Pennsylvania Academy of the Fine Arts, October 25, 1884, Pennsylvania Academy of the Fine Arts, Wylie File.

84. Frederick Ramsey, as told to his son, Ramsey Archive.

85. J. Alden Weir Papers, Archives of American Art, Weir, February 20, 1877.

86. Ethel Ramsey Davenport, *op. cit.*

87. Edward W. Emerson, "An American Landscape Painter," *The Century Magazine*, vol. LXII, 1901, p. 711.

88. D. Maitland Armstrong, *Day Before Yesterday*, New York, 1920, p. 280f.

89. Sadakichi Hartmann, *A History of American Art*, vol. I, Boston, 1902, p. 84f.

90. Clement Swift Papers, Archives of American Art, Smithsonian Institution, lent for filming by Sylvia H. Knowles, "Kroas Ar Laer Krow," an unpublished short story by Swift based on real events in Pont-Aven.

91. Henry Blackburn, "Pont-Aven and Douarnenez," *The Magazine of Art*, 1879, p. 9.

92. *Ibid.*, p. 6f.

93. L. Birge Harrison, "Quaint Artistic Haunts in Brittany; Pont-Aven and Concarneau," *Outing*, vol. XXIV, April, 1894, p. 26f.

94. Anne C. Goater, "A Summer in an Artistic Haunt," *Outing*, vol. VII, October, 1885, p. 11.

95. Arthur Hoeber, "A Summer in Brittany," *The Monthly Illustrator*, vol. IV, no. 2, 1895, pp. 74-80.

96. L. Birge Harrison, *op. cit.*, p. 30f.

97. Edward Simmons, *From Seven to Seventy*, New York/London, 1922, p. 141f.

98. *Ibid.*, p. 145.

99. George W. Sheldon, *Recent Ideals in American Art*, New York, 1890, p. 107f.

100. Alexander Harrison File, Pennsylvania Academy of the Fine Arts, Harrison to Corliss, August 8, 1883.

101. Edward Simmons, *op. cit.*, p. 145.

102. Archibald S. Hartrick, *A Painter's Pilgrimage Through Fifty Years*, Cambridge, England, 1939, p. 28f.

103. Cecilia Beaux, *Background with Figures*, Boston/New York, 1930, p. 149.

104. Harrison S. Morris, *Confessions in Art*, New York, 1930.

105. Cecilia Beaux, *op. cit.*, p. 150.

106. William Rothenstein, *Men and Memories*, vol. I, Cambridge, England, 1931, p. 77.

107. Howard Russell Butler Papers, Archives of American Art, Butler, May 24, 1885.

108. *Ibid.*

109. *Ibid.* The Grayson painting was purchased by the Corcoran Gallery of Art, and later deaccessioned. Present whereabouts unknown.

110. *Ibid.*

111. John Shirley-Fox, *An Art Student's Reminiscences of Paris in the Eighties*, London, 1909, p. 81ff.

112. E.A. Taylor, "The American Colony of Artists in Paris," pt. II, *International Studio*, vol. XLV, August, 1911, p. 112.

113. Cecilia Beaux, *op. cit.*, p. 127.

114. Frederick C. Moffatt, "The Breton Years of Arthur Wesley Dow," *Archives of American Art Journal*, vol. XV, no. 2, 1975, p. 6f.

115. E.A. Taylor, *op. cit.*, p. 112.

116. Cecilia Beaux Papers, Archives of American Art, Smithsonian Institution, gift of Harrison Culfra, 1968 and Catherine Drinker Bowen, 1970, Beaux, January 20, 1889. See also Elizabeth G. Bailey, "The Cecilia Beaux Papers," *Archives of American Art Journal*, vol. XIII, no. 4, 1973.

117. Cecilia Beaux, *Background with Figures, op. cit.*, p. 140.

118. Cecilia Beaux Papers, Archives of American Art, *op. cit.*, Beaux, n.d.

119. *Ibid.*

120. Dorothy Weir Young, *op. cit.*, p. 123, J. Alden Weir to parents, May 1, 1877, "The man" could well have been Victor Chocquet, who was much in attendance in 1877.

121. Harrison S. Morris, *op. cit.*, p. 6.

122. Denys Sutton, *Gauguin and the Pont-Aven Group* (exhibition catalogue, introduction), Tate Gallery, London, Arts Council of Great Britain, 1966, p. 9.

123. Maxime Maufra, "Souvenirs de Pont-Aven et le Pouldu," editors Francois Bergot and Patrick Ramade, in *Pont-Aven*, special number of *AMR*, Bulletin of the Art Museum of Rennes, Summer, 1978, p. 20.

124. Sutton, *op. cit.*, p. 21.

125. Hartrick, *op. cit.*, p. 32.

126. *Ibid.*, p. 36.

127. Sutton, *op. cit.*, p. 8.

128. Hartrick, *op. cit.*, p. 30.

129. Wladyslawa Jaworska, *Gauguin and the Pont-Aven School*, New York Graphic Society, New York, 1972, p. 88.

130. *Ibid.*, p. 90.

131. Frederick C. Moffatt, *Arthur Wesley Dow*, Smithsonian Institution Press, Washington, D.C., 1977, p. 29.

132. *Ibid.*, p. 28.

133. *Ibid.*, p. 32.

134. Frederick C. Moffatt, "The Breton Years of Arthur Wesley Dow," *op. cit.*, p. 6.

135. Jerome R. Van Liere kindly furnished copies of these letters, discovered recently in his research on Henry Kenyon. I am also grateful to Elsie Reinert of Ipswich for putting me in touch with Professor Van Liere and other invaluable assistance.

136. *Ibid.*

137. René Klein, "Concarneau, Ville de Peintres," *Les Cahiers de L'Iroise: Société d'Etudes de Brest et de Léon*, vol., XII, April–June 1965, p. 124. Klein cites as source René Maurice, Autour de Gauguin, Sa Rixe a Concarneau avec les Marins Bretons, N.R.B., 1953.

138. William I. Homer, *Robert Henri and His Circle*, Cornell University Press, Ithaca/London, 1969, p. 48.

139. *Ibid.*, p. 51.

140. Robert Henri Papers, Yale University, letter dated September 16, 1889. Professor Homer kindly provided me a copy from his files.

141. *Ibid.*

142. Homer, *op. cit.*, p. 49.

143. Letter cited, September 16, 1889.

144. From Thiebaut-Sisson, *Gustave Loiseau*, Paris, 1930, p. 24. Information provided by Charles-Guy Le Paul.

145. Marcia M. Mathews, *Henry Ossawa Tanner, American Artist*, University of Chicago Press, Chicago/London, 1969, p. 70.

146. Charles Fromuth *Journals*, unpublished manuscript reminiscences and associated materials of more than forty-five years in Concarneau. (see bibliography for a preliminary analysis by Elva Fromuth Loe.). All following materials quoting Fromuth are drawn from his journals, Library of Congress.

147. *Ibid.*, p. 72ff.

148. *Ibid.*, p. 568.

149. Information from Mary Anne Goley, drawn from the reminiscences and diaries of Mrs. John W. Alexander, which Goley is preparing for publication.

150. Quoted through the generosity of Mary Anne Goley.

151. Dawson Dawson-Watson, "The Real Story of Giverny," in Eliot Clark, *Theodore Robinson, His Life and Art*, R.H. Love, Chicago, 1975.

152. William Rothenstein, *op. cit.*, p. 49f.

153. Will H. Low, *op. cit.*, 446f.

154. Jean-Marie Toulgouat is preparing an analysis of the Register for publication.

155. Elizabeth DeVeer, "Willard Metcalf's *Ten Cent Breakfast*," *19th Century*, vol. III, no. 4, 1977, p. 51ff.

156. The Philip L. Hale Papers in the Archives of American Art, Smithsonian Institution are an invaluable fund of information on Giverny and its artists.

157. Will H. Low, *op. cit.*, p. 208f.

158. Sona Johnston, *Theodore Robinson* (exhibition catalogue), Baltimore Museum of Art, Baltimore, Maryland, 1973, p. 44f.

159. Theodore Robinson, *Diaries*, Frick Art Reference Library, New York, quoted in Sona Johnston, *Theodore Robinson*, *op. cit.*, p. 42. Claire Joyes shared her observations on this subject.

160. Lilla Cabot Perry, "Reminiscences of Claude Monet from 1889 to 1909," *The American Magazine of Art*, vol. XVIII, no. 3, 1927, p. 119.

161. *Ibid.*, p. 119.

162. Cecilia Beaux, *Background with Figures*, *op. cit.*, p. 201f.

163. Philip L. Hale Papers, Archives of American Art, *op. cit.* Theodore Butler to Hale, 1903.

164. Philip L. Hale Papers, Archives of American Art, *op. cit.*, Theodore Butler to Hale, after 1894.

165. Cecilia Beaux, *op. cit.*, p. 90f.

166. Will H. Low, *op. cit.*, p. 449.

167. Cecilia Beaux, *op. cit.*, p. 221.

168. Sara Dodge Kimbrough, *Drawn from Life*, University of Mississippi Press, Jackson, 1976, p. 66.

169. *Ibid.*, p. 69f.

170. Abel Warshawsky, *The Memories of an American Impressionist*, Kent State University Press, Kent, Ohio, 1980, p. 97.

171. I am particularly grateful to Frances Frieseke Kilmer for her enlightening comments and recollections of Giverny.

172. Philip L. Hale Papers, Archives of American Art, *op. cit.*, Theodore Butler to Hale, July 21, 1908.

173. For American artist life in Giverny, see the following: Pierre Toulgouat, "Skylights in Normandy," *Holiday Magazine*, August, 1948, pp. 66-70; also his "Peintres Americains à Giverny," *Rapports France – États Unis*, 62, 1952, pp. 65-73. For a broader look at both the Americans and their relationship with Monet, see: Claire Joyes, *Monet at Giverny*, Mathews Miller Dunbar, London, 1975.

174. Will H. Low, *op. cit.*, p. 450.

175. Sara Dodge Kimbrough, *op. cit.*, p. 114f.

176. E.A. Taylor, "The American Colony of Artists in Paris," pt. I, *International Studio*, vol. XLV, June, 1911, p. 263.

177. Philip L. Hale Papers, Archives of American Art, *op. cit.*, Theodore Butler to Hale, February 27, 1905.

178. Blanche E. Wheeler Williams, *Mary C. Wheeler*, Boston, 1934, *passim*.

179. Charles Fromuth, *Journal*, *op. cit.*

180. Denys Sutton, *op. cit.*, p. 16. The author of the pamphlet, H.A. Vachell, was a popular writer whose *Face of Clay* is based on the artist life of Pont-Aven, but does not have the ring of authentic and sincere reportage of either Swift in Pont-Aven or Howard in Concarneau.

181. Frederick C. Moffatt, "The Breton Years of Arthur Wesley Dow," *op. cit.*, p. 7.

# Pont-Aven At The End Of The Nineteenth Century

## Essay on Physical and Human Geography

by Charles Guy LePaul

### Physical Description

This essay is written without claiming to have produced either an historical account of Pont-Aven, which has already been partially done by local experts, or a complete and definitive work on the character of the town in Gauguin's time. We simply believe that publications up to the present time about the School of Pont-Aven have lacked an accurate and thoughtful general overview of the city and its outskirts around 1886 as well as a treatment and description of conditions of life and work that affected the painters living there at that time. At any rate, photographs exist in the form of numerous old post cards depicting Pont-Aven, its river, port and mills. No doubt many of them date later than the period we are interested in, but since essential elements of the landscape changed very little from the end of the nineteenth century to about 1930, the sum of these documents allows us to rather accurately determine the reality of the period, as much concerning physical geography as the human environment.

One important fact generally overlooked by historians is the total transformation of the landscape due to rapid growth of vegetation during the last fifty years. What appears today as a valley with wooded knolls looked then like a rock-filled ravine washed by a torrent and enclosed between hills which were, except for scattered granite boulders, totally bare. The essential reason for this change was a complete break in the customs and way of life of the people – wood, hitherto valued for its many functions, especially heating, was replaced by new combustibles such as fuel oil, gas, coal and electricty. Firewood, which was a basic necessity in 1886, became completely useless and abandoned, especially after the 1920s. Furthermore, at the end of the nineteenth century, owners of the first villas (both on the coast, until then deserted, and further inland) became involved in planting trees as much to protect themselves from westerly winds as to create parks and woodlands. Most of the great cypress trees and vast pine forests that one sees today on the coasts of Port-Manech, Kerfany and Cabellou date from this period.

The city itself was smaller in size than it is today. The stone bridge that spans the river and gives the town its name – being its center both in a physical and human sense – also separates it into two parts. On the right bank is the old section, the axis of which is the *rue vieille du quai*, lined with houses (some date back to the 16th and 17th centuries). Narrow and dark, intersected by smaller streets still more narrow and dark which lead up to Bel Air, it stretches from the Church, upstream, to the port below. On the left bank is the large village square, which occupies a gentle slope and is bordered by more recent buildings modifying the old location of hotels, marketplaces and city hall. This triangular-shaped square, bounded on the north by the axis of the *rue du Gac* and on the south by that of the *côte de Toullifo*, widens eastward from the bridge, where the two axes converge, to the houses which border it at its highest extremity – there the Hotel des Voyageurs is located, later known as the Julia Hotel.

To go from Paris to Pont-Aven at the end of the nineteenth century was a trip both in space and time. From deliberations of the Pont-Aven Council on December 24, 1890, we know that the train from Lorient (which left Paris the day before) arrived at the station in Quimperlé at 12:09 p.m., and that one had to wait there patiently for the connecting coach to Pont-Aven which departed at 6:24 p.m. That connection, which linked Pont-Aven to Quimperlé twice a day, was a public conveyance transporting passengers, dispatches and parcels all in the same vehicle. It was thus around ten o'clock that the traveler first reached Pont-Aven, after crossing the outskirts of Quimperlé, Baye and Riec for an hour and a half in a conveyance drawn by four horses,

91

# A Walking Tour of Pont-Aven

1. Church
2. Bridge
3. Roche Gargantua (rock shaped like an old shoe)
4. Rue Neuve du Quai
5. Port and Quays
6. Moulin Ligeour
7. Slip-dock
8. Roche-ferme
9. Cale du Calvaire
10. Saint-Guénolé Fountain
11. Bas Bourgneuf
12. Moulin Simonou (or Moulin Ty Meur)
13. Gloanec Hotel
14. Lion d'Or
15. Limbour Mill
16. Penanros Mill
17. David Mill
18. Le Poche-menu
19. Bois d'Amour
20. Tremalo Chapel
21. Inn owned by Charles Gueguen
22. Bel Air
23. Cemetery
24. Rue Veille du Quai
25. Rue Saint Mathurin
26. Lezaven
27. Haymaking Field
28. Foothills of Ty-Comic
29. Rue Veille du Quai
30. Hôtel Julia (Hôtel des Voyageurs)
31. Cafe des Arts et Hôtel de Bretagne

going up rugged hills and down steep slopes over 14 kilometers in an almost straight line. From the hills of the old route of Riec, level with the Saint-Guénolé Mountain, the whole countryside spread out at one's feet. Coming down the very steep Toullifo Hill, the coach landed on the square of Pont-Aven and stopped abruptly at its angle in front of the Hotel des Voyageurs, which has always been the mail stop.

The tourist could then stay at the "chic" and relatively expensive boarding-house run by Miss Julia Guillou ("la bonne hotesse" who succeeded Mrs. Feutray in 1870) or else – passing the Hôtel du Lion d'Or, the covered market-place (which is no longer standing), and the former city hall capped with its little belfry – he could go, at the bottom of the square, to a modest hotel set just slightly back from the bridge. Run by a widow, Marie Jeanne Gloanec, and her son Armand (together they first got the business, founded in 1842 by Joseph Gloanec, "shop-keeper," on its feet) this boarding-house had for more than 20 years, since 1863, established the practice of taking in artists and – not satisfied with providing good food and lodging – extending them credit. Naturally this establishment had a popularity and fame far beyond its truly modest size, so that many customers, taking meals at the inn, had to stay with local families. In 1892 the Hôtel du Lion d'Or was purchased by Armand Gloanec. Enlarged and modernized, adjacent to the annex built by Julia on the side of three old thatched houses in 1888, it became in 1893 the Hôtel Gloanec (later the name was gallicized to the Hôtel le Glouannec). On the other side of the square a fourth hotel faced the Lion d'Or. Owned by the Pelletier family, it took pride in its double sign – l'Hôtel de Bretagne and Café des Arts. It was there in 1892 that Renoir, who was a boarder at Julia's, met Gabrielle.

Finally, it is important to remember that at that time people generally traveled on horseback, by carriage or on foot. That fact alone explains two things: first the narrow and sinuous nature of roads and highways and second the rather limited territory visited by painters (it is still restricted today). Not needing to go very far to find subjects in open fields, they usually went there on foot.

## A walking tour of Pont-Aven

Surrounded, as we have seen, by neighboring hills, the Aven – which comes from Rosporden, digging meanders at the bottom of its deeply embanked bed – has the course of a mountain torrent with rocky, steep slopes. Its water makes a great uproar, breaking countless times against the rounded masses of the innumerable pieces of granite, fallen from the mountains, which litter its bed. Thus, inlet channels, diversionary channels, discharge channels, reaches of water, pools, reservoirs, dikes, foot-bridges and wooden locks are found along the Aven as are fords and washing-places set between the numerous mills.

This charming and "capricious" waterway separates the left bank, occupied by the square and its inns, from the right bank which is dominated by the Church (1) – a modern building in neo-gothic style that replaced, in 1875, a smaller one. The first houses were constructed around the older church on the portion of land relatively flat and unoccupied by the river at the base of the hill. Thus the town is stretched out lengthwise, wedged from one end to the other between the mountain and the river, in the direction of the port.

Four hundred meters downstream from the bridge (2) which connects the two banks and over which has always passed the old route from Concarneau to Quimperlé, the scattered boulders disappear. In fact, at the Roche Gargantua (3, the rock shaped like an old shoe), the valley widens to accommodate the maritime or navigable portion of the Aven where the mills end and the boats come to shore. The wharfs, constructed a few years earlier, in 1873, border the navigable channel of the river for exactly 221 meters, permitting vessels carrying several tons to dock without difficulty. On these quays, lengthened by a towpath 170 meters long, all the ocean and river activity of the town takes place. Not only fishing boats but also boats loaded with sand containing shells, coasting vessels and schooners make this port – which moves 9,000 tons per year, not counting 12,000 tons of chalky sand used to improve soil – one of the most important on the coast of Brittany.

Near the mill at the port (6, the moulin Ligeour), after passing the mills which border the rue neuve du quai on the right bank, the tourist on foot reaches the first slip-dock (7) where the fresh water of the Aven at last mingles with the flow of the ocean tide. Straight up from there (on the right, at the side of the mountain, above the thatched houses), is an old narrow road full of pebbles which joins Pont-Aven to Keramperchec, a village scarcely a kilometer away. Every day local women go to draw water at the old well there. Opposite, on the left bank, sailors can easily tie up their boats at an old iron ring attached to the Roche-ferme, after jumping onto a little ramp of earth and dry rocks called the cale du calvaire (9). Above the small dock, the Saint-Guénolé Mountain rises steeply, covered with barren land and boulders. On it, only a few meters above the water, is a calvary

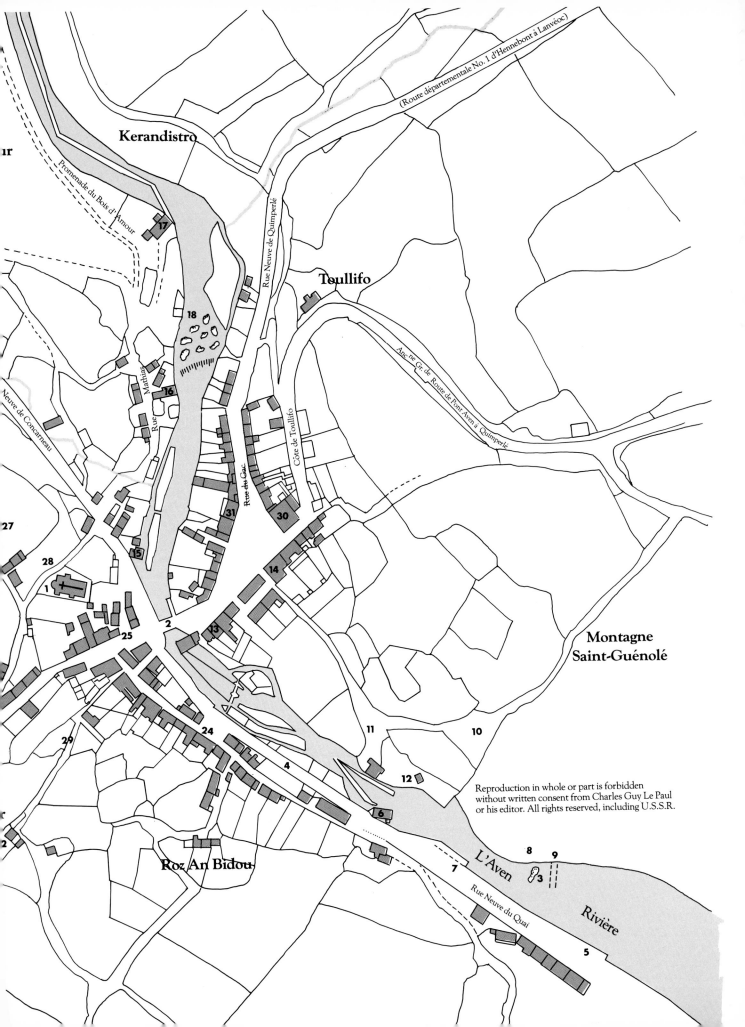

Kerandistro

Toullifo

Montagne
Saint-Guénolé

Roz An Bidou

L'Aven

Rivière

Promenade du Bois d'Amour

(Route départementale No. 1 d'Hennebont à Lanvéoc)

Rue Neuve de Quimperlé

Anc.ne Gr. de Route de Pont Aven à Quimperlé

Neuve de Concarneau

Rue Mathias

Côte de Toullifo

Route du Gac

Rue Neuve du Quai

17
18
16
31
30
15
14
1
28
27
2
25
13
2
24
29
4
11
10
12
6
8
9
3
7
5

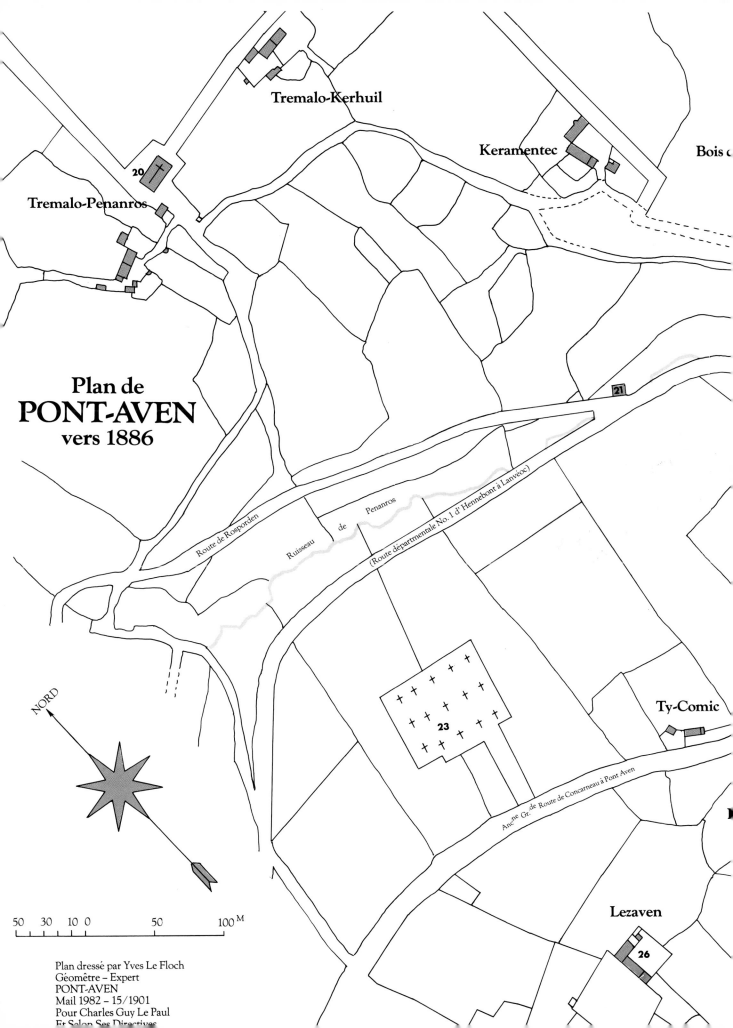

Tremalo-Kerhuil

Keramentec

Bois

20 ✝

Tremalo-Penanros

21

Plan de
**PONT-AVEN**
vers 1886

Route de Rosporden

Ruisseau      de      Penanros

(Route départtmentale No. 1 d' Hennebont à Lanvéoc)

Ty-Comic

NORD

✝ ✝ ✝ ✝
✝ ✝ ✝ ✝ ✝
✝ **23** ✝ ✝
✝ ✝ ✝

Anc.ne Gr. de Route de Concarneau à Pont Aven

50  30  10  0          50          100 ᴹ

Lezaven

26

Plan dressé par Yves Le Floch
Géomêtre – Expert
PONT-AVEN
Mail 1982 – 15/1901
Pour Charles Guy Le Paul
Et Selon Ses Directives

– the only evidence of an antique chapel which was erected here and has since disappeared. A few feet away murmurs the Saint-Guénolé fountain (10), no doubt a stopping-place for water used by the first seamen to frequent the area. One had to find an obliging boatman in order to cross the river without getting wet since no foot-bridge existed then at that place.

Suppose, on the contrary, that the traveler on foot chooses to go upward along the Aven instead of going downstream. On the river bank opposite the Church is the Limbour Mill (15), and several steps past it on the right begins the old *rue Mathias*. Skirting the mills along the right bank, it leads first of all to the Penanros Mill (16), which rises at the junction of Penanros Stream and the Aven – there, it separates into two branches. The right branch, following along the river, leads to and ends at the David Mill (17), passing before a group of scattered rocks in the water called *le poche-menu* (18), where the youngsters of the region play and bathe themselves. Here, Gauguin found the subject of several paintings – the wrestlers and children who swim in the water.

The left branch, rising amidst thatched houses on the side of a hill, immediately comes back down to follow the river again. Large beech trees planted along the water shade the road. Here begins the Bois d'Amour (19) and the lands of the aristocratic du Plessis family, whose manor dominates the valley. The Bois d'Amour, frequented by the entire population, is the special meeting place of Pont-Aven. Strolling is easy because the ground is flat, and the shade of the big beech trees protects the fair skin of women and young ladies who come there. Then, Aven, moderated by a series of reaches, widens at the *moulin neuf*, which is situated halfway and about 800 steps from the du Plessis Mill. Painters in bohemian attire, bourgeois ladies wearing long dresses and carrying parasols, peasants in costumes (either barefoot or wearing wooden shoes), youngsters in long smocks with large berets on their heads – everyone, after the Sunday meal, immediately heads for the Bois d'Amour, beautifully dressed, mothers with their babies, pretty young girls with their sweethearts, painters with their easels (Gauguin was no exception to the rule when he went there with Sérusier to make him paint the famous Talisman, in which one can see, way in the background above the trees, the slate-roofed gable of the *moulin neuf*).

The steep inclines of the Bois d'Amour lead quickly to the Tremalo Chapel which dominates the village (20), shaded by oak trees, a beautiful walk lined with beeches, a calvary made of granite, a menhir at the apse of the church (testimony to the eternity of worship), a group of thatched houses – it was here that Gauguin, in the dim light of the humble sanctuary with whitewashed walls, discovered for the first time the charm and ruggedness, the naïveté and evocative power of the old statues of Brittany. Christ on the cross, several centuries old yet ageless, became the model of his famous *Yellow Christ*.

The return to the village is easy – one simply goes down an old road which joins the *rue neuve de Concarneau* near the Penanros Stream. Taxes on alcoholic beverages entering Pont-Aven are not collected at an inn there owned by Charles Guéguen (21) since the building oddly straddles two towns – Pont-Aven and Nizon. Because the town's rural policemen can't issue infractions, it's an appreciated stopping-place that is very popular on marketing days.

Having explored the outskirts to the north and south of the inn, let us now look to the west. After crossing the bridge again, the steep old road to Concarneau rises straight ahead between two hills with Bel Air (22) on the left and the cemetery on the right (23). The street *vieille du quai* (24), lined with old houses, takes off on the left, while on the right the *rue Sait Mathurin* (25) leads towards St. Joseph's Church. Many of Gauguin's canvases were painted from these heights, whether the hills of Bel Air, around and below Lezaven (26), or those around the graveyard – particularly in the field known as the haymaking field (27) or the field belonging to the Lolichon family – and the presbytery.

Thus the promenade terminates with a comprehensive view of Pont-Aven, a view which miraculously is the same today as it was one hundred years ago – wild, tranquil, almost beyond time and ignored for the most part. It is the best place to meditate while recalling that multitude of painters who came sometimes from the ends of the earth "faire, à l'instar de Gauguin, de l'art dans un trou..." ("to create art, following Gauguin's example, in a hole...") and who made of this "hole" a capital of art.

This study on Pont-Aven is extracted from the more general work of Charles Guy Le Paul, L'impressionisme dans l'école de Pont-Aven, Gauguin, Monet, Renoir, Signac et leurs disciples," in the series *Bibliothèque des Arts*, Paris-Lausanne.

# Giverny's Meeting House, The Hôtel Baudy

by Claire Joyes

The history of the Baudy family and American painters probably goes back to the summer of 1886. Lucien Baudy and his wife, Angélina (née Ledoyen), lived at the Ferme de la Côte, birthplace of the Ledoyen family. They bought a small house a little further down in the village, at the site of the future hotel, and Lucien became a traveling salesman for the manufacturer of "White" sewing machines. Angélina was what was called at the time a "maîtresse d'hôtel" and ran the family café/grocery store. Human memory changes past events so that sometimes it is difficult to distinguish truth from fantasy in the inextricable jungle of things recalled. If only Madame Baudy had kept a journal!...

Painters had to decide where to go for the summer months when studios at the Beaux-Arts or the Académies were closed, and since the eyes never rest, their vacations were little more than a new campaign for painting. But why did they choose Giverny?...No one really knows. And why did they knock at the door of the Café Baudy in particular when at the time there were four cafés in the village? Monet stayed at one, near the train station and opposite the marshlands, before he could settle in his house. It was called "La Grenouillère" (Frog Pond), a name impossible to forget.

It is very likely that the first American painters who came to Giverny did not know that Monet lived there. Traditionally, the Hoschedé-Monet family claims that when Robinson was working at Barbizon around 1885, he was introduced to Monet by the French painter Deconchy, a mutual friend who owned a house at Gasny, four kilometers from Giverny. In 1886 Metcalf supposedly came by himself. Looking for a room, he approached Madame Baudy who, unaccustomed to foreigners, shut the door. Enchanted by the scenery and refusing to give up, Metcalf came back again with Breck, Taylor, Blair-Bruce and Wendel. Later, Sargent, who was already

well-acquainted with Monet and who frequented the American circles in Paris, would have recommended Giverny, where he painted in 1887, to several of his comrades, such as Hart, Beckwith and Theodore Butler. Gossip in the studios at Paris accomplished the rest.

Consequently, one day our American painters, taking the train that went to Vernon from the Saint-Lazare station, noticed the village with its church on the side of a hill and its wide meadows spread out between the Seine, the Epte and the Ru. From Vernon to Giverny the journey must have been delightful. A little train crossed a bridge over the Seine – the bridge was destroyed during World War II and never rebuilt – reaching the opposite bank at Vernonnet very near the house where Bonnard would later live. It then followed the valley of the Epte River at the foot of hills covered with orchards, vineyards, and fields of grain.

Our painters easily found motifs; accommodations, however, were less certain. They entered the Café Baudy, and this time Lucien and Angélina Baudy were persuaded. They found lodging for them with local families wherever possible and even gave up their own room. Metcalf stayed at the Ferme de la Côte, and Madame Baudy cooked for them. The Americans were delighted but clamored for an inn. Madame Baudy would later confide that encouraged by them and at the instigation of Robinson she decided to build the studio. They all convinced her she would be able to keep boarders the year round because of it.

Neither the Baudys nor their clients were rich, but the idea excited them. The studio was erected in 1887, the year when the guest register began. Then was born the hotel for painters, the true Hôtel Baudy. It was still modest in size, but its rapid success quickly necessitated modifications and additions. It grew little by little. In 1888 the outbuildings were

# The Artists at Giverny

## Claude Monet

1. *House and Garden*
2. *Lily Pond*
3. *Ile aux Orties (Nettle Island)* woman with parasol, boat cabins, the Yolles, the Norwegians, boat rides on the Seine

## Artists Contemporary with Claude Monet

4. *L'Hôtel Baudy:* Theodore Robinson, Paul Cezanne, Carrol Beckwith, John Breck, Peixotto, Stirling Dyce, Theodore Wendel
5. *La Masion Rose* (boarding house): Isadora Duncan, Howard William Hart
6. *Falaise (The Cliff):* Lilla Cabot Perry
7. *Maison en face de la Gare* (House opposite the station): Edmund Graecen, Dr. Johnston
8. *Le Hameau (The Hamlet, rue du Pressoir):* Perry, Dawson – Watson, Frieseke, Miss Wheeler's School (young girls from Providence, Rhode Island)
9. *La Ferme de la Côte* (Farm on the Hill): Willard Metcalf
10. *Maison de Madame Baudy* (Rue Blanche Hoschedé-Monet): Radinsky, Collins
11. *Maison Tellier* (Le Maréchal-Ferrant, rue du Colombier): Louis Ritman and the models Gaby and Fonchon
12. *Maison rue du Colombier:* Theodore Earl Butler, James P. Butler
13. *Moulin des Chènevières:* Stanton Young
14. *La Dîme:* Writers and artists of the Surrealist group
15. *Le Vivier* (Fish Pond): Frieseke, Ritman, Mary Mac Monnies, Borgord (they had models pose outdoors)
16. *Les Pilotis:* Butler, James P. Butler, Finn
17. *Le Moutier (The Monastery):* Mary Mac Monnies, Frederick Mac Monnies
18. *Sente des grosses Eaux;* the large house: Perry
19. *Sente des grosses Eaux;* the house with the pergola: Ethel Rose and Guy Rose

added, and the essential part of the main building was built between 1888 and 1891. At that time, taxes were calculated according to the number of doors and windows in a building. In 1891 there were 30 plus a porte-cochère for carriages. Upstairs in the main house there were two studios.

Things happen quickly; the first three years in the register are eloquent. Among the names listed are Robinson, Harrison, Breck, Dawson-Watson, Butler, Wendel, Hale, Lilla Cabot Perry, Hart, Rothenstein and Peixotto. There were painters, sculptors, art historians and travelers who came alone or with their families. Most often they came to paint for the entire season. The strong natural light of the valley, constantly transforming the landscape, was one of the most interesting attractions of Giverny. And the village itself was an inexhaustible source of subjects – scenes of peasant life and of young girls simply taking walks, their faces barely hidden behind parasols. Even at the inn there were subjects everywhere, such as guests seated around tables under the trees, card players, linen maids, and Gaston himself behind the counter. Lucien and Angélina were assisted by their son Gaston and his wife Clarisse.

At the Hôtel Baudy, with its iron beds and cotton coverlets, there were no luxuries. The maids, scarcely trained but willing young girls from the country, carried water pitchers upstairs for the guests' toilette, knocked on the doors and announced, "Warm water, Monsieur!" Oil lamps were used until 1902, then came gas. The inn was well-kept, the food excellent, and the owners' benevolence proverbial. Madame Baudy was good to her boarders even when they could not pay their bill. She often had to give them money for train fare – Dawson Watson was an example at the end of his last visit. They left paintings in lieu of money (cat. 90, 92, 93, 94, 95).

Clearly this adventure fascinated the Baudys and, as extreme evidence of her dedication, Madame Baudy became an agent for the well-reputed company, Lefevre and Foinet. On her premises one could buy paint, canvas and brushes. New rites were introduced at the Hôtel Baudy, a village inn specializing in foreigners, particularly Americans. As temporary inhabitants of Giverny, young artists far away from home were treated like members of the family. Great care was bestowed upon the fragile Robinson, and Madame Baudy learned to make their favorite recipes. Christmas pudding was procured, and Thanksgiving was celebrated there just as it was in America.

Early on, Monet came to the hotel to visit his American friends. He welcomed the very first arrivals to his home (a photograph shows him in his garden with Madame Hoschedé's daughters and in the company of Bruce, Taylor and Breck). However, he soon became alarmed at the growing number of artists in the village, especially since he had come to Giverny looking for tranquillity, and refused to entertain guests or – as always – to give lessons. His visits to the Hôtel Baudy became less frequent, then stopped altogether. Nevertheless, one of Cézanne's hotel bills reveals that Monet did come to have a glass of whiskey with him. There were too many people, too much noise, and probably a generation problem. He was glad that his children had friends like Rose or Metcalf, who was enthused about ornithology and collected birds' eggs, but reluctantly he gave permission to skate with the Americans in the evening on the lantern-lit ice at the Marais. When Blanche Hoschedé, a painter, shared Breck's enthusiasm for the subject and fell in love with him, Monet forced her to end the relationship. Soon afterward, the same situation developed between Suzanne Hoschedé and Theodore Butler.

Madame Hoschedé told Monet about the young couple's intentions in March 1892, just after the house was purchased and one year before Monet's famed lily pond was built. He was then working on his cathedrals at Rouen, and responded: "My dear friend, if you only knew how much your letter upset me! Since this morning I have been able to think of nothing else... It is highly unlikely that this young man would have dared to visit you unless Suzanne had responded to his advances. Furthermore, I find it strange that again things began to happen in my absence. This young man may be a good fellow, but what we know about his adventurous life and his situation is far from reassuring. ...Having said that, whether you act upon what I have said or not, it is impossible for me to remain any longer at Giverny. I want to sell the house right away. You know what I did about Breck and the other one, and you know what the result of it was – I don't want to start all over again (March 10, 1892)."

Madame Lucien Baudy treated Watson, Robinson and Butler like her own children – they were about the same age as her son Gaston and friends of his. Thus she hastened to the couple's rescue. She sent letters; Beckwith obtained information from the United States, and Robinson reassured Monet and Madame Hoschedé. The marriage took place on July 20, 1892, with Philip Hale as witness. Robinson painted it (catalogue number 88) and noted in his journal on August 5: "A dense fog early clearing off later, and commenced my "Wedding March," my model being the groom's silk hat, lent me by Gaston."

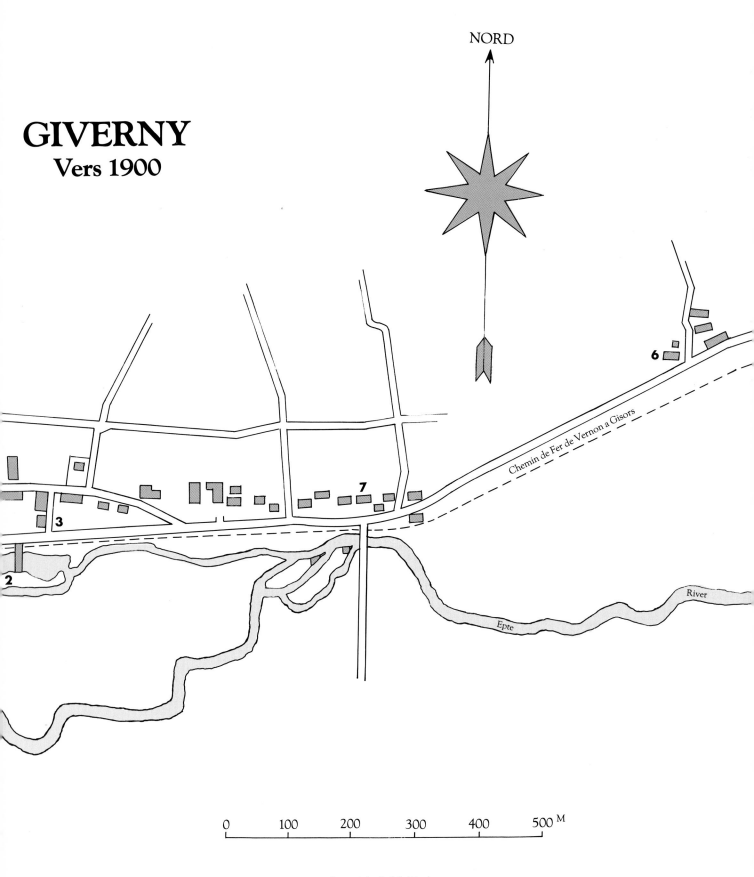

# GIVERNY
## Vers 1900

NORD

6

Chemin de Fer de Vernon a Gisors

7

3

2

Epte                    River

0    100    200    300    400    500 M

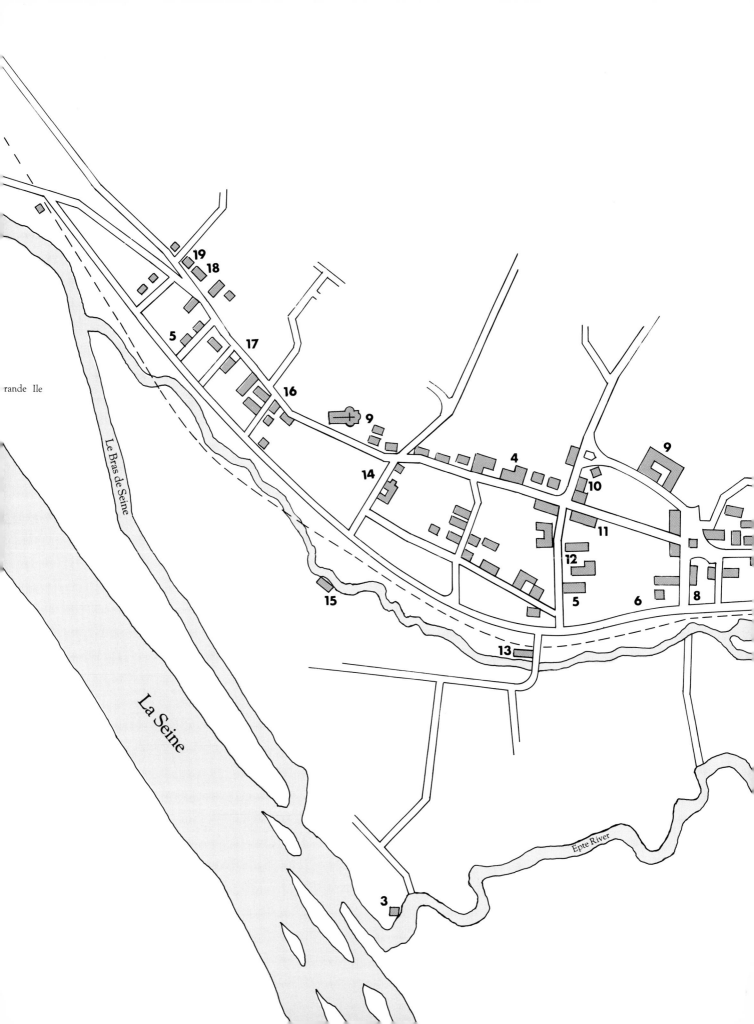

rande Ile

Le Bras de Seine

La Seine

Epte River

19
18
5
17
16
9
14
4
9
10
11
12
5
6
8
15
13
3

At the Hôtel Baudy, now the heart of a long and narrow village, one painted of course, but one also gave parties. Although the boarders were painters first, many of them were good writers, musicians and athletes. Far from feeling estranged, the villagers continued coming to the café so that painters and village folk knew each other, waved to each other, and drank together. This joyous activity rescued Giverny from a deep stupor. The walls in the dining room were inscribed and decorated by the boarders. Two paintings of dances, which were organized on Saturdays, inspire nostalgia: one by Metcalf, the other by Robert Chambers. The people of Giverny came to see the costumes when there were masked balls, to hear piano music or banjo playing, and to watch billiard championships.

In the park people played croquet. Soon Stanton Young started the tennis courts of the Hôtel Baudy, which attracted many spectators on the terrace. Despite this apparent frivolity, the boarders were capable of reasonable behavior and felt themselves sufficiently a part of the village to take a position in 1904 against the destruction of the natural landscape. The issue was setting up a shooting range in the quarries between Giverny and the Bois-Gérôme. A petition circulated in the village signed by Monet, Alice Monet, Germaine and Albert Salerou, Mrs. Mac Monnies and, at the Hôtel Baudy, by Beaudoin, Hopkins, Van Buren, West, Whitman and Ethel Rose.

The Hôtel Baudy had boarders even during the winter, and the summer months filled it up. It could not absorb everyone and therefore had annexes of a sort. One of them, where Robinson, then Collins, Whitman and Radimsky lived, was called Madame Baudy's "petite maison." Another "annex" located right next to Monet's house and owned by cousins of the Baudys living at Le Havre, was rented to Lilla Cabot Perry. Then Frederick Mac Monnies built a studio there. It was later inhabited by Frieseke, and still later by Miss Wheeler and her students. Contrary to legend, there was no lake in the garden and Robinson never lived there. The house with a pond in the garden was called "le Vivier" (the fish pond) and would be used by Frieseke and Borgord. The painters of Giverny who stayed with the Baudys before finding the house or atelier of their dreams are numerous. And even when they lived elsewhere in the village they kept up the habit of eating all their meals with the Baudys or dined there from time to time.

In 1888, one year after the Guest Register was started and the atelier built, we find concurrently at the hotel, Breck, Dawson Watson, Wendel and Butler joined by Philip Hale. The following year in 1889 Robinson left but Butler, Breck, Watson and Wendel were there when Lilla Cabot Perry arrived with her family to spend the summer. We find Peixotto, Watson and Robert Chambers as well as Dyce and Borgord with Philip Hale. We can imagine at leisure their conversations and cannot help thinking that it must have been a great day at the Baudys in November, 1894 when Mary Cassatt was in the dining room at the same time as Cézanne, whom she described marvelously in a letter to Mrs. Stillman.

At the death of Gaston Baudy in 1920, it was necessary to sell the hotel and it remained an inn until 1960 with mediocre success. Today it is no longer even a hotel. The host's table which welcomed Robinson's vexed humor, the conversations of Rothenstein or of Berenson, the atelier that witnessed Cézanne's torments are deserted. It merely exists, an institution soon to be forgotten if its history is not recorded. Not beautiful but charming, it seems sad – even tragic – in its abandonment. Proudly, it rises above the deserted tennis courts as if oblivious to the passage of time. The park is overgrown but retains a wild beauty.

What is a studio without an artist? What is a house if it is not loved and celebrated? Its sign is still there and the heart of the Hôtel Baudy is waiting to be taken.

*These observations by Claire Joyes are excerpts from a more extensive paper she is preparing for publication, and serve to introduce the Baudy family and many of the places designated on the accompanying map of Giverny. In commenting on Monet's relationship with the Americans, the author also noted the withdrawal of the French master in the face of the expanding invasion, and his distress at the discovery of the involvement of several of his step-daughters with the young strangers. Having successfully intervened in the romance of Blanche and Breck, he discovered that of Suzanne and Theodore Butler. To escape entanglement with untried foreign painters, Monet even considered giving up his newly purchased Giverny house and gardens and the projected water-garden, so important to his great series of Water-lilies, as Joyes points out in introducing the following leters from the artist to Alice Hoschedé. Monet's reconciliation with Butler, or at least initial resignation to the match, stayed his flight.*
*—D.S.*

# Appendix

(Rouen) Saturday, 8 p.m.
April 9, 1892

I would like to announce that I am indeed arriving tomorrow, but despite my desire and need to return to Giverny, I must, because of where I am now, do everything to finish my paintings. I have been enormously lucky weather-wise, but have adopted such a strange method of working that, no matter what, things are not advancing quickly, all the more in that each day I discover things not seen the day before. I gain and lose certain things. Really, I am striving for the impossible. So, I will come home tomorrow only if the weather clouds up toward evening, and still I have to think about the morning paintings for Monday. What a rat race! If I don't come it's because I honestly couldn't get away. Anyway, maybe I will come, but nothing is less certain.

Robinson's letter is truly charming and full of heart, but as for me – and you know all my apprehensions – time will tell. How distressing! Each time this issue comes up, all my worries come back, and besides a young girl as nice as Suzanne deserves better than a good fellow. Good heavens, I hope she considers things well while waiting for more information. To marry a painter, if he won't amount to much, is distressing, especially for someone like Suzanne.

I am exhausted, broken, enervated when evening comes. I need all of you then. I can only write to you.

I received a good letter from Jean.

Kisses for everyone and best wishes to your nephew.

Your Claude

Did you know that a mediocre and old *Vue de Rouen* just sold at Drouot's for 9500 francs? Depeaux authorized spending 5000 francs for it, thinking he would get it. He is unhappy, of course.

From Wildenstein's catalogue raisonné, *Monet: Vie et Oeuvre*, volume 3, p. 266. Letter no. 1151 to Alice Hoschedé.

(Rouen) Thursday
March 10, 1892

My dear friend,

If you only knew how much your letter upset me! Since this morning I have been able to think of nothing else, and the more I think about it, the more I find it worrisome and sad. But I don't share your astonishment, having foreseen that these skating parties would have this result. And when recently in a letter that Jean addressed to the girls he complimented Mr. Butler, I saw clearly that there were other encounters besides skating. What surprises me more is that after their past frustrations and disappointments the girls could respond to advances from Americans passing through Giverny. It is highly unlikely that this young man would have dared to visit you unless Suzanne had responded to his advances. Furthermore, I find it strange that again things begin to happen in my absence. This young man may be a good fellow, but what we know about his adventurous life and his situation is far from reassuring. You don't have the right to refuse offers for your children, but your duty is to supervise the choice, especially when it's a lottery like the one we have. You have the right, after what has happened, to refuse your daughter to an American unless we know him through friends or he is introduced to us – but not just encountered in the street. As for me, I think you should obtain a frank response from Suzanne. If she is madly in love or simply infatuated, make her see the problems after you have received more information. If the situation is not insurmountable, which should be the case, cut short any hope whatsoever.

Having said that, whether you act upon what I have said or not, it is impossible for me to remain any longer at Giverny. I want to sell the house right away. You know what I did about Breck and the other one and you know what the result of it was – I don't want to start all over again.

Alas, alas, I am more miserable than you shall ever know. Everything I have just said, I said because I am not deceiving myself and I love the children, but my situation is delicate. I said nothing when the skating parties were going on because you would have criticized me for forever seeing the negative side of things. Above all, I was confident in the girls' good sense.

As for information about the Americans, there is no one who could boast about not having civil status or papers. Only their friends at the inn will tell you good things about them.

I kiss you and send you my heart.

Your Claude

I will come home tomorrow no doubt, but very upset.

From Daniel Wildenstein's catalogue raisonné, *Monet: Vie et Oeuvre*, volume 3, p. 264. Letter no. 1139 to Alice Hoschedé.

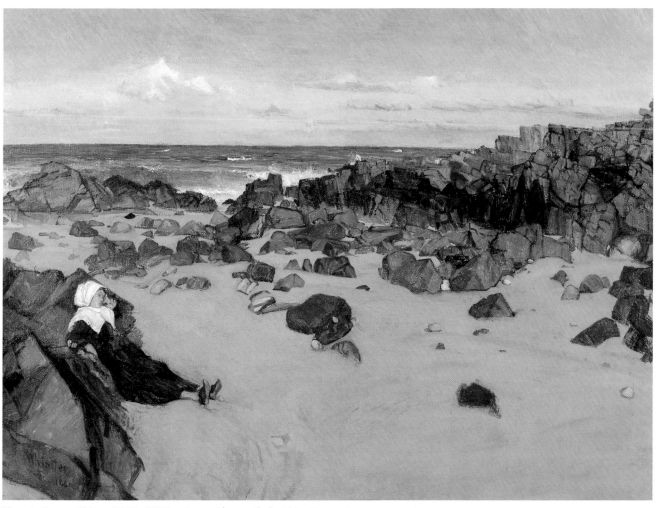

Plate 1. James Abbott McNeill Whistler    *Alone with the Tide (Coast of Brittany)*, 1861                    Catalogue Number 6

105

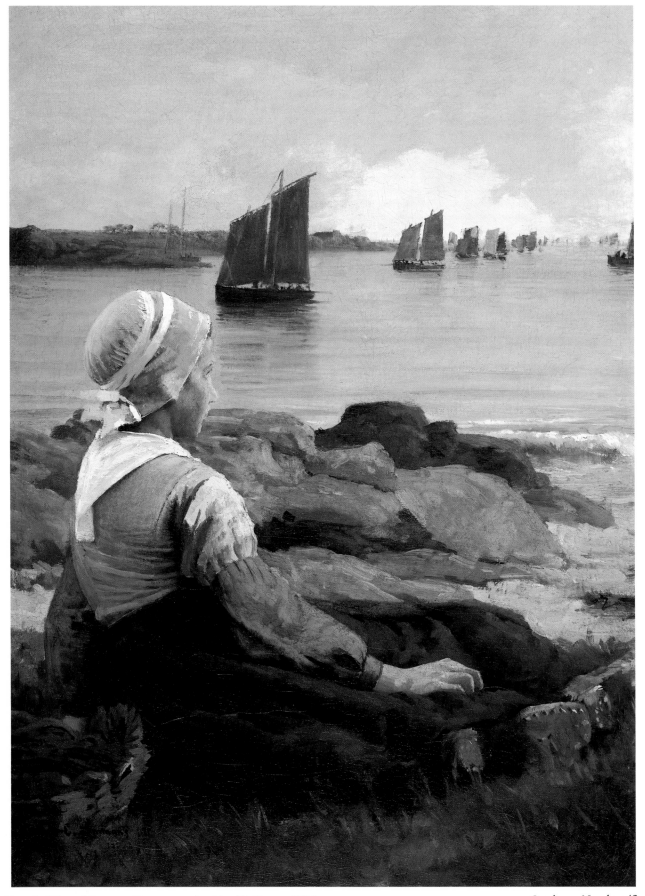

Plate 2. Edward Emerson Simmons    *Awaiting His Return, 1884*                          Catalogue Number 42

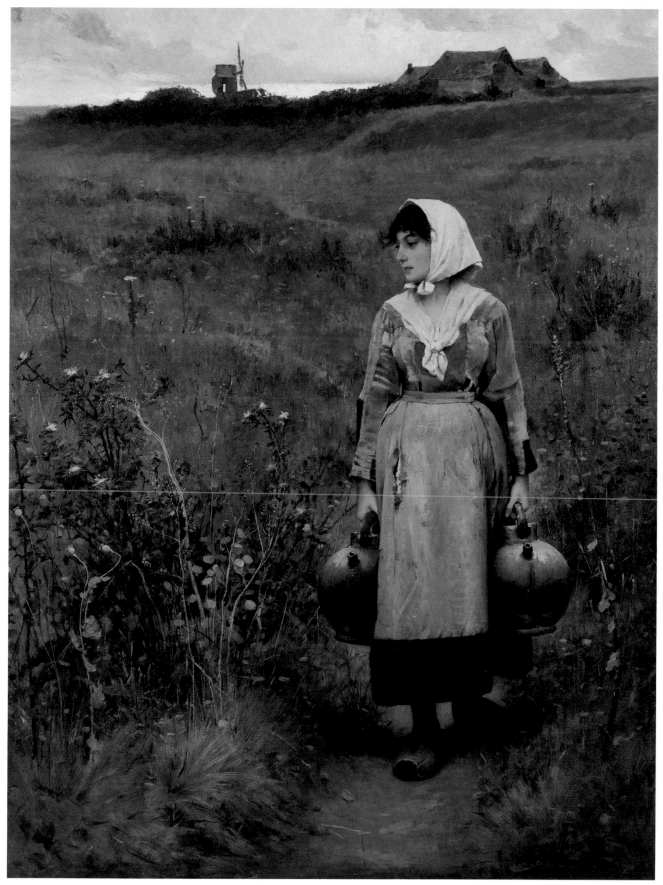

Plate 3.  Charles Sprague Pearce   *Water Carrier*, 1883

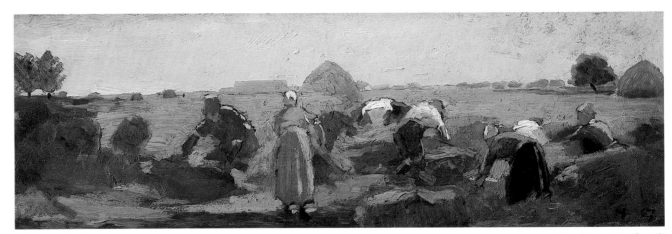

Plate 4.  Winslow Homer    *The Gleaners*, 1867                                    Catalogue Number 62

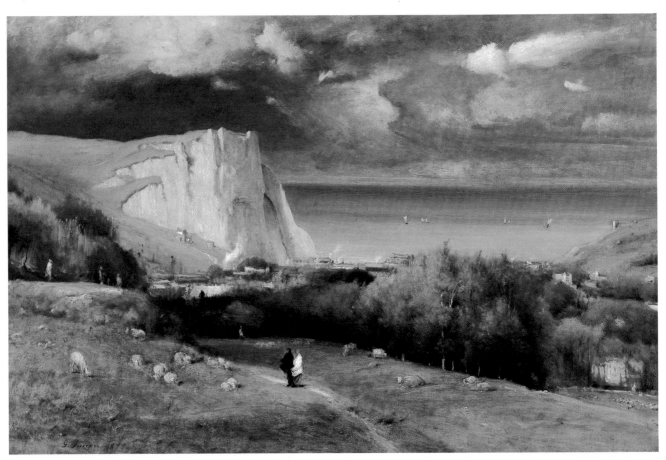

Plate 5.  George Inness    *Etretat*, 1875                                    Catalogue Number 64

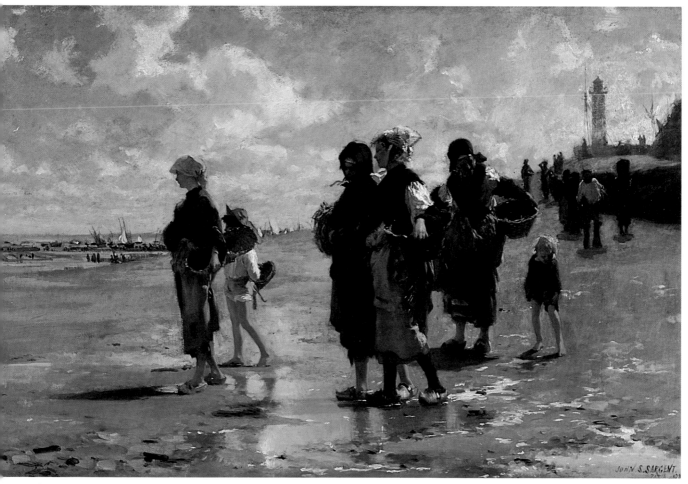

Plate 6. John Singer Sargent    *The Oyster Gatherers at Cancale*, 1878

Catalogue Number 12

Plate 7. Robert Wylie  *A Fortune Teller of Brittany*, 1871-72          Catalogue Number 10

110

Plate 8. Thomas Hovenden   *Breton Interior: Vendean Volunteer 1793*, 1878          Catalogue Number 25

111

Plate 9. Frederick Arthur Bridgman    *American Circus in Brittany, 1869-1870*    Catalogue Number 19

112

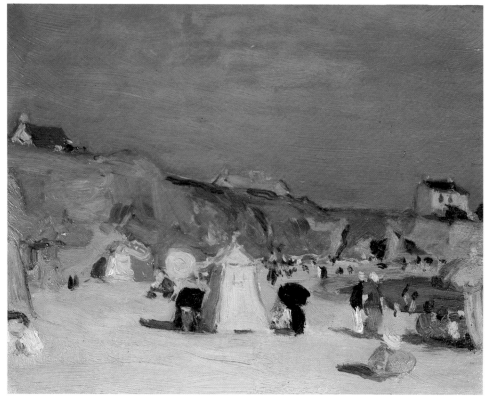

Plate 10.  Robert Henry Logan    *Crowded Beach, Le Pouldu*, c. 1900          Catalogue Number 54

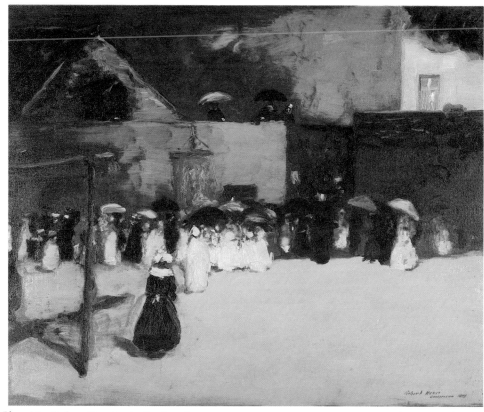

Plate 11.  Robert Henri    *Le Pardon – Concarneau*, 1899          Catalogue Number 47

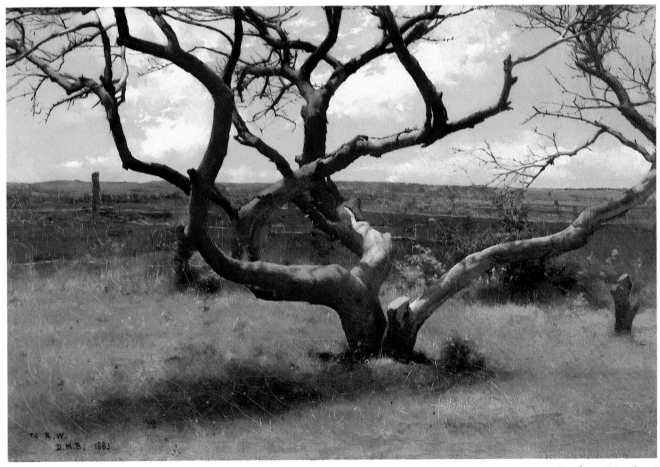

Plate 12.  Dennis Miller Bunker    *Tree*, 1885

Catalogue Number 8

Plate 13.  William Lamb Picknell    *The Road to Concarneau*, 1880                    Catalogue Number 29

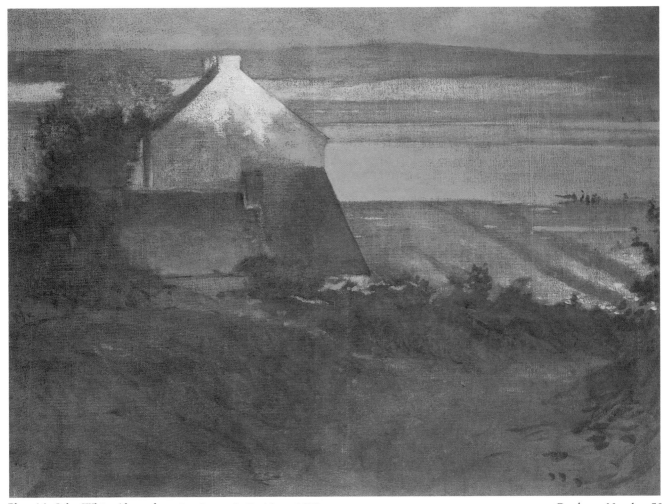

Plate 14. John White Alexander    *Landscape, Le Pouldu*, c. 1892                    Catalogue Number 50

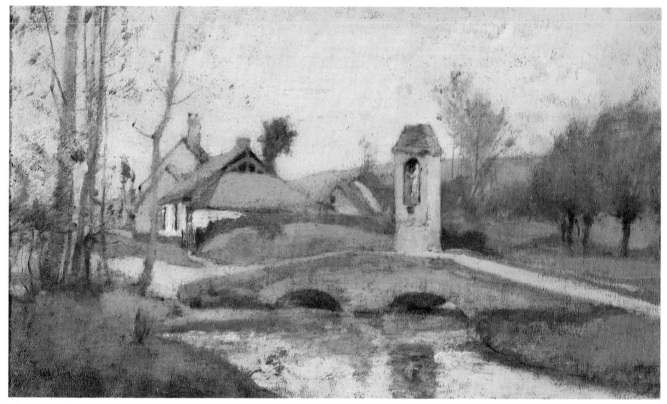

Plate 15. John Henry Twachtman    *Shrine on the Bridge, Honfleur, Normandy, c. 1883*                    Catalogue Number 51

117

Plate 16. T. Alexander Harrison    *The Wave*, 1884-85

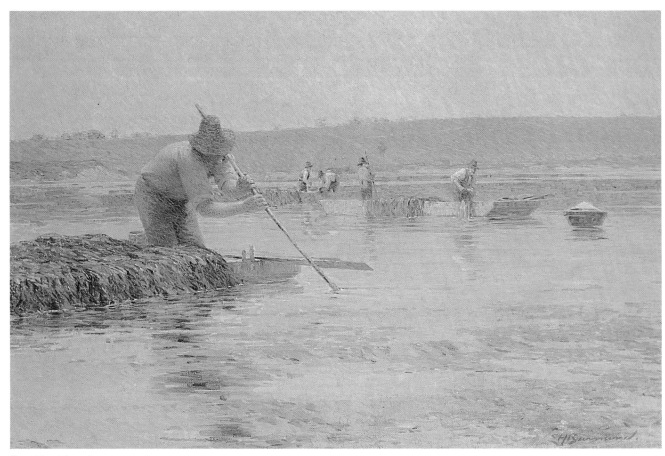

Plate 17. Edward H. Barnard   *River Weeders*, c. 1890                    Catalogue Number 98

Plate 18.  Theodore Wendel  *Girl with Turkeys, Giverny*, 1886

Catalogue Number 97

Plate 19.  Lilla Cabot Perry  *Giverny Landscape (In Monet's Garden)*

Catalogue Number 101

Plate 20.  Edmund William Greacen    *The River Epte*, 1907                    Catalogue Number 104

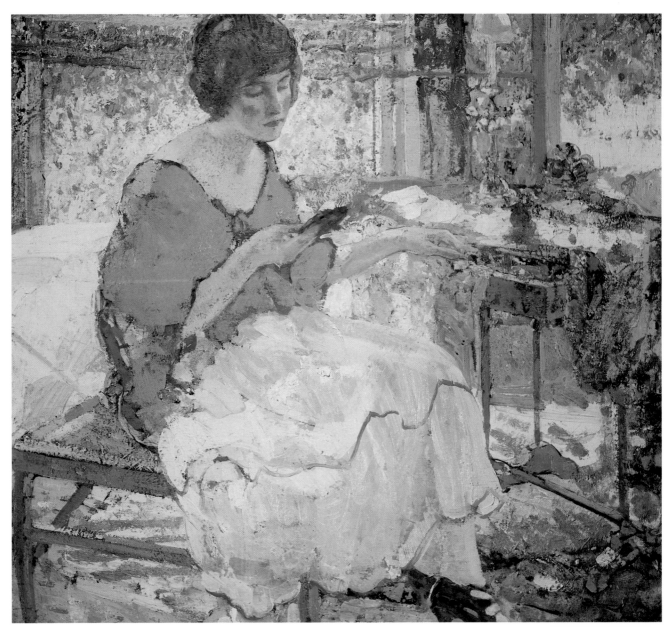

Plate 21. Richard E. Miller  *Interior, c. 1910*

Catalogue Number 105

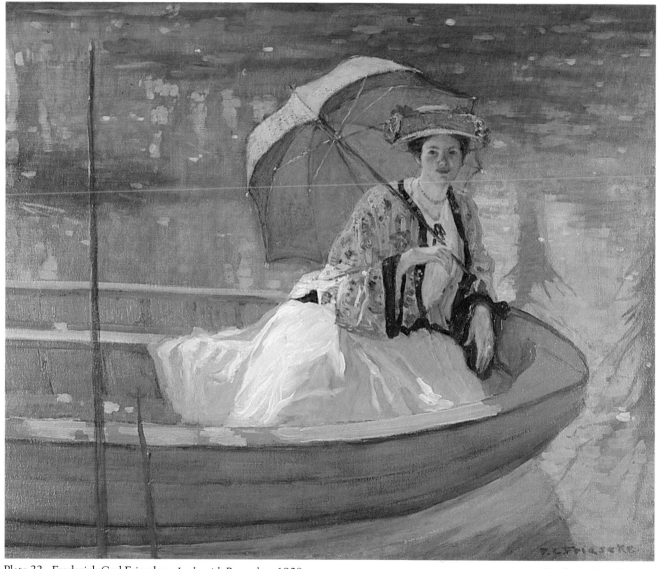

Plate 22. Frederick Carl Frieseke   *Lady with Parasol*, c. 1908          Catalogue Number 107

125

## Exhibition Catalogue

The catalogue entries are divided into two general groups, Brittany and Normandy. Arrangement in each group is roughly chronological according to the date of the painter's first visit to the region. Some deviation is allowed for the convenience of design.

Dimensions for each work are given first in inches, height preceding width; followed in parenthesis by the metric measure in centimeters.

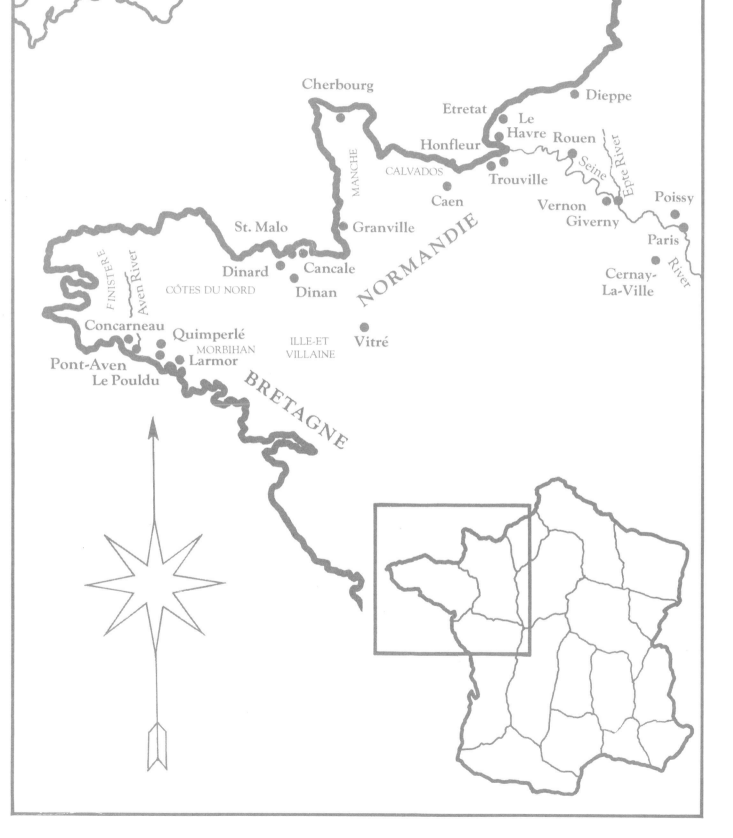

# William Morris Hunt (1824-1879)

1. *Dinan*, 1866
oil on canvas
22 x 36 (55.8 x 91.4)
Private Collection

The paintings of Whistler, with those done by Hunt and Vedder when together in Brittany in 1866, offer a good glimpse of Americans in France at that time. Hunt had left the tight linear discipline of the Dusseldorf School twenty years before to come and study with Thomas Couture in Paris, sharing an apartment with his architect brother, a student at the Beaux-Arts, during the years after 1847. Hunt bought a version of Millet's *Sower* in 1851, and the following year was introduced to the artist in Barbizon. For several years Hunt had close contact with him, developing his tonalist style under a combination of Couture and Millet influences before returning to Boston in 1855, the year Whistler came to France. He was the moving force in Boston and Newport in the creation of a taste for French art of the Barbizon mode. A founder of the Allston Club in Boston for the promotion of Modern Art, Hunt was instrumental in 1866 in the purchase for $5,000 of Courbet's *La Curée*, the first Courbet in America. Then he left for France, where his friend Vedder joined him in Brittany.

Vedder had painted among the most modern painters of Florence before he had known Hunt in Boston. When he joined him in Brittany in 1866, he painted *The Tinker* in the manner of Millet – meaning in the manner of Hunt – just to show Hunt he could do it if he wanted. Vedder then resumed the less modeled, pure color spot painting that he preferred, as in the little studies done in Vitré.

2. *Woman Planting a Flower Pot, Vitré*, 1866
oil on board
7¾ x 11¼ (19.7 x 28.6)
Collection of The Hudson River Museum, Gift of the American Academy of Arts and Letters

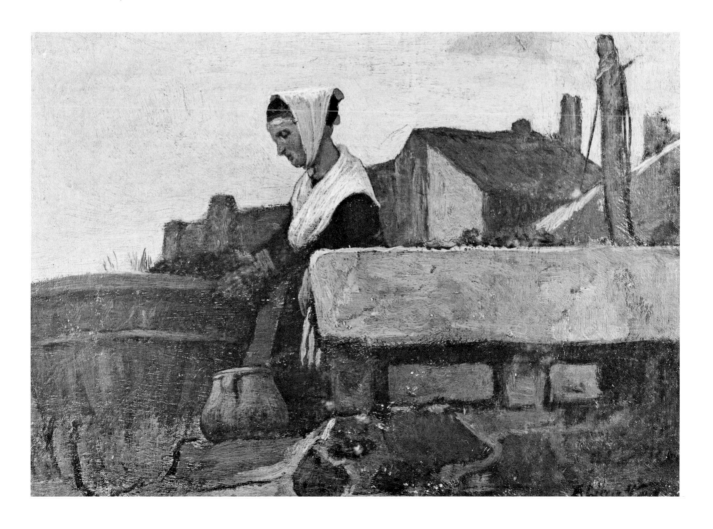

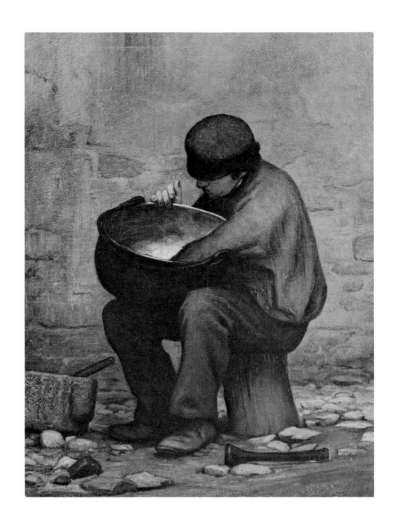

3. *The Tinker*, 1866
oil on canvas
24 x 18 (61.0 x 45.7)
Staten Island Museum, Gift of the American Academy
of Arts and Letters, 1955

4. *Vitré, Evening*, 1866
oil on canvas
5 x 13 (12.7 x 33.0)
National Academy of Design, New York City

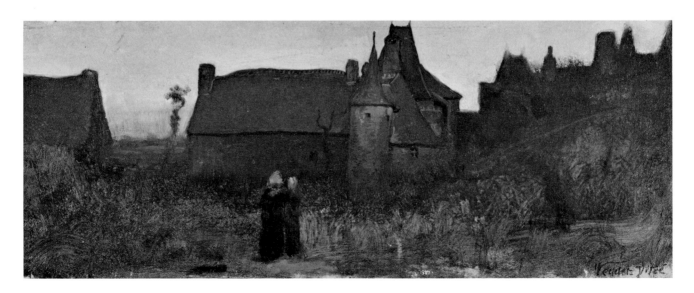

# James Abbott McNeill Whistler (1834-1903)

6. *Alone with the Tide (Coast of Brittany),* 1861
oil on canvas
34⁵/₁₆ x 45⁹/₁₆ (87.1 x 115.7)
Wadsworth Atheneum, Hartford: In memory of William Arnold
Healy, given by his daughter, Susie Healy Camp
color plate 1

5. *The Sea,* c. 1865
oil on canvas
20¾ x 37¾ (52.7 x 95.9)
Montclair Art Museum, Montclair, New Jersey, Purchase, 1960

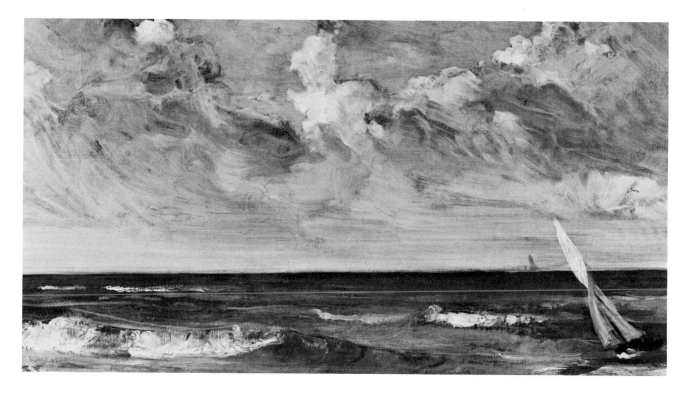

While Whistler is best known for his "arrangements" and "nocturnes", or Venetian etchings, his first recognition came as a Realist in the French mold of Courbet. One of the finest of these early paintings in the harshly unprettified but very painterly manner commences the exhibition, *Alone with the Tide,* done in Brittany in 1861. It is followed by an only slightly later work from the coast of Normandy, done in the company of his friend Courbet at Trouville, but somewhat softened by the new tendencies of Manet and Monet, and by Whistler's own emerging elegant style. Whistler, in his lifetime, was the only American artist to enjoy recognition for his art in America, England and France, with the possible exception of Sargent. His own direct impact on American artists did not commence until around

1878 when he met Duveneck's Boys in Venice, but from then it was continuous and strong, and re-emerges in the 'eighties and 'nineties as old friends like John White Alexander renew their acquaintance in Paris, or as new generations come to France to study and discover him all over again. The realism of Courbet that is so strong in Whistler's early work appealed directly to the Americans who came to France around 1865 and discovered the rich natural colors and unidealized rugged landscapes of the French master for themselves in the Salons and in the Courbet Pavillion of the International Exposition of 1867. He appealed especially to those who went out to paint in the rugged countryside bound by the rock-ribbed coast of Finistère in Brittany.

131

# Charles Adams Platt (1861-1933)

7. *Brittany*, c. 1885
oil on canvas
15 x 22 (38.1 x 55.8)
The Century Association

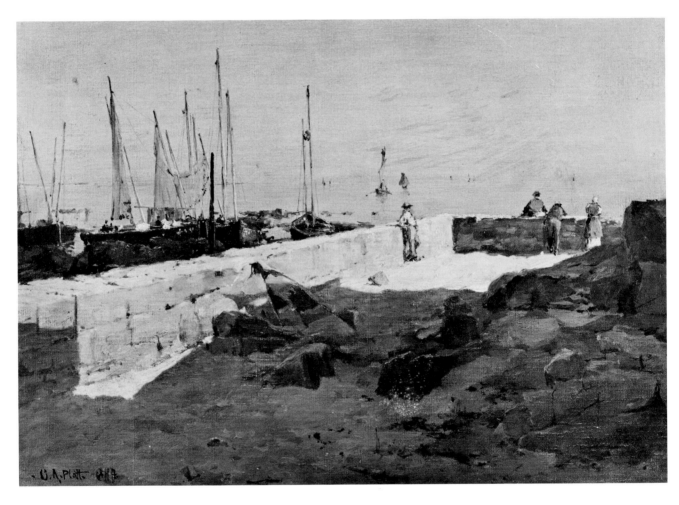

Charles A. Platt is best known today for his landscape architecture and building design. To him we owe the Freer Gallery in Washington and many majestic villas. As a boy in Connecticut he began painting landscape and studied at the National Academy and the Art Students' League of New York. Stephen Parrish encouraged the younger man to take up etching, and he became accomplished in that field. In 1882 he enrolled in the Académie Julian in Paris under Boulanger and Lefebvre. Dennis Bunker was enrolled at the Julian that same year in a different atelier. Bunker, Platt and Kenneth Cranford painted together in the summers, and were probably together on the Breton coast around Larmor in July 1884. Platt remained five years, returning to America with a bride. After the death of his wife, he married Dennis Bunker's widow. The Platts were a part of the community around Cornish, New Hampshire with Augustus St. Gaudens, Kenyon Cox and Stephen and Maxfield Parrish.

132

# Dennis Miller Bunker (1861-1890)

8. *Tree,* 1885
oil on canvas
10⅝ x 16 (27.6 x 40.6)
Private Collection
color plate 12

9. *Larmor,* 1884
oil on canvas
18 x 25½ (45.7 x 64.8)
Private Collection
(overleaf)

Bunker is one of those lamented masters who died in his full first flower before the age of 35 but by the sheer quality of his work deserves attention by anyone interested in 19th century American painting. He studied at the new Art Students' League with Chase and others, and painted during the summers of 1881 and 1882 on Nantucket with his friends, Abbott Thayer and Joe Evans, who both had been fellow students with Theodore Robinson in the atelier of Gérôme at the École des Beaux-Arts. Robinson also painted with Thayer and Evans in Nantucket that summer of 1882, when Bunker was deliberating on whether to go to France.

Bunker went to Paris in the fall, enrolling with Gérôme in January 1883, and remained in France until early spring of 1885. In the company of Charles Platt and Kenneth Cranford, Bunker traveled in Brittany during that brief stay. Bunker's handling of raking light over broad planes of spring greens shows individual genius in interpreting nature, coupled with a mastery of aspects of the work of Corot, Daubigny and Courbet as well as of the drawing required of students of the Gérôme atelier.

His painting of the *Apple Tree* has sometimes been thought to be a Nantucket subject, but it was probably done in Brittany. Cider was the national refreshment; the greens of the fields are of early spring when the tree was not yet in blossom, and the sluice gates in the background are of a type common in Brittany. It was painted in or before 1885, when it was dedicated to a friend in Massachusetts. He was not in America until past the season clearly depicted, and he was a plein-air painter, so Brittany is the best candidate for location, with a date of execution in 1884 or early 1885. In Brittany in 1884 he painted several fresh and beautiful views of the coastal village of Larmor. The year after his return to Boston, Bunker was painting in Woodstock, Connecticut, with Thayer, and wrote to a friend of his problems with light:

"The days are distressingly bright for me and I long for a solemn sky and gray world. In France it is just the other way, and the sunless days are in the majority. I like them so much better to paint, because they don't change and one can paint calmly. That's a great thing, to know that you have time and your subject is to be just the same for hours. In sunlight it is never the same, the shadows which seem to be nearly in the same places when you are not painting them, really move with dreadful swiftness when you are...

"I find that power lies as much in gentleness as anything else, as much in being led, as in leading; Gérôme used to say that, but I never understood what it meant. He used to say 'Jamais de la violence.' Never be violent."[1]

In Boston, Bunker got a position teaching at the Cowle's School. One of his pupils was Lilla Cabot Perry, soon to become a mainstay of the Giverny community.

[1]Dennis Bunker to Anne Page, September 1, 1886, Archives of American Art, Bunker Collection, reel 1817, frames 240-244.

DENNIS M. BUNKER
LARMOR 1884

# Robert Wylie (1839-1877)

10. *A Fortune Teller of Brittany*, 1871-72
oil on canvas
33⅞ x 47¾ (86.0 x 121.3)
In the Collection of the Corcoran Gallery of Art
color plate 7

Robert Wylie was the founder of the Pont-Aven colony. He was awarded a medal of the second class for the *Breton Fortune Teller* at the Salon of 1872, the highest award available to a foreigner, the first ever given an American. The fortune teller or witch held a position comparable to the parish priest in Breton village life. She could lay or lift a curse, cure the sick, and read the future. Wylie has chosen such a séance to support his motif of figures in a typical Breton interior. The bold modeling bespeaks his training as a sculptor, and the unconventional manner of buttering the paint onto canvas with palette knife reveals his personal interpretation of the technique of Courbet, the realist, while the dramatic light and contrasting shadow reflects the recently rediscovered Spanish "tenebrist" painters of the Baroque. True to his models, Wylie used the same ones in other paintings, today unlocated, but clearly recognizable in reproductions of the period. Wylie is discussed at length in the exhibition essay.

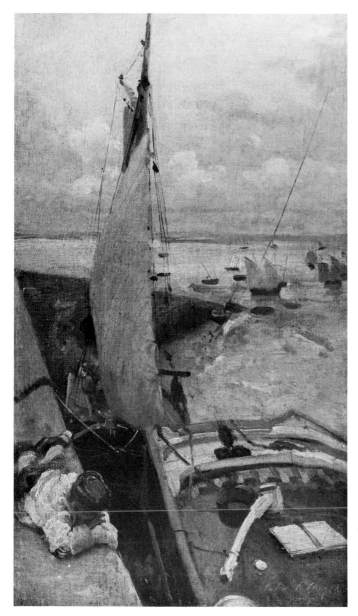

11. *Low Tide at Cancale Harbor*, 1877
oil on canvas
18¾ x 11 (47.6 x 27.9)
Museum of Fine Arts, Boston, Zoe Oliver Sherman Collection

Sargent was an accomplished artist at 18, with training in Florence and extensive European travel, when he enrolled in the predominantly American atelier of Carolus-Duran in Paris during 1874. It was an American who induced the master to teach a few years earlier and who managed the rental, heating and hiring of models for the classes, which included Will Low and Carroll Beckwith. The little study of *Octopi* freshly caught completed in Brittany in 1875 reveals Sargent's brilliant handling of paint and texture. Two years later he was back in Brittany at Cancale painting studies in the open sunlight for his *Oyster Gatherers*. Studies done that summer in Cancale are on exhibition here along with the Salon painting finished back in his Paris studio. It won him recognition at the Salon of 1878, and a full study for it (Museum of Fine Arts, Boston) same simultaneously in the second Society of American Arts exhibition in New York.

Five years later Sargent returned to Brittany making studies for his great painting of *Mme. X*, the vain beauty from Parlange Plantation on False River, Louisiana. *The Oyster Gatherers* shows a mastery of Carolus-Duran's "direct painting," but retains an Italian virtuosity in depicting strong outdoor light. Before he won further recognition and notoriety with his *Boit Children* and *Mme. X*, he had been absorbed totally in the silvery tonalities of the great Spanish artist Velasquez, whom he copied in Madrid in the interim.

14. *Young Boy on the Beach: Sketch for the Oyster Gatherers at Cancale*, 1877
oil on canvas
17 x 10 (43.1 x 25.4)
Daniel J. Terra Collection: The Terra Museum of American Art

12. *The Oyster Gatherers at Cancale*, 1878
oil on canvas
31⅛ x 48½ (79.1 x 123.0)
In the Collection of the Corcoran Gallery of Art
color plate 6

13. *Octopi on Deck of Fishing Smack*, 1875
oil on canvas
16 x 12½ (40.0 x 31.3)
Henry C. White

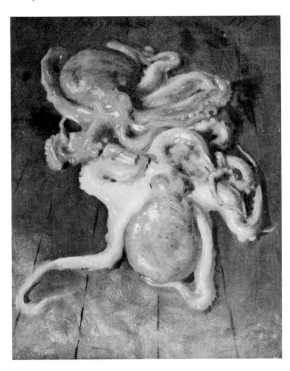

15. *Breton Girl with a Basket, Sketch for the Oyster*
*Gatherers at Cancale*, 1877
oil on canvas
19 x 11½ (48.2 x 29.2)
Daniel J. Terra Collection: The Terra Museum of American Art

16. *Sketch for the Oyster Gatherers of Cancale*, 1877
oil on canvas
19 x 11 (48.2 x 27.9)
Daniel J. Terra Collection: The Terra Museum of American Art

137

# Frederick Arthur Bridgman (1847-1928)

That the Americans were considered completely moral and respectable people is proclaimed in the little picture of a girl of Pont-Aven dressing her hair (perhaps Marie Mower, one of the first models to sit for Bridgman in the first years of the art colony). For a girl to show her hair in public was considered provocative and indecent. Later artists commented on unsuccessful attempts to have the girls uncover their hair, and symbolist paintings showing naked models with coif in place are satyrical. The toilette consisted of twisting a long strand, illustrated by Bridgman, tying the hair tightly with it, confining it in a cap, and over that the local coif or headdress. No nun could be more pious about showing her hair. This was prompted partially by the fact that often there was none; wig makers and hair merchants harvested the severely depressed area of Brittany and a girl in need of extra money could sell her crowning glory without anyone knowing it was missing. Bridgman's *Circus* is discussed at length in the text, but the following is a contemporary description:

> Mr. Bridgman's *Circus* was painted when he was scarcely more than a student, and, when exhibited, the masterly character of the composition and brilliancy of its colouring excited general admiration, even among the critics of Paris. The scene represents the interior of an American circus. A famous athlete and woman rider are performing a "two-horse act," as described in the bills of the day. The trained horses are making the round of the ring in a gentle canter, urged by the crack of the ring-master's whip; and the so-called "trick-clown" and his companion, the jester, are engaged in their usual antics for the delectation of the admiring crowd. In the original painting this central tableau forms a superb study of colour. The athlete, in crimson jacket and buff trunks, and the woman, in her gauzy costume glittering with spangles, together with the sturdy horses, and the clowns in their raiments of many colours, was a bold subject to handle for so young an artist, but it was successful...As a study of character, the little group of rustics on the left can hardly be excelled...In the background the usual mixed audience is shown with the band throwing out its sweet strains to the measured tread of the horses, and the "Rocky Mountain Indian," seated in the broad light near the grand entrance."[1]

Bridgman's dependence on the methods of his teacher Gérôme is nowhere more evident than in his painting of fishermen at the boatyard at le Richardais near St. Mâlo. He delights in the perspective problems of the anchor, the anatomy of the figures, and the specific effects of time and place. The solicitous young wife and mother, whose headgear proclaims she is from another village, feeds her husband at the end of a day's work as a sea-breeze wafts the older man's pipe smoke inland. The composition is tight, but Bridgman *was* a composer. He wrote a symphony that was performed in France, and gave his painted compositions opus numbers, this one being Opus cccix. In the absence of a relative chronology, dating is still conjectural. After Nile voyages (from 1873) he continued to paint in both Normandy and Brittany, although he became better known in America as an orientalist. In many ways this is a more accomplished work than the *Circus*, but still close to Gérôme. The New York Times of February 25, 1877, commented on a related painting in which, "The bright green of the sea-weed, the brown of the old anchor on which a tattered fisher-boy stands, the bright surf and water fading up through the cliffs to a dark cloudy sky, are all fresh and suggestive." A date between 1870 and 1876 is suggested.

[1]*Art Journal*, vol. II, 1876, p. 48.

17. *Study of a Young Girl, Pont-Aven,* 1869
oil on canvas
25⅝ x 22⅝ (65.7 x 58.0)
National Museum of American Art, Smithsonian Institution

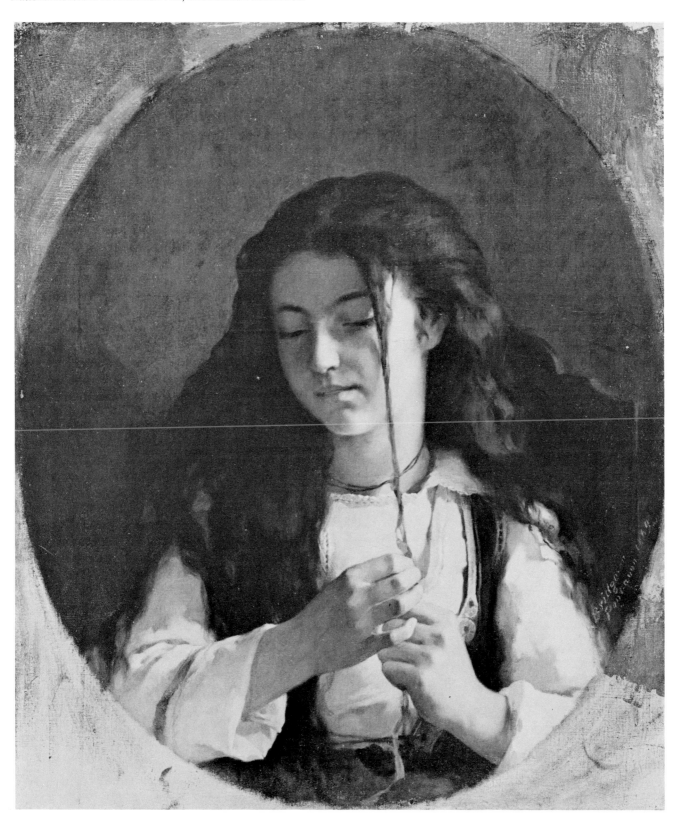

19. *American Circus in Brittany*, 1869-1870
oil on canvas
23 x 48 (58.4 x 121.9)
Nelson Holbrook White
color plate 9

18. *Fisherman at Le Richardais, Brittany*, c. 1875
oil on canvas
27¼ x 36½ (65.2 x 92.7)
Private Collection

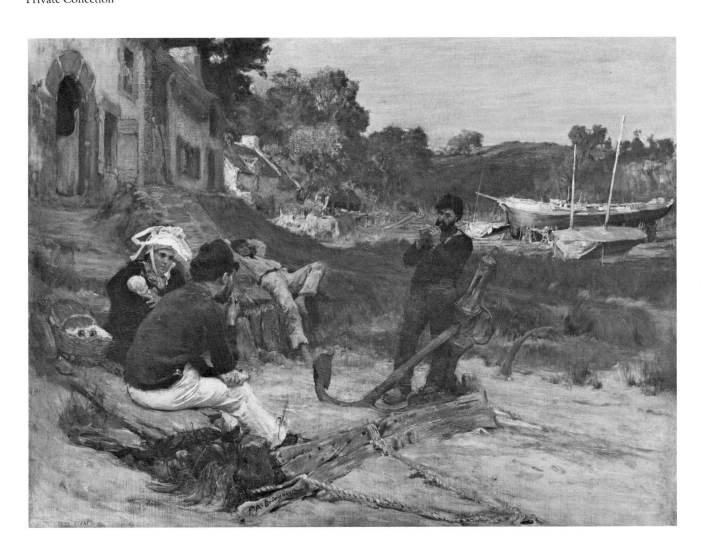

20.  *Une Épave (The Spar)*, 1879
oil on canvas
42 x 94 (105.0 x 235.0)
Free Public Library, New Bedford, Massachusetts

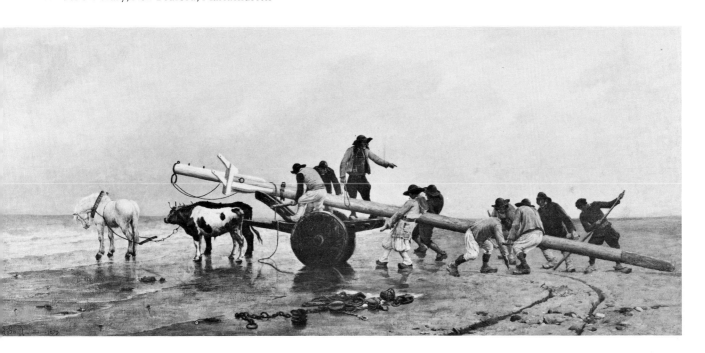

As a youth in Acushnet, Massachusetts, Swift showed talent for animal painting. Boston painter Robert Hinkley advised the youth to go to France for study, which he did in 1867, in the ateliers of Adolph Yvon and Henri Harpignies. At the outbreak of the Franco-Prussian War he left Paris for Pont-Aven, submitted to the magnetism of Robert Wylie and soon became immersed in Breton lore, writing informative local history in thinly disguised novelettes. He stayed ten years. His first Salon success in 1872 also dealt with a local cottage industry: *The Wreckers.* Along the opposite coasts of Finistère and Cornwall, the plundering of ships lured onto the clawing rocks by bobbing lights tied to the tails of cows ashore was legendary. There were never survivors. *The Spar,* (his own title was *une Epave,* or waif) might simply be the harvest of chance, rather than of a disaster carefully sown. A spar with its blocks and tackle is loaded aboard an ox-cart on the beach upon which it had been cast by the waves. *The Spar* was medaled in the Salon of 1879. Swift wanted to "improve" the painting in 1910 by making some changes in the figures, but the trustees of the New Bedford Public Library refused, having bought the painting as we view it in 1879.

# J. Alden Weir (1852-1919)

21. *Breton Farm*, 1874
oil on canvas
19⅜ x 24 (49.2 x 61.0)
Helen E. Peixotto

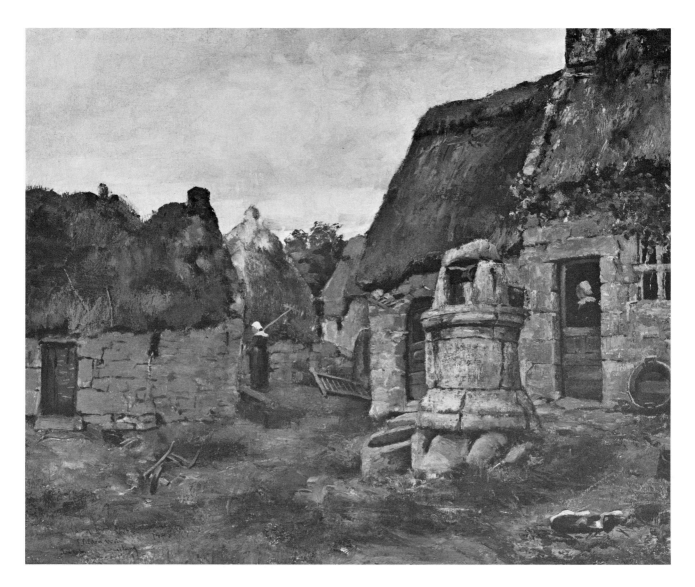

Weir came to Pont-Aven in 1874 with Edgar M. Ward, a fellow student of Gérôme at the Beaux-Arts. He stayed only one season, but while there gathered material for what he hoped would be his first Salon painting, a harvest scene. Apparently he came on the American colony and Wylie without knowing what was there, because he had bought costumes and bric-à-brac for accessories along the way, only to arrive at the Chateau de Lezaven and its fully stocked property closet. In Pont-Aven he found sage counsel and plenty of models and motifs, in-cluding farms with well-heads like the one shown here. This painting is dedicated to Mr. Valentine in the 1880s, but it must be one of the studies that Weir made in 1874 in Pont-Aven, a student work by one of the artists later to become one of those Americans most closely associated with Impressionism. The Impressionists had their first exhibition in Paris the year this was painted, and nothing could have been farther from Weir's mind at the time, when carrying values across the surface from one area to another was the prime concern.

22. *Houses, Pont-Aven*, 1878
oil on canvas
12¾ x 13⁵/₁₆ (31.9 x 33.3)
The Holyoke Museum, Holyoke Public Library

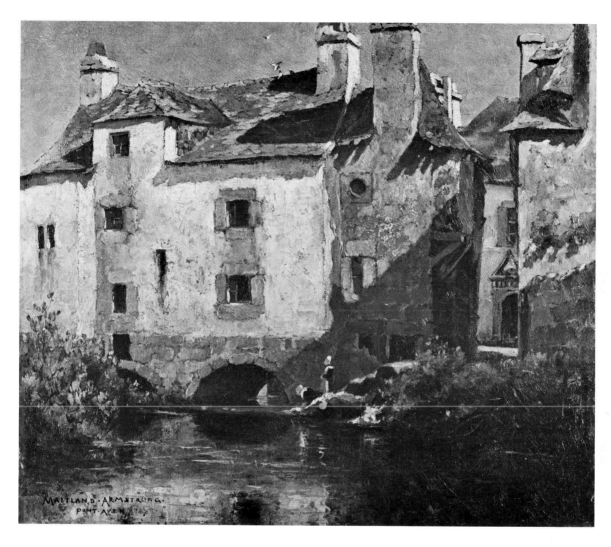

Armstrong had a B.A. degree from Trinity College and studied law in New York City where he was admitted to the bar in 1862. In 1869 he was appointed American Consul to the Papal States and was in Rome during three dramatic and turbulent years. There, as part of the artistic fraternity, he knew Vedder and Charles C. Coleman, who had painted with Hunt in Brittany a few years earlier, the sculptors, Henry Rinehart and the young Augustus St. Gaudens, whom he met in 1872. They renewed their friendship the following year in New York and later in Paris. St. Gaudens was a particularly close friend of Bastien-Lepage, whose *Joan of Arc* Armstrong watched in progress, and of Luc-Olivier Merson. The latter took on Armstrong as a pupil. Merson's method of com-posing was to make wax figures clothed in colored paper or rags to get the light effects. In 1878 Armstrong was appointed through his diplomatic connections to the directorship of Fine Arts of the American section of the International Exposition in Paris and he chose St. Gaudens to assist him in selecting and hanging American works submitted by the Paris based artists. He was awarded the Legion of Honor for his work, along with Thomas A. Edison for inventing the phonograph. Armstrong then took the summer to paint in Pont-Aven with his American friends. While his choice of subject is characteristic of the village, his vantage point and light seem to reflect more his Mediterranean background than his French training.

# Edwin Howland Blashfield (1848-1936)

23. *On the Beach*, c. 1876
oil on canvas
14¼ x 17½ (36.2 x 44.5)
Montclair Art Museum, Montclair, New Jersey,
Gift of Dr. and Mrs. Jack M. Singer, 1981

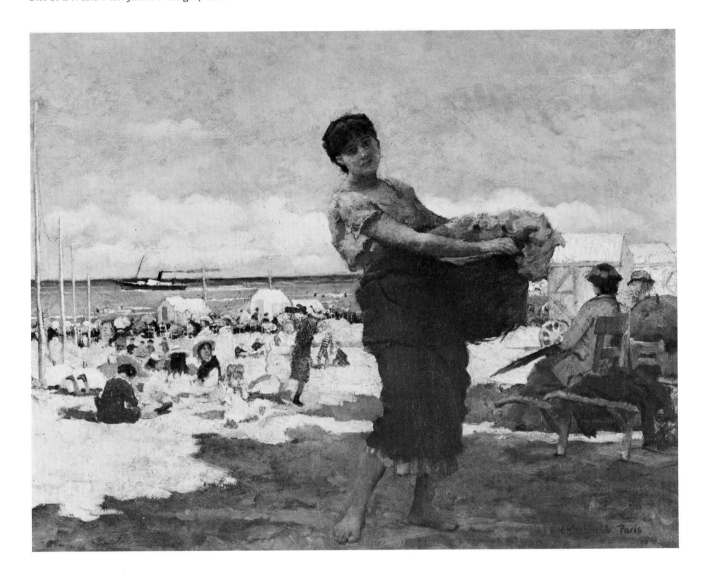

Before Blashfield went to Paris to study art in 1867 he obtained engineering training in Munich and Boston. In Paris he studied in the atelier of Léon Bonnat, and lived with his fellow student Milne Ramsey at 5 rue Douai, made famous in the novel *Trilby*. With the outbreak of the war with Prussia he returned to New York, but returned for another six years with Bonnat in 1874, when he shared a Paris studio with Charles Sprague Pearce, William Lippincott, and Ramsey; with Bridgman just down the hall. They had regular group exhibitions together at Salon time, and during the International Exposition of 1878. The site of this beach is not identified, although the painting was worked up in Paris. In style it would seem to date around 1876 when he was in Pont-Aven with his friends, the Ramseys and Helen Corson. In the Ramsey archives there is an amusing cartoon by Blashfield commemorating a day on just such a beach in their company, along with Mlle. Julia, when Annie Ramsey's lost wedding ring was miraculously recovered from the surf by the artist. Bonnat put his students to work directly from models, working in bold contrasts, and not drawing from casts. Blashfield arrived at his personal ideal in his later work, and is best known today for the murals in the cupola of the Library of Congress.

24. *Breton Courtyard*, 1878
oil on canvas
18 x 22 (45.7 x 55.8)
Nancy Corson

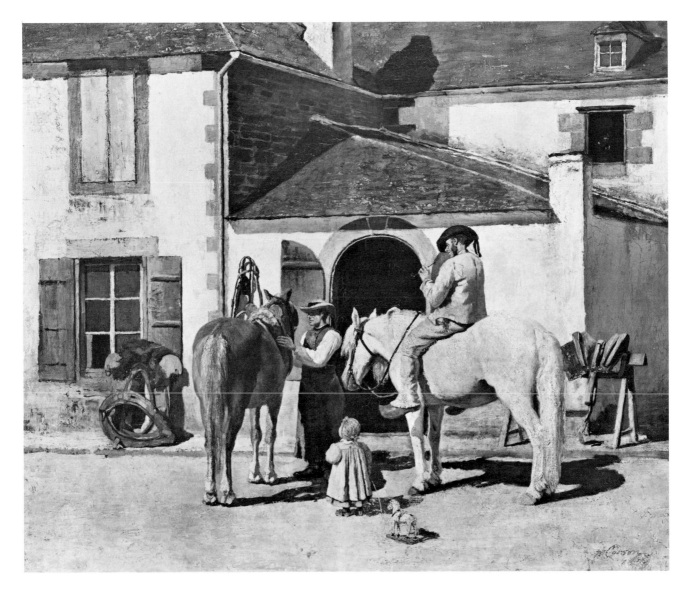

Helen Corson of Philadelphia showed early interest in animal painting and enrolled as a student at the Pennsylvania Academy along with Eakins, Cassatt, Roberts, Shinn and Ramsey when Wylie was curator. Corson did not get to go to France until 1875, when she accompanied Milne and Annie Ramsey to Paris and Pont-Aven. In Brittany she pursued her interest in photography, recording the village and its people and animals with the camera, as well as with brush and palette. To the Pennsylvania Academy of the Fine Arts Annual of 1877, she sent a painting of *Tremalo*, the chapel later represented by Childe Hassam and many others, and the following year she painted *Breton Courtyard*, which shows the influence of Wylie in paint manipulation, and a relationship with paintings by Maitland Armstrong, Burr Nicholls and Picknell done at the same time. Helen Corson was a popular young woman and had many admirers among the American artists in the Ramsey circle; in 1881 she married Thomas Hovenden in Plymouth Meeting, Pennsylvania.

# Thomas Hovenden (1840-1895)

Hovenden found compatible surroundings in Pont-Aven with Robert Wylie. Although he had studied with Cabanel at the Beaux-Arts in Paris, he developed his mature style of painting at the Chateau de Lezaven. In 1878 Hovenden exhibited this picture at the International Exposition in Paris. In the aftermath of the French Revolution, in support of the Crown and in resistance to the Terror, natives of the Vendée region of West France rebelled in a hopeless but devoted struggle. Here, in an episode which recalls the old stories of Yankees melting down the family pewter for bullets, a young volunteer awaits while the father inspects the blade he has honed to razor edge, while a wife guards the cradle, and in the foreground the crucible transforms heirlooms into ammunition.

25. *Breton Interior: Vendean Volunteer 1793*, 1878
oil on canvas
38¼ x 54 (97.1 x 137.4)
Dr. and Mrs. Robert M. Carroll
color plate 8

26. *The Path to the Spring*, 1879
oil on canvas
16¾ x 21⅛ (42.5 x 53.7)
Nancy Corson

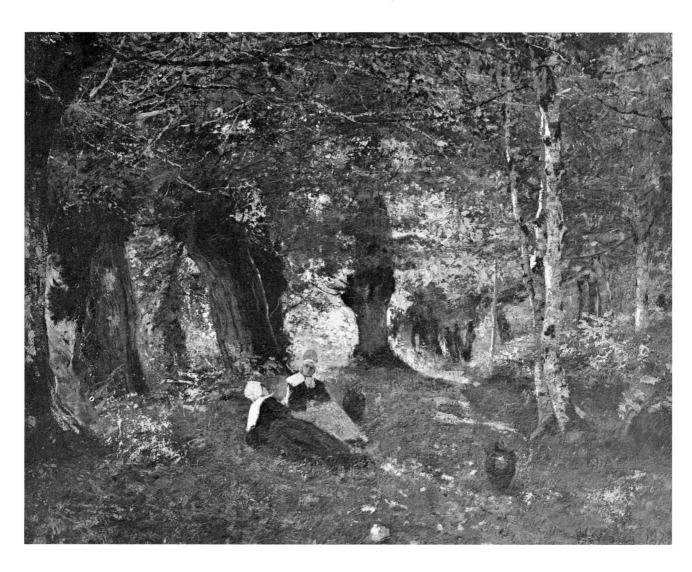

27. *Farm Interior: Breton Children Feeding Rabbits,* 1878
oil on canvas
21½ x 25¾ (54.6 x 65.4)
Mr. and Mrs. Abbot W. Vose, Boston

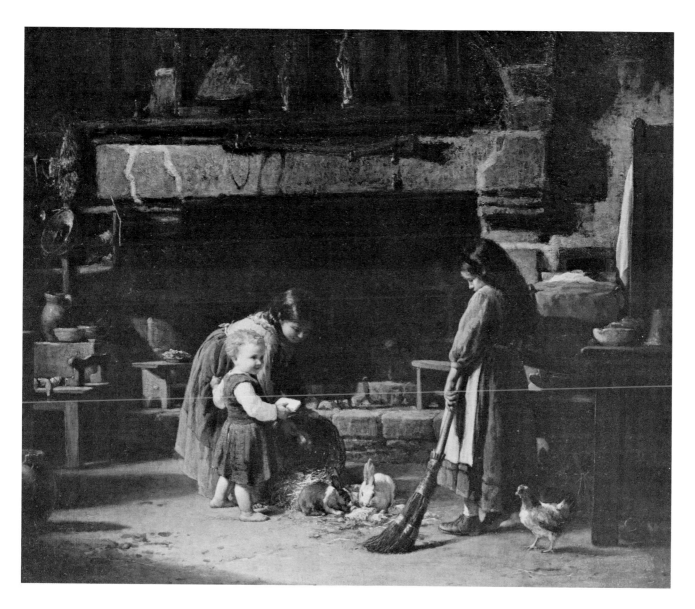

A Philadelphian, and student in the old Academy and member of the Philadelphia Sketch Club, Lippincott spent eight years in France before establishing himself in New York. In Paris he was a student in the atelier of Bonnat, and shared a studio with Ramsey, Pearce and Blashfield; in 1878 Bridgman's was down the hall. Although sometimes associated with the peasant genre interior painters of the ''Écouen School'' of Edouard Frére, Lippincott reflects in this painting his Breton experience, as well as the dark palette of his master Bonnat, but without the painterly quality of Wylie. He was in Pont-Aven with the Ramsey entourage in 1875, and this work of 1878 is typical of the Breton peasant interior, with its raised hearth and spacious fireplace with seating within the embrasure, where a small fagot or charcoal fire is kept burning, and knick-knacks ornament the mantel above. Small animals ran loose on the tamped earth floor. He later taught at the National Academy of Design, to which he was elected a member.

# William Lamb Picknell (1854-1897)

For Picknell's biography, the reader should consult the text, and for his sources of style see the paintings of George Inness and Robert Wylie. His progress as a painter is clearly charted in the paintings on exhibition, from the realism of the rugged commons of the *Landes* around Pont-Aven in 1877, to a broader handling in open sunlight, perhaps under the influence of the French painter Pelouse who was in Pont-Aven with his own following of landscape painters at this period. Wylie and nature were Picknell's real teachers, although he had some criticism from Inness and brief study with Gérôme. From Wylie he got his facility with the palette knife and a realist's approach to nature that is akin to Courbet's in dealing with landscape. Unlike Harrison, Picknell could not paint what he did not see before him. When painting a winter picture at Hovenden's Plymouth Meeting studio, he did it from a glass shanty and not from memory. In his view of the Pont-Aven harbor everything is accurate and recognizable from a point looking up toward the last mill and the fall-line, below which is the Grand Sabot, the large rock that legend held to be the shoe of Gargantua. The Chateau de Lezaven is out of sight, up the hill to the left. Picknell sold a small version of the *Road to Concarneau* to the New York collector Robert Gordon before doing the large one here, which Mlle. Julia financed, since Picknell could not afford canvas, paint, or frame at the time, let alone the cost of daily transportation out to the point midway between Pont-Aven and Concarneau along the road of dazzling white crushed quartz that was a marvel of engineering of the Second Empire. Here was a view of modern Brittany, not of the quaint and picturesque, and its success at the Salon led Goupil's Gallery in Paris to offer to take all Picknell could paint, as they had for Wylie. After ten years abroad, Picknell returned to Boston with little to show, since most of his work was sold in Europe, but in Plymouth Meeting, California, Anisquam and Florida he found similar subjects to paint. He died at the age of 42 in 1897.

*The Road to Concarneau* was bought by Fairman Rogers, who was the Pennsylvania Academy's chairman of the Committee on Instruction. Always highly regarded, the picture passed to Thomas B. Clarke, from whose sale it was acquired by William Corcoran for his Gallery.

28. *Landscape, Brittany*, 1877
oil on canvas
22 x 43¾ (55.9 x 111.1)
Private Collection

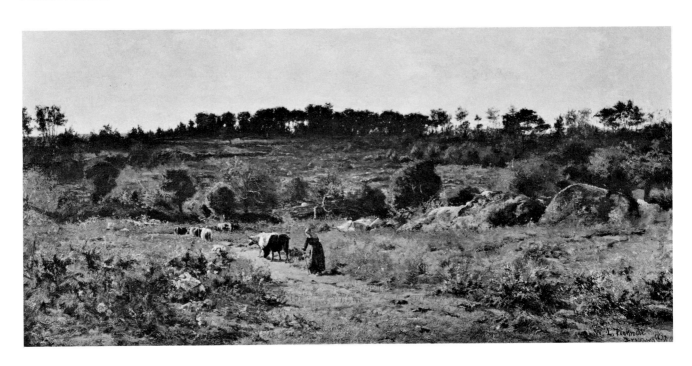

29. *The Road to Concarneau*, 1880
oil on canvas
42⅜ x 79¾ (107.0 x 202.5)
In the Collection of the Corcoran Gallery of Art
color plate 13

30. *Pont-Aven Harbor*, 1879
oil on canvas
30¾ x 45½ (78.1 x 115.6)
Phoenix Art Museum

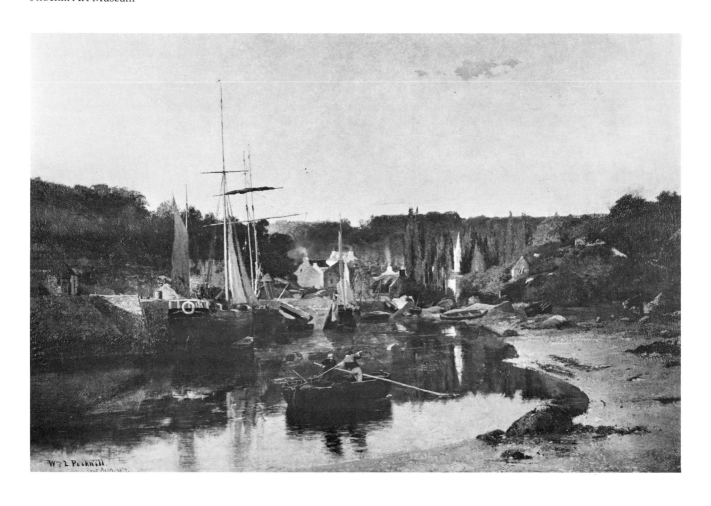

# Milne Ramsey (1847-1915)

31. *Road in Brittany*, 1882
oil on canvas
27¾ x 35¾ (70.5 x 90.8)
Mint Museum Collection: 50th Anniversary Gift of the
Family of Mr. and Mrs. Willis Frank Dowd

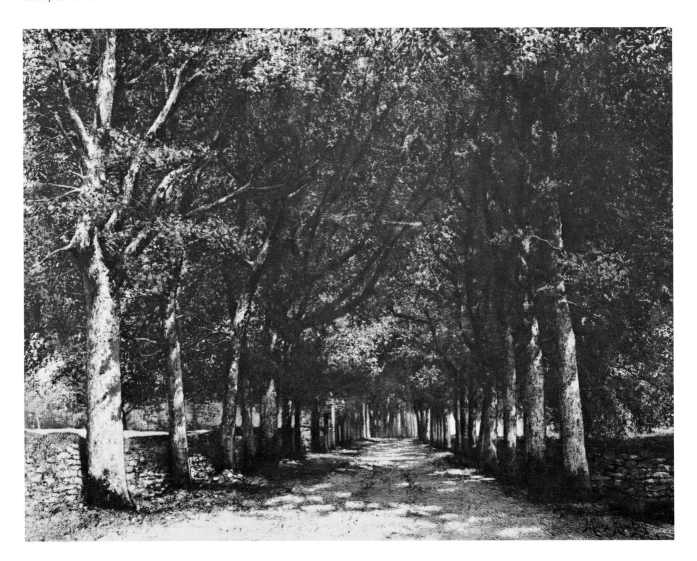

Ramsey had an exhibition of ninety-two Breton and Normandy paintings in 1882, yet few of his Breton paintings are known or recognized today. His first Salon of 1869 was a *Still Life*, and he was given to rococo narrative themes; however, there are several pictures of the roads and allées of trees around the chapel of Tremalo above Pont-Aven, such as this one, which show the thick impasto of Wylie and the general tendency of his circle to an uncompromising and unglamorous realism. Ramsey was a student at the Pennsylvania Academy in 1861. In Paris in 1867, he was with Blashfield in Bonnat's atelier, and later worked with Lippincott and Charles Sprague Pearce there. During the Franco-Prussian War he was in Pont-Aven with Wylie, Bridgman and Swift, and returned later in 1875 with his family and Helen Corson, who was traveling with them. This road to Tremalo might have been in response to the popularity of Picknell's *Road to Concarneau* about the same time.

# Hugh Bolton Jones
## (1848-1927)

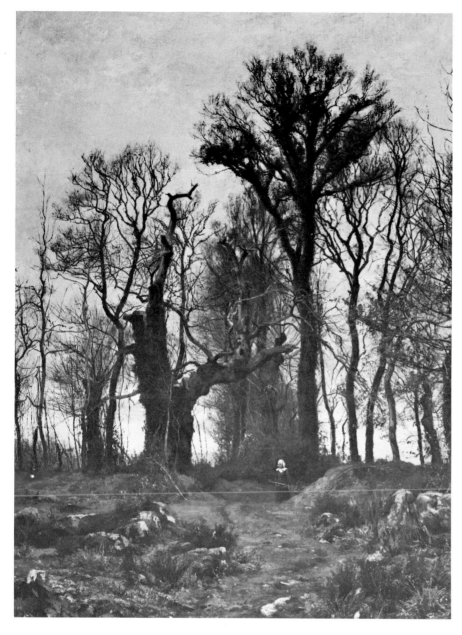

32. *Edge of the Moor, Brittany,* 1877
oil on canvas
31 x 23 (77.5 x 57.5)
Peter H. Moeller

H. Bolton Jones studied in his native Baltimore at the Maryland Institute, and shared a studio with Thomas Hovenden before the departure of the latter for France in 1874. Jones followed, with his brother Frank, and arrived in Paris in 1876. All three painters went that same year to Pont-Aven. The Joneses stayed a year, taking a trip to Spain and North Africa in 1877, but Bolton Jones returned to Pont-Aven in 1878. In the Paris Exposition and in the Salon of that year he exhibited Breton subjects, while a large *Silver Birches* of 1878 (Walker Art Gallery, Liverpool) was exhibited in the Royal Academy of 1880, with a title adapted to the English taste: "When drop the leaves from branches sere, As fade the hopes a vanished year." In 1880, Jones returned to the United States and established a studio with his brother in New York. During the late seventies his style and that of Picknell are very similar, heavily influenced by the personal admonitions of Robert Wylie to be true to nature, and by his own heavy impasto technique. They worked side by side in the open before similar landscape motifs, as can be seen by the Picknell painting of the Breton *Landes* of the same year as Jones' *Edge of the Moor.* Picknell and Jones remained friends in America and painted together with the thirty or so Pont-Aven veterans at Anisquam, Massachusetts.

# Henry Mosler (1841-1920)

Born in New York, Mosler was taken as a boy to Cincinnati where his father opened a lithography shop. While apprenticed to a wood engraver, Mosler was instructed in art by James Beard. After serving as an illustrator for *Harper's* with the Union Army for two years, he continued his art training in Dusseldorf in 1863, returning to Cincinnati in 1866 via Paris, where he studied six months with Hébert. By 1869 he earned enough to return to Munich. There he continued his studies with Alexander Wagner and Piloty, but after his marriage in 1870, Mosler found it hard to make a living in Germany. Colleagues advised him to try Paris, where he moved with his family in 1874.

With the exception of an interlude among Apache Indians in New Mexico, Mosler spent most of the next twenty years in Paris, with summers in Brittany and Normandy. His studio at 11 rue Navarin was furnished with Breton antiquities, which appear in many of his interiors. In 1878, the same year as Hovenden's *Volunteer*, he felt ready to submit to the Salon and had two paintings accepted. The following year he submitted two paintings. Going with his wife to the opening, he was disheartened not to find his pictures; turning into the Gallery reserved for pictures that had been awarded honors and attracted by a crowd around a picture, he was delighted to find the picture to be his own, *le Retour*, which had earned him honorable mention. Two weeks later it was purchased by the State for the Luxembourg Museum, the first work by an American to be so honored. It established his reputation in France and America.

In 1883 Mosler advertised his willingness to receive pupils of both sexes in his atelier in Paris. He became a highly respected member of the American and international communities in the city. Mosler painted his Indian canvases in Paris, as well as his Breton interiors and Normandy coastal scenes, done from sketches and accessories gathered on location. His expense accounts show such items as the purchase of a "tent for the seashore" and installation of glass in his "Breton window." The characteristic *lit clos* (the cupboard bed) in the *Return of the Prodigal* was one of his studio props.

Mosler won many honors in Europe, including the Legion of Honor and election to the French Academy, gold medal at the Salon and silver at the Paris Exposition of 1889. Having been passed over repeatedly by the National Academy for full membership, he resigned as Associate in 1915.

33. *Le Retour*, 1879
oil on canvas
47¼ x 39½ (120.0 x 101.0)
Musée Departemental Breton – Quimper, France

# Burr H. Nicholls (1848-1915)

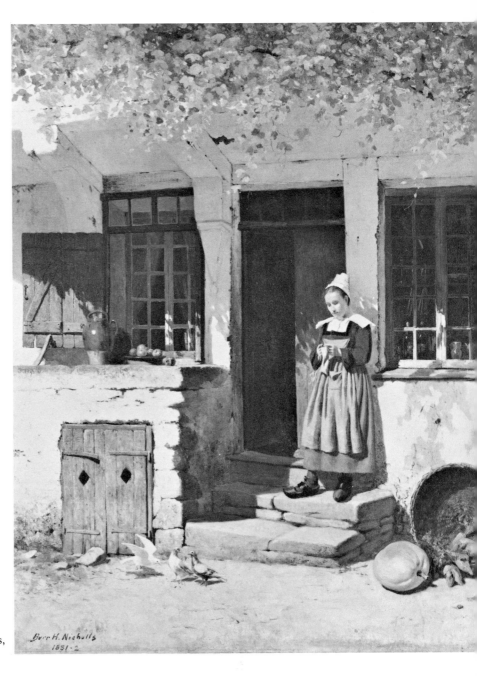

34. *Sunlight Effect*, 1881-82
oil on canvas
51 x 42 (129.5 x 106.6)
The Pennsylvania Academy of the Fine Arts,
Presented by Joseph E. Temple

Burr Nicholls was born in Lockport, New York and studied art in Buffalo with Lars G. Sellstedt before going to Paris and the atelier of Carolus-Duran. He and Frank Penfold, his contemporary from both Lockport and the Buffalo Academy, probably went to Pont-Aven together, since both were there in 1881 and 1882. About 1881 Nicholls was photographed in front of the Pension Gloanec with fellow painters Hovenden, Picknell and Harrison, probably by Helen Corson. All of those who were in Pont-Aven at that time and were concerned with figure painting in broad sunlight effects, gave no concessions to the new theories of Impressionism.

Two of Penfold's paintings were acquired by the French nation, and he exhibited many paintings and monotypes of Breton subjects at the Albright Gallery in 1907, but no appropriate works were located in time for this project. Penfold remained an expatriate and a fixture in Pont-Aven, and around 1900 announced art instruction for students at the Hotel Julia. His suicide by drowning in Concarneau precluded burial in the churchyard, so like Wylie, he found his final rest in Mlle. Julia's family plot.

154

# Arthur Wesley Dow (1857-1922)

Dow arrived in Paris from Boston after several years of rudimentary instruction and in the fall of 1884 enrolled at the Académie Julian in the atelier of Boulanger. With his Boston propensity towards Barbizon tonalism and the big event of the Bastien-Lepage retrospective in the spring of that year, it is not surprising to find Dow attracted to the pearly light of the Breton landscape painters; a landscape that differs little from some parts of the familiar New England coast. During the summer of 1885, Dow went to Pont-Aven and Concarneau, the year H.R.

Butler arrived and the year of the rival baseball series. He visited Simmons (the "Hamor" of the novel *Guenn*) his last year there. Dow returned to the region in 1886 and again in 1888 when he painted *Au Soir* under the criticism of "Shorty" Lasar and Alexander Harrison. This was the summer Beaux painted *Twilight Confidences* and when Gauguin was in Pont-Aven. *Au Soir* won Dow honorable mention at the International Exposition of 1889 and the artist considered it one of his finest paintings.

# T. Alexander Harrison (1853-1930)

36. *In Arcadia: Study,* c. 1885
oil on panel
8¾ x 16¼ (22.2 x 41.3)
Mrs. and Mrs. Jeffrey R. Brown

37. *The Wave,* 1884-85
oil on canvas
39¼ x 118 (99.7 x 299.7)
The Pennsylvania Academy of the Fine Arts, Temple
Fund Purchase
color plate 16

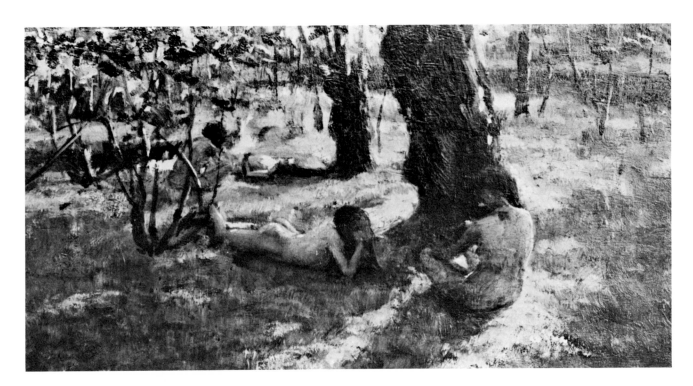

Since Harrison is dealt with at length in the text, it is only necessary to underscore that his present oblivion is in direct contrast to his real importance and solid reputation during his lifetime. From Philadelphia, and with art training in San Francisco, his feel for the coast probably reflects his experience, like Whistler and H.R. Butler, with the U.S. Coastal Survey. Harrison arrived in Pont-Aven before the dispersal of Wylie's circle (Hovenden, Swift, Picknell, and others) and painted figures in the open light of the Chateau courtyard. Later he evolved the technique of working large from memory, from observation of sunlight effects and twilight moments, aided by quick studies like the one of the nude figures in the sun-dappled grove. This was one of the studies done for his *In Arcadia,* later acquired by the French State, and very influential on the international Paris art community. Sargent painted naked bathers on a Capri beach, and the Impressionists were doing the same in their gardens, but somehow Harrison made it respectable on a large scale for official exhibition, and the trend continues among Americans until the motif is typical in Giverny by 1910. In Paris and Concarneau he was an extremely influential teacher, with a particular charm for the ladies like Cecilia Beaux and Kate Kinsella, but was highly regarded also by Robert Henri and Edward Redfield, who sought him out in Concarneau. Harrison visited Giverny as well, and may have painted there, but is most closely associated with Concarneau and Pont-Aven.

39. *Girl Knitting, Concarneau*, 1882
oil on canvas
18 x 15 (45.7 x 65.1)
Private Collection
(overleaf)

38. *Le Pardon*, 1893
oil on canvas
28½ x 51 (72.4 x 129.5)
Colby College Museum of Art, Gift of
Mr. and Mrs. Bronson W. Griscom

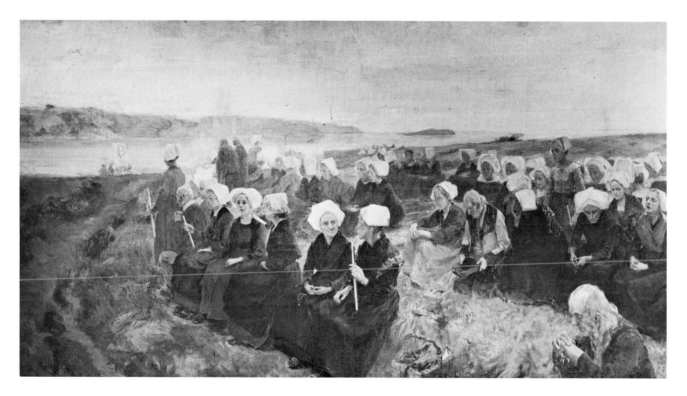

Before going to Paris in 1876, Gay briefly herded cattle in Nebraska on an uncle's ranch. In his native Massachusetts, he had studied painting with another uncle, W. Allan Gay, a pupil of Troyon and a veteran Barbizon painter from 1847 to 1850. In Paris Gay studied two years with Léon Bonnat, making a special trip to Madrid on the advice of his professor to see Velasquez and the Spanish tenebrists. His first Salon picture was in 1878 and he exhibited regularly thereafter, earning honorable mention. In 1889 his first large figure painting was acquired from the Salon for the Luxembourg. In the fall of 1882 Gay was in Pont-Aven, Rustephan and in Concarneau, where he painted the *Girl Knitting*. Gay was one of the first generation of Concarneau painters, along with Sim-

mons, Hoeber and the Harrisons. The Pardons of Brittany were religious festivals commemorating local saints' days or events of regional significance, and were occasions for assembly and parades in the finest costume, a popular motif for painters in the area. Gay's *Waiting for the Pardon* was done in 1893, and many of his most successful paintings were of Breton subjects. He married in 1889 and his lifestyle and subject matter changed. "Before 1895 we had visited Normandy, Brittany...and Tourraine. The trains were inconvenient, the inns detestable, but the monuments and the landscape made up for material drawbacks, and our great luxury was that we met no tourists," he wrote in his memoirs.

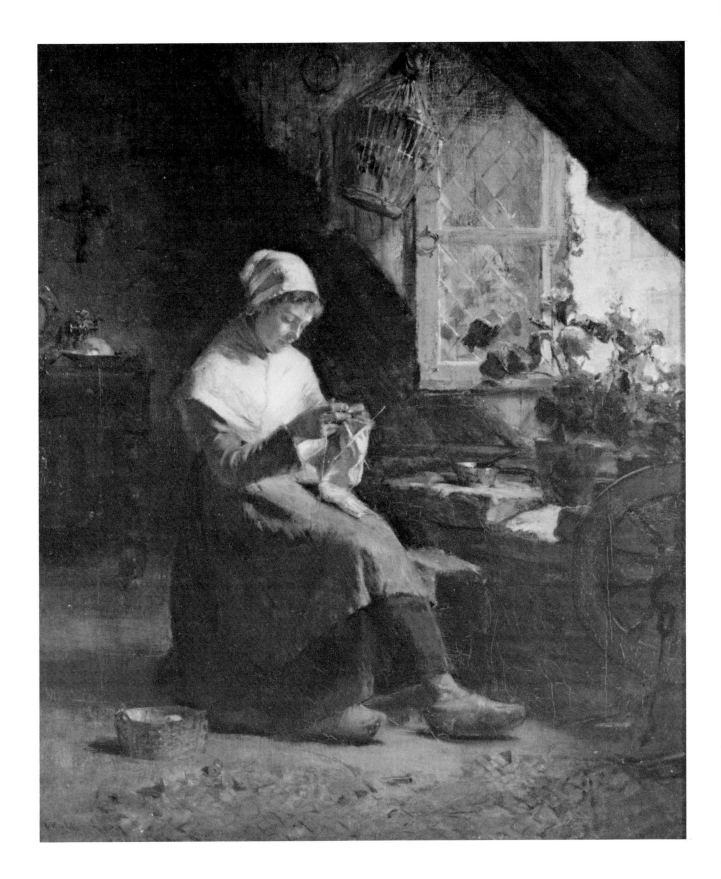

40. *A Breton Sunday*, c. 1890
oil on canvas
36½ x 29⅛ (92.6 x 74.0)
National Museum of American Art, Smithsonian
Institution, Gift of Mary B. Longyear

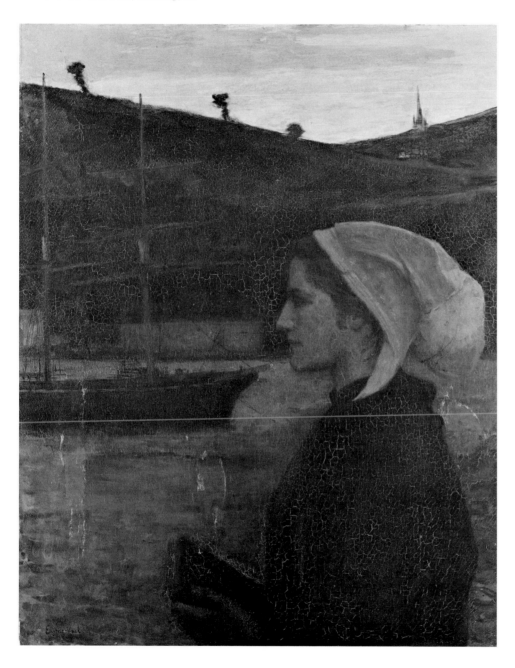

Vail was born in Brittany, in St. Mâlo or nearby St-Servan, to an American father and Breton mother. Before embarking on a career in art, studying with William M. Chase and Beckwith at the Art Students' League, Vail earned an engineering degree at Stevens Institute in Hoboken, N.J. In 1882 he was back in France at the École des Beaux-Arts with Cabanel, and painting in Pont-Aven, Concarneau and along the coast of Brittany. The composition and mood of this painting suggests an awareness of the symbolist painters of Pont-Aven of the 1880s. Vail married an American from Providence, Rhode Island, but remained an expatriate in France, earning honors in International exhibitions and the highly prized Legion of Honor.

# Howard Russell Butler (1856-1934)

Butler studied drawing as a boy in Yonkers before earning degrees in science and law from Princeton and Columbia. In 1877 he went west to the Rockies with a scientific expedition before returning to New York to do legal and scientific work with the telegraph and telephone, and to practice electrical patent law. Deciding on a career in art in 1884, Butler studied in Mexico with the topographical painter of cosmic panorama, Frederick E. Church, and at the Art Students' League under Beckwith and Brush, old students of Carolus-Duran and Gérôme. He also frequented a Bohemian restaurant where he met artists back from France, such as Blashfield, Bunker and others familiar with Brittany. Going to Paris in May 1885, he saw Harrison's *Wave* at the Salon and soon afterwards followed the American artist summer migration to Concarneau, where he painted the studies for the *Seaweed Gatherers*, a painting which was to win him a mention at the Salon and the Temple Gold Medal at the Pennsylvania Academy. Although he later received instruction in Paris from Roll and Gervex and Dagnan-Bouveret, whom he probably met in Concarneau, this painting was done under the guidance of Alexander Harrison and Lasar before he had the benefit of academic instruction in Paris.

41. *The Seaweed Gatherers,* 1886
oil on canvas
46¾ x 96¼ (118.7 x 245.1)
National Museum of American Art, Smithsonian Institution,
Gift of Howard Russell Butler, Jr.

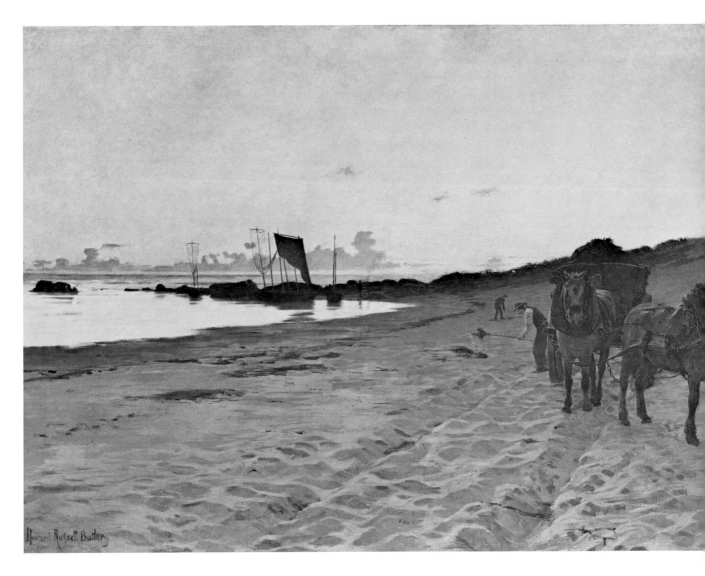

# Edward Emerson Simmons (1852-1931)

42. *Awaiting His Return*, 1884
oil on canvas
21 x 15¼ (53.3 x 38.7)
Mr. and Mrs. Tony D. Andress, Sr.
color plate 2

Simmons was brought up in the Old Manse in Concord, Massachusetts, knew Thoreau as a boy, graduated from Harvard in 1874 and decided to try his luck in the West. Fired as an oil salesman in Cincinnati, he went to San Francisco, and quit a clerk's job to go to a frontier school as teacher. Returning east after good adventure, he taught art in Bangor, Maine, studied painting at the Boston Museum School and studied anatomy with Dr. Rimmer before leaving for France and the Académie Julian in 1879. With his admission to the Salon in 1881 he established his studio in Concarneau. Simmons is the basis for the character Hamor in the novel, *Guenn*, discussed elsewhere in the text, and the real focus of the initial American group at Concarneau, where he was soon joined by Alexander Harrison, Gay, Lasar and others, to whom he left the honor in 1886 when he helped, unwittingly, to establish the St. Ives colony in Cornwall, across the Channel. In both colonies the plein-air realism and "square brush" painting of Bastien-Lepage was highly influential, and for Simmons it established the high key on the tonal scale common to painters in the broad open daylight. His model for the girl awaiting the return of the fishing fleet may not be *Guenn*, but she is typical of the girls of "Sardine-opolis," as Harrison called Concarneau, as is the practice established by Simmons of posing them in the sunlight. Simmons was later a charter member of the group of New Yorkers known as "The Ten," and a distinguished muralist.

# Henry R. Kenyon (d. 1937)

43. *Breton Landscape (near Pont-Aven)*, c. 1886
oil on canvas
10 x 16 (25.4 x 40.6)
Private Collection

This Breton landscape, painted by the Providence, Rhode Island artist Henry Kenyon, was given to his friend Arthur Dow, whom he met in Paris. They were together at Julian's, and in 1885, 1886 and 1888 were in Pont-Aven and Concarneau. Kenyon knew Alexander Harrison and Lasar, and would have heard their views on art. In Pont-Aven he had ample opportunity to know those of Gauguin's circle. He painted directly with a loaded brush, a technique fairly typical of the landscapes of the plein-air painters of the time. Kenyon later shared a studio with Dow in Ipswich, Massachusetts, where they were joined by other artists of their generation who had worked in Pont-Aven and its environs.

# Charles Augustus Lasar (1856-1936)

**44.** *Farmhouse in Normandy*, c. 1900
oil on canvas
13 x 16 (33.0 x 40.6)
Private Collection

"Charles A. Lasar, 80 year old artist and teacher, who is known to practically all artists who have visited Paris as 'Shorty', is reportedly seriously ill," reported *The Art Digest* on January 15, 1936, adding that 'Shorty' is one of "the most widely loved men who ever lived." He was a fixture of the Montparnasse colony in Paris, where he established an art school, wrote a book on art hints for students, and was a regular at the Café le Dôme. Like an athletic Toulouse-Lautrec in stature, he managed the Concarneau baseball team in 1886, and after World War I was still able to snag a high fly with mighty leaps, or play billiards with the best by climbing on the table. Howard R. Butler, Arthur W. Dow, Cecilia Beaux, and Robert Henri were among those to benefit from his criticism in Concarneau in the 1880s. A student of Gérôme at the Beaux-Arts, Lasar evolved his own theories that each painting should be different, suggesting its own style, so it is today difficult to generalize about his art until more of it is located. Macbeth Gallery in New York exhibited his paintings, but he found few buyers in this country.

# Cecilia Beaux (1855-1942)

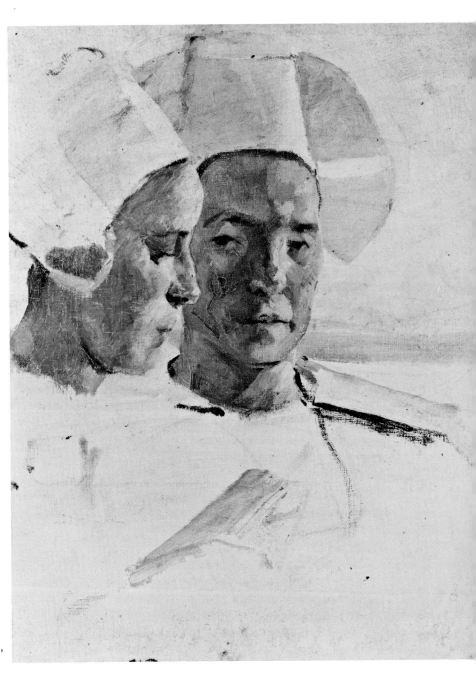

45. *Study for Twilight Confidences:*
*Two Heads (Two Breton Women*
*by the Seashore),* 1888
oil on canvas
10⅝ x 15⅛ (27.0 x 38.4)
The Pennsylvania Academy of the Fine Arts,
Gift of Henry Sandwith Drinker

*Twilight Confidences,* like the painting by Simmons posed for by Guenn, was successfully exhibited in the United States, and has since vanished from view. It was closely based upon the advanced study included here, which was done in the studio from annotated studies on the beach at Concarneau during the fifteen minute passage of the transient effect of approaching dusk. During this summer of 1888, under the criticism of Harrison and Lasar, Beaux abandoned the dark tonalities she had acquired from Eakins and his students in favor of the higher key of plein-air painting.

46. *Girl on Beach (Concarneau)*, 1889
oil on canvas
13 x 16 (33.0 x 40.6)
Chapellier Galleries, New York

47. *Le Pardon – Concarneau*, 1899
oil on canvas
25¾ x 32 (65.4 x 81.3)
Collection of Cornelia and Meredith Long
*Exhibited in Phoenix and Washington, D.C. only*
color plate 11

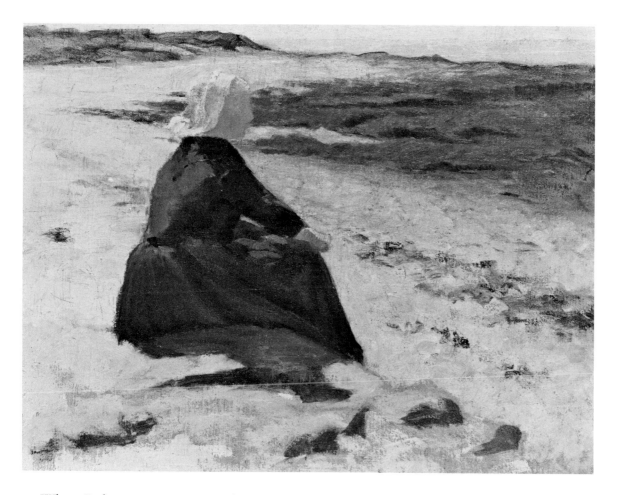

When Robert Henri came to the Pennsylvania Academy as a student in 1886, Thomas Eakins was gone but his program was still fundamentally intact, with the addition of separate professors for drawing, painting, sculpture, and so on. This replaced what had in effect been the Eakins atelier. Thomas Anshutz taught the fundamentals and Thomas Hovenden was professor of painting when Henri, Edward Redfield, Alexander S. Calder and others started their studies. They had the benefit, therefore, of one of the strongest artistic anatomy courses in existence, thorough grounding in life class and cast drawing (which Anshutz had re-emphasized), and also the criticism of the old comrade of Robert Wylie from Pont-Aven. Hovenden lived with his wife Helen Corson in nearby Plymouth Meeting, a gathering place for the old Pont-Aven painters like Picknell and Bolton Jones. Henri and some others went to Paris and the Académie Julian in 1888. After taking in the Expositon they had their first experience painting the figure directly in the open light on the beach at Concarneau, under the critical supervision of "Shorty" Lasar and Alexander Harrison. On his return to Philadelphia Henri studied with Robert Vonnoh at the Academy, so he was well grounded in Impressionist theory. This he rejected on his return to France in 1895, and the Breton paintings of 1899 are brooding and darkly painted expressions. In 1899 the French State bought one of his paintings for the National collections, still a rare compliment for an American.

48. *Farmhouse in Brittany,* 1902
oil on canvas
26 x 32 (66.0 x 81.3)
Chapellier Galleries, New York

49. *Breton Street,* 1902
oil on canvas
6½ x 10 (15.2 x 24.1)
Mr. and Mrs. Thomas A. Campbell, Jr.

# John White Alexander (1856-1915)

50. *Landscape, Le Pouldu*, c. 1892
oil on canvas
35½ x 47¾ (90.2 x 121.3)
Natalie Reed
color plate 14

51. *Shrine on the Bridge, Honfleur, Normandy*, c. 1883
oil on panel
10 x 17 (25.4 x 43.2)
Private Collection
color plate 15

John White Alexander, like Mary Cassatt, was from Allegheny City near Pittsburgh, but of a younger generation. After a few years in New York working as an illustrator for *Harper's Weekly* he set out for Munich, and in 1877 was with Twachtman and the other Americans around Chase and Duveneck at Polling. He was with the "Duveneck Boys" in Venice in 1879, when Whistler made his everlasting impression on them, and returned to the United States in 1881. In New York he found himself again at work as an illustrator, and Henry James urged him to go back to Europe. In 1891 he was in France, with renewed contact with Whistler in Paris, when health required him to withdraw from the city. It was then that the Alexanders found their way to the hotel Goulven in Le Pouldu. Guy Ferris Maynard was also there, and in a village with only two inns and a few houses, they could not have missed knowing the decorations that filled the other inn of Marie "Poupée," which was still in operation in the summer of 1892. Gauguin was not there, but many of his entourage still made it their retreat, and with the walls, windows, and woodwork covered with their paintings it must have made a Serbian monastery look tame by comparison. Alexander's painting looking over the estuary is serene by any standards, and shows no sign of recognition of the revolution going on next door. It has instead the same broad and horizontal rhythms as landscapes done in Arques-la-Bataille and Bethune by his fellow student in Munich and Polling, John Twachtman, on his introduction to France and renewed awareness of Whistler.

Twachtman was a visitor in Normandy, and not a settler in any art colony. His early life was spent in the German community of Cincinnati, where he worked in his father's trade as a window shade decorator and studied art at the mechanics Institute and McMicken School. Frank Duveneck was back from Munich doing portraits, and when he returned in 1875 the young art student accompanied him, studying at the Bavarian Royal Academy and working with other Americans in nearby Polling; with them he went to Venice in 1877. After a few years in Cincinnati and New York, Twachtman returned to Florence as an instructor in Duveneck's school during 1880-81, and when the school closed he returned to New York. It was not until his next tour of Europe between 1883 and 1885 that he surrendered his dark Munich manner to French plein-air influence. He enrolled at the Académie Julian in the Boulanger-Lefebvre atelier and painted landscapes in Normandy and Picardy. This combination of Munich-Venice-Paris at this time seems to have been a potent formula for him, as well as for William M. Chase, Theodore Robinson, Theodore Wendel and John White Alexander. Without losing rich, broad paint surface, the palette lightens, and in the case of Alexander and Twachtman there is an apparent reaffirmation of Whistler's influence, to which they had already been exposed in Venice. The Honfleur paintings by Homer Martin and Frank Boggs were done at about this same time, and offer interesting contrast.

# Robert Henry Logan (1874-1942)

52. *Cider Drinkers*, c. 1900
oil on canvas
15 x 18 (38.1 x 45.7)
Mr. and Mrs. Howard Kiviat

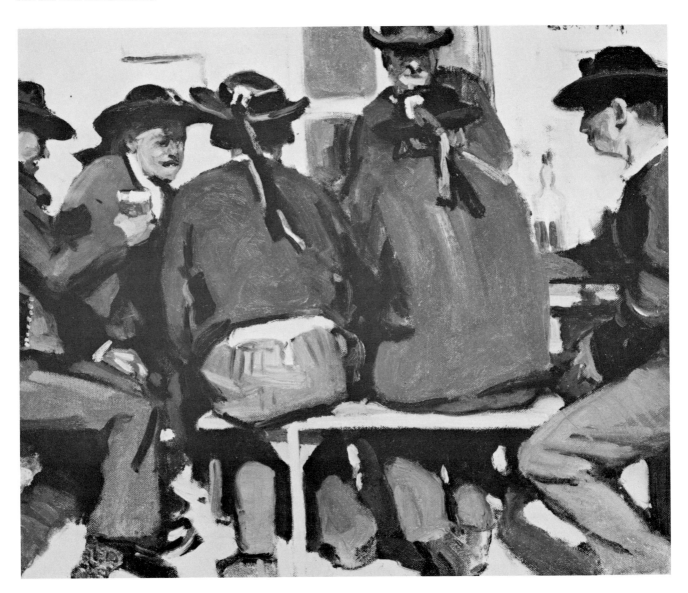

Logan was eighteen when he entered the Boston Museum School and studied with Frank Benson and Edmund Tarbell. In 1895 he went abroad and was intermittently at the Julian school for the next eight years. Soon after his arrival he joined the atelier formed that year by Robert Henri, and took a studio in the same building as Henri and J.W. Morrice. Around 1900 all of them were frequent visitors to Concarneau and le Pouldu and other areas of Finistère. Like many others Logan used the "pencil of nature" of photography to compose pictures, and was an excellent composer with the camera. He also did very electric direct impressions in his *pochades* at the beach of le Pouldu – vivid little color notes brushed thickly onto small panels. He returned to Massachusetts in 1910.

**54.** *Crowded Beach, Le Pouldu*, c. 1900
oil on panel
7⁷/₁₆ x 9¹¹/₁₆ (19.0 x 24.4)
The Shepard Family Trust
color plate 10

**53.** *Red Bather*, c. 1900
oil on panel
7⁷/₁₆ x 9 ¹¹/₁₆ (19.0 x 24.4)
The Shepard Family Trust

55.  *The Dock in an Art Humor,* 1909
pastel on paper
36 x 18½ (91.4 x 47.0)
Alice Fromuth Robinson

Charles Fromuth studied at the Pennsylvania Academy for five years with Thomas Eakins, and became prosector of his anatomy course. In 1889 he had earned enough money by textile design and model making to go to France, and arrived in Paris in time to catch the Exposition. His experience at Julian's with Bouguereau was more annoyance than education, since he found his own background in Philadelphia far more comprehensive than what was offered. He went to Brittany in 1889 with the intention of living in Pont-Aven, but stopped at Concarneau. He remained a fixture in the village for more than forty years, using the sardine fleet and the harbor in its every mood for his motif, establishing pastel as his chief medium.

56. *The Green Dock Waters #1,* 1897
pastel on paper
12½ x 24 (31.7 x 60.9)
Alice Fromuth Robinson

# Childe Hassam (1859-1935)

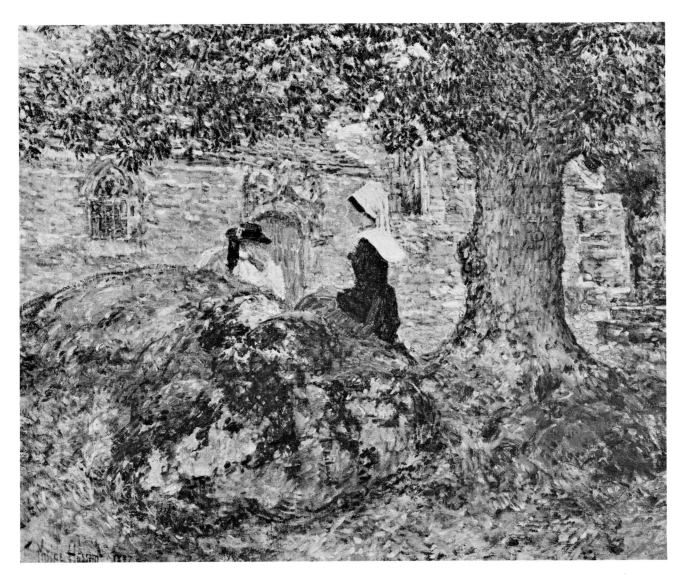

Hassam was an accomplished landscape painter and a married man before he went to Paris for study. He had some training in art, was a skilled wood engraver, and had toured Europe, but in 1886 he enrolled in the atelier of Boulanger and Lefebvre at the Académie Julian for three years, during which time he won notice for cityscapes exhibited at the Salons and was medaled at the Exposition of 1889. It was more an education by osmosis than a process of formation. During the 1890s he was closely associated with Robinson, Twachtman and Weir, and before he returned to France and Pont-Aven in 1897 he had become a part of their Cos Cob colony in the United States. He must have spent a good bit of time in Pont-Aven during his year's stay, given the number of known works done there. In contrast to the earlier Paris paintings, which belong to an international Impressionist movement, the Pont-Aven paintings are more cerebral, more cognizant of the use to which Pissarro put *pointillisme* and of the brush stroke of Van Gogh. Many have an experimental quality that he seems to abandon on his return to America in favor of a full-blown optical Impressionism. The year of his return he joined the group that became known as "The Ten," and that summer of 1898 went with Alexander Harrison to paint in the art colony at East Hampton, Long Island.

57. *In Brittany (Tremalo)*, 1897
oil on canvas
23½ x 28⅞ (59.7 x 73.3)
Hirschl and Adler Galleries, Inc., New York
(also cover illustration, upper)

58. *Pont-Aven*, 1897
oil on canvas
35¾ x 31⅝ (90.8 x 80.8)
Private Collection

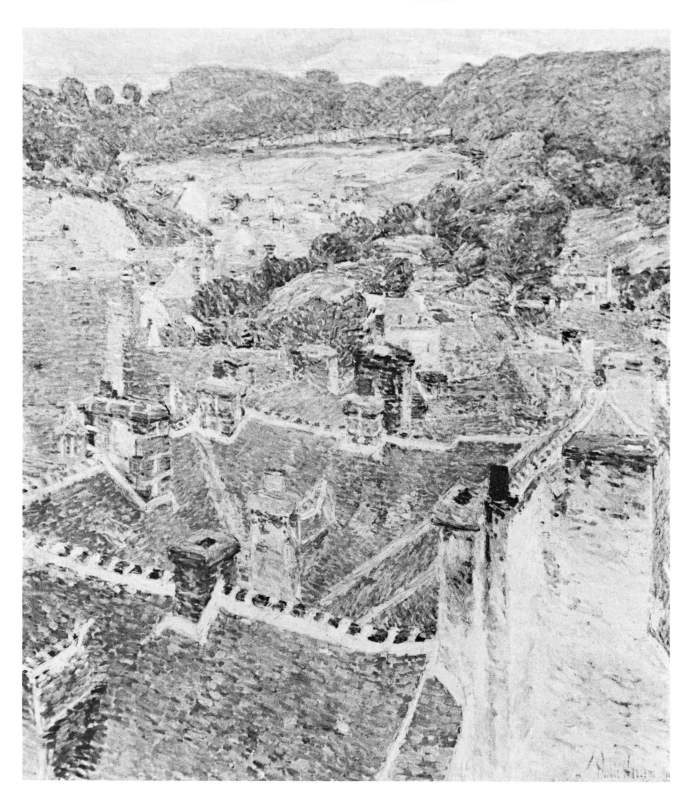

# Guy Ferris Maynard (1856-1936)

59. *Breton Interior*, c. 1895
oil on canvas
25¼ x 20¾ (64.0 x 53.0)
Private Collection, France

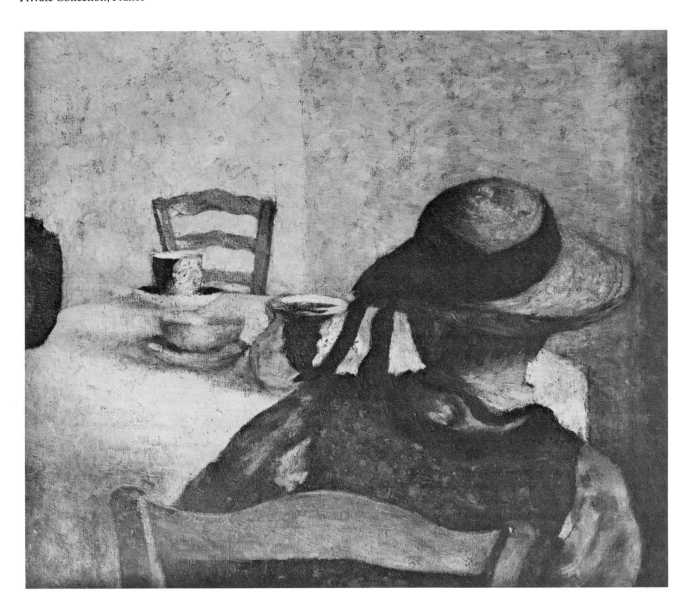

Of Guy Ferris Maynard there is little known at present. The few biographical notices in the American Art Annual mention only that he was born in Chicago and studied at the Chicago Art Institute. Between 1895 and 1902 he exhibited a dozen or more paintings there – landscape, still-life and other titles. As early as 1886 he was a guest at the Hotel Chevillon in Grez, and gave his address as Grez in 1903, but apparently his particular association was with Brittany. He was in le Pouldu with the John

White Alexanders in 1891, and Mrs. Alexander left the graphic description that is reprinted in the text. During the late 1920s he was present with Charles Fromuth at a gathering of the old guard of the international artist community in Concarneau, and was photographed with Charles Fromuth, Hirschfeld and others. The lender of the present example found the work in a flea market in France, and attempts to locate other examples in public or private collections in this country have so far met with no success.

174

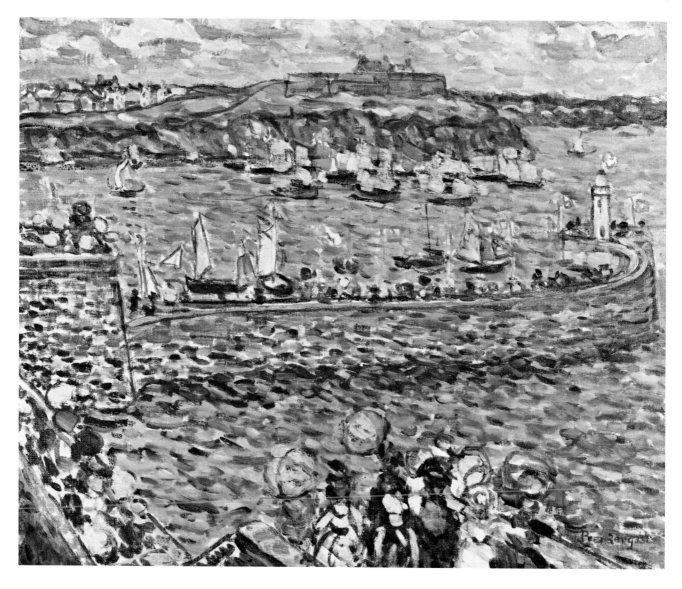

Prendergast arrived in Paris from Boston in 1891, the year of the first exhibition of the group that called itself the *Nabis.* Paintings done shortly after his arrival in Dinan and Dieppe on the coast show a sensitivity to surface pattern, but by 1892, when he painted again at Dieppe, he had absorbed much of what his fellow Julian students espoused, to the extent that the Whitney Museum picture could have been shown at the time along with Bonnard, Vuillard and Valloton without seeming out of place. There is a masterful balance between image and design, field and ground. It is bold in the abstract pattern of horizontal banding and vertical line, and the laying on of the paint fortells his later New York Central Park pictures. He was already in the vanguard of modern French art in 1892, the art he brought back to Boston in 1895. The 1909 view of St. Malo exhibited here was done after several more European voyages, each one of which brought new stimuli. Venice introduced him to the rich color of the Adriatic and of Byzantine Mosaic. In Paris in 1907 he was so exhilarated by the watercolors of Cézanne and the new paintings of Matisse and the Fauves that he "had to run up and down the boulevards to work off steam!...I am delighted with the younger Bohemian crowd. They outrage even the Byzantines...with their brilliant colors."[1] Of the group called "The Eight" with which he exhibited the following year he was the only truly international contemporary artist, and his paintings were called "slop" by the critics, and likened to an explosion in a color factory.

[1]Eleanor Green, *Maurice Prendergast: Art of Impulse and Color* (exhibition-catalogue), 1976, University of Maryland Art Gallery, p. 23.

60. *The Lighthouse, St. Malo,* 1909
oil on canvas
20 x 24⅝ (50.8 x 62.9)
The William Benton Museum of Art, The University of
Connecticut, Anonymous Donor
(preceding page)

61. *Dieppe,* 1892
oil on canvas
13 x 9¾ (33.0 x 24.8)
Whitney Museum of American Art, New York, 1939

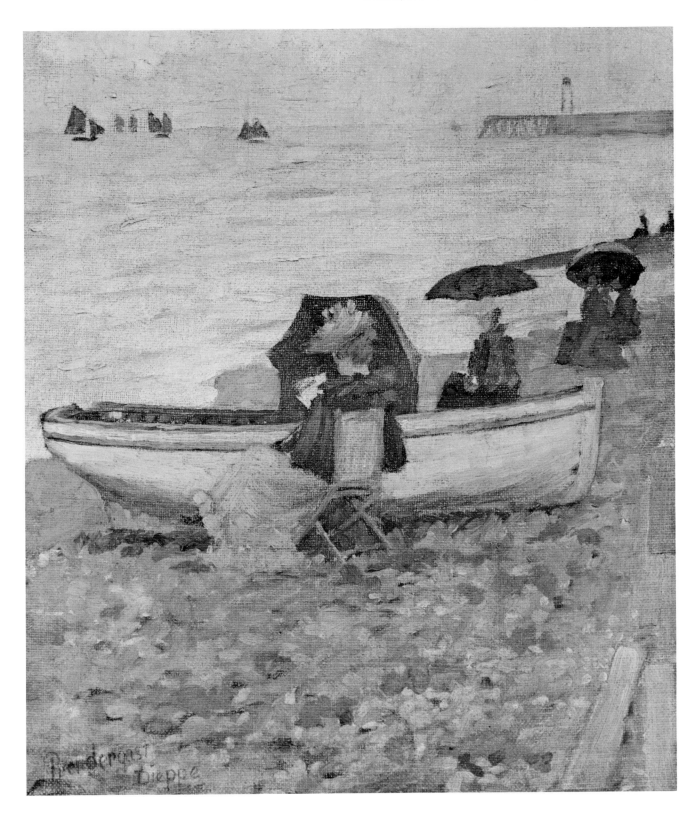

# Normandy

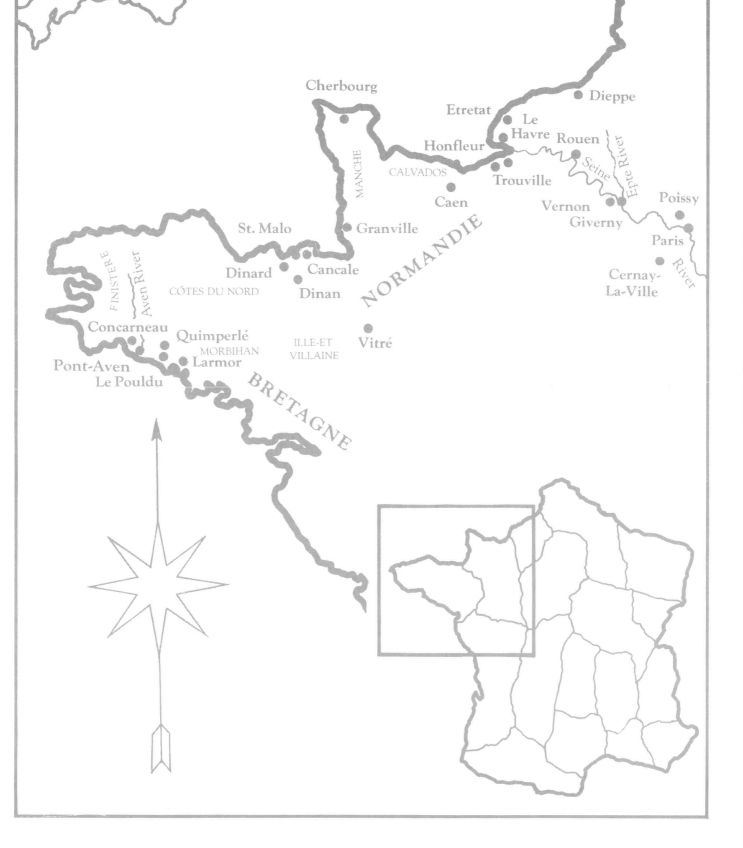

# Winslow Homer (1836-1910)

62.  *The Gleaners*, 1867
oil on panel
6 x 18 (15.2 x 45.7)
Courtesy of Peter H. Davidson & Co., Inc.
color plate 4

Halfway between Paris and Chartres, Cernay la Ville is not strictly within our exhibition confines, but it is westward, and was a favorite village for painters because of a sympathetic hotel and abundant motifs. This panel by Homer was done during his stay in France after the Exposition of 1867, painted as a souvenir panel for the hotel in which he stayed. Homer was there with J. Foxcroft Cole, and several of his paintings from Cernay are known. He painted in a manner quite similar to Vedder, with whom he had painted in Newport prior to his travels in France.

In France, Homer saw the world's art at the Exposition, sketched in the Louvre, and had the free society of French and American landscape artists out in their natural habitat at Cernay before going home to take up painting in earnest.

64. *Etretat*, 1875
oil on canvas
29⅞ x 44¹⁵/₁₆ (75.8 x 114.1)
Wadsworth Atheneum, Hartford, The Ella Gallup Sumner
and Mary Catlin Sumner Collection
color plate 5

63. *Etretat*, 1875
oil on canvas
30¼ x 45¼ (76.2 x 114.9)
The Art Institute of Chicago, Gift of Edward B. Butler

Inness was a contemporary of William M. Hunt, but while Hunt was studying with Couture and at the feet of Millet in Barbizon, Inness was mastering the structure of landscape in the clear light of the Roman Campagna. With solid work behind him, he came to Paris in 1854 when the three-way controversy among the Classic, Romantic and Realist artists was at one of its periodic climaxes, and found French landscape painters a revelation. Like Hunt, he returned to America at about the time Whistler arrived in Paris to commence his studies. But while Hunt brought Barbizon Tonalism to Boston, Inness bathed the *Lackawanna Valley* in Italian light in his landmark painting of 1855 in the National Gallery. Maintaining studios in New York and near Boston, and painting

his own broadly atmospheric renditions of motifs dear to the old Hudson River and White Mountain painters, he inspired and encouraged young artists like William E. Norton to follow their inclination to paint landscape in their own manner.

Inness was in Boston for the influx of Barbizon painting encouraged by Hunt and the Allston Club, and for the arrival of the great Courbet *La Curée* and innumerable Corots and Millets. When he returned to Europe in 1870 it was again to Italy for several years. He returned to Boston in 1875, but not before a sojourn in Paris and Etretat, where he seems to have renewed his contact with the robust Realism of Courbet.

**65.** *Rocs de Toqueville*, 1878
oil on canvas
33 x 63 (83.8 x 160.0)
Private Collection

# Edward Moran (1829-1901)

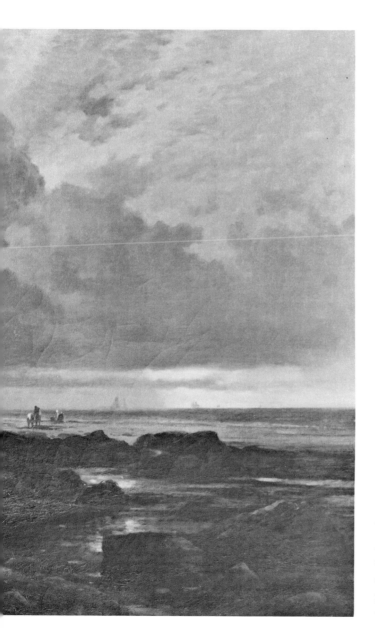

Marine painter Edward Moran, older brother of Peter and Thomas Moran, emigrated with his family as a boy from England to Baltimore. Weavers by trade, they found themselves weaving again in America and, in 1852, Edward was a power-loom boss in Philadelphia. Meanwhile, he studied drawing with Paul Weber and James Hamilton, a painter of dramatic sea pictures in the manner of Turner. Before returning to Europe in 1861, he had established himself in Philadelphia as a painter of substance and was elected a Pennsylvania Academician. This honor he renounced in 1869 after a bellicose confrontation at the previous annual exhibition when, dissatisfied with the position given his works, he cut one from the frame and blanked out the ones he left with an opaque solution on "varnishing day." In 1870 he removed to New York, which was not a bad move considering that the only art institution in Philadelphia closed down until 1876. He sold the contents of his studio in 1877 to finance a trip abroad and arrived that summer with his family for a year in France where he painted *Rocs de Toqueville*, one of his most dramatic paintings, still in the tradition of Turner and James Hamilton. France did not affect Moran that much, and it is of particular interest to see what Americans like Inness, Moran, Sargent and Cole were doing about the same time on the French coast. Moran probably went to Pont-Aven to visit his friends the Ramseys, as Annie Ruff Ramsey's souvenir scrap-book suggests.

181

# Stephen Parrish (1846-1938)

66. *Drying Sails at Granville, Normandy,* c. 1885
oil on canvas
28½ x 35½ (72.4 x 90.1)
Mr. and Mrs. Roy Garrand

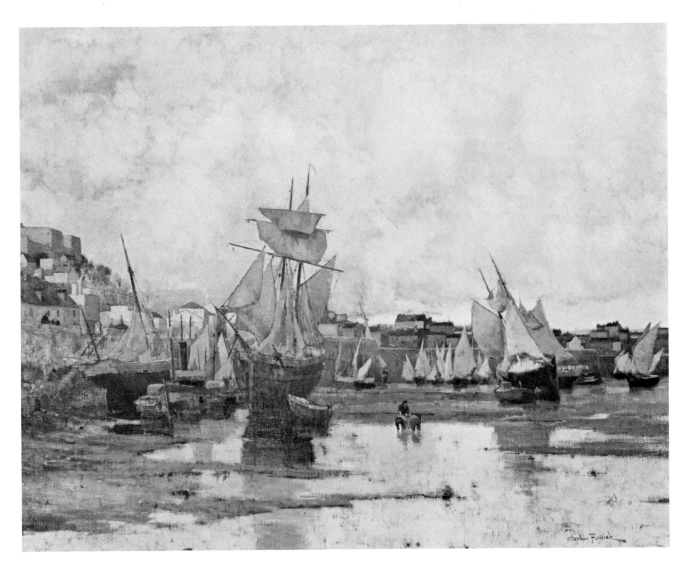

Parrish was born and raised in Philadelphia. He liked to say he was self-taught. However he did have some local instruction and was active in the Philadelphia Sketch Club. During these years while his interest in art was maturing, between 1870 and 1877, there were no Pennsylvania Academy courses. Joseph Pennell was active in Philadelphia at this time when Parrish began his own career as an etcher. From 1884 to 1886 he traveled to France with his wife and son Maxfield, and spent some time in Normandy and Brittany working on the Rance River, which flows north from Rennes through Dinan to Dinard and St. Mâlo, and at Granville to the north in Normandy. This large painting of *Drying Sails* was painted in Granville about the time his friends Charles Platt and Dennis Bunker were painting together in Brittany.

67. *A Rough Day at Honfleur Harbor*, 1884
oil on canvas
65 x 38 (165.1 x 96.5)
Museum of Fine Arts, Boston, Gift of the
American Art Association

Frank Boggs was a wood engraver with Harper's before going to Paris in 1876 to the atelier of Gérôme in the École des Beaux-Arts, one month before Theodore Robinson entered the atelier. He remained two years, returned to New York for two years and then went back to Paris in 1880, when he first exhibited at the Salon. In 1883 a painting was purchased by the French State for the National Museums, and the following year he painted *A Rough Day in the Harbor of Honfleur*, which was awarded the American Art Gallery prize the following year. He was best known for his harbor views in France, Holland and New York, and his paintings have the international character of the painters of the coast from the mouth of the Seine to the mouth of the Rhine.

# James David Smillie (1833-1909)

68. *Le Manneporte, Etretat*, 1884
oil on canvas
16 x 23 (40.6 x 58.4)
Jeffrey R. Brown Fine Arts

69. *Falaise d'Aval, Etretat*, 1884
oil on canvas
22 x 15¾ (55.8 x 40.0)
Jeffrey R. Brown Fine Arts
(opposite)

Born in New York, the son of an engraver, Smillie was trained in the craft and began work for the American Bank Note Company, before branching out into more creative forms of graphics. Aside from a brief trip to Europe in 1862, his entire art experience while maturing was in America. In August of 1884 he was in Etretat and painted the motifs so familiar to us through Courbet, Monet, Inness, and Bacon. His dramatic lighting, color and composition are reminiscent of Thomas Moran's western American landscapes, and indeed the two artists were associated on at least one western journey before these Etretat paintings were executed.

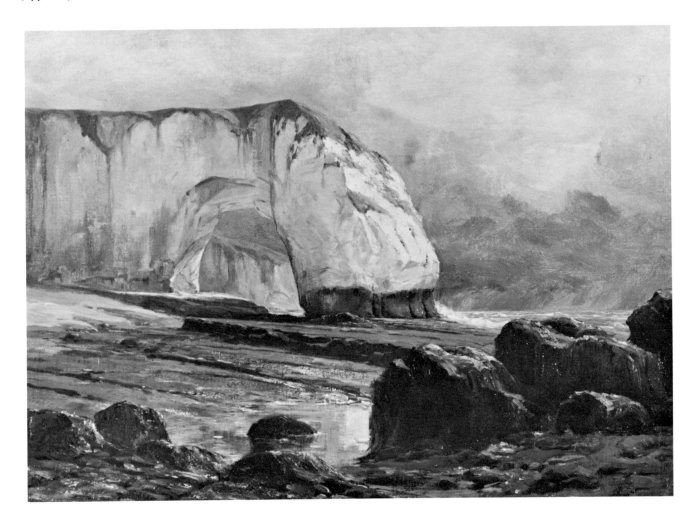

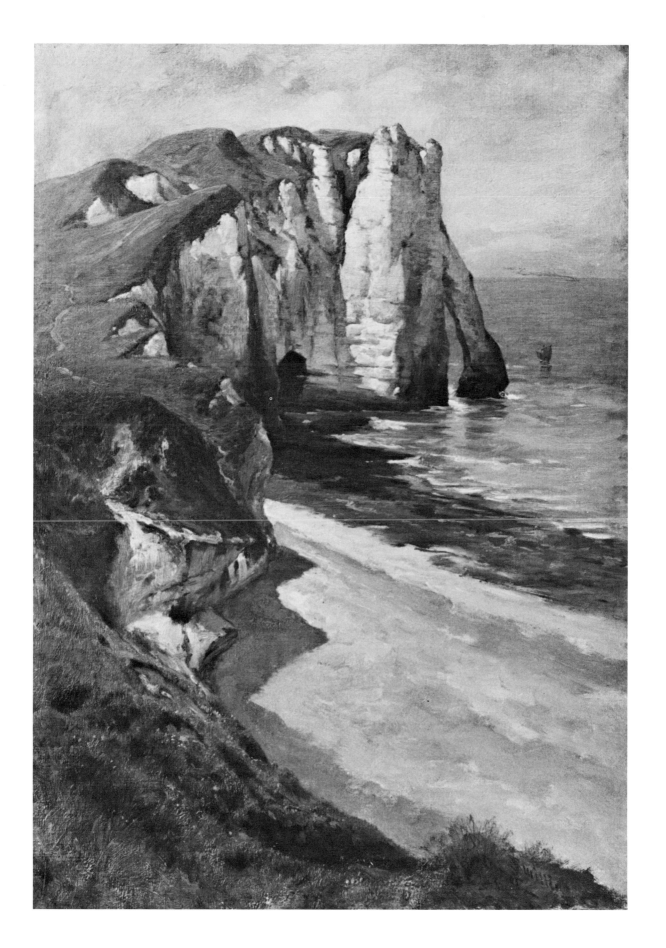

# William Edward Norton (1843-1916)

70. *The Last Load*, c. 1908
oil on canvas
18 x 24 (45.7 x 60.9)
The Holyoke Museum, Holyoke Public Library

Born in Boston to a family of seafarers and sail-makers, Norton went to sea as a boy, but for a trade was apprenticed to a house and sign painter. Interested in drawing, he studied nights at the Lowell Institute, and drew anatomical sections in the dissecting room of Harvard Medical College. When he opened his studio about 1864, George Inness gave him encouragement and criticism. After several more sea voyages, he auctioned more than one hundred paintings to finance a trip to Europe. In 1877 he was in England, then in France until 1882, studying with Antoine Vollon and Jacquesson, preferring academic art to the new Impressionism, which he thought "interesting but incomplete." His paintings of seaweed gatherers on the Norman coast are very much in the mood of Vollon – monumental but unidealized figures isolated on the seashore. He knew his craft, commanded his subject, and presented his fisher-folk without apology or message. He lived much of his life in England, going to France regularly on painting excursions, and exhibited both in Paris and London, as well as Boston and New York.

71. *Normandy Pastoral Near Honfleur,* 1875
oil on canvas
38 x 53¾ (96.5 x 136.5)
Museum of Fine Arts, Boston, Gift by subscription and Everett Fund

Like his fellow apprentice Winslow Homer, Cole learned his trade in Boston in Bufford's lithography shop, but left it for further study in France in 1860, where he entered the atelier of Emile Lambinet, a landscape painter of singular sensitivity with a penchant for painting pastoral scenes on the Norman coast. James J. Jarves said of Lambinet in *Art Thoughts* that he suggested details by emphasis of brush rather than finish, and that, "He fills his pictures with clear, bright light, rivaling Nature's tones as fully as pigments may. But it is a hazardous process, and no way so satisfactory as the lower tone of Corot, whose treatment of light is unequalled." It is just this freshness that Cole picked up from his master. This was not dampened by his further education in 1865 in the studio of the animal painter of Barbizon, Charles Jacque.

That year he married a Belgian musician and their Paris apartment became the resort of artists and musicians, so when Homer came to France he found good fellowship. After 1870 Cole became almost a commuter between Boston and Paris, with long painting sessions on the Norman coast. There he painted with American and French artist friends, and in 1875 did the *Normandy Pastoral Near Honfleur,* which he exhibited at the Salon and the Philadelphia Centennial, where he was awarded a medal.

# Homer Dodge Martin (1836-1897)

Martin is the solitary Romantic artist, the self-taught seeker whose groping vision haunts the imagination. In his native Albany, Martin got a few tips from James MacDougal Hart, then established a studio in that city's old Museum building. Going to paint with James Smillie in 1862-63 in the Tenth Street Studio in New York, Martin maintained a studio there until 1881. He met Whistler in 1876 on his first trip abroad, and again when he spent five years in France from 1881 to 1886, where he painted in Villerville and Honfleur. In 1892 he again visited France briefly. It is not easy to classify or date Martin's works, which did not find a ready market, and which he worked on from old sketches, or worked over as it pleased him. Like Ryder he was a painter of mood. A writer in the *Art Journal* of April 1878 said of one of his things: "This painting haunts one like a melancholy dream, and we wonder what sad mood it was in the artist that could have clothed itself in a scene so dreary and hopeless as this. As a purely 'impressionist' picture this takes its place with the dreamy distances of Corot or the 'Silver Nocturnes' of Whistler." Let this comment alert the reader that plein-air painting in general was called impressionist, and well into the twentieth century what we know as Impressionism was called luminism. Martin would work up his pictures from the meagerest of sketches, adding trees from one leaf, and a distant view from another, adjusting as he went along his masses and color relationships. Of the *Honfleur Light* James Thomas Flexner commented:

Martin viewed Nature not with Kensett's contemplative admiration but rather as an antagonist trying to hide from him an invaluable secret. A physical and nervous invalid with the temperament of a Titan, personally repulsive to all but the intimate friends who loved him, Martin tried to extract by main force from the most brutal aspects of inanimate nature – barren rocks, stunted trees, the dreadful solitude of arid or blasted places – some meaning that would be a release from personal anguish. The result was clashing pictures, successful and unsuccessful, some savage, some catching happily, in a glow of color against somberness, a touching burst of joy. Color was to be his release, but this he did not truly discover until he was an old, wrecked invalid, almost blind, who absorbed in France the brightness of the newly risen Impressionists. Employing a technique very different from theirs (he kneaded his paint together into a thick mat); holding on to much of the Hudson River School emphasis on definition of shape and depth of air, Martin brought to his canvases a jewel-like glow. The pictures create a visual world from which sorrow and pain seem completely alien. I spend several hours a week in the presence of his *Honfleur Light*, and I never look to that side of the room (it is a room where Martin himself often sat) without being moved by the vision of beauty, found at long last, after a desperate career, by a dying man. [1]

[1] J.T. Flexner, *Nineteenth Century American Painting*, (1970), p. 179.

72. *Honfleur Light*
oil on canvas
23⅝ x 36⅜ (65.1 x 92.4)
The Century Association

# Dwight W. Tryon (1849-1925)

73.  *Granville: Mouth of the Bay (Bay St. Michel)*, 1878
oil on cardboard panel
10¾ x 15⅜ (27.3 x 39.0)
Smith College Museum of Art, Northampton, Massachusetts,
Dwight W. Tryon Bequest, 1930

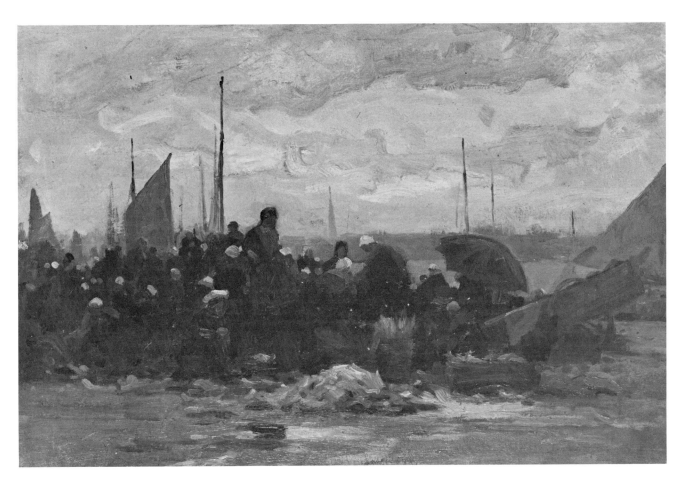

In 1876, Tryon gathered all of his work from some years of painting in and around Hartford and New England, had an auction and, with $2,000, left for France with his wife, despite warnings from his friend Mark Twain that he was better off as a shopkeeper with an income than being an artist. Having once entertained the idea of becoming a surgeon, he arrived with a thorough knowledge of human anatomy. He enrolled in the atelier of Jacquesson, where friends from Hartford, Robert Brandegee, William Faxon and Montague Flagg were fellow students. Jacquesson was famous – to some, notorious – for keeping his students drawing from life and from cast. Painting was left to the students' spare time. In the summer of 1877, Tryon joined Abbott Thayer on the Isle of Guernsey; the following summer he painted with fellow students in Cancale, probably drawn by the recent Salon successes of Sargent and Feyen depicting Breton subjects, and to Granville, Normandy, where the present *pochade* was executed. During later summers they traveled to Venice and the coast of Holland. By 1881 Tryon was accepted at the Salon with a Normandy harvest scene and several Dutch subjects. In painting he had criticism from Daubigny, Harpignies and Guillemet, all distinguished landscape painters.

# Daniel Ridgway Knight (1839-1924)

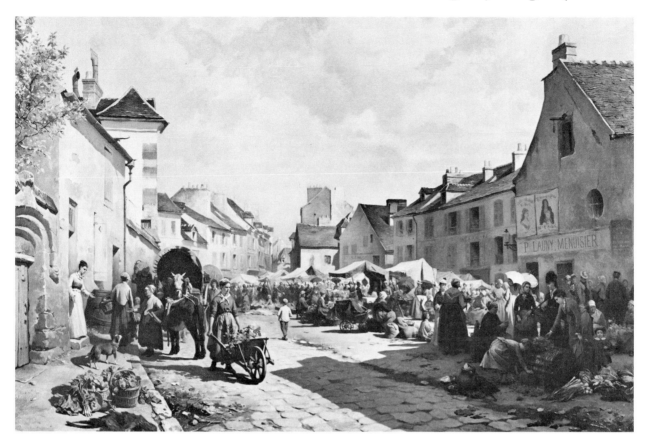

Ridgway Knight was a student at the Pennsylvania Academy of the Fine Arts and a founder of the Philadelphia Sketch Club before he went to France in 1861. A student of Gleyre, along with Joseph Woodwell, Pierce Francis Connelly, Renoir and Sisley, Knight returned to Philadelphia in 1863 to defend his city against apparent threat of invasion. It took him eight years to earn enough to get back to France, where he remained the rest of his life. In 1872 his studio was next to that of a painter named Steinheil, the brother-in-law of the painter Meissonier, who befriended Knight and gave him criticism. He did not take students, but Meissonier permitted Knight to sign himself as such in submitting work to the Salon, thereby insuring him respectful treatment by the jury. Knight moved to Poissy outside Paris where Meissonier had his studio. In 1875 he exhibited his first peasant subject at the Salon. His 1876 painting, *Market Day in Poissy*, shows that he had mastered well the crisp drawing and detail of his nearby master. Being drawn to the plein-air esthetic of Bastien, he did some delightful studies – *pochades* and small works out of doors, and traveled extensively in Normandy, bringing back his studies to the studio in Poissy.

Mr. Knight has built in the garden attached to his house at Poissy a studio of glass, like an ordinary hothouse. Here the artist can work in all weathers except the warmest, and in the winter with the snow upon the ground, is able to sit comfortably and finish pictures commenced in the summer, posing the model in a diffused light similar to that in which it had been begun by a country roadside.[1]

At his best, Knight was of the first rank of plein-air painters to follow the example of Jules Breton and Bastien-Lepage. In 1888 he won a third class medal at the Salon, in 1889 a silver medal at the Exposition and in 1892 was given the Legion of Honor. Honors in the United States, Germany and elsewhere followed, but the real measure of his recognition in America is the number of copies that can be found today in antique and junk shops of his *Hailing the Ferry* in pencil, marble-dust scratch board, watercolor, crayon and oil. After Beatrice Cenci, Raphael's *Madonna della Sedia* and Herring's *Horses*, no other painting has been so copied in America.

[1]Henry Bacon, *Parisian Art and Artists*, Boston, 1883, p. 211.

74. *Market at Poissy,* 1876
oil on canvas
40 x 59¾ (101.6 x 151.8)
Drexel University Museum
(preceding page)

75. *Hailing the Ferry,* 1888
oil on canvas
64½ x 83 (163.8 x 210.8)
The Pennsylvania Academy of the Fine Arts, Presented
by John H. Converse
*Exhibited in Philadelphia, Ft. Worth and Phoenix*

76.*Flatboat Fishing,* c. 1877
oil on panel
8 x 5½ (20.3 x 13.9)
Amherst College, Mead Art Museum, The Hollis W. Plimpton,
'15 Memorial Collection

# Chester Loomis (1854-1924)

77. *Normandy Milkmaid*, c. 1885
oil on canvas
56 x 69 (132.2 x 175.3)
Private Collection

Loomis came to France in 1875 after some study with Harry Ives Thompson in West Haven, Connecticut. In Paris he enrolled in the Académie Julian and with Bonnat. He remained eleven years in France, returning to America in 1885 to his brother's ranch on the San Saaba River in Texas and later to Englewood, New Jersey. *Normandy Milkmaid* won him a gold medal from the Massachusetts Charitable and Mechanics Institute in 1907, but it is certainly from 1885 or earlier, about the time of the paintings by Charles Sprague Pearce and D. Ridgway Knight, with which it shares a common plein-air Bastien-Lepage tradition.

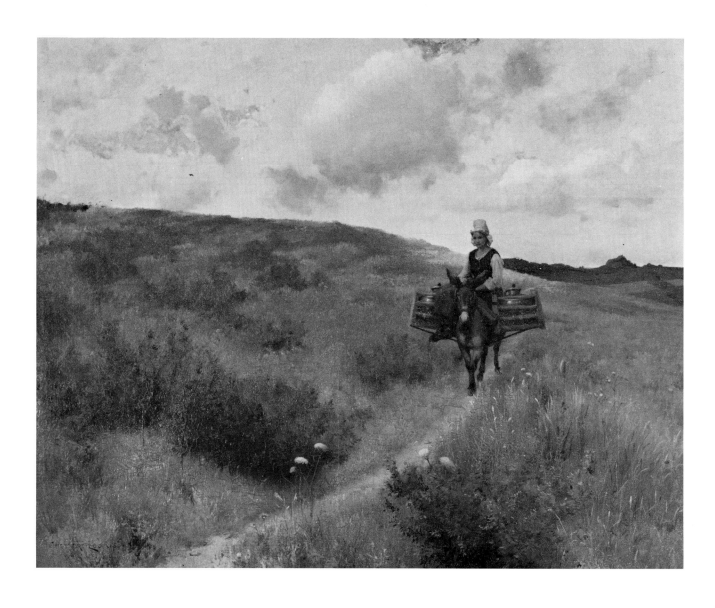

79. *Beach at Etretat*, September 3, 1883
oil on canvas
9½ x 12½ (24.1 x 31.8)
Private Collection
(overleaf)

80. *Etretat*, 1890
oil on canvas
12 x 16 (30.5 x 40.6)
Private Collection
(overleaf)

## Charles Sprague Pearce (1851-1914)

78. *Water Carrier*, 1883
oil on canvas
56 x 44 (142.2 x 111.7)
Jordan-Volpe Gallery, Inc.
color plate 3

A Bostonian, Pearce was advised by William Morris Hunt in 1872 to study in Paris; he enrolled in the private atelier of Léon Bonnat, where a fellow student was John Singer Sargent. During 1873 and 1874, he went with Frederick Bridgman on a trip up the Nile and painted a number of canvases depicting Egyptian scenes. He was a member of the circle of Loomis, Blashfield, Ramsey and Bridgman in the Paris studio; in Philadelphia he exhibited at the 1876 Centennial. His Salon entry of that year launched him on a successful career. Pearce remained an expatriate and in 1885 took up residence in Auvers-sur-Oise. There he had the same sort of hot-house plein-air studio as Ridgway Knight, where he did much the same sort of painting, but in a more solidly modeled manner, tending to place the figure with the background surrounding it. His honors include the Legion of Honor in 1894 and many awards and medals. Pearce was important in Paris for Americans because of his position on international juries.

Like Winslow Homer and Henry Mosler, Bacon was a war correspondent. Badly wounded while with the 13th Regiment of Massachusetts Volunteers, he went with his young bride to Paris and was one of the first Americans to be admitted to the reformed École des Beaux-Arts, entering Cabanel's atelier in 1864. He was still at the Beaux-Arts when Eakins, Shinn and Frederick Bridgman enrolled in 1866-67 and, by his own account, was their fellow student in Gérôme's studio. Bacon earned a meagre living by writing "penny-a-liners" for the Boston newspapers and articles for journals. Summers he studied, along with Harry Bispham, J. Wells Champney, Mary Cassatt and other Americans, at Écouen, where Edouard Frére took students. Cassatt, Bridgman and Bacon were all accepted at the Salon of 1868, and he was thereafter continually hung "on the line" until ceasing to exhibit around 1895. He then turned to water-colors and Oriental and African subjects, spending much of the rest of his life in London, Italy, Ceylon, Greece and Egypt, where he died. In France, he is particularly associated with Etretat and published a book on the French art colony and resort.

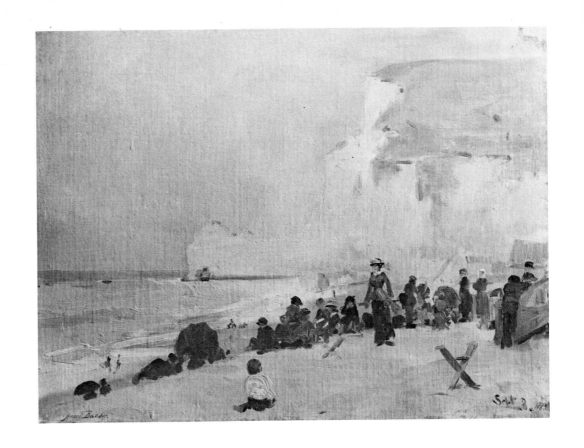

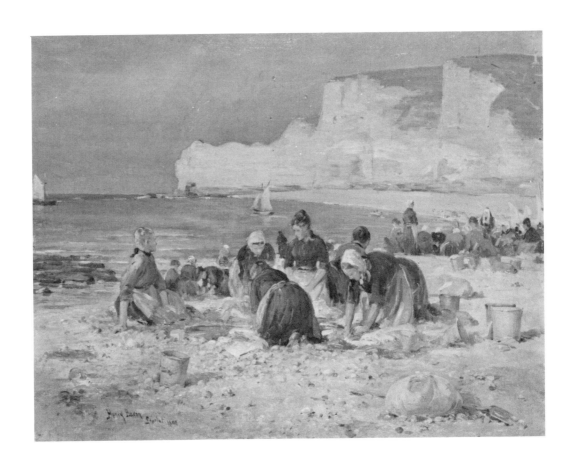

196

81. *The Ornithologist,* 1888
oil on canvas
39½ x 48½ (100.3 x 123.2)
Private Collection

# Philip Leslie Hale (1865-1931)

Philip Hale was the son of Boston clergyman and patriotic author Edward Everett Hale, but selected art study over a classical education at Harvard. After some preparation at the Boston Museum School he went to the Art Students' League in New York, where he was a fellow student of Hart and Theodore Butler, gaining particular satisfaction from J. Alden Weir's teaching. He went with Butler to Paris and enrolled with Boulanger and Lefebvre at Julian, and took the trouble to matriculate as a regular student at the École des Beaux-Arts at the end of the 1887 school year. Hale shared a studio apartment with William Hart for a year and then they all discovered Giverny, where Hale completed his *Ornithologist,* a dark painting and no way inclined toward Impressionism. Both

Hart and Butler goaded Hale to stop being so intellectual about his painting, and to loosen up. Before his return to Boston, Hale courted the beautiful Kate Kinsella, who weaves in and out of the American art colonies of Paris, Giverny and Concarneau, and continued his ardent suit by correspondence, to no avail. On his return he took an appointment as a teacher at the Boston Museum School, and taught a few years at the Pennsylvania Academy. He gained honors at the Buffalo and St. Louis Expositions. He remained a life-long friend of Theodore Butler. The Hale papers preserved in the Archives of American Art are an invaluable source for study for the Giverny community.

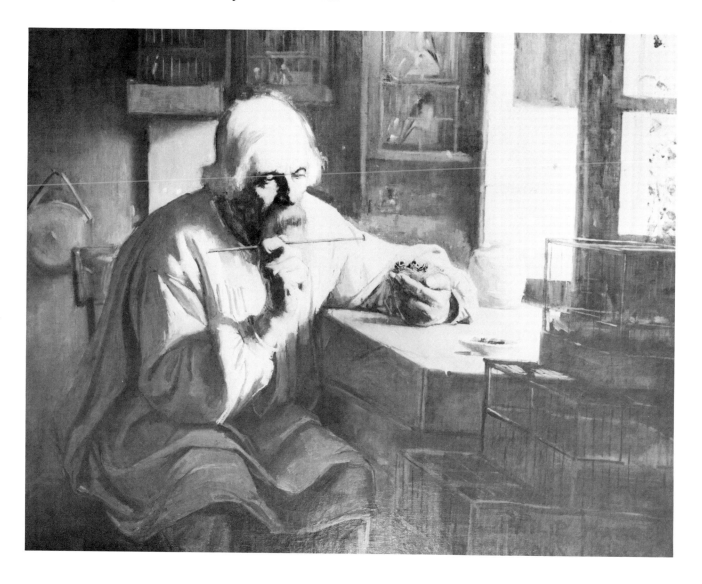

# Willard Leroy Metcalf (1858-1925)

82. *Petit Dejeuner a Quatre Sous: The Ten Cent Breakfast*, 1887
oil on canvas
14½ x 21⁵⁄₁₆ (37.0 x 54.1)
The Denver Art Museum, The Hanley Collection

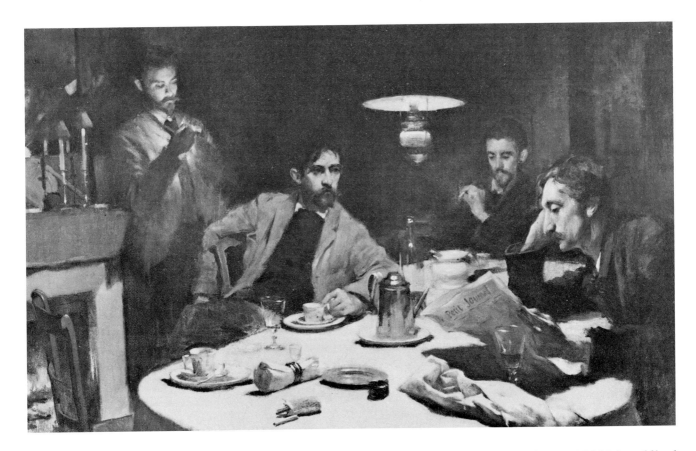

Metcalf was a veteran of both American colonies at Pont-Aven and Giverny, although nothing of his Brittany experience is in this exhibition. In Boston he had his apprenticeship painting on the *Panorama of Rome* with the "American Claude," George Loring Brown. From 1881 he was for several years among the Zuni Indians of New Mexico and Arizona with Frank Hamilton Cushing, illustrating for *Harper's* and *Century Magazine*, but went to Paris in 1883 to the Académie Julian in the atelier of Lefebvre and Boulanger. He and Arthur Hoeber traveled together to Pont-Aven in the summer of 1884. During the next several years he was in Grez and planned trips with fellow artists Theodore Robinson, Louis Ritter and Wendel to Dieppe, but they all ended up in Giverny in 1887. Before that, in 1885 Metcalf had been in Grez on the Loing, near Barbizon. It seems most probable that it was there that he began studies for the picture he finished in Giverny in 1887 called the *Ten Cent Breakfast*, for only then would the cast of characters have been available in Grez or Paris – John Twachtman, Theodore Robinson, and Robert Louis Stevenson and a fourth man standing in the background who may be the artist himself. The painting, therefore, is probably an evocation of prior times in Paris or Grez, or a fabrication of a meeting of friends in the memory of the artist, executed in the dark manner of times before awareness of Impressionism had lightened his palette, as it soon did in his landscapes.

198

83. *Little Stream at Giverny*, 1887
oil on canvas
12 x 15⅜ (30.0 x 39.1)
Jeffrey R. Brown Fine Arts

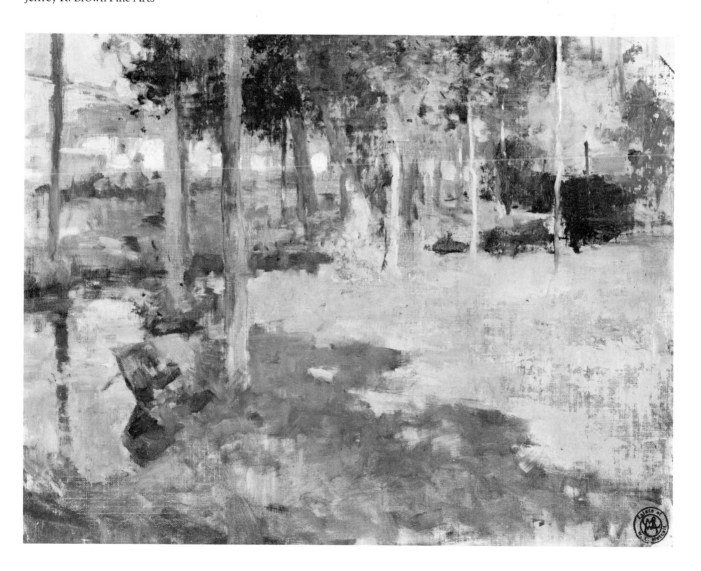

84. *Midsummer Twilight*, 1887-88
oil on canvas
32¼ x 35⅝ (81.9 x 90.9)
National Gallery of Art, Gift of Admiral Neill Phillips
in memory of Grace Hendricks Phillips, 1976

# Theodore Robinson (1852-1896)

85. *Giverny*, 1889
oil on canvas
15½ x 22 (39.4 x 55.9)
The Phillips Collection, Washington, D.C.

Robinson might have been the silent discoverer of Giverny, if Monet family tradition is correct that he visited Monet before 1887. If so he was circumvented by his enthusiastic comrades who descended upon the village in 1887 and helped establish the hotel Baudy. Robinson himself avoided the hotel and its social life out of self-protection, and was a part of the inner circle around Monet. Much of this is detailed in the text. The works included in the exhibition demonstrate the range of his experimentation during his Giverny years, which lasted into 1892 with regular visits to America. Between 1876 and 1880 he had studied with Carolus-Duran, sharing studio space at various intervals with Will Low,

Beckwith, Sargent, and Birge Harrison, and going to Barbizon with Low, Robert Louis Stevenson and his painter cousin R.A.M. Stevenson. Before returning home, Robinson met the "Duveneck Boys" and Whistler in Venice. After four years of teaching and doing decorative work with John La Farge, Robinson revisited France and was there for the retrospective exhibition of the greatly admired and lamented Bastien-Lepage. The works included here range from the figure painting and landscapes of the plein-air tradition of Bastien, to the divisionist immediacy of transient effect of Monet, and the wonderful celebration of the wedding of his friend Theodore Butler to Monet's step-daughter Suzanne.

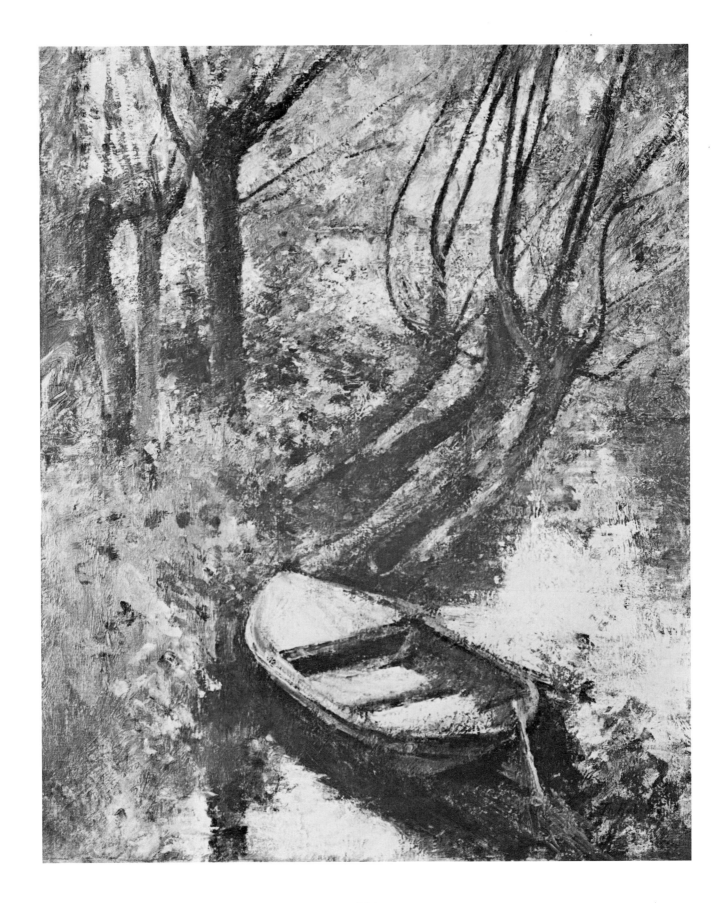

86. *Along the Stream*, c. 1889
oil on canvas
24 x 20 (60.9 x 50.8)
Jeffrey R. Brown Fine Arts
(opposite)

87. *Two in a Boat*, 1891
oil on canvas
9¾ x 14 (24.4 x 35.0)
The Phillips Collection, Washington, D.C.

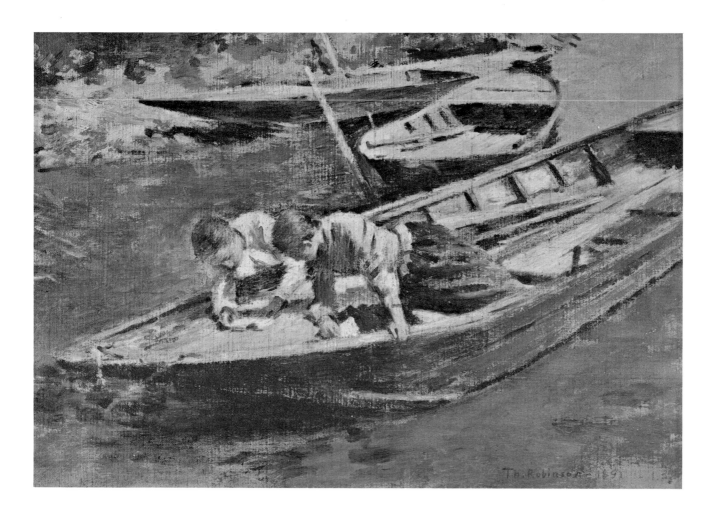

88. *The Wedding March*, 1892
oil on canvas
22 x 26 (55.9 x 66.0)
Daniel J. Terra Collection: Terra Museum of American Art
(also cover illustration, lower)

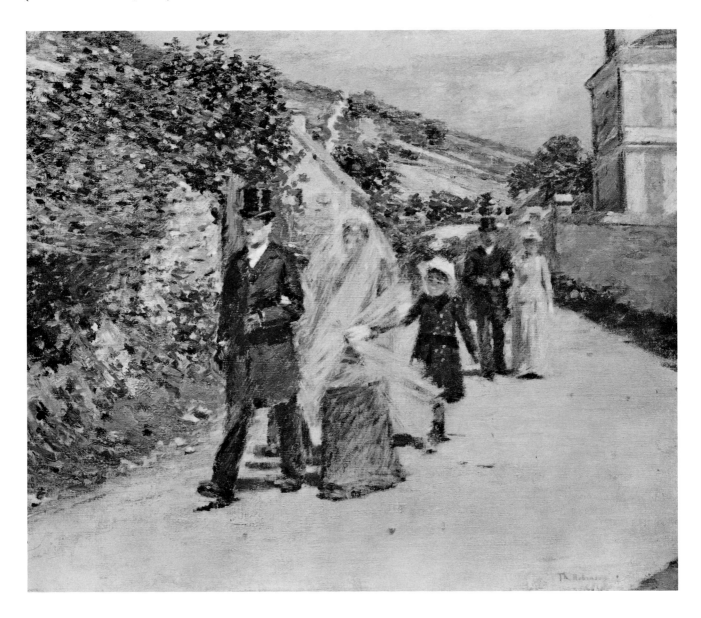

## Theodore Earl Butler (1861-1936)

89. *Bathing the Child,* 1893
oil on canvas
19½ x 24 (49.5 x 61.0)
Janet Fleisher Gallery, Philadelphia

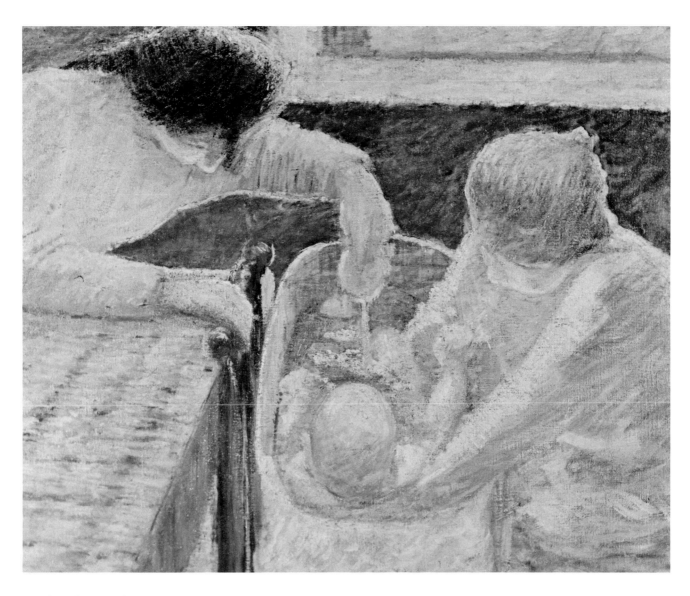

Theodore Butler was from Ohio, but not a part of the German community that fed Munich. After he graduated from college he headed for New York and the Art Students' League, where he was a student from 1882 to 1885. During that time his fellow students with Kenyon Cox and J. Alden Weir were his future companions in the Académie Julian and Giverny, Philip Hale and William H. "Peggy" Hart (Beckwith was also on the faculty at the time). Hale and Butler went to Paris in January of 1887 and Hart followed. Butler's recognition with an honorable mention at the Salon of 1888 was swift, and not quickly repeated. He settled in Giverny and in 1892 married Suzanne Hoschedé, and thus became a member of the Monet household. Their son James was born in 1893 and daughter Lili in 1895, both subjects of pictures in this exhibition. His treatment of color and light and composition in these indoor works goes beyond Impressionism, which he was close to in his landscape painting. Comparison between the *Card Players* and Metcalf's *Ten Cent Breakfast* of only a decade before, essentially the same painting as far as motif is concerned, shows the extent of the artistic revolution of the early 1890s.

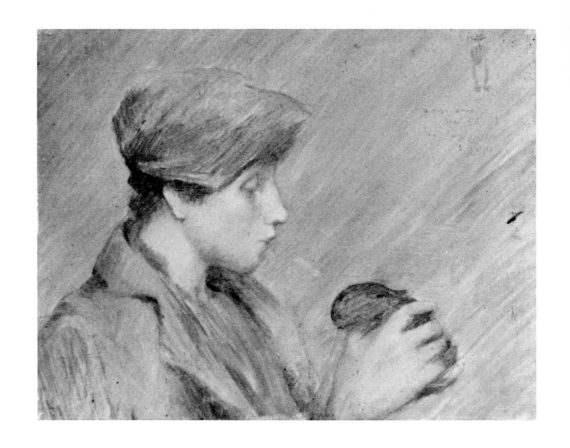

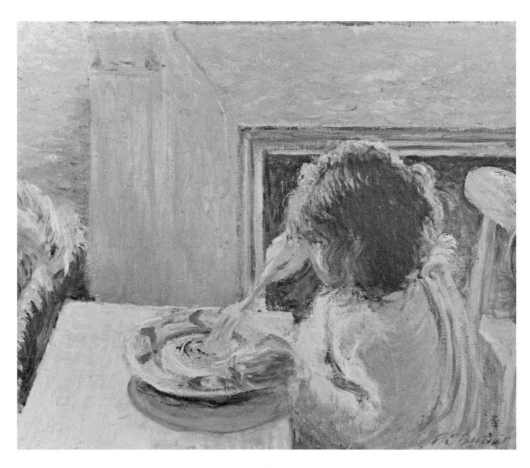

90. *Suzanne (Hoschedé) au Lapin,* 1891
oil on canvas
13¾ x 17¾ (35.0 x 45.0)
Private Collection
(opposite)

91. *Le Dejeuner,* 1897
oil on canvas
21½ x 25½ (54.6 x 64.7)
Janet Fleisher Gallery, Philadelphia
(opposite)

92. *Card Players at Giverny,* 1898
oil on canvas
25½ x 31⅝ (65.0 x 81.0)
Jean Marie Toulgouat

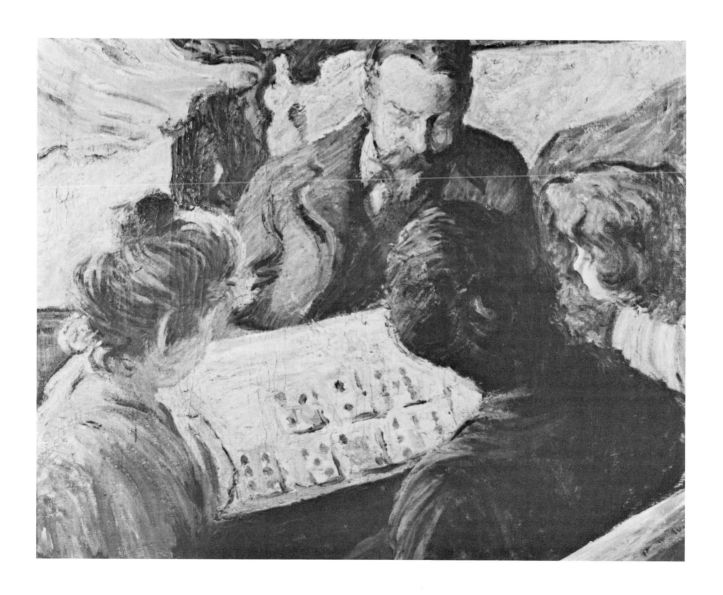

# James Carroll Beckwith (1852-1917)

93. *Portrait of John L. Breck*, 1891
oil on canvas
13¾ x 17¼ (35.0 x 44.0)
Private Collection

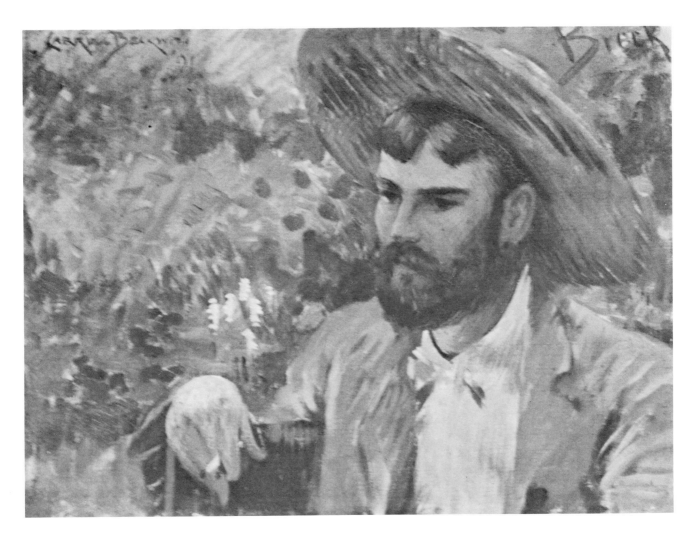

Beckwith is both fundamental and incidental in this study in that he seems simply to have been passing through Giverny, just as his old comrade John Sargent did, and left this souvenir portrait of John L. Breck; but he had a greater hand than that. Like Thomas Eakins in Philadelphia, Beckwith played an important part in the teaching of art in New York. Carroll Beckwith (he tried all his life to lose the first name and initial) was brought up in Chicago and had his first instruction with Walter Shirlaw. After the Chicago fire he went to the National Academy in New York before traveling to France in 1873. At the École des Beaux-Arts he entered the Cours Yvon, conducted by Adolphe Yvon, but soon joined the Americans at the newly formed atelier of Carolus-Duran, and shared a studio with young John Sargent at the time Sargent did the Brittany paintings in this exhibition. He could not bear Chicago on his return, so moved to New York, where he became a regular supporter of the new Society of American Artists. From 1880 he was instructor in the antique and life classes of the Art Students' League, so his personal and professional influence was great on the younger generation who departed New York for Paris.

208

94. *M. Baudy Behind His Desk at the*
*Café of the Hotel Baudy,* 1888
oil on canvas
13¾ x 17¾ (35.0 x 45.0)
Private Collection

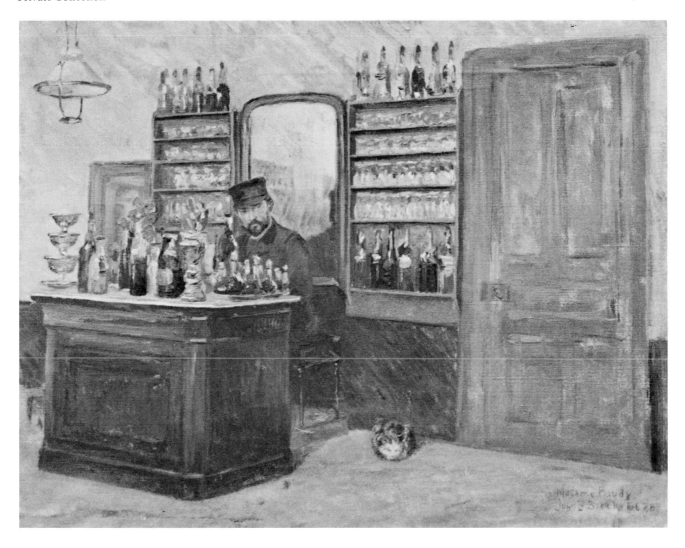

John L. Breck is one of the founders of the American colony at Giverny, and seems to have been the one most responsible for advertising the charms of the village and the new hotel Baudy. This would have been reason enough for Monet to intervene when he discovered a romance between Breck and one of his step-daughters. In 1891 Beckwith did Breck's portrait, when Theodore Butler did the little portrait of Suzanne Hoschedé, another Monet step-daughter. Like Wendel, Breck had training in Munich before coming to France and the atelier of Boulanger and Lefebvre at Julian's. Born at sea near Hong Kong to a Boston family, he studied briefly in Leipzig and three years in Munich and Antwerp before going to Paris. With Wendel, Robinson, Metcalf and Butler he went to Giverny in 1887 and remained until 1891, during which time he painted the little winter view of the village and the interior of the hotel café with Gaston Baudy as bartender, paintings still belonging to the Baudy family. The walls depicted would soon be full of just such souvenirs as this. His romance terminated firmly by Monet, Breck went to California in 1891 before returning to Boston, where he died at the age of thirty-nine.

95. *Giverny Winter*, 1888
oil on canvas
13¾ x 17¾ (35.0 x 45.0)
Private Collection

# Theodore Wendel (1857-1932)

96. *Girl Fishing in a Stream*, c. 1887
oil on canvas
16¼ x 19½ (41.3 x 49.5)
Courtesy of Vose Galleries of Boston, Inc.

97. *Girl with Turkeys, Giverny*, 1886
oil on canvas
23 x 29 (58.4 x 73.7)
Courtesy of Vose Galleries of Boston, Inc.
color plate 18

Theodore "Teddy" Wendel was from Ohio, and took the well worn road from there to Munich, following his friend Joseph De Camp. Thus he had the benefit of the fellowship of the Polling and Munich group, and went with the "Duveneck Boys" to Florence and Venice, so he knew Twachtman, Alexander, and met and watched Whistler at work. After a few years in Newport, Rhode Island, sharing a studio with Kenyon Cox, who had recently returned from study with Gérôme, Cabanel and Carolus-Duran, Wendel was in Paris by 1886 at the Julian, and part of the group that first discovered Giverny. If the 1886 date on the picture of the girl fishing is of the time, it corroborates an earlier incursion of

Americans at Giverny than the one attested to by Dawson Dawson-Watson in 1887. The Baudy hotel itself was established in 1887, but perhaps Robinson and Wendel came the year before. By 1889 Wendel was back in Newport, and in 1892 had an exhibition with Theodore Robinson in Boston. At the turn of the century he settled in Ipswich, becoming a neighbor of Arthur Wesley Dow. In New England, proximity does not guarantee even the most rudimentary communication, even among artists, and there seems to have been none between the yankee clergyman's son and the ex-circus tumbler and bon vivant, who did not see eye to eye on anything, including art.

# Edward H. Barnard (1855-1909)

# Louis Ritter (1854-1892)

98. *River Weeders*, c. 1890
oil on canvas
40 x 60 (101.6 x 152.4)
Mr. and Mrs. Abbot W. Vose, Boston
color plate 17

99. *Giverny*, 1887
oil on canvas
25¾ x 21¼ (65.4 x 54.0)
Jeffrey R. Brown Fine Arts
(opposite)

Edward H. Barnard studied architecture at the Massachusetts Institute of Technology and painting in the new Boston Museum School before going to the Académie Julian in Paris to study with Boulanger and Lefebvre. Little is known about him today, but he received medals from the Massachusetts Charitable Mechanics Association exhibitions and for this painting won an honorable mention in the Tennessee Centennial at Nashville in 1897. A self-portrait dated 1889 in Paris is known, and it seems probable that the *River Weeders* would date from this time, a provocative painting, well constructed and modeled with the brush-stroke in a manner more typical of artists working with the point of a pastel or crayon, like some of these of Millet so admired by Seurat. The painting does not fit into any easy category, but has such a superior and distinctive quality that it deserves to stand among the artists of the end of the century who were exploring and synthesizing contemporary French art. It makes interesting comparison with Hassam's *In Brittany*, painted in Pont-Aven the year this work received honors in Tennessee. Barnard died in his native Belmont, Massachusetts in 1909.

Louis Ritter was trained in art at the McMicken School in his native Cincinnati, worked as a lithographer there and in 1878 took the customary voyage to Munich and the Royal Academy. In 1879 he was one of the "Duveneck Boys" in Florence and Venice, so his training was similar to that of Twachtman, Wendel and John White Alexander. By 1884 he was back in Cincinnati, but departed to settle in Boston. Ritter was apparently in Europe in 1887 and 1888, and in the latter year painted the Villa Castellani in Florence, where Duveneck and Elizabeth Boott had lived, the year Elizabeth died suddenly in Paris. This Giverny landscape gives no concession to either Impressionism or the "square brush," plein-air techniques of Metcalf or Wendel. Theodore Robinson's little painting of willows on the Epte (cat. 86) was given to Ritter by the artist, and makes an interesting comparison of opposing treatment of a similar motif.

213

# Lilla Cabot Perry (1848-1933)

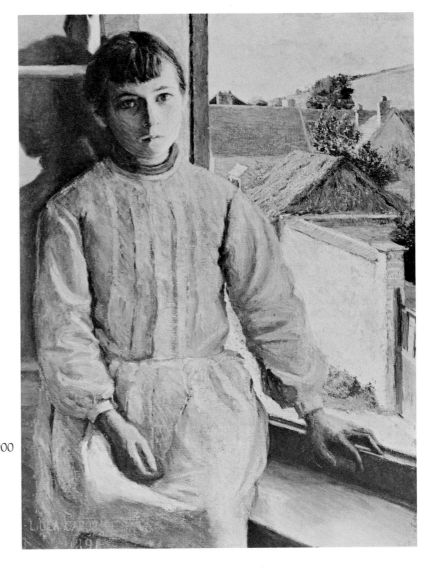

100. *Angela*, 1891
oil on canvas
36¼ x 27 (92.0 x 68.6)
Private Collection

101. *Giverny Landscape (In Monet's Garden)*, c. 1900
oil on canvas
26 x 32 (66.0 x 81.2)
Private Collection:
Courtesy of R.H. Love Galleries, Inc., Chicago
color plate 19

Before meeting Monet in Giverny in 1889, Lilla Cabot Perry had studied in the Cowles School in Boston with Dennis Bunker and Robert Vonnoh. She therefore had the best possible exposure to both the plein-air tradition and Impressionism before enrolling in the schools of Paris or meeting Monet. John LaFarge was married to her husband's sister, and Tom Perry was a professor of literature, amateur painter, and author. Between 1889 and 1909 they spent some ten seasons in Giverny, and resided for a time in Japan. Tom Perry was of the Admiral's family, and from Rhode Island. As Philadelphia seems to have a large hand in the Breton colonies, Boston and Rhode Island favored Giverny. Butler's

mother was from Rhode Island; Wendel went back to work in Newport; and Miss Wheeler's Providence school bought a house and established a regular session in the village. After that, Giverny was almost a Providence summer campus for the decade before World War I. Lilla Perry's two paintings show the same ambivalence as the work of Theodore Robinson in Giverny, and the general absorption of easel painters of the Impressionist approach. One is a solidly painted figure in the diffused light favored by the plein-air painters. The other, painted in Monet's garden, is an accomplished divisionist color painting in the Impressionist manner.

102. *Late Afternoon, Giverny*, c. 1910
oil on canvas
23¾ x 28¾ (60.3 x 73.0)
San Diego Museum of Art: Fine Arts Society Purchase

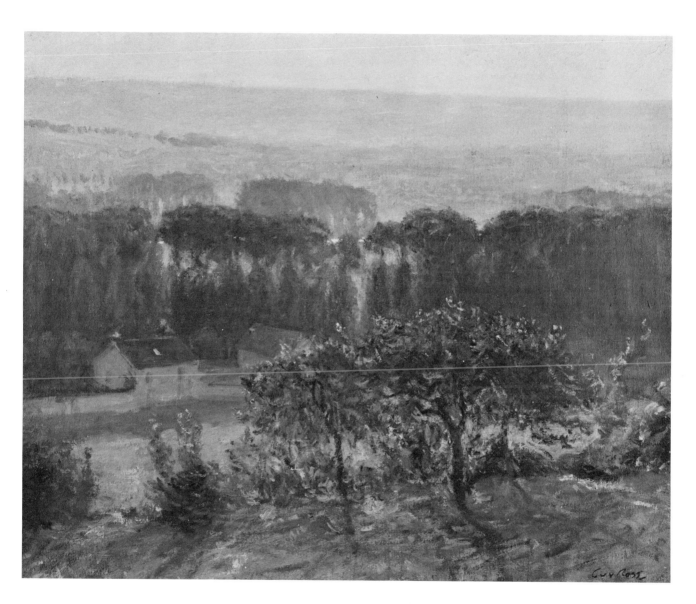

Writing to Philip Hale in Boston from Giverny, Kate Kinsella said on the 14th of July, 1890: "We have a queer household. Mr. Robinson sits at the head of the table. I next on his left – Joe (a Kinsella sister) – and then an entire family, sisters and mother of a painter called Rose. I believe he is a Julian man."[1] Robinson told her stories about Monet and talked about Hale. Guy Rose, a Californian, was there at the Baudy hotel again in following years, brought his wife there in 1899, and eventually bought a house in Giverny. Like Frieseke he was an avid fisherman, and despite differences in style they exhibited together in New York with what became known as the Giverny Group: Rose, Frieseke, Parker, Miller, Anderson and Greacen.

[1]Philip Hale Papers, Archives of American Art, Smithsonian Institution, gift, D98.

# Edmund William Greacen (1876-1949)

103. *The Farm, Giverny*, 1907
oil on canvas
21 x 35 (53.3 x 88.9)
Janet Fleisher Gallery, Philadelphia

104. *The River Epte*, 1907
oil on canvas
26 x 31⅞ (66.0 x 80.9)
Courtesy Meredith Long & Co., Houston, Texas
color plate 20

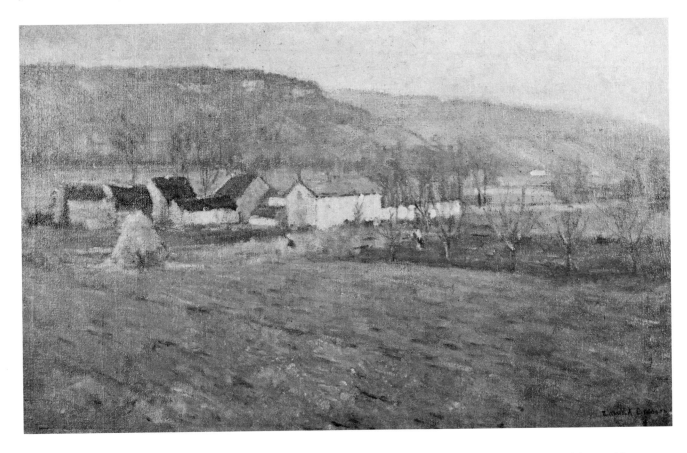

Edmund Greacen led a privileged life. After getting a B.A. degree from New York University his family sent him on a world cruise to distract him from joining in the Spanish American war. On his return he took courses at the Art Students' League, and then with Chase and Henri at the Chase School. In 1905 he went to Spain with Chase and like everyone else copied Velasquez. He and his wife rented a house in Giverny in 1907, where they stayed two years. While friends of the Butlers, he met Monet only once, the old painter having put as much distance between the outsiders and himself as possible. Back in New York he exhibited with the Independent Artists and had the first of many solo exhibitions, and joined the summer colony at Old Lyme, and later became extremely influential in American art education. His own brand of Impressionism, with the almost stucco surface quality and high key, as here in the view on the Epte, is characteristic of what art students would be striving for in America about the time of the Armory Show.

# Richard E. Miller (1875-1943)

105. *Interior*, c. 1910
oil on panel
24 x 26 (60.9 x 66.0)
Furman Collection:
Courtesy of R.H. Love Galleries, Inc., Chicago
color plate 21

Richard Miller studied art at the St. Louis School of Fine Arts in his native city from 1893 to 1897, when he got a job as artist reporting for the *St. Louis Post Dispatch*. A scholarship enabled him to continue his studies in Paris, and from 1898 to 1901 he was at the Julian school with Laurens and Constant. Between 1901 and 1906 he became an instructor in the rival art school of Colarossi. Before 1910 he was awarded the Legion of Honor, had work purchased by the State for the National Collection, and was medalled at the Salon. Miller taught a peripatetic summer session for female art students in Giverny and St. Jean du Doight in Brittany during these years. He eventually returned to the United States and established his studio in Provincetown, Massachusetts, where Greacen also ran his summer school. Like Parker and some of the others in the Giverny Group, Miller mapped out his figure compositions in broad areas on the surface, and, while he adopted the dry texture of Impressionism, and much of its palette, he asserted local color and firm edges, unifying the whole by a dominant hue.

Frederick Frieseke studied at the Chicago Art Institute for three years, 1893 to 1896, and then a year in New York at the Art Students' League before departing for France and the Académie Julian. There he was in the atelier of Constant and Laurens, and in Paris also received criticism from Whistler. Whistler's influence at the turn of the century is as strong as at the beginning of the period under study, but more for the arrangement of large shapes on the surface than for the suggestive treatment of transient atmospheric effect so imitated in the 'seventies. Before 1910 Frieseke had been medaled at St. Louis and Munich, purchased for the French National Collection, been represented with seventeen pictures at the Venice Bienniale, and painted several large murals for New York and Atlantic City. From 1900 he spent summers in Giverny, and from 1906 the Friesekes rented a house next to Monet. Like Miller, Frieseke adopted from Impressionism what suited him, but without sacrifice of solidly constructed composition. The *Yellow Room* reveals the same tendency to unify the whole with a dominant color, while expressing brush-stroke and flat texture. Such rooms, however one must remember did exist, and were not just artistic conventions. Whistler's butlers wore livery to match the walls, and Monet in Giverny had a yellow room and a blue room in which furniture, even to the tall case clock, was painted to set off the prints and porcelains. From 1903 Frieseke reveled in the problems of close up figure painting in the open sunlight, and frequently explored vibrant and expressive color reminiscent of the Fauves.

107. *Lady with Parasol*, c. 1908
oil on canvas
25½ x 32 (64.7 x 81.2)
Collection of Cornelia and Meredith Long
*Exhibited in Phoenix and Washington, D.C. only*
color plate 22

106. *The Yellow Room*, c. 1902
oil on canvas
32¼ x 32¼ (81.9 x 81.9)
Museum of Fine Arts, Boston, Bequest of John T. Spaulding

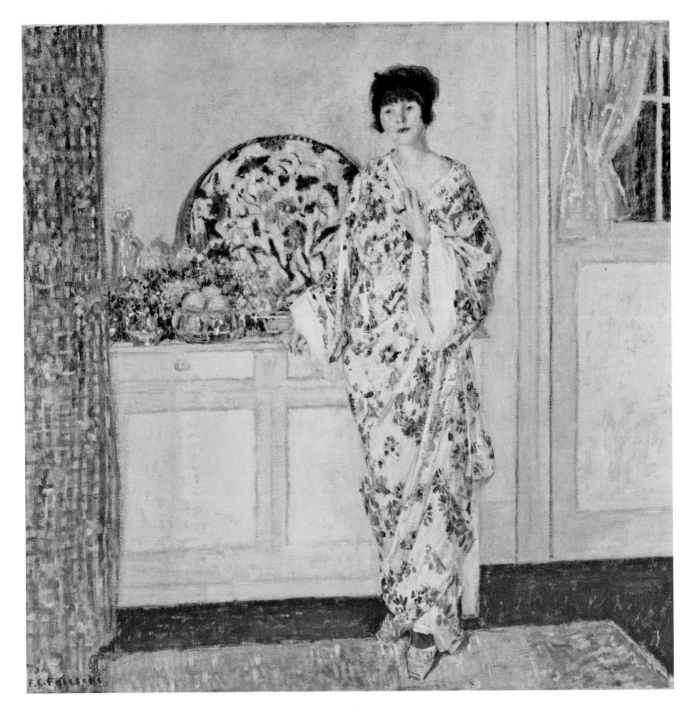

# Karl Anderson (1874-1934)

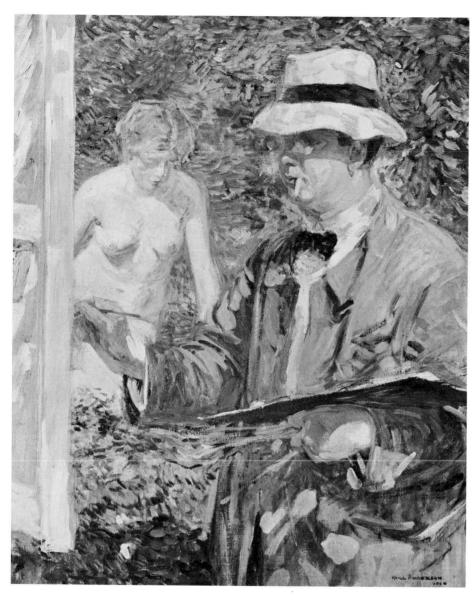

108. *Portrait of Frieseke Painting*, 1910
oil on canvas
36 x 30 (91.4 x 76.2)
Frances Frieseke Kilmer

Karl Anderson was the oldest of five boys, one of whom was the writer Sherwood Anderson. Raised in a small Ohio town, and apprenticed at thirteen to a harness maker, Anderson dreamed of being an artist. From tinting photographs and hack illustration in Chicago, he managed to study part time at the Chicago Art Institute for some five years, after which he saved enough from magazine illustration in Springfield, Ohio to travel to France. In Paris he studied at Colarossi's, joining a summer class in Holland with George Hitchcock, which was his first introduction to color and painting in the open air. Before spending the summer of 1910 at Giverny, he had been admitted to the Salon with a figure painting, and made the obligatory trip to Madrid to copy Velasquez. From Colarossi and Montparnasse he knew Frieseke and Miller, and in 1910 Anderson joined Frieseke in the walled garden painting nudes in the sunlight. A large canvas called *The Idlers* done that summer was awarded the Carnegie silver medal and was purchased by the Chicago Art Institute, and his career was firmly launched. His painting of Frieseke painting a nude in the sunny garden in Giverny is practically a manifesto of the idyllic state of American art in 1910, at a time when new movements were boiling up in the Paris studios that would soon challenge everything for which art stood.

# Lawton S. Parker (1868-1954)

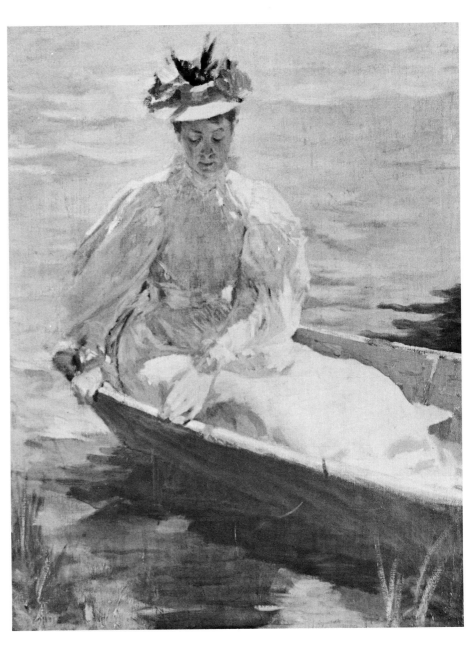

109. *Woman in a Boat*, c. 1910
oil on canvas
30 x 24 (76.2 x 60.9)
Goldfield Galleries, LTD.

Lawton Parker was a student of the Art Institute of Chicago, and in 1889 was at the Julian with Bouguereau and Robert Tony-Fleury. Following study at the Art Students' League with Chase and Mowbray, he returned to Paris and studied mural painting with Besnard, and enrolled at the Beaux-Arts in 1897 in Gérôme's atelier. It was, therefore, with a thorough academic background that he arrived in Giverny around 1902 with the express purpose of getting the model out of the studio and into the open sunlight and bent on being more than a successful portraitist, which by then he was. "It is a somewhat new kind of Impressionism which has been practiced in recent years at Giverny by Parker and other Americans," said a writer for the *International Studio* (December, 1915, p. 37). "Simply because Parker does not see Nature in the way of the French Impressionists, he does not adopt their method of broken color. ... He prepares his colors on the palette, matching his greens to those of nature, his blues to her blues ... while rendering warm sunlight, cool shadows and the brilliant hues of foliage and flowers, he also suggests the luminosity of nature and the softening influence of the atmosphere."

## William de Leftwich Dodge
## (1867-1935)

111. *L'Interlude: Jardin de MacMonnies*, c. 1907
oil on canvas
19¼ x 25½ (48.9 x 64.7)
University of Virginia Art Museum, Charlottesville
(overleaf, lower)

Will Low was an old friend of Theodore Robinson, and had introduced him to the artist colony life of Barbizon and Grez many years before he painted this picture in Giverny. By then Robinson was long dead, and the attraction for Low was Mary Fairchild MacMonnies, who he married in 1909 after she secured a divorce from her errant husband. In his autobiography of 1907 Low mentions spending a delightful summer with Mary Fairchild and her two daughters, and this can only commemorate that summer. It is a reminder that painters like Will Low and William De Leftwich Dodge, and others who had turned to mural painting, borrowed little from the new movements except the color scale, and that the so-called American Renaissance in architecture encouraged a new surge of Beaux-Arts classicism.

110. *The Music Lesson, Giverny*, c. 1898
oil on panel
11¾ x 52 (29.8 x 132.0)
Balogh Gallery, Inc., Charlottesville, Virginia
(overleaf, upper)

Dodge studied at the École des Beaux-Arts with Gérôme, and was a close friend of the sculptors MacMonnies and George Gray Barnard. He was primarily a muralist, beginning his career at the Columbian Exposition, but was in Giverny around 1898 in a house adjoining MacMonnies'. There he painted three pictures of this model, imported from Paris for the purpose, out in the sunlight. Painting the nude in the open light had become increasingly popular since Alexander Harrison introduced it in the American colony with his *In Arcadia*. Like Will Low painting in MacMonnies' Garden, Dodge does not engage the abstract problem of light as did Anderson in his painting of Frieseke, and clothes it in classical narrative.

221

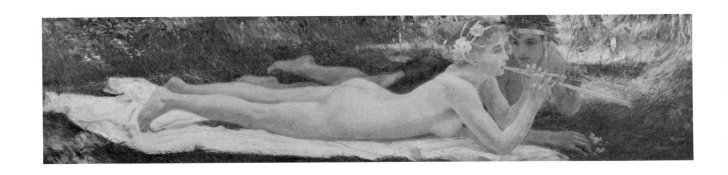

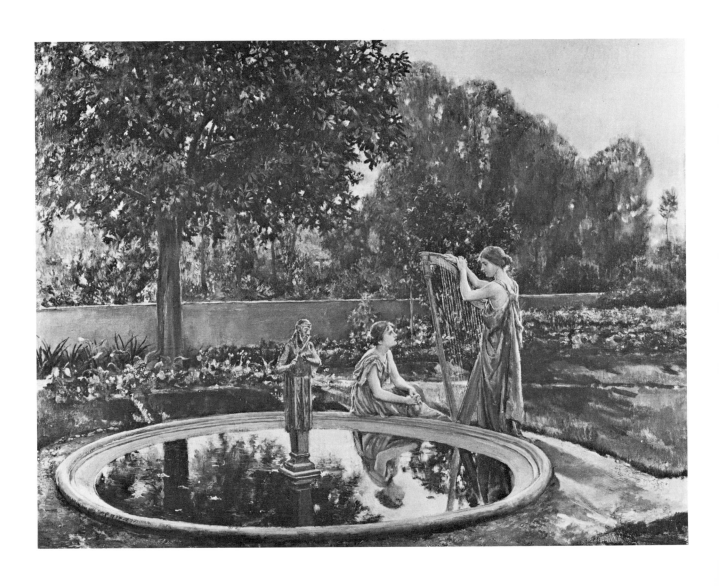

# Frederick William MacMonnies
# (1863-1937)

112. *Portrait of the Artist*, 1898
oil on canvas
31 x 25 (78.7 x 63.5)
The Metropolitan Museum of Art, Mrs. James Fosburgh Gift, 1967
(overleaf)

MacMonnies started out as a painter at the Cooper Union, National Academy and Art Students' League, but at about sixteen apprenticed to Augustus St. Gaudens in sculpture, and pursued his studies in Paris at the Beaux-Arts under Falguière. In 1888 he married a painter of great ability, Mary Fairchild, and they started visiting Giverny and soon became regular fixtures. MacMonnies was sponsored in his studies by Charles F. McKim, with whom he was a frequent collaborator. One side of Giverny that the exhibition does not touch on is the activity in the village by mural painters like James Wall Finn, and the mural work done there by Theodore Butler. There were large barns available for the indoor work. MacMonnies soon settled in large quarters for his sculpture, and built a painting studio in the corner of the garden. He went to Spain in 1898 and copied Velasquez in one of his periodic returns to painting. This self portrait was done in his Giverny painting studio, as shown by the reflected image of one of his copies done in Spain, a copy that still hangs in the studio today.

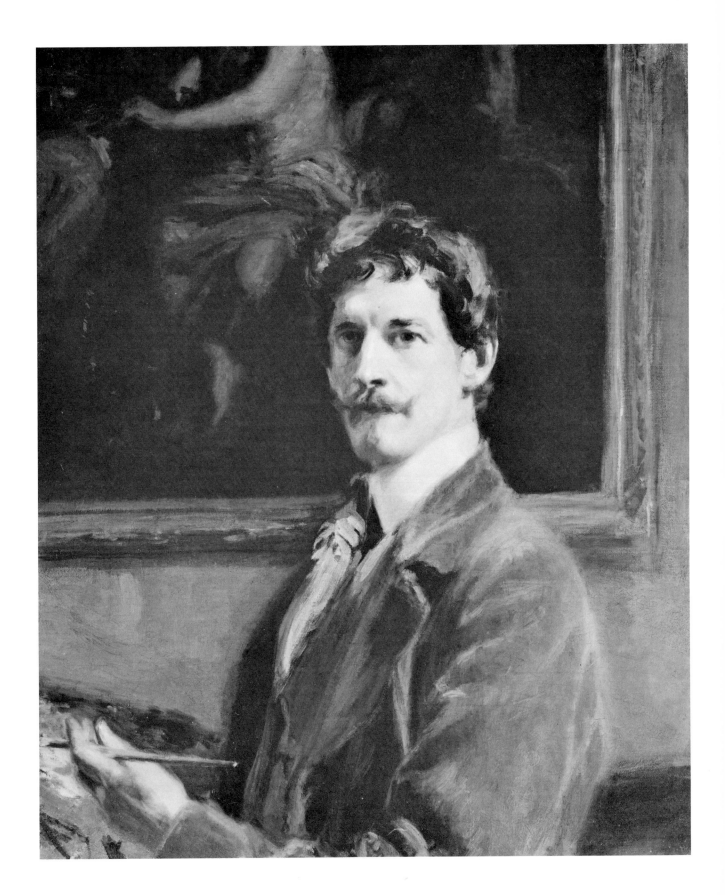

# Index of Artists' Entries and Titles

ALEXANDER, JOHN WHITE ............... 167
   *Landscape, Le Pouldu* ...................... 116
ANDERSON, KARL ........................ 219
   *Portrait of Frieseke Painting* ............... 219
ARMSTRONG, DAVID MAITLAND ........... 143
   *Houses, Pont-Aven* ....................... 143
BACON, HENRY .......................... 195
   *Beach at Etretat* ......................... 196
   *Etretat* ................................. 196
BARNARD, EDWARD H. .................... 212
   *River Weeders* ........................... 120
BEAUX, CECILIA ......................... 164
   *Study for Twilight Confidences: Two Heads*
   *(Two Breton Women by the Seashore)* ....... 164
BECKWITH, JAMES CARROLL ............... 208
   *Portrait of John L. Breck* .................. 208
BLASHFIELD, EDWIN HOWLAND ........... 144
   *On the Beach* ............................ 144
BOGGS, FRANK .......................... 183
   *A Rough Day at Honfleur Harbor* ........... 183
BRECK, JOHN LESLIE ..................... 209
   *M. Baudy Behind his Desk at the Café of*
   *the Hotel Baudy* .......................... 209
   *Giverny Winter* .......................... 210
BRIDGMAN, FREDERICK ARTHUR .......... 138
   *American Circus in Brittany* ................ 112
   *Study of a Young Girl, Pont-Aven* .......... 139
   *Fisherman at Le Richardais, Brittany* ....... 140
BUNKER, DENNIS MILLER ................ 133
   *Larmor* ................................. 134
   *Tree* ................................... 114
BUTLER, HOWARD RUSSELL .............. 160
   *The Seaweed Gatherers* ................... 160
BUTLER, THEODORE EARL ............... 205
   *Bathing the Child* ........................ 205
   *Card Players at Giverny* ................... 207
   *Le Dejeuner* ............................. 206
   *Suzanne (Hoschedé) au Lapin* .............. 206

COLE, J. FOXCROFT ..................... 187
   *Normandy Pastoral Near Honfleur* .......... 187
CORSON, HELEN ......................... 145
   *Breton Courtyard* ........................ 145
DODGE, WILLIAM LEFTWICH ............. 221
   *The Music Lesson, Giverny* ................ 222
DOW, ARTHUR WESLEY .................. 155
   *Au Soir* ................................. 155
FRIESEKE, FREDERICK CARL ............. 217
   *Lady with Parasol* ........................ 125
   *The Yellow Room* ........................ 218
FROMUTH, CHARLES HENRY ............. 171
   *The Dock in an Art Humor* ................ 170
   *The Green Dock Waters #1* ................ 171
GAY, WALTER .......................... 157
   *Girl Knitting, Concarneau* ................. 158
   *Le Pardon* .............................. 157
GREACEN, EDMUND WILLIAM ............ 216
   *The Farm, Giverny* ....................... 216
   *The River Epte* .......................... 123
HALE, PHILIP LESLIE ................... 197
   *The Ornithologist* ........................ 197
HARRISON, T. ALEXANDER .............. 156
   *In Arcadia: Study* ........................ 156
   *The Wave* ......................... 118, 119
HASSAM, CHILDE ....................... 172
   *In Brittany (Tremalo)* ......... Front Cover, 172
   *Pont-Aven* .............................. 173
HENRI, ROBERT ........................ 165
   *Breton Street* ........................... 166
   *Farmhouse in Brittany* .................... 166
   *Girl on Beach (Concarneau)* ............... 165
   *Le Pardon – Concarneau* .................. 113
HOMER, WINSLOW ...................... 178
   *The Gleaners* ............................ 108
HOVENDEN, THOMAS .................... 146
   *Breton Interior: Vendean Volunteer 1793* .... 111
   *The Path to the Spring* .................... 146

HUNT, WILLIAM MORRIS . . . . . . . . . . . . . . . . . . . . . 128
    *Dinan* . . . . . . . . . . . . . . . . . . . . . . . . . . . . . . . . . . . *128*
INNESS, GEORGE . . . . . . . . . . . . . . . . . . . . . . . . . 179
    *Etretat* . . . . . . . . . . . . . . . . . . . . . . . . . . . . . . . . . *108*
    *Etretat* . . . . . . . . . . . . . . . . . . . . . . . . . . . . . . . . . *179*
JONES, HUGH BOLTON . . . . . . . . . . . . . . . . . . . . 151
    *Edge of the Moor, Brittany* . . . . . . . . . . . . . . . . . *151*
KENYON, HENRY R. . . . . . . . . . . . . . . . . . . . . . . . 162
    *Breton Landscape (near Pont-Aven)* . . . . . . . . . *162*
KNIGHT, DANIEL RIDGWAY . . . . . . . . . . . . . . . 191
    *Flatboat Fishing* . . . . . . . . . . . . . . . . . . . . . . . . . *193*
    *Hailing the Ferry* . . . . . . . . . . . . . . . . . . . . . . . . *192*
    *Market at Poissy* . . . . . . . . . . . . . . . . . . . . . . . . *191*
LASAR, CHARLES AUGUSTUS . . . . . . . . . . . . . . 163
    *Farmhouse in Normandy* . . . . . . . . . . . . . . . . . . *163*
LIPPINCOTT, WILLIAM HENRY . . . . . . . . . . . . 147
    *Farm Interior: Breton Children Feeding Rabbits* . . . . . . . *147*
LOGAN, ROBERT HENRY . . . . . . . . . . . . . . . . . . 168
    *Cider Drinkers* . . . . . . . . . . . . . . . . . . . . . . . . . . *168*
    *Crowded Beach, Le Pouldu* . . . . . . . . . . . . . . . . *113*
    *Red Bather* . . . . . . . . . . . . . . . . . . . . . . . . . . . . . *169*
LOOMIS, CHESTER . . . . . . . . . . . . . . . . . . . . . . . 194
    *Normandy Milkmaid* . . . . . . . . . . . . . . . . . . . . . *194*
LOW, WILL HICOK . . . . . . . . . . . . . . . . . . . . . . . 221
    *L'Interlude: Jardin de MacMonnies* . . . . . . . . . *222*
MacMONNIES, FREDERICK WILLIAM . . . . . . . . 223
    *Portrait of the Artist* . . . . . . . . . . . . . . . . . . . . . *224*
MARTIN, HOMER DODGE . . . . . . . . . . . . . . . . . 188
    *Honfleur Light* . . . . . . . . . . . . . . . . . . . . . . . . . . *189*
MAYNARD, GUY FERRIS . . . . . . . . . . . . . . . . . . 174
    *Breton Interior* . . . . . . . . . . . . . . . . . . . . . . . . . . *174*
METCALF, WILLARD LEROY . . . . . . . . . . . . . . . 198
    *Little Stream at Giverny* . . . . . . . . . . . . . . . . . . *199*
    *Midsummer Twilight* . . . . . . . . . . . . . . . . . . . . . *200*
    *Petit Dejeuner a Quatre Sous:*
    *The Ten Cent Breakfast* . . . . . . . . . . . . . . . . . . *198*
MILLER, RICHARD E. . . . . . . . . . . . . . . . . . . . . . 217
    *Interior* . . . . . . . . . . . . . . . . . . . . . . . . . . . . . . . . *124*
MORAN, EDWARD . . . . . . . . . . . . . . . . . . . . . . . 181
    *Rocs de Toqueville* . . . . . . . . . . . . . . . . . . *180, 181*
MOSLER, HENRY . . . . . . . . . . . . . . . . . . . . . . . . 152
    *Le Retour* . . . . . . . . . . . . . . . . . . . . . . . . . . . . . *153*
NICHOLLS, BURR H. . . . . . . . . . . . . . . . . . . . . . . 154
    *Sunlight Effect* . . . . . . . . . . . . . . . . . . . . . . . . . *154*
NORTON, WILLIAM EDWARD . . . . . . . . . . . . . 186
    *The Last Load* . . . . . . . . . . . . . . . . . . . . . . . . . . *186*
PARKER, LAWTON S. . . . . . . . . . . . . . . . . . . . . . 220
    *Woman in a Boat* . . . . . . . . . . . . . . . . . . . . . . . *220*
PARRISH, STEPHEN . . . . . . . . . . . . . . . . . . . . . . 182
    *Drying Sails at Granville, Normandy* . . . . . . . . *182*
PEARCE, CHARLES SPRAGUE . . . . . . . . . . . . . . 195
    *Water Carrier* . . . . . . . . . . . . . . . . . . . . . . . . . . *107*
PERRY, LILLA CABOT . . . . . . . . . . . . . . . . . . . . 214
    *Angela* . . . . . . . . . . . . . . . . . . . . . . . . . . . . . . . . *214*
    *Giverny Landscape (In Monet's Garden)* . . . . . . *122*
PICKNELL, WILLIAM LAMB . . . . . . . . . . . . . . . 148
    *Landscape, Brittany* . . . . . . . . . . . . . . . . . . . . . *148*
    *Pont-Aven Harbor* . . . . . . . . . . . . . . . . . . . . . . *149*
    *The Road to Concarneau* . . . . . . . . . . . . . . . . . *115*

PLATT, CHARLES ADAMS . . . . . . . . . . . . . . . . . 132
    *Brittany* . . . . . . . . . . . . . . . . . . . . . . . . . . . . . . . *132*
PRENDERGAST, MAURICE . . . . . . . . . . . . . . . . 175
    *Dieppe* . . . . . . . . . . . . . . . . . . . . . . . . . . . . . . . . *176*
    *The Lighthouse, St. Malo* . . . . . . . . . . . . . . . . . *175*
RAMSEY, MILNE . . . . . . . . . . . . . . . . . . . . . . . . . 150
    *Road in Brittany* . . . . . . . . . . . . . . . . . . . . . . . . *150*
RITTER, LOUIS . . . . . . . . . . . . . . . . . . . . . . . . . . 212
    *Giverny* . . . . . . . . . . . . . . . . . . . . . . . . . . . . . . . *213*
ROBINSON, THEODORE . . . . . . . . . . . . . . . . . . 201
    *Along the Stream* . . . . . . . . . . . . . . . . . . . . . . . *202*
    *Giverny* . . . . . . . . . . . . . . . . . . . . . . . . . . . . . . . *201*
    *Two in a Boat* . . . . . . . . . . . . . . . . . . . . . . . . . . *203*
    *The Wedding March* . . . . . . . . . . . . . *Front Cover, 204*
ROSE, GUY . . . . . . . . . . . . . . . . . . . . . . . . . . . . . 215
    *Late Afternoon, Giverny* . . . . . . . . . . . . . . . . . . *215*
SARGENT, JOHN SINGER . . . . . . . . . . . . . . . . . 135
    *Breton Girl with a Basket, Sketch for the*
    *Oyster Gatherers at Cancale* . . . . . . . . . . . . . . *137*
    *Low Tide at Cancale Harbor* . . . . . . . . . . . . . . . *135*
    *Octopi on Deck of Fishing Smack* . . . . . . . . . . . *136*
    *The Oyster Gatherers at Cancale* . . . . . . . . . . . *109*
    *Sketch for the Oyster Gatherers at Cancale* . . . . *137*
    *Young Boy on the Beach: Sketch for the*
    *Oyster Gatherers at Cancale* . . . . . . . . . . . . . . *136*
SIMMONS, EDWARD EMERSON . . . . . . . . . . . . 161
    *Awaiting His Return* . . . . . . . . . . . . . . . . . . . . . *106*
SMILLIE, JAMES DAVID . . . . . . . . . . . . . . . . . . 184
    *Falaise d'Aval, Etretat* . . . . . . . . . . . . . . . . . . . *185*
    *Le Manneporte, Etretat* . . . . . . . . . . . . . . . . . . *184*
SWIFT, CLEMENT . . . . . . . . . . . . . . . . . . . . . . . . 141
    *Une Épave (The Spar)* . . . . . . . . . . . . . . . . . . . . *141*
TRYON, DWIGHT W. . . . . . . . . . . . . . . . . . . . . . 190
    *Granville: Mouth of the Bay (Bay St. Michel)* . . . *190*
TWACHTMAN, JOHN HENRY . . . . . . . . . . . . . . 167
    *Shrine on the Bridge, Honfleur, Normandy* . . . . . . . *117*
VAIL, EUGENE LAURENT . . . . . . . . . . . . . . . . . 159
    *A Breton Sunday* . . . . . . . . . . . . . . . . . . . . . . . *159*
VEDDER, ELIHU . . . . . . . . . . . . . . . . . . . . . . . . . 129
    *The Tinker* . . . . . . . . . . . . . . . . . . . . . . . . . . . . *130*
    *Vitré, Evening* . . . . . . . . . . . . . . . . . . . . . . . . . . *130*
    *Woman Planting a Flower Pot, Vitré* . . . . . . . . . *129*
WEIR, JULIAN ALDEN . . . . . . . . . . . . . . . . . . . . 142
    *Breton Farm* . . . . . . . . . . . . . . . . . . . . . . . . . . . *142*
WENDEL, THEODORE . . . . . . . . . . . . . . . . . . . . 211
    *Girl Fishing in a Stream* . . . . . . . . . . . . . . . . . . *211*
    *Girl with Turkeys, Giverny* . . . . . . . . . . . . . . . . *121*
WHISTLER, JAMES ABBOTT McNEILL . . . . . . . . 131
    *Alone with the Tide (Coast of Brittany)* . . . . . . . *105*
    *The Sea* . . . . . . . . . . . . . . . . . . . . . . . . . . . . . . . *131*
WYLIE, ROBERT . . . . . . . . . . . . . . . . . . . . . . . . . 134
    *A Fortune Teller of Brittany* . . . . . . . . . . . . . . . *110*

# Bibliography

**Compiled by David Sellin**

## Books and Exhibition Catalogues

Armstrong, D. Maitland, *Day Before Yesterday, Reminiscences of a Varied Life*, New York, 1920.

Art Institute of Chicago, *Paintings by Lawton Parker* (exhibition catalogue), Chicago, 1912.

Bacon, Henry, *Parisian Art and Artists*, Boston, 1883.

Beaux, Cecilia, *Background with Figures*, Boston / New York, 1930.

Bermingham, Peter, *American Art in the Barbizon Mood* (exhibition catalogue), National Collection of Fine Arts, Smithsonian Institution Press, Washington, D.C., 1975.

Bizardel, Yvon, *American Painters in Paris*, New York, 1960.

Blackburn, Henry, *Breton Folk, An Artistic Tour in Brittany*, Boston, 1881.

Boas, George (ed.), *Courbet and the Naturalist Movement: Essays Read at the Baltimore Museum of Art*, Baltimore, 1938.

Boime, Albert, *The Academy and French Painting in the Nineteenth Century*, London, 1971.

Boyle, Richard, *American Impressionism*, New York Graphic Society, Boston, 1974.

Burke, Doreen Bolger, *American Paintings in the Metropolitan Museum of Art*, vol. III, New York, 1980.

Caffin, Charles H., *The Story of American Painting*, New York, 1907.

Champney, Benjamin, *Sixty Years' Memories of Art and Artists*, Woburn, Massachusetts, 1900.

City Museum of St. Louis, Chicago Art Institute, Worcester Art Museum, *Retrospective Exhibition of Paintings by Alexander Harrison, N.A. and Birge Harrison, N.A.*, introduction by Arthur Hoeber, 1913-14.

Clark, Eliot, *Theodore Robinson: His Life and Art*, R.H. Love, Chicago, 1975.

Clark, Eliot, *History of the National Academy of Design, 1825-1953*, New York, 1954.

Cook, Clarence, *Art and Artists of Our Time*, 3 volumes, New York, 1888.

Cummer Gallery of Art, *Edmund W. Greacen, N.A., American Impressionist* (exhibition catalogue), Jacksonville, Florida, 1972.

Delauche, Denise, *Peintres de la Bretagne: Decouvert d'une Province*, Publications de l'Université de Haute Bretagne, Librairie Klincksieck, Rennes, 1977.

Domit, Moussa, *American Impressionist Painting* (exhibition catalogue), National Gallery of Art, Washington, D.C., 1973.

Douglas Hyde Gallery, Trinity College, *The Peasant in French 19th Century Art*, Dublin 1980; Essays by James Thompson, John Horne, Madeleine Fidell-Beaufort, Monique de Pelley Fonteny, Julian Campbell.

Feldman, William Stephen, *The Life and Work of Bastien-Lepage*, Ph.D. Dissertation, New York University, New York, 1973.

Ferguson, Charles B., *Dennis Miller Bunker Rediscovered* (exhibition catalogue), New Britain Museum of American Art, Connecticut, 1978.

Fidell-Beaufort, Madeleine, *The Peasant in French 19th Century Art* (exhibition catalogue), Douglas Hyde Gallery, "Peasants, Painters and Purchasers," Trinity College, Dublin, 1980.

Flexner, James Thomas, *Nineteenth Century American Painting*, G.P. Putnam's Sons, New York, 1970.

Gay, Walter, *Memories of Walter Gay*, New York, 1930.

Gerdts, William H., *American Impressionism* (exhibition catalogue), The Henry Art Gallery, University of Washington, Seattle, 1980.

Goley, Mary Anne, *John White Alexander* (exhibition catalogue), National Collection of Fine Arts, Smithsonian Institution Press, Washington, D.C., 1977.

Guild Hall, *East Hampton: The American Barbizon, 1850-1900* (exhibition catalogue), East Hampton, New York, 1969.

Grey Art Gallery, *Walter Gay, A Retrospective* (exhibition catalogue), essay by Gary A. Reynolds, New York University, New York, 1980.

Hartmann, Sadakichi, *A History of American Art*, vol. I, Boston, 1902.

Hartrick, Archibald S., *A Painter's Pilgrimage Through Fifty Years*, Cambridge, 1939.

Havens, George R., *Frederick J. Waugh, American Marine Painter*, Orono, Maine, 1969.

Hills, Patricia, *Turn-of-the-Century America* (exhibition catalogue), Whitney Museum of American Art, New York, 1977.

Hirshl-Adler Galleries, *Lilla Cabot Perry: A Retrospective Exhibition*, New York, 1969.

Homer, William Inness, *Robert Henri and His Circle*, Cornell University Press, Ithaca, New York / London, 1969.

Hoopes, Donelson F., *The American Impressionists*, Watson-Guptil, New York, 1972.

Howard, Blanche Willis, *Guenn, A Wave on the Breton Coast*, Boston, 1883.

Jaworska, Wdadyslawk, *Gauguin and the Pont-Aven School*, New York Graphic Society, Boston, 1972.

Johnson, Arthur W., *Arthur Wesley Dow*, Ipswich, Massachusetts, 1934.

Johnston, Sona, *Theodore Robinson* (exhibition catalogue), Baltimore Museum of Art, 1973.

Joyes, Claire, *Monet at Giverny*, Mathews Miller Dunbar, London, 1975.

Kimbrough, Sara Dodge, *Drawn from Life*, University of Mississippi Press, Jackson, 1976.

Lasar, Charles Augustus, *Practical Hints to Art Students*, New York, 1910.

Loe, Elva Fromuth, *The Fromuth Journal: Reflections on Art by an American Painter in France*, unpublished Master's Thesis, Catholic University, Washington, D.C., 1960.

Love, Richard H., *Theodore Earl Butler* (exhibition catalogue), Signature Galleries, Chicago, 1976.

Low, Will H., *Chronicles of Friendship*, New York, 1908.

Marlor, Clark S., *A History of the Brooklyn Art Association with an Index of Exhibitions*, James F. Carr, New York, 1970.

Mathews, Marcia M., *Henry Ossawa Tanner, American Artist*, University of Chicago Press, Chicago/London, 1969.

Maxwell Galleries, *A Retrospective Exhibition of the Work of F.C. Frieseke*, San Francisco, 1982.

Moffatt, Frederick C., *Arthur Wesley Dow (1857-1922)* (exhibition catalogue), National Collection of Fine Arts, Smithsonian Institution Press, Washington, D.C., 1977.

Morris, Harrison S., *Confessions in Art*, New York, 1930.

National Collection of Fine Arts, *Perceptions and Evocations: The Art of Elihu Vedder* (exhibition catalogue), Smithsonian Institution Press, Washington, D.C., 1979.

Novak, Barbara, *American Painting in the Nineteenth Century*, New York, 1969.

Ormond, Richard, *John Singer Sargent*, New York/Evanston, 1970.

Pennsylvania Academy of the Fine Arts, *Cecilia Beaux: Portrait of an Artist* (exhibition catalogue), introduction by Richard J. Boyle, Philadelphia, 1974.

Quick, Michael, *American Expatriate Painters of the Late Nineteenth Century* (exhibition catalogue), The Dayton Art Institute, Ohio, 1976.

Rewald, John, *The History of Impressionism*, 4th revised edition, Museum of Modern Art, New York, 1973.

Rothenstein, William, *Men and Memories*, vol. I, Cambridge, 1931.

Schweitzer, Paul D., *Edward Moran* (exhibition catalogue), Delaware Art Museum, Wilmington, 1979.

Sellin, David, *The First Pose: Howard Roberts, Thomas Eakins and a Century of Philadelphia Nudes*, New York, 1976.

Sheldon, George W., *American Painters*, New York, 1881.

Sheldon, George W., *Recent Ideals in American Art*, New York, 1890.

Shinn, Earl (pseud. Edward Strahan), *The Art Treasures of America*, three volumes, Philadelphia, 1880.

Shinn, Earl (pseud. Edward Strahan), *The Chefs d'Oeuvres of the Exposition*, Philadelphia, 1878.

Shirley-Fox, John, *An Art Student's Reminiscences of Paris in the Eighties*, London, 1909.

Simmons, Edward, *From Seven to Seventy, Memories of a Painter and a Yankee*, New York/London, 1922.

Slatkin, Charles E., *Claude Monet and the Giverny Artists* (exhibition catalogue), essays by Robert M. Coates, "Recollections of Giverny" and Malcolm Cowley, "The Butlers of Giverny," Slatkin Galleries, New York, 1960.

Smithsonian Institution Traveling Exhibition Service, *Impressionistes Americains*, introduction by Barbara Novak, Smithsonian Institution Press, Washington, D.C., 1982.

Soria, Regina, *Elihu Vedder: American Visionary Artist in Rome*, Fairleigh Dickinson University Press, Rutherford, New Jersey, 1970.

Stranahan, C.H., *A History of French Painting from its Earliest to its Latest Practice*, New York, 1888.

Sturgis, Russell, *The Appreciation of Pictures*, New York, 1905.

Sutton, Denys, *Gauguin and the Pont-Aven Group*, Arts Council of Great Britain, London, 1966.

Vachell, Horace Annesley, *The Face of Clay, an Interpretation*, New York, 1906.

Vedder, Elihu, *The Digressions of V*, Boston/New York, 1910.

Venturi, Lionello, *Les Archives de l'Impressionisme*, two volumes, Paris/New York, 1939.

Warshawsky, Abel G., *The Memories of an American Impressionist*, Kent State University Press, Ohio, 1980.

White, Henry C., *The Life and Art of Dwight W. Tryon*, Boston/New York, 1930.

Wildenstein Galleries and the Philadelphia Museum of Art, *From Realism to Symbolism: Whistler and His World* (exhibition catalogue), New York, 1971.

William Benton Museum of Art, *Connecticut and American Impressionism* (exhibition catalogue), three essays: Jeffrey W. Anderson, "The Art Colony at Old Lyme," Susan G. Larkin, "The Cos Cob Clapboard School" and Harold Spencer, "Reflections on Impressionism, Its Genesis and American Phase," University of Connecticut, Storrs, 1980.

Williams, Blanche E. Wheeler, *Mary C. Wheeler, Leader in Art Education*, Boston, 1934.

Yarnall, James L., *The Role of Landscape in the Art of John La Farge*, Ph.D. Dissertation, University of Chicago, 1981.

Young, Andrew McLaren and Margaret MacDonald, Robin Spencer, Hamish Miles, *The Paintings of James McNeill Whistler*, two volumes, Yale University Press, New Haven/London, 1980.

Young, Dorothy Weir, *The Life and Letters of J. Alden Weir*, Yale University Press, New Haven, 1960.

## Manuscripts

Unpublished manuscript sources are cited in the notes to the text as they are quoted or used.

# Periodicals

Bailey, Elizabeth G., "The Cecilia Beaux Papers," *Archives of American Art Journal*, vol. XIII, no. 4, 1973, pp. 14-19.

Baur, John I.H., "Introducing Theodore Wendel," *Art in America*, vol. LXIV, no. 6, 1976, pp. 102-112.

Blackburn, Henry, "Pont-Aven and Douarnenez," *The Magazine of Art*, 1878, pp. 6-9.

Borgmeyer, Charles L., "Alexander Harrison," *Fine Arts Journal*, vol. XXIX, 3 September, 1913, pp. 515-544.

Butler, A.V., "Robert Wylie," *The Aldine*, vol. IX, 1878-1879, p. 77f.

Childs, Theodore, "American Artists at the Paris Exposition," *Harper's New Monthly Magazine*, vol. LXXIX, 472, 1889, pp. 489-521.

Coburn, Frank W., "Philip L. Hale," *The Art Students New England Magazine*, vol. XXXVIII, no. 2, 1908, pp. 196-197.

Coburn, Frank W., "Philip L. Hale, Artist and Critic," *The World Today*, vol. XIV, no. 1, 1908, pp. 59-67.

Cooper, W.A., "Artists in Their Studios: Henry Mosler," *Godey's Magazine*, vol. CXXX, June, 1895, pp. 564-570.

Delouche, Denise, "Pont-Aven Avant Gauguin," *Bulletin des Amis du Musée de Rennes*, Summer, 1978, Special number on Pont-Aven.

DeVere, Elizabeth, "Willard Metcalf's 'Ten Cent Breakfast'," *19th Century Magazine*, vol. III, no. 4, 1977, pp. 51-53.

Eldredge, Charles, "Connecticut Impressionists: The Spirit of Place," *Art in America*, vol. LXII, no. 5, 1974, pp. 84-90.

Emanuel, Frank L., "Concarneau, a Sketching Ground," *Studio*, vol. IV, 1895, p. 180.

Emerson, Edward Waldo, "An American Landscape Painter: William Lamb Picknell," *The Century Magazine*, vol. LXII, 1901, p. 710f.

Fink, Lois, "American Artists in France, 1850-1870," *The American Art Journal*, vol. V, November, 1973, pp. 32-49.

Goater, Anne C., "A Summer in an Artistic Haunt," *Outing*, vol. VII, October, 1885, pp. 2-12.

Harrison, L. Birge, "Quaint Artistic Haunts in Brittany, Pont-Aven and Concarneau," *Outing*, vol. XXIV, April 1894, pp. 25-32.

Harrison, L. Birge, "In Search of Paradise with Camera and Palette," *Outing*, vol. XXI, 1893, pp. 310-318.

Harrison, L. Birge, "The New Departure in Parisian Art," *Atlantic Monthly*, vol. LXVI, 1890, pp. 753-764.

Heaton, Augustus G., "The Nutshell," N.B. an irregular periodical privately published by the author and distributed to subscribers. The only complete collection bound in one volume is in the Office of the Architect, U.S. Capitol, Washington, D.C., the gift of the artist.

Hoeber, Arthur, "A Summer in Brittany," *The Monthly Illustrator*, vol. IV, no. 2, 1895, pp. 74-80.

Hooper, Lucy H., "American Art in Paris," *The Art Journal*, vol. IV, 1878, p. 89ff.

Inness, George, "An Artist on Art" (interview), *Harper's New Monthly Magazine*, vol. LVI, 1878, pp. 458-461.

Klein, René, "Concarneau, Ville de Peintres," *Les Cahiers de l'Irois, Société d'Etudes de Brest et de Léon*, vol. XII, April-June, 1965.

Maurice, Rene, "Autour de Gauguin, Sa Rixe à Concarneau avec les Marins Bretons," *NRB*, 1953.

Moffatt, Frederick C., "The Breton Years of Arthur Wesley Dow," *Archives of American Art Journal*, vol. XV, no. 2, 1975, pp. 2-8.

Pach, Walter, "At the Studio of Claude Monet," *Scribner's Magazine*, vol. XLIII, 1908, pp. 765-768.

Perry, Lilla Cabot, "Reminiscences of Claude Monet from 1889 to 1909," *The American Magazine of Art*, vol. XVIII, no. 3, 1927, p. 119ff.

*Pont-Aven*, AMR: Bulletin of the Museum of Art of Rennes, Summer, 1978. Special issue entirely devoted to articles on the art of Pont-Aven.

Price, Newlin, "Karl Anderson, American," *International Studio*, November, 1922, pp. 132-139.

Quigley, J., "Some Art Colonies in Brittany," *The Craftsman*, 1906, pp. 701-706.

Sadler, Fernande, "L'Hotel Chevillon et les Artistes de Grès-sur-Loing," *L'Informateur de Seine-et-Marne: Fontainbleau*, n.d.

Shinn, Earl (pseud. Edward Strahan), "Art Study in the Imperial School at Paris," *The Nation*, vol. IX, July 22, 1869, pp. 67-69.

Shinn, Earl (pseud. Edward Strahan), "Frederick A. Bridgman," *Harper's*, vol. LXIII, 1881, pp. 694-705.

Shinn, Earl (pseud. L'Enfant Perdu), "Rash Steps," *The Philadelphia Bulletin*, passim, 1866-1867.

Shinn, Earl (pseud. Edward Strahan), "Works of American Artists Abroad: The Second Philadelphia Exhibition," *Art Amateur*, vol. VI, December, 1881, pp. 4-6.

Sutton, Denys, "Echoes from Pont-Aven," *Apollo*, May, 1864, pp. 403-406.

Taylor, E.A., "The American Colony of Artists in Paris" (3 parts), *International Studio*, June, 1911, pp. 263-281, August, 1911, pp. 103-115, June, 1912, pp. 280-284.

Todd, Charles Burr, "The American Barbizon," *Lippincott's Magazine*, vol. V, 1883, pp. 321-328.

Toulgouat, Pierre, "Peintres Americains a Giverny," *Rapports France–Etats Unis*, no. 62, 1952, pp. 65-73.

Toulgouat, Pierre, "Skylights in Normandy," *Holiday*, August, 1948, pp. 66-70.

Weinberg, J. Barbara, "Nineteenth-Century American Painters at the École des Beaux Arts," *The American Art Journal*, vol. XIII, no. 4, 1981, pp. 66-84.

Weller, Allen S., "Frederick C. Frieseke: The Opinions of an American Impressionist," *Art Journal*, vol. XXVIII, Winter, 1968-1969, pp. 160-165.

Zug, George B., "The Art of Lawton Parker," *The International Studio*, vol. LVII, December, 1915, pp. 37-43.

Anonymous. "Bridgman's 'American Circus in France'," *The Art Journal*, vol. II, 1876, pp. 48-49.

Anonymous. "A Visit de Bois d'Amour," *Belgravia*, 1893, p. 283.

## Credits

Catalogue and essay by David Sellin
Exhibition organized by James K. Ballinger
Giverny map by Jean Marie Toulgouat
Giverny text for map by Claire Joyes
Pont-Aven map and text by Charles Guy LePaul
Catalogue design and production by Theron Hardes
Typography by Central Avenue Typesetting
Lithography by Prismagraphic Corporation